Seasons in Basilicata

Seasons in Basilicata

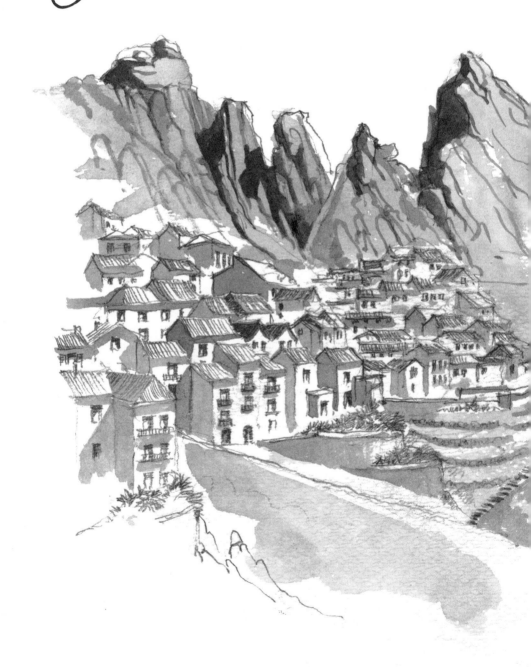

A Year in a Southern Italian Hill Village

Written and Illustrated by
DAVID YEADON

*HarperCollins*Publishers

HarperCollins books may be purchased for educational, business, or sales promotional use. For information, please write: Special Markets Department, HarperCollins Publishers Inc., 10 East 53rd Street, New York, NY 10022.

FIRST EDITION

Designed by Nicola Ferguson

Printed on acid-free paper

Library of Congress Cataloging-in-Publication Data

Yeadon, David.
Seasons in Basilicata : a year in a southern italian hill village / written and illustrated by David Yeadon—1st ed
p. cm.
ISBN 0-06-053110-X
1. Basilicata (Italy)—Description and travel. 2. Basilicata (Italy)—Social life and customs. 3. Yeadon, David—Homes and haunts—Italy— Basilicata. 4. Authors, American—20th century—Biography. I. Title.

DG975.B3Y43 2004
945'.772—dc22
[B] 2004042894

04 05 06 07 08 ❖/RRD 10 9 8 7 6 5 4 3 2 1

FOR

CARLO LEVI

WHOSE BOOK

Christ Stopped at Eboli

INSPIRED US

TO EMBARK ON THE JOURNEY

AND LIVE THE ADVENTURE

AND

ALL OUR BASILICATAN FRIENDS

WHO MADE OUR EXPERIENCES

SO DEEPLY MEANINGFUL

—AND ALWAYS ENJOYABLE

This is a closed world, shrouded in black veils, bloody and earthy—that other world where the peasants live and which no one can enter without a magic key . . .

—Carlo Levi, *Christ Stopped at Eboli*

Contents

Illustrations {xi}
A Few Notes {xiii}

THE FIRST SPRING
 Prologue: A View from Our Terrace {3}
 Chapter 1 : The Lure of Levi {11}
 Chapter 2 : Entering "The Land of the Magic Key" {36}
 Chapter 3 : Seeking a Home {82}
 Chapter 4 : A Home in Aliano {115}

SUMMER
 Introduction {155}
 Chapter 5 : Mood Shifts {157}
 Chapter 6 : Celebrations {193}
 Chapter 7 : Strangenesses {237}

AUTUMN
 Introduction {283}
 Chapter 8 : Rhythms and Rites {285}
 Chapter 9 : Flowing {321}

WINTER
 Introduction {357}
 Chapter 10 : Going Deeper {361}
 Chapter 11 : Closures {432}

Illustrations

Map of Italy/Aliano {endpapers}

SPRING
Castelmezzano and the Lucanian Dolomites {iv–v}
Aliano and the *calanchi* landscape {xvi–1}
Accettura Alley {9}
Carlo Levi {13}
Basilicatan panorama {16}
Maratea Porto (near Sapri) {30}
Maratea {37}
Castelmezzano {47}
Pietrapertosa {50}
Matera {60}
Matera montage {69}
Fossa del Bersagliere—Aliano {87}
Accettura {94–95}
Accettura's *Maggio* Festival {103}
Giuliano {109}
Don Pierino {119}
View from our Aliano terrace {134–35}
Woman in "Lower" Aliano {147}

SUMMER
Craco ghost village {152–53}
Man at Carlo Levi house {167}
Felicia {173}

xii

Traditional bagpipe band {190}
Aliano alley {202}
Pastori shepherd {215}
Stigliano potter {234}
Craco {247}
Terroni couple {261}
Elderly village woman {279}

AUTUMN
Missanello {280–281}
Spagna family crest {289}
Vito {294}
Giuliano's *vendemmia* equipment {301}
Vittoria {309}
Olive tree {317}
Margherita and Tori's estate {333}
Missanello scene {347}

WINTER
Aliano *Carnevale* {354–55}
Typical olive mill {364}
Calanchi landscape {372–73}
The pig slaughter {381}
Mingalone *cantina* {397}
Hill town near Potenza {423}
Giulia Venere (Levi's witch) {439}
Aliano *Carnevale* {451}
Aliano—enduring, ongoing… {463}

A Few Notes

Interpreters and Translators

Readers might be impressed by the apparent alacrity with which Anne and I mastered the Italian language, particularly as this was only our third visit to the country and our initial linguistic capabilities were little more than a quickly learned series of "Useful Words and Phrases for Travelers" found at the back of a guidebook.

And, to be honest, even when we left Basilicata almost a year later, our Italian was still rather elementary and our grasp of local dialects almost nonexistent. (Even the locals in different villages have problems with multitudinous regional dialects.) Fortunately Italians tend to have a far better grasp of English than Anglophones have of Italian, and we invariably found people close at hand who were willing to interpret for us. For longer interviews we usually asked our many friends in the villages to help out, which they usually did with surprising eagerness. People such as the Mingalones, the Villanis, Antonio Pagnotta, and Maria Cecere deserve special mention, not only for their interpretive skills but also for their many other kindnesses throughout our stay.

Illustrations

Some readers might also be curious about the intended mélange of styles I've chosen to use for my illustrations. In previous books I've

tended to select one particular medium and stick with it throughout. But in the case of this book the images were often so distinct and strong in character that I decided to let them tell me which medium I should use—pencil, pen, bamboo pen, ink and wash, etc. I used a similar "let the subject speak" approach in a previous book, *The Way of the Wanderer: Discovering Your True Self Through Travel*. But of course that book was also about the way in which true travel can release "multi-self" aspects of oneself—the protean potentials we all possess but often, for one reason or another, choose to ignore. Being a celebrant of Walt Whitman's "I contain multitudes" philosophy, James Hillman's "community of many interior persons" approach, and Thomas Moore's view that there is a "peacock's tail" of human possibilities in each individual, I try to allow the serendipity and constant surprise of "randoming" travel nudge less familiar facets of myself out into the light of day to play. Ditto the approach to my illustrations. They're all mine. They just reflect very different subjects and different "me"s.

Individual Privacy

Wherever possible I have retained the real names of the people we met in Basilicata, but in cases where they requested anonymity or where I sensed a potential cause for embarrassment, I have changed the names. But they know who they are . . . and how grateful we remain for their advice, kindnesses, and revelations.

Seasons in Basilicata

The First Spring

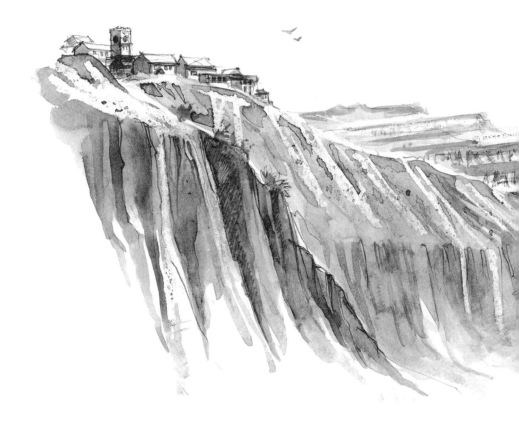

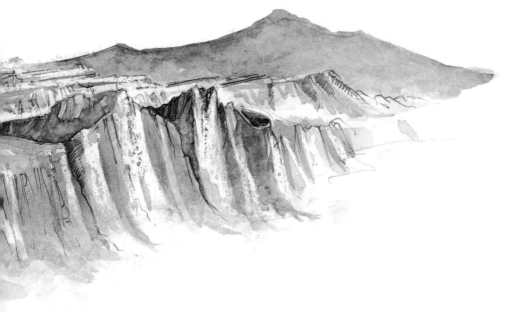

ALIANO'S *CALANCHI* LANDSCAPE

PROLOGUE

A View from Our Terrace

Mussolini was restless.

The name of Massimo's retired hunting dog was really Federico, but the animal's arrogant, swaggering gait had always seemed so remarkably Mussolini-like in flair and style that his nickname had stuck. Now his enormous paunch heaved and rolled listlessly, and his legs and arms quivered, each to a different rhythm.

"It's spring. In winter he sleeps without moving, but when the blossoms come he's always dreaming and twitching. He's somewhere far away, in dog heaven," murmured Massimo. He had a quiet way of talking, as if there were parts of himself he was disinclined to disturb. A single translucent bead of perspiration slipped gently down his bronzed forehead, along the bridge of his nose, and came to rest, slightly wobbly, on the tip.

Massimo, a young, cherub-faced man, was owner with his father, Angelo, of the small Hotel SanGiuliano, in the town of Accettura. He had taken Anne and me under his wing when we first arrived in Basilicata and quickly became a close friend and general "facilitator" of our social and other local affairs. Today we'd invited him over to see our new rented home in Aliano.

The three of us lay sprawled in various ungainly postures of utter relaxation on our terrace chairs overlooking the main piazza of our

adopted hill village, a tiny community of a thousand residents, perched on a barely accessible ridgetop bound by canyons and gorges hundreds of feet deep. Here we were at last, deep in the mountains and forests of Basilicata, a wild and remarkably unexplored region in the instep of Italy's "boot," in a small settlement that can trace its origins back to at least 6000 B.C.

It was unseasonably hot; even the normally cool breeze had heat in it. Massimo called it "the breath of Africa," but at least it wasn't the blast-furnace *scirocco*, a hot wind full of Saharan sand, that is the curse of Mezzogiorno (southern Italy) summers. In the distance the high, dark ridges of the forest of Gallipoli Cognato rippled in the heat haze. Far, far below, the broad valley of the Agri River was lost in ethereal mists.

The scene before us would have done justice to Dante's *Paradiso*. While the far ridges were thickly wooded, the valley sides were a quiltlike profusion of early-spring cherry and peach blossoms; ragged rows of olive trees with their tiny fluttering green-silver leaves and contorted monsterlike trunks; patches of tilled earth, moist and gleaming, awaiting early crop plantings; and the occasional golden-stone barn or small farmhouse wrapped in trellised vines. Incongruous clusters of Lombardy poplars rose like tall, green flames against the stony horizontals of classical Roman–era terraces. Despite a definite Dakota-like wildness in the scenery immediately around Aliano, the place exuded proud self-sufficiency, built upon an ancient peasant legacy of rites and rituals, and a deep trust in the munificence of nature. It felt strong, long rooted, and enduring.

Attention turned to our impromptu picnic among the rooftops. On a large, flat village-made *piatto* (plate) lay wafer-thin, almost translucent slices of *prosciutto crudo*, a gift from Giuliano, our sprightly, sixty-three-year-old friend, also from Accettura. The *prosciutto* had maintained its purple-red luster and salty sweetness. "This piece has been cured in my *cantina* [garage] for two years," Giuliano had told Anne with pride the previous evening as he handed her a hefty slab of pig thigh wrapped in cheesecloth. He was

a stocky little bull of a man, with a raspy voice, a lilting lisp, due largely to the absence of front teeth, and an almost constant cherubic grin that wobbled his facial tundra of sun-scorched cheeks and jowls beneath his sweat-stained, flat *coppola* cap. "I use only salt. No chemicals. They spoil flavor. This one is special one. More deeper taste. Most peoples have a pig, but I feed mine on special nuts. Makes very, very tasty."

Giuliano had also handed Anne an enormous round of golden, crisp-crusted, high-domed bread. "From Rosa, my wife. More better than from *forno* [bakery]. She thinks you very nice lady." Anne had smiled, maybe even blushed a little. But Giuliano had blushed even more when he added, "And me, *permesso*, also I think same." Then he promptly covered up his embarrassment at such an intimate revelation and insisted that "one day, very soon, you will come for big country breakfast on big fire down at my kiln in the valley." This was his great pride—an ancient, three generations' old brick kiln and clay pit, at which, he claimed, he worked as the last handicrafter in Basilicata of classical Roman–style curved roof pantiles.

The other snacks for our picnic had come courtesy of Massimo himself, who, like most male residents of Accettura, considered himself something of a do-it-yourself *macellaio* (butcher). Deep from his own cellar he'd brought pungent slices of mortadella (baloney), *soppressata* (head cheese), *pancetta* (bacon), a dark and chewy salami, and moist chunks of *coppa* (cured neck of pork), along with a garlic and scorching-hot *peperoncini* dipping sauce and a delicious olive oil–shiny *caponata* of chopped eggplant, tomatoes, and olives.

"My own tomatoes and my own olives," he'd boasted, stretching out his hands and long fingers, delicate as praying mantises. Almost every family in the village seemed to have its own small vegetable plot, and all invariably claimed to produce "the best." And then, almost as an afterthought, he'd pulled out a bottle of wine from his ever-present shoulder bag of boar hide with needle-like sproutings of boar hair. "I think . . . I hope you will both like this," he said as he vigorously stroked his cheek, then ran a thick-

fingered hand through his unruly mop of black hair (both signs, we'd learned, of his quirky, gift-giving insecurity) and gently handed us a ten-year-old Aglianico del Vulture, the pride of Basilicatan wine making, and one of southern Italy's most renowned reds. The label was Paternoster, according to the oenophilic cognoscenti the finest winery of the region, way up in the northeastern sector of Basilicata, near the ancient pre-Roman city of Melfi.

"*Bellissimo!*" I said, as we gushed our gratitude.

"*Andiamo,*" said Massimo. "Let's go, let's eat." But we could tell he enjoyed our thanks. He loved giving little spontaneous gifts, and his face glowed like a happy, benevolent angel.

And that was our downfall on that warm afternoon: A couple of glasses each of that gorgeous, almost black, wine, along with the ham, salami, olives, Rosa's bread, and golden chunks of homemade sheep's-milk pecorino cheese—courtesy of Nicolà, Massimo's grandfather, who lived in "the family Great House" over in the next valley—and we had little incentive or energy to do anything other than watch the doings and dawdlings in the piazza below us.

THE DAY OF MASSIMO's *merenda* picnic on our terrace had begun early. Very early. The emergence of dawn—which Anne and I loved to watch from our terrace—had brought the usual dove-and-cockerel chorus, echoing along the spooling streets and alleys that tumbled down the hillside and rolled to a stop around the church and the ancient village fountain. Then came the regular, and very traditional, flurry of activity: the four coffee bars along Via Roma opened promptly at six-thirty, doling out endless tiny cups of super-strength espresso, *corretto* shots of grab-your-throat grappa ("*eau de vie*"), and *cornetti* (sweet croissantlike pastries). The slowly expanding huddles of older men in berets and ancient, battered trilby hats began to gather around the bars. The oldest, some barely able to walk, held court from their plastic chairs, while the "younger" men (the sixty-to-seventy-five age group) stood respectfully nearby, listening to the murmured wisdom of their elders.

Then the small stores began to open: the *latteria, farmacia, frutteria, tabaccheria,* and the two *macellerie.*

By this time the two street sweepers were out, the brothers Antonio and Salvatore Grossi. Each wielded his handcrafted broom, the brushes of which were actually made from still-green branches and sharp little leaves of broom, a tough plant that grows in wild, clumpish profusion all around the town on the rock-pocked slopes beneath the wild *calanchi* canyons and buttes. In the distance were the vast oak forests of Montepiano and Parco Gallipoli, and the exotically eroded pinnacles and fangs of the Lucanian Dolomites. This had become one of my favorite places to sketch, around these soaring, four-hundred-foot-high spearheads of stone, home to the tight-packed, chaotically mazed and alleyed hill villages of Pietrapertosa and Castelmezzano, and their even more intensely warrened and nearly vertical "Rabatanas," or "Saracen quarters." I've found no places anywhere in Italy quite so hidden or dramatically blended with the landscape as these places. And I've looked. I'm a fanatical lover of hill towns and their jumbled fantasy forms. But these two tiny communities are indeed unique and, as will be revealed later, in far more intriguing ways than merely for their idiosyncratic architectural attributes.

As lunchtime approached, the midday heat increased in the piazza and it began to empty, except for the ever-present, neurotically active Pietro Petracca, Aliano's notorious geriatric parking attendant. Despite the absence of any significant traffic (Aliano is, after all, very much off Basilicata's beaten track and Basilicata doesn't really even *have* much in the way of beaten track in the first place), Pietro somehow manages to ticket enough unfortunate locals for minute regulatory transgressions to justify his job—much to the chagrin of the village's young drivers, who have been plotting revenge for his vigilance for months but don't seem to have arrived at any concerted plan yet.

We watched the older men slowly disappear into the maze of wriggling, shadowy alleys and stepped streets that lead to the "high town" on top of Aliano's hill and curl around its main church. This

edifice is impressive externally, with its bold brick-and-stone massiveness, but dustily threadbare and devoid of decoration inside. The residents of Aliano are mainly small-plot farmers and olive-growers, so excessive churchly exuberance does not reflect their ancient peasant and, as they proudly call them, *pagani* ways.

Two sequences of the daily up-and-down, street-climbing rituals that are typical of all hill villages were now complete. After a long lunch and traditional siesta, there would be another downhill flow to the coffee bars in the late afternoon, followed by the evening ritual of the *passeggiata*, which, in the warm months, is a nightly norm across much of Italy. This is a time when you truly feel the throbbing heart of the community, with its ageless tradition of eventide bonding and mingling—older couples serenely strolling in fine attire (dressing appropriately for the ritual is still considered important by most participants); young families with their baby carriages gazing adoringly at their extravagantly indulged offspring; young men, bulging with adolescent angst and machismo, emerging from shadowy huddles to see and be seen, and to wink at and whisper to the *molto belle* primped girls walking arm in arm. Pretending not to notice, particularly if their parents are close by (which they usually are), the girls, in turn, giggle, wriggle, and flounce their long, dark hair in coquettish disdain. Meanwhile, the huddles of stooped octogenarians observe everything while continuing their never-ending, arm-waving, gesture-accompanied debates, like true characters from central casting. But there are subtleties too—unspoken rites of passage, performance, and manners—which were only slowly revealed to us over our long stay there.

MUSSOLINI GAVE A DISTINCTLY eloquent burp but remained asleep and still comically restless. We laughed and raised our glasses to his neurotic obliviousness. "I think it is not so easy for him at this time," Massimo said sleepily. "He's my hunting dog. He goes with me in late autumn, when we shoot the *cinghiale* [boar] and the *capriolo* [deer] in the forest—our wonderful winter meat! Then he's not so fat. Last year he was very energetic, fit. He almost caught a wolf . . ." Massimo paused for effect, ". . . and also a bear!"

"A bear!" I was impressed.

"Yes. We still have . . ." Massimo's eyes twinkled. "Well, some people say so . . ."

I was now less impressed. "Right," I said sarcastically. Anne nudged me and gave me one of those "don't be so rude" glances.

"And Doctor Carlo Levi, the man who was imprisoned here in this village, just a little way down the street, during the war, he says—"

ACCETTURA ALLEY

"You know about Levi?" I interrupted.

Massimo raised himself in his chair and looked at me indignantly. "Of course I know about him. He is very famous writer. He wrote many things about our places here."

"Yes, I know, in his book *Christ Stopped at Eboli.*"

"Yes. *Cristo si è fermato a Eboli*—the same."

"But that's one of the main reasons we first came here, Massimo. Ever since we read his book years ago we have wanted to explore Basilicata—or, as he called it, Lucania, its ancient name."

"Yes, Lucania, the name of our province in Greek times, long before all those other peoples invaded us—the Saracens, Byzantines, Normans, Angevins, Albanians! Can you believe that? Even the Albanians! And Carlo Levi is still very big man here. Next week, in Stigliano, just over the mountain, they are having a theatre of his book. Everybody is going. Is very important thing."

"But he painted such a dark and mysterious portrait of this part of Basilicata—all that poverty, all those tales of *pagani* [pagans], sorcerers, strange creatures, all the stuff about witches and werewolves and death curses. . . ."

"Yes, of course, we know. These things existed. Some still do. But they are *our* things. My grandfather, Nicolà, he will tell you stories. He knows about many strange things here. He says to me often about Basilicata, *'Mare e munne non se trouet u funne.'* 'You'll never find the true bottom of the sea or the bottom of our world.' "

"I'd like to meet him."

"Of course. You will. And you will both see, you will understand, that Doctor Levi was not dreaming any of his stories. Everything is true."

"Still true?" I asked.

Massimo laughed and then drank the last of his wine. His eyes had that tantalizing twinkle again. "Ah, well, that is something you must both decide for yourselves, isn't it? Don't forget another one of our local sayings, *'Ogne tempe arrivete, ogne frutte ammaturete.'* 'All seasons will come, all fruits will ripen.' You will know when you know."

A wise young man, our Massimo.

CHAPTER I

The Lure of Levi

> This is a closed world, shrouded in black veils, bloody and earthy—
> that other world where the peasants live and which no one can enter
> without a magic key . . . Here there is no definite boundary between
> the world of human beings and that of animals and even monsters.
> And there are many strange creatures here who have a dual
> nature . . . everything is bound up in natural magic . . . and a sub-
> terranean deity, black with shadows of the bowels of the earth . . .
>
> CARLO LEVI, *Christ Stopped at Eboli*

Some say his coffin is full of rocks.

It lies deep in the heavy clay soil at the edge of the cemetery in
Aliano. The cemetery is at the highest point of the village, on a
watershed ridge above the Sauro and Agri Valleys. The views from
there across the eroded *calanchi* canyons, which seem to be melting
like cake frosting into the scrubby and scraggly olive orchards far
below, are the finest in the village. And Carlo Levi's grave has the
best view of all, west across the *calanchi*, the muscular outlines of the
Pollino range and, on a clear spring day, the massive bulk of
the Calabrian massif.

The grave site has recently been rebuilt with a simple two-walled
enclosure overlooking a deep gorge, but the headstone remains
the same as before, bearing its simple inscription: *Carlo Levi*
12.11.1902–4.1.1975.

Others say his actual remains are in Rome, jealously guarded by
a lover. His nephew, Giovani Levi, who lives in Venice, is vague

about the whole matter and prefers to discuss the impact of his uncle's books and political career on the Mezzogiorno, "Land of the Midday Sun," that wild region dismissed by refined, affluent northerners as "the South" (with the usual complacent smirk) or, more offensively, "the land of the *terroni*" (peasants). As with everything involving Carlo Levi, opinions are divided, sometimes dramatically, ferociously. But all that will be revealed later.

For the moment Anne and I are sitting in the shade of a line of pine trees by Levi's grave, watching hawks float on the spirals in the heat of the "sacred time," the afternoon siesta. We're thinking about the life of this man who worked so arduously on behalf of his "beloved peasants," attempting to eradicate the centuries-old inequities of a harsh feudal system and create conditions conducive to human dignity and new economic progress in the South.

We're remembering his most famous book, *Christ Stopped at Eboli*—first published in English in 1947—and its impact on us both when we first read it years ago. One reviewer described it as "an unforgettable journey into the dark, ancient and richly human ethos of Southern Italy." Others saw deeper, more holistic nuances. An eminent European sociologist even suggested that the primitive elements Levi discovered here reflected "the deepest, darkest parts of the Soul of our World"—elements also dramatically reflected in Francesco Rosi's famous 1978 film of the book, featuring Italian heartthrob Gian Maria Volentè as Levi and Irene Pappas as his witch-housekeeper, Giulia Venere (Mango).

Levi wrote his masterwork following his *confino*, his house arrest in the remote Basilicatan hill town of Aliano, where he was exiled before World War II by an irate Mussolini, il Duce, who was determined to quell Levi's rampant, antifascist activities and writings. Almost sixty years later Levi's book, translated into thirty-seven languages, continues to provide insights into this wild region, located in the instep of Italy's "boot." Still mysterious and elusively tied to a darker age and deeper *pagani* touchstones of knowledge and belief, the region is relatively unchanged by the country's overreaching Catholic influence.

The First Spring

A true Renaissance man—physician, philosopher, artist, writer, inspired speaker, and later a senator in the Italian government— Levi was born in Turin on November 29, 1902, into an affluent, talented, and respected Jewish family. He graduated in medicine at the early age of twenty-two. That same year, he exhibited his artwork at the *Biennale* of Venice and began his vociferous antifascist activities, with the *Giustizia e Libertà* movement, which ultimately condemned him as a "threat to national security." He was sentenced to five years

CARLO LEVI

confino in one of Italy's wildest regions, a term that was reduced to seven months (from October 3, 1935, to May 20, 1936), following Mussolini's conquest of Ethiopia.

Those less impressed by Carlo Levi's political values and writings often refer dismissively to *Christ Stopped at Eboli* as a "novel," implying that much of the dark, bleak, primitive, *sempre miseria* ("always misery") peasant world in Aliano he describes—a world "which no one can enter without a magic key"—is largely fictitious. To some, it is either a figment of a vehemently antifascist, pro-underclass imagination or, according to other cynics, a masterful work of mystical fantasy.

Prior to our time in Aliano and other places in a region that once harbored a host of strident socialist critics, the plight of Mezzogiorno peasants was regarded as beneath the dignity of national politicians to investigate and certainly never to acknowledge. One of the most outspoken "revolutionaries" was Rocco Scotellaro, a close friend of Levi's, who appeared in redheaded rhetorical fury in many of Levi's Aliano-period paintings. As a poet and ultimately the mayor (*sindico*) of Tricarico, Scotellaro used his verses and vision as powerful instruments for social and economic emancipation. Similarly, in the village of Tursi to the Southeast, Albino Pierro, a renowned poet who wrote in the local Arab-tinged dialect and was once a candidate for the Nobel Prize for Literature, was also a reformist for the *sperduti* ("the forgotten people").

Levi saw himself primarily as a physician and a painter, and certainly never claimed to be a poet. However, both his art and his eloquent prose paint an intriguing and almost poetical portrait of Aliano, his place of exile in 1935–1936, the most strident era of the Mussolini fascist dictatorship. And there is no doubt, based upon our own time there, that Levi's descriptions of the setting and mood of the village of Aliano could not be bettered. Certainly not by me.

Here's a brief collage of Levi's impressions from his world-famous book, which, as one critic suggested, became "the symbol of many other dire realities in our divided world today." That thought

was echoed by the famous Italian writer Italo Calvino, who called Levi "the ambassador of another world in our world."

> *I left dear Grassano, a streak of white at the summit of a bare hill, a sort of miniature imaginary Jerusalem in the solitude of the desert . . . and entered the desolate reaches of Lucania (Basilicata). . . . This shadowy land is like being in a sea of chalk—a bare and dramatic austerity—the haunts of caves and brigands . . . I sense the bottomless sadness of this desolate countryside . . . Broom is practically the only flower that blooms in this desert. The wind comes up in cold spirals from the ravines . . . mountain tops stick out of a weary pallor of mist like islands in a shapeless ocean of vapidity. And there was Gagliano [as Levi calls Aliano in the book] perched on a sort of jagged saddle rising among ravines. It wound its way like a worm on either side of a single street which sloped abruptly down the narrow ridge between two ravines . . . steep slopes of white clay with houses hanging from them . . . the peasants' houses were all alike consisting of only one room . . . At night the empty blackness of the sky hung over the darkened village. But eventually I came to understand the hidden virtues of this bare land and to love it.*

I remember Anne's reaction after reading Levi's book for the first time. She turned to me, fixed me with one of her "please listen, this is serious" looks, and said, "Y' know, darling" ("darling" invariably indicates something serious to be discussed), "you've written so many books and articles on world travel. Off you go, sometimes with me in tow" (our work schedules do not always coincide), "and burrow deeply into places, but then, just when we're beginning to learn and understand some of the deeper nuances and strangeness of life there, we're off again, on to somewhere else."

I stared at her, not sure exactly how to interpret her summary of my travel-writing life. She took my silence, I guess, as an affirmation and continued: "So, why don't we try something different?

Let's go and live in just one place for a year or so, through all the seasons, and become part of it. Let's see what happens—a book, illustrations, articles, or just lots of new experiences. Whatever. We won't force it. Let's allow the place to show us how best to use what we learn."

"Like Levi," I said.

"Exactly. Like Levi."

"And where," I said, already guessing the answer, "do you think we might go to enjoy our year or so of seasons?"

Anne laughed. "I think you know where. You're already thinking about it! Remember Rumi: 'Your own story is calling you.' "

Levi's book on Basilicata was our first and most transforming inspiration. His descriptions were siren calls to us: "The seasons pass today over the toil of the peasants, just as they did 3,000 years before Christ; no message, human or divine, has reached this stub-

BASILICATAN PANORAMA

born poverty." But other writers have also explored this wild, strange, and little-known region. In particular, its dark and ancient mysteries intrigued the ever-curious and remarkably intrepid Norman Douglas. His 1915 book, *Old Calabria,* remains one of the most in-depth explorations of southern Italy (his Calabria had broad boundaries), despite the challenges he faced in finding his way into the psyche of a remote peasant culture steeped in intractable stubbornness and a deep and ancient silence.

Douglas, "a genial, charming, obtuse, dogmatic, arrogant and overbearing Scot, who stalked about the world with the assurance of some Highland laird" (according to one of his publishers), was never a man to mince words or actions, neither in his highly controversial personal life nor certainly as the author of such revelatory books as *South Wind* and *Alone.* He has been compared with some of literature's "greatest scoffers and debunkers"—Dr. Samuel

Johnson, Voltaire, Orwell, and Graves—whose primary collective purpose seemed to be to "clear minds of cant!" Douglas effectively describes the "ghostly phantoms of the past" that permeate this region, once "a cauldron of demonology . . . infested with brigandage" and (still a major Italian problem) "an army of official loafers who infest the land, and would be far better employed themselves planting onions." And while Douglas admired the *malizia* (craftiness) and *interesse* (self-interest) of the region's "sturdy brood" of peasant farmers ("*che bella gioventù!*") and the fact that "wise women and wizards abound," he seemed constantly to face invisible barriers to true insight. Frustrated, he wandered the region—through the "sunless and cobwebby labyrinth, the old woman pensioners flitting round me like bats in the twilight"— seeking deeper knowledge of "the old tangled ways," and pursuing tales of supernatural creatures.

He heard a few of the more "enlightened" village mayors and community leaders claim "the days of such fabulous monsters are over" and that fifteenth-century Spanish invasions of the South "withered up the pagan myth-making faculty." But he didn't believe it. Like others who have ventured there, Douglas continued to sense the dark and enduring underpinnings of the region's strange and often unsettling heritage. "No wonder North Italians . . . regard all Calabrians as savages," he wrote, both in admiration and exasperation. The unique southern region is "not a land to traverse alone," he warned at the end of *Old Calabria*. And yet he obviously learned to love this bizarre region: "Such torrid splendour, drenching a land of austerest simplicity, decomposes the mind into corresponding states of primal contentment and resilience."

Douglas also apparently had a great affection for George Gissing's book *By the Ionian Sea*, which describes Gissing's 1897 journey along the southern Italian coast. However, I must admit to a certain personal frustration with this scholarly gentleman's constant moaning and groaning about his ill health, the atrocious food, the climate, the poor state of historic preservation, the constantly irritating *scirocco* "African" wind (although, this complaint I can

endorse wholeheartedly), and the invariable closing of museums for "renovation" (this too). But there is one moving passage in the Gissing book that made me realize that he had the capacity, as Douglas had, to empathize with the plight of Italy's southerners and to understand the poundings of history that these stoic people have had to endure for century after century:

> *One remembers all they have suffered, all they have achieved in spite of wrong. Brute races have flung themselves, one after another, upon this sweet and glorious land; conquest and slavery, from age to age, have been the people's lot. Tread where one will, the soil has been drenched with blood. An immemorial woe sounds even through the lilting notes of Italian gaiety. It is a country wearied and regretful, looking ever backward to the things of old; trivial in its latter life, and unable to hope sincerely for the future.*

Gissing failed to mention the more recent plagues of nineteenth-century mountain brigands, renowned for their kidnap-and-ransom antics (primarily on the local populace, not tourists), and the insidious power of the Calabrian Mafia or *'Ndrangheta*, which still has tentacles there today. But then he adds, in a rare moment of emotional uplift: "Listen to a . . . peasant singing as he follows his oxen along the furrow, or as he shakes the branches of his olive tree. That wailing voice amid the ancient silence, that long lament solacing ill-rewarded toil, comes from the heart of Italy herself, and wakes the memory of mankind." And then he admits, in an unexpected apologia from such a finicky, disgruntled traveler: "In the first pause of the music I reproach myself bitterly for narrowness and ingratitude. All the faults of the Italian people are whelmed in forgiveness as soon as their music sounds under the Italian sky. . . . Moved by these voices . . . I asked pardon for all my foolish irritation, my impertinent fault-finding."

How can one not forgive Gissing when he exhibits such insight, graciousness, and genuine humility?

But back to Norman Douglas. In addition to the music, which he loved as much as did Gissing, there was also something about the region's cheerful pagan quality—he called it the "tigerish flavour" of the Mezzogiorno—that greatly appealed to this driven wanderer. And scholar too—a fine scholar of layered history who advised that "the magic of south Italy deserves to be well studied, for the country is a cauldron of demonology wherein Oriental beliefs—imported direct from Egypt, the classic home of witchcraft—commingled with those of the West." He was particularly intrigued by the depths of such "demonology": "priests are . . . mere decorative survivals, that look well enough in the landscape, but are not taken seriously save in their match-making and money-lending capacities." Further on, Douglas writes "The records show that the common people never took their saints to heart in the northern fashion—as moral exemplars; from beginning to end, they have only utilized them as a pretext for fun and festivals, a means of brightening the cata-combic, the essentially sunless, character of Christianity."

At one point he describes the night he saw a werewolf—a *lupomannaro* ("not popular as a subject of conversation" in the South)—in a remote mountain community, and a villager explained that he was one of "the more old-fashioned werewolves" . . . "and in that case only the pigs . . . are dowered with the faculty of distinguishing them in daytime, when they look like any other 'Christian.' " Even in the midday heat as well as the night-gloom, Douglas sensed deeper forces and presences: "This noontide is the 'heavy' hour . . . *controra* they now call it—the ominous hour. Man and beast are fettered in sleep, while spirits walk abroad, as at midnight. The midday demon—that southern Haunter of calm blue spaces."

Douglas found his fascination for such aspects of Mezzogiorno life constantly rejected by local mayors, minor officials, and power-brokers. And when he delved deeper, he found that: "a foreigner is at an unfortunate disadvantage; if he ask questions, he will only get answers dictated by suspicion or a deliberate desire to mislead." So, never one to be at a loose end for research, he set off exploring some of the legends surrounding the multitudinous local saints and

discovered an intriguing retinue of flying monks, raisers of the dead, and other assorted miracle- and marvel-makers, many with distinct *pagani* attributes.

But Douglas also discovered larger and more enduring characters in the Mezzogiorno. In the ancient and mysterious mores of the south "there arises . . . a new perspective of human affairs; a suggestion of well-being wherein the futile complexities and disharmonies of our age shall have no place, and which claim kinship with some elemental and robust archetype. . . ."

Finally, ever a non-admirer of the more modern confusions and complexities of Christianity, which he called "that scarecrow of a theory which would have us neglect what is earthly, tangible," he found in Calabria and Basilicata that "a landscape so luminous, so resolutely scornful of accessories . . . brings us to the ground, where we belong. . . . What is life well lived but a blithe discarding of primordial husks, of those comfortable intangibilities that lurk about us, waiting for our weak moments."

And in the inhabitants—despite their living conditions, which often shocked Douglas into despair—who were so obviously outcasts from "life's feast" and whose depths he was never able to plumb fully, he invariably sensed that "the sage, that perfect savage, will be the last to withdraw himself from the influence of these radiant realities."

THUS WE WERE LURED into the land of Levi, and his pursuit of his "magic key" unlocking the "radiant realities" of a wilderness so loved by Douglas. And we began, like Gissing, to be "moved by the voices and spirits" of the people we met and befriended there. Times for us were not always easy, and our adventures didn't always turn out quite the way we might have liked, but we never once stopped celebrating our good fortune at being able to share our lives with our newfound friends in Aliano and the surrounding hill villages. Like Levi, we came to "understand this land and love it," and like Douglas, we caught glimpses of Italy as a bizarre "cauldron of demonology," while admiring the region's "elemental and robust

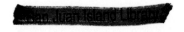

archetype" character. And we found, just as Pico Iyer, that renowned travel writer–philosopher, suggests, that "All the great travel books are love stories, and all great journeys are, like love, about being carried out of yourself and deposited in the midst of terror and wonder." (We were never at a loss for either of those.)

Best of all, we revived and expanded our own lives together through our experiences, and gleaned intriguing and powerful insights there in that beautiful and beautifully strange Basilicata.

The Adventure Begins

Browmmmmm . . . browmmmmm . . . swiiiiish . . . browmmmmm . . . swiiiiish . . .

Well, that, I thought, as I was abruptly awakened in utter darkness, is certainly a sound you don't hear every day.

If it is indeed daytime here.

Wherever "here" is.

Then came that whirling panic of utter disconnectedness, a smothering blankness of confusion, made even more terrifying by those strange sounds coming from somewhere very close by and getting louder and stronger . . . booming, swishing, booming . . .

Thankfully, the mental curtain rises suddenly, and I know I'm not in the United States in our New York home with Anne snuggled beside me or in our other cozy little *tatami*-matted retreat in Japan.

I'm in Rome. Rome, Italy. And I'm alone. Anne is still teaching at her university at Kyushu.

After long and tediously cramped flights, from Japan via the U.S.A. and England, I'm finally here. But not in the Rome of the glossy brochures—the Rome of soaring Corinthian columns and rubble-strewn ruins and tiny piazzas with trellised trattorias and the whine of *motorini* (mopeds) and the hosts of tottering, weary tourists and the cacophony of honking traffic, always jammed and always oblivious to stoplights (in Italy they are regarded merely as suggestions), pedestrians, and even other traffic.

The First Spring

No, definitely not *that* Rome. I'd been there before and, quite frankly, after landing at Leonardo da Vinci airport (more commonly known as "Fiumicino") the previous afternoon, after a soul-stirring flight over the pristine peaks of the Swiss Alps, I hadn't been in the mood for the tumult and tensions and crackle and din and the utter sensory overload of the historic core of that flamboyant and heavily testosteroned urban chaos. Neither was I ready to leap into my rented car and drive immediately to the South for a first glimpse of a region that, after all my readings and weeks of anxious prepara-tion, had begun to take on a character of almost mythic proportions.

What I needed the day of my arrival was precisely what I found: a fishing village with a vast beach of smooth blond sand, a quaint boat-filled harbor, a choice of inexpensive hotels and good restau-rants, and all within a few minutes' driving distance west of the air-port (so close in fact that one wonders why planes don't occasionally splash down in its harbor).

Almost as in a dream, where things wished for can become tan-gibly real, I arrived in the little seashore town of Fiumicino. And all these delights were presented in such a quiet, off-season, sedate kind of way that I had to blink furiously to assure myself that this was indeed not a dream . . . especially when my car literally drove itself into a small, vine arbor–shaded car park beside a charming *pensione* complete with a flower-bedecked restaurant. And at the restaurant, with its meticulously laid tables of shining crystal glasses, three charming, elderly-lady proprietors welcomed me like a long-lost relative, with a grace and tenderness befitting a Jane Austen novel. The oldest one appeared to be a permanent fixture in her antique chair by the cash register. Under her meticulously plaited silver hair glowed two azure blue eyes, and her smiling lips were the epitome of welcome.

So that's where I am, I thought, as yesterday's memories flooded in. And those sounds are, I assume, the sounds of fishing boats fir-ing up their engines and swishing their way down the long, narrow inlet of the harbor and out into the open sea.

I groped my way out of bed, shuffled across the cool tile floor to

the window, and flung open the shutters. And there they were: a dozen or more large trawler-tough boats gliding past as the sun yolked up above the rooftops of houses and nautical workshops on the far side of the harbor and the screech of gulls and the briny-fishy aroma of morning rolled into my room. And I smiled. A big, happy, yawny kind of smile.

And I thought, so this is where our adventure begins.

A WHILE LATER, after a long hot shower and a leisurely search of my suitcase for something not too creased to wear (if I'd allowed Anne to pack for me, as she'd suggested, nothing would have been creased), I ambled down from my room to an adjoining coffee bar by the harbor to start my first day with a frothy-topped cappuccino dusted with powdered chocolate, and a very large and very flaky *cornetto*. And then, as I watched the huddle of locals around the bar from my chair on the sidewalk, I realized I was missing one of the key ingredients, a traditional morning *corretto*—that small glass of something strong and revitalizing to kickstart the body and mind. So, as a salute to the "when in Rome" (literally) spirit, a second cappuccino with a small anise chaser was ordered and I returned to my chair and grinned at the sun as the pungent alcohol raced through my still semi-dormant system and made all my appendages, including my nose and ears for some odd reason, tingle in a most beguiling manner.

What now, I wondered? Stay here by the harbor for another day and sort of ease into the mood and pace of things? Or maybe play tourist and plunge into the tumult of the city for a quick scramble up the dome of St. Peter's and a stroll through the ancient monoliths of the forum and amphitheater? Or . . .

"GO SOUTH," a voice insisted. "TODAY. NOW!"

This was my favorite inner voice—the impulsive, occasionally intrepid, explorer voice, and the one I invariably follow. He always seems to know intuitively what I really want to do, no matter how much I might try to propose or rationalize other perfectly reasonable options.

"Rome will wait. And you can come back to this little *pensione*, too. But today, now, GO SOUTH!"

So, south it was to be.

"But go leisurely," the victorious voice suggested. "There's no rush. Meander a little and get a feel for the place. Time is all yours for as long as you need, or wish."

And with that tantalizing thought, I gathered up my belongings from the room and bid farewell to the three matronly ladies (emphasizing that I would indeed be back). Even before the Roman rush hour had begun, I was off, following the big green freeway signs south toward Naples, singing silly, mindless tunes to myself, and inviting serendipity to set the course and pace of my long journey down into the depths and mysteries of Basilicata.

"No One Travels to the South"

Smiling, I watched the morning traffic jams intensify—I smiled because the jams applied only to traffic bound for the chaotic heart of Rome. I, on the other hand, was just leaving Rome and had most of the freeway to myself. As I drove happily southward, my mind was kind of freewheeling through the arrival antics of the day before, and one small incident—shards of overheard conversation—stood out.

I couldn't believe I'd actually heard and understood them (thanks to the interpretive abilities of a fellow passenger). And in such an auspicious place as the airport, as I was finalizing the laborious long-term rental arrangements for my little toy Lancia DoDo. In hindsight, it would have been far more expedient and far less expensive to have purchased a car of my own on day one. Or at the very least I should have avoided renting any car named after an extremely dumb and therefore extinct overgrown turkey.

A well-dressed woman—actually, a superbly attired and manicured lady, as only Italian ladies can be—was also reaching the end of signing her seemingly endless forms for the release of her car, a

black Mercedes turbo, which she referred to loudly and proudly on at least three separate occasions during the red-tape rituals.

"And where are you planning to visit?" the young girl behind the counter asked the woman pleasantly, her dimpled apple cheeks glowing. "The South, maybe?"

The lady, who was undoubtedly northern Italian born and bred—tall, svelte, and queenlike in attitude and disposition, making a true *bella figura*—paused in mid-pen-flourish and stared at the girl in utter surprise.

When she had regained her composure, she said in a stiletto-sharp voice with a strident, clipped Milanese accent. "The South!? *O Dio*, no! No one travels to the South surely! *Solo i fessi stanno laggiù!* ['Only fools stay down there.']—Rome is quite far enough."

The girl behind the counter smiled brightly, probably assuming that this was just one of those little comedies of colliding cultures and Mezzogiorno jibes that northerners liked to make every once in a while to remind anyone who had the patience to listen that, of course, the North *was* Italy and the South was, well, the South. Another country. An undesirable, uncultivated appendage to the "true" Italy, full of muddled remnants of Saracens, Albanians, and suchlike "uncivilized peoples." The land of the *terroni* ("the little peasants"). More African and Arabic than European. And certainly not a place to be driven through in a black Mercedes turbo, thank you very much. And, no, she was not joking. She spoke in the superior manner of the supremely confident, complacently full of old-money, high-culture *snobismo*. The counter girl understood this quite clearly, I think, and with a rapidly rising blush that suggested a possible southern heritage, she looked away and pretended to be searching for more interminable papers for the lady from the North to sign.

THIS ENDURING DICHOTOMY between North and South is not altogether unfamiliar in other countries—particularly Great Britain and the U.S.A.—but in Italy it seems far more potent. Whether it is due to the fact that, until 1861, Italy was essentially a batch of loosely related nation-states, or to the striking economic

disparities between the two halves of the nation—the rich, industrialized, fertile, sophisticated, architecturely resplendent North, and the far more agrarian and underdeveloped South, with its rugged and ragged history of invasion and conquests—who can tell? Certainly the North African Arab invasions of portions of Europe from the seventh to the tenth centuries, most notably in southern Spain, southern Italy, and Sicily, reinforced the prejudices of northerners that these regions had become tainted, "foreign," and strange. Such a sentiment is reinforced today by clear radio reception in the South of wailing, quarter-tone music, obviously Arabic, from nearby countries such as Algeria, Morocco, and Tunisia, the last only ninety miles or so south across the Mediterranean from Sicily.

The fact is the dichotomy truly exists, and discussions about "solving the dilemma of the South" invariably and quickly lead to entrenched positions and virulent verbal skirmishes. One charmingly outspoken woman later told me in all seriousness that the South should declare itself a separate nation and "let the Mafia run it. They're much better at running things down here than any elected government!"

Carlo Levi's position on the subject is interesting, and indeed his antifascist ideas, which obviously ran counter to those of Mussolini and his cohorts, got him quickly arrested and placed in *confino* in Basilicata. Levi saw a very different future for the region, one far more radical than today's ambiguous and ambitionless policies and plans, most of which fade and fail through a potent combination of bureaucratic lethargy and incompetence, fiscal corruption, impractical visions, ineffective implementation, chaotic political continuity (fifty-nine Italian prime ministers since the end of World War II!), and more corruption—right up to the present day. Even Italy's media-mogul, billionaire prime minister Silvio Berlusconi has been implicated. In power during our stay in Basilicata, he was desperately fighting a cartload of corruption indictments that threatened to decimate his political career.

Levi had no qualms about declaring that "many" have claimed to have mediated upon the "problem of the South" and to have formu-

28

lated plans for its solution. "But just as their schemes and the very language in which they were couched would have been incomprehensible to the peasants (still a majority of the population in the south), so were the life and needs of the peasants a closed book to them, and one which they did not even bother to open." He concluded that: "The state cannot solve the problem of the south because the problem is none other than the state itself . . . Plans laid by a central government still leave two hostile Italy's on either side of the abyss!" In the South he cited particularly the problems of "big landlord estates and their owners" and "middle class village tyrants . . . who cut the peasants off from any hope of freedom and a decent existence." Levi's solution was dramatic in its visionary simplicity: "All of Italy . . . must be renewed from top to bottom. We must rebuild the foundations . . . with the concept of the individual. The name of this way out is autonomy . . . self-governing rural communities." This, Levi stated vehemently "is what I learned from a year of life underground."

Good heavens, I thought, as I signed the papers for my rental car and watched the northern lady stride off to claim her Mercedes, just what kind of place am I going to?

THE DRIVE SOUTH became increasingly dramatic. As I left the great bowl of Rome behind, the mountains began to surge in on both sides of the freeway. To the east the snowcapped peaks of the Monti Simbruini, part of the Abruzzese Appennine chain, rose like cloaked wraiths above rugged foothills sprinkled with white hilltop towns. There they were, perched like clustered fairy-tale villages on the edge of impossible precipices, some so high above the Sacco River Valley that they seemed disconnected, inaccessible, and dreamily surreal. Rugged remnants of eleventh-century Norman castles, peering down from high-vantage-point aeries, added to the aura of romantic fantasy.

The mountains to the west rose abruptly, aggressively, from the valley floor and huddled, huge and ogre-like, striated with eroded, skeletal-white strata, their summits bare and wild. Freeway signs to

The First Spring

Naples, "Capital of the South," beckoned, but I decided to save that intense and intrigue-laced city for a future visit and instead soared on southwards around cloud-cocooned Vesuvius and down into the mammoth ranges of the Alburni, Maddalena and Cilento Mountains. Here, I sensed, was the true topographic barrier between North and South, the place where the strangeness begins, a gateway to the great bastion of Basilicata itself.

At Lagonegro, perched high in a mountain cleft, I paused at one of those remarkable freeway service centers, gaudy with restaurants, motels, and mini-supermarkets crammed with elegant and tantalizing displays of regional delights—huge, golden wheels of bread; aged, mold-encrusted cheeses; wrinkled salamis; prosciutto; odd-shaped pastas; oils; olives; wine; and endless bizarre liqueurs. This was my first real encounter with Italian gastronomic overabundance, and my basket seemed to fill itself, abundantly. I obviously bought far too much but convinced myself that, if I got into the impromptu Italian picnic mode, nothing would be wasted. My enthusiasm was doused somewhat as I handed over a king's ransom in brand-new euro bills to the cashier, but her empathetic nods and her obviously impressed smile at my gourmand's selection and capacity made me feel I was already adopting the appropriate *dolce vita* attitude toward gustatory excess.

On the way out, manhandling two enormous shopping bags, I noticed a photograph on a promotional display showing the nearby and very appealing little coastal town of Sapri, sprinkled around an idyllic bay against a backdrop of soaring ranges. My impulsive explorer—self immediately resurfaced, informing me that this was obviously an ideal place for a brief sortie. "Time is all yours," he reminded me, "for as long as you need or wish." And that little encouraging mantra kept repeating itself as I hairpinned down two thousand feet of riotous mountainscape to the Caribbean blue Tyrrhenian Sea.

Viva's Views on Almost Everything

"You can call me Viva," she said. "It's Louisa Vita, really, but I like Viva better, don't you?"

I do, particularly after half an hour with this dynamic young lady of light and life, who spoke excellent English and happened to be the breakfast hostess at a little hotel I'd discovered right on the beachfront in Sapri. This funky-spirited, smart-dowdy, rich-poor, want-to-be-better-but-can't-seem-to-make-it-happen seaside community just on the wrong side of the Basilicatan border had

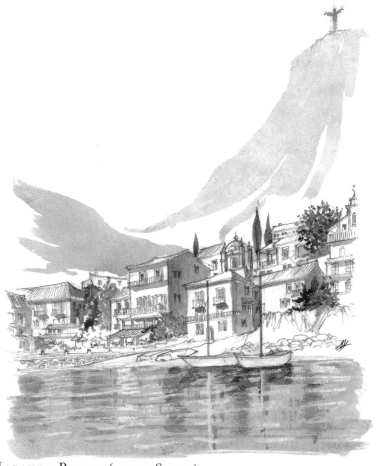

MARATEA PORTO (NEAR SAPRI)

turned out to be a perfect place to pause for a day or so before continuing on into the increasingly dramatic mountainscapes of the South.

Viva is one of those buoyant young women whose lives have suffered unseemly numbers of slings and arrows and yet who still seem to emerge more sprightly, and certainly wiser, than ever. She'd asked if I'd like coffee, and I nodded blearily. Then we began talking, and the only time during our long roller-coaster chat—and a most unmemorable "continental" breakfast at the hotel ("You'd like an omelet?" she said. "Well, so would I, so would everybody. But, in this place, no omelets. No cook!")—that I ever saw her vivacity wane was when she mentioned her husband . . . her *ex*-husband.

"I made mistake," she said. But it wasn't too clear if she was talking about her divorce or her decision to move to Sapri. "There's nothing to do here. *Nothing!* I don't know why I came. Escape maybe. To get far enough away, and hide. It's happening so much in Italy now. After seven years of marriage: divorce, with one child. Did you know we have lowest birthrate in Europe? In Italy! The land of romance, love, and passion! Isn't that crazy? But it's the way things are. And the family gives everything for that one child. Especially if the child is a boy, and even if he's thirty he's still a child and often lives at home with Mamma. Or if not, the family follows him around to look after him. But it's always work. Work, work, work. Men, women: everybody work all the time to buy things and make it good for family, and for that one child! Stupid! Here I work in this hotel from *h*eight (Viva had an endearing habit of adding *h*'s in the oddest places) to ten in the morning, and I get a thousand *h*euros a month, but my rent is five hundred, my babysitter is three hundred, my car and food and things, five hundred, so I don't know what to do. Where are all the rich men, I ask! Maybe I could meet a nice doctor, but they are all married. They make lots of money and, just like all those lazy *statali* government workers, retire early and go and live in other fancy places. Never Sapri, of course. Never Sapri!"

"Viva," I said, stopping her strident flow and trying once again to keep her on track. "You were telling me about the divorce."

She paused in mid-breath. Her vibrant, vivacious face puckered for an instant. "Mistake. *Aghh!*" She shook her head. It was a sign to move on to other subjects.

"Anyway, you were also telling me earlier about the problems in the Mezzogiorno."

"Ah, Mezzogiorno!" Life returns. Viva revived, in that press-button passionate way Italians have of dealing with their rousting, everything-out-in-the-open emotions. "Those politicians. Talk, talk, talk. Promise, promise, promise. You give me your vote and I'll bring you lots of jobs and factories and better roads and new houses. And what happens? Nothing! Nothing, nothing, nothing! Have you seen the A3 road from Salerno to Reggio? The main highway from the North to the South. How many years have they been 'improving' that stupid road? And look at it! It's rubbish! The most dangerous main road in the country! And all those villages on the tops of the mountains. All full of old people. All the young ones have gone to the cities. Just the very old ones left. And even if the young ones stay because the politicians say, 'We will bring you jobs, *molto lavoro*,' what do you get? Stupid jobs for a few weeks, building a road or a public toilet that nobody needs or uses, or a wall around the town hall, and then, no job! So, no pension. No—how you say?—security. And then they say, 'Let's bring tourists,' and all the mayors say, 'My town first! My town first!' So they all try fancy ideas to bring tourists. And in Sapri, you know what the last idea was? You saw that huge, half-finished building as you come in from Maratea? Massive, isn't it? Well, it was supposed to be a cement factory about thirty years ago, and they said, 'No, cement is wrong. We need tourists.' So they left the thing just standing there like it was a bombed building and they tried to get people from the North to come down and make it into a fancy resort and, oh dear, surprise, surprise! Nobody came."

Viva paused for breath, and I tried to change the subject again but I wasn't quite fast enough (not even fast enough to remind her about my coffee).

"Mezzogiorno! All stupid!" she continued in her charmingly

railroading fashion. "And everything so corrupt. *Dio cristo!* You can't trust anybody. Everybody expecting their little *bustarelle* ["gift envelopes," aka bribes]. And they talk so much about the stupid 'plans for the South.' The *Cassa per il Mezzogiorno*—that was one of them. And what happened to that? They tried to stop malaria, which had always been so bad in this area. Everybody sick all the time. They built a few roads, some places for industries that never come, some public housing where the earthquakes in 1980 had collapsed some of the villages, you know, like the one recently not so far away, in Puglia—you know about that?"

"Yes, it was in all the international newspapers. The school that collapsed and killed more than twenty children."

"Yes, that is right. And it was not a very old school either. Now they say there was corruption, stealing, and the people who built it did a very bad job because they put so much money in their pockets. *Ma!* Is that a surprise? No, I don't think so, thank you very much. It happens all the time everywhere. And down here, particularly in Calabria, where they have a 'second government'—Oh, you don't know about that? Well, maybe it's better you don't. Not so long ago peoples was very frightened to travel to Calabria and Reggio. There were many robbers—*briganti*—in the mountains and you could be attacked or kidnapped, even killed."

"Is that so today?"

Viva gave one of her endearingly sly, ironic smiles, and I was thinking what a great guest she would make on one of those TV talking-head shows, of which there were many in Italy. Her face, her mind were so animated and volatile. Of course, that's not unlike most Italians, who seem to possess an inbred natural ability to express all their emotions instantaneously, using numerous body parts, from their eyes and mouths to extravagant shrugs to whirling arms and even legs. (Watch one of those talk shows and see how far apart they have to seat people to prevent serious physiological damage from the guests' emotive outbursts.) In Viva's case, she used mainly her face, but with the skill and dexterity of a contortionist.

"Well, today they are clever. The brigands are now the *'Ndrangheta,'* the Calabrian Mafia."

"And they're the 'second government'?"

She laughed and raised her eyes heavenward. "Some say they're actually the first! That all the elected peoples and the police and all the others get their little *bustarelle* and sit around not doing very much while the *'Ndrangheta* organizes everything."

"Do you think that's true?"

But she was on a roll now, and although I was beginning to lose hope of ever being served my morning coffee, I had no intention of restricting the flow of her eloquent tirade.

"Well, I'll tell you what I think. I think we should tell Rome to keep all its stupid plans, and the European Union too. They say Basilicata is a 'priority development area,' but I think they just want our oil. Yes! Didn't you know? We've just found oil, a lot of oil, in Basilicata here. I think we should forget the euro too—going up, up, up. This is no good for us. Our main market in Italy is export, but a strong euro makes everything too expensive to sell. So, this is what I think. The neo-fascists keep saying we should go back to having autonomous republics like it was before 1860, when Garibaldi came to unite Italy as one country. The Northern League wants to forget the South completely. They say the government has spent over three hundred fifty billion euros on the South over the last twenty years. But they say we wasted the money, or stole it, and then peoples from the South all go north for work . . . and steal jobs! So, why don't we just say Mezzogiorno is a new country, separate from everybody, and we put *'Ndrangheta* in charge? Let them work it all out. That's what they do anyway. All those different southern Mafia organizations— the *Camorra* in Naples, the *Sacra Corona Unita* and *La Rosa* in Apulia, and of course the *Cosa Nostra* in Sicily. And I think they're richer than the government. They have so many businesses with good profits. So, why not let them run the Mezzogiorno like a good business? They know all about this. Andreotti [the ex-prime minister recently under indictment for collaboration with the Mafia] knew the truth. He was real in his thinking. So maybe we have to be real

also. We have to recognize the power of our Mafia. We have to—how you say?—involve, no *integrate*, them to improve our economy for everyone here. The government hasn't, cannot do this. And there are many who think like this too."

"Fascinating idea, Viva. They say that southern people are tough. They've been going their own way for centuries."

"Yes, yes, it's true. We are tough. Just think of our history: all those peoples invading us—Greeks, Arabs, Normans—and wars all the time. And the people living in a medieval—how you say?—feudal system, full of superstitions and witches and things. And that terrible time—the Kingdom of The Two Sicilies. And earthquakes and landslides—always earthquakes and landslides—and malaria that killed so many. And even Spartacus—you remember?—that great rebellion of the Roman slaves in 73 B.C. He destroyed so much of Basilicata. And other diseases and plagues, too. And the Catholic Church saying to all the poor people, 'Just be good and peaceful and obey the big bosses—the *baroni* and the *padroni* and all the others—and you'll be happy one day.' Not here, of course. Not now. Not on this earth. But certainly in that beautiful heaven with all the angels singing and . . ." She paused in mid-flow and gave a Edith Piaf–like 'pouf!' and hunched her shoulders in a huge shrug.

And then she began again, a little quieter this time. "But you know something? In spite of all this, we have a good life. We are not rich, but we know, we have learned, how to live well in our poverty. The North don't know how to do this. To grow and make what you need for yourself—olives, sheep, pigs, vegetables, wines, tomato sauces, fruit, wheat for your own pasta and bread. They don't know up north these things like we do, and even when they are rich, they are not so happy. We are so different here. Like I say, we are a separate people, a separate country!"

There was a long pause, a satisfied pause, in Viva's case. She'd made her points, exhaustively.

"Viva?"

"Oh yes, what please?"

"Any chance of that coffee now?"

Entering "The Land of the Magic Key"

Sapri is a beguiling little place despite, or maybe because of, its not-quite-successful attempts to become another Amalfi or Sorrento. Those two world-renowned hotspots on the Punta Campanella peninsula south of Naples, along with the nearby Isle of Capri, offer a scintillating summer scene of Eurotrash jet-setters, gorgeous gigolos, fashion-fad fanatics, infotech multimillionaires, dazzling stars of stage and screen, and myriad ogling, wannabe watchers and adulators.

Sapri does not.

Despite an idyllic location on a broad, curving bay with a mountain backdrop of almost alpine majesty, the little town is still celebrated primarily by its own residents. The nightly *passeggiata*, snaking past the coffee bars, pubs, and restaurants on the seafront, is still the high point of slow languid summer days. Fishermen still make a decent living here and can afford to own their own homes, untouched by the mega-inflation that has made property unaffordable for most locals in the hip commercial coastal communities farther to the north.

The town beckoned and invited me to stay. "What are a few more lazy days of indolence and indulgence when you have all the time in the world to do whatever you wish?" I heard the little town

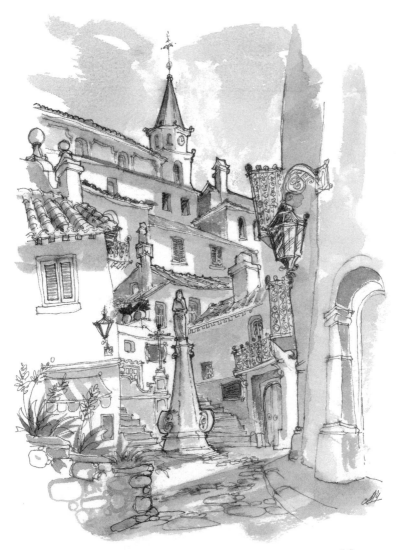

MARATEA

say. So, without too much resistance on my part—particularly since I was enjoying a virtually free hotel and a bedroom terrace overlooking the beach, bay, and mountains—I did indeed stay longer than intended. Pizzas, pastas, ridiculously inexpensive bottles of local wine with every meal, and seafood squiggly fresh

from the adjoining sea, helped pass the time easily and effort-lessly.

But eventually, as I knew he would, my wanderer-self emerged, restless again for the open road.

"But it's so beautiful and relaxing here," I tried to explain.

He would have none of it.

"GO SOUTH," he demanded once again, just as he had a few days earlier at Fiumicino, outside Rome. And so, the following morning, after another long diatribe from Viva and another almost-coffeeless breakfast, I left little Sapri, vowing to return with Anne when she arrived in a couple of weeks.

And thus I finally entered Basilicata, beginning a year-long love affair with "The Land of the Magic Key."

Basilicata actually began just a few miles south along the coast. A hair-raisingly dramatic swirl of corniche-like *tornanti* (hairpin bends) led me along a narrow road, perched on eroded precipices hundreds of feet above an azure blue ocean, across the border with Campania and into the town of Maratea.

Maratea turned out to be a confusing collection of communities: the small but elegant *porto* clustered like a mini-Amalfi around its tiny harbor; the elegant and lush Marina di Maratea resort (strict controls on rabid development here reflect a local policy of "non-aggressive tourism"); remnants of Maratea Superiore, a "settlement of uncertain origin," but likely an eighth-century B.C. Greek colony; a thirteenth-century "lower town," and finally the tightly clustered medieval glories of Maratea Inferiore, itself set on a steep moun-tainside beneath a seventy-foot-high gleaming white *Statua del Redentore* (statue of Christ the Redeemer), arms outstretched beneath a placid Buddha-like face.

If this were a guidebook, pages could be devoted to the architec-tural charms and ecclesiastical glories of this little town. Suffice to say, I was entranced by its tiny coffee bar–studded piazzas; its wriggling, stepped, and tunneled alleys; and the rich, interlocking complexities of houses, stores, churches, richly stuccoed palazzi, fountains, and statues, all jumbled together in typical Italian hill-town intensity.

I sat for a bit, trying to capture all this in a sketch while happily sipping my cappuccino and grappa—a little Italian habit I'd picked up and had found most conducive as a mid-morning pick-me-up. But *only* morning, mind you: The locals tend to have very rigid rules about coffee-drinking; after midday, the only drink is one of those malicious caffeine-jolt espressos the size of a thimble, and which are tippled in one gulp like a neat bourbon. *Stranieri* (foreigners) ordering post-lunch cappuccinos are regarded as bizarre curiosities, ignorant of traditional mores. My problem was that I still had not accepted the idea of paying eighty cents for an ounce or so of pungent molasses-thick brew and ingesting it with barely a scintilla of a palate appreciation when, for almost the same price, I could sit for quarter of an hour with a frothy cappuccino and enjoy every leisurely sip.

Doubtless my initiation and acceptance would come. But not yet. At that point I was still happy to be seen as a *straniero* and to do whatever I felt like doing.

"Very nice picture, Signore," a voice whispered in my right ear.

I looked up from my sketch quickly, maybe too quickly, and alarmed an elderly, wrinkled, and extremely bent gentleman wearing a lopsided trilby hat and carrying a knobby olive-branch cane.

"Ah, *scusi, scusi!*" he said, and backed away nervously.

"No, no, thank you. I'm glad you like."

The man smiled and inched back. I invited him to join me at my table. (Another oddity I discovered in these parts is that if you sit down at a table to enjoy your coffee, it can cost you double the price of the stand-at-the-counter, quick-tipple-and-out practice of most locals.)

The man accepted, and we began what was rapidly to become my regular mode of conversation with the locals—lots of gesticulating; elaborate hand, eye, wink, and nod communication; and wide smiles and laughter—as my Italian-English ("Italianish") and his raw dialect, only truly understood in Basilicata and its environs, intertwined in hilariously confusing attempts at coherent dialogue.

But something useful did emerge on this occasion, something along the lines of "If you think this place is special, wait until you get

farther north, through the mountains and into the Lucanian Dolomites, and there you'll find two villages like no others in Italy."

From the chaotic convolutions of that chat over coffee emerged the names Pietrapertosa and Castelmezzano. I looked at my map. The towns were indeed a long way to the north, far from Aliano, but as it was my plan to loop and spiral my way through the heart of Basilicata before focusing on Levi's *confino* village, I decided to take the old man's advice and head due north, directly across the mountains.

"DUE NORTH" is an utter oxymoron, particularly in this wild, soaring, broken, twisted topography. But despite endless hairpin turns and the most dangerously narrow, tortuous roads I'd faced just about anywhere in all my wordly wanderings, the position of the sun informed me, throughout that long, laborious day, that I was indeed edging northward through the ranges.

And what ranges they were! They buckled and twisted like snakes with broken spines around six-thousand-three-hundred-foot-high Monte Sirino and the Riserva Naturale Foce Sele-Tanagro. A brief moment of respite was offered as I descended past the hilltop aerie of Moliterno and the Roman ruins of Grumentum—abandoned around the year 1000 A.D., following repeated attacks by Saracen invaders—and eased out into the wide Agri Valley.

I paused for a restorative coffee—a post-lunch cappuccino, much to the confusion of the bartender—at a gas station on the main valley highway linking the Basilicatan coast near Policoro and Metaponto with the A3 Naples-to-Reggio freeway. For a few minutes I reentered the twenty-first century: Cars and huge tractor trailers whizzed past (whizzing is apparently the only mode of movement for Italian drivers); billboards rose high on huge pillars, displaying evocatively underdressed young ladies sucking with erotic delight on Coke bottles or sprawling invitingly across gleaming latest-model automobiles. Farmers were out in ultra-fertile and immense fields with huge machines very unlike the donkey and oxen contraptions and tiny, waddling Ape trucks I'd noticed in the

pocket-handkerchief patches of hardscrabble land way up in the mountains.

But soon it was northward again, hairpinning like a pinball, dizzied by heights and constant glimpses of vertical-sided canyons and gorges dropping off a few inches from my front wheel.

Infrequent white hill villages popped up, perched on distant puys, and then vanished almost magically into the swirl and tumble of the ranges. The lower foothills were often cloaked in deep, dark forests of oak, beech, and holly, while the higher peaks—Volturino, Caperino, and Montemurro—rose bold and bare, the great ancient bastions of Basilicata.

"No wonder Christ stopped at Eboli," a wisecracker once suggested. "Our mountains keep out anyone coming from the North."

"Well, they didn't stop all those invasions though, did they?" I wisecracked back, only to be told with fierce southern logic that "the invaders cheated and came by sea!"

I was tempted to remind the wisecracker that Christ could walk on water and obviously had the option therefore of entering Basilicata by the aquatic route. However, as would happen later in Basilicata, I found it best not to carry my "Italianish" repartee too far. A lot gets lost in the translation, and apologies for unintended slights are not always accepted gracefully.

Just outside Laurenzana, one of the larger hill towns of the region, and perched even more precariously than most on a sheer precipice of rock, an ancient castle tower rose like a warning finger . . . one I perhaps should have heeded because I was soon about to have my first little meeting with misfortune—and the "dark side" strangeness—in this desolate realm.

IT ALL BEGAN PLEASANTLY enough as I came upon a sign handpainted on a rough slab of wood. It read Castelmezzano and pointed down an enticing-looking backroad that sinewed its way across the top of a high forested ridge. My map showed no such road, but I'd been told that Italian maps, despite their elegantly nuanced colors and air of authorative accuracy, were often notoriously defi-

cient in the finer points of what one might call definitive cartography. So, off I went down the road, dust clouds spuming behind me from the unpaved but relatively rutless surface.

It was a little late in the evening, and dusky shadows were rising up from the valleys far below as the sun began its final declining arc, spraying the higher hills with brilliant flares of gold and amber. According to my crow-flying estimates, Castelmezzano couldn't have been more than twenty miles or so to the north, so I reckoned I should reach the comforts of an evening coffee—or maybe even a real cocktail, a multicourse Italian dinner, and a cozy bed in some local *pensione*—in an hour, tops.

A few miles farther on, deeper and deeper into those silent, seemingly unpopulated ranges, my schedule became somewhat disjointed. As did my little Lancia DoDo. (I knew I shouldn't have trusted a car with such a dumb name.)

Maybe I'd become a little too cocky on this particular backroad, but its relatively rutless, uncorrugated surface encouraged speed and the pleasure of seeing half a mile of dust trailing behind me in true outback-explorer fashion was captivatingly hypnotic.

Then came the rut. Some massive gouge out of the road's surface possibly caused by erratic drainage following one of Basilicata's sudden and very fickle spring thunderstorms. Anyway, the rut came, and I didn't see it, and the little DoDo slammed into it at full speed. First there was an abrupt downward crunch, then a wheel-spinning surge upward, with the impact of an untamed bucking bronco, and then the car crashed back down onto the road, pebbles and rocks flying, dust everywhere, me choking and spitting . . . and the engine dead.

Dead, as you might appropriately say, as a DoDo—that huge, ungainly mega-turkey creature from Mauritius that has been extinct for centuries. It was one of the most trusting birds ever in existence, virtually inviting its own demise just by standing around haplessly waiting to be clubbed over the head by hungry sailors.

I sat for a moment to regain my equilibrium (maybe even contemplating my own hapless, DoDo-like demise), then turned the

ignition, listened to the whirrings of the flywheel, and waited for the sudden reassuring power-burst of valves and pistons . . . which never came.

I waited a few more minutes, humming some inane tune and trying to assure myself that all would be well and that I'd soon be in Castelmezzano enjoying its abundant comforts and coddlings.

But the engine still refused to revive itself. The road rut must have really done a number on something or other in the crammed mechanical complexities under the hood, of which, I admit, I know very little. I've never been much of a spark plug, carburetor, and alternator nut and I invariably stand in awe as friends of mine, immensely knowledgeable, tinker around with the oddest of instruments in the belly of their beasts and produce remarkable purring, jetlike sounds from their beloved machines. "Wow," I'll normally say as they try to explain to me the subtleties of electronic ignitions and torque and traction and valve synchronization and Lord knows what else, and claim that "it's not quite right yet." And I'll mumble inanities like "Well, it sounds great to me," and they'll give me side-long glances and smile tolerantly like dads with blissfully ignorant offspring, and say things like "Right, Dave" or, worse, nothing at all.

But, for all their gentle, patronizing put-downs, I'd have welcomed any one of them there right at that moment to help me out of this rather difficult situation—what with darkness creeping in, chilly breezes filtering through the forests on either side of the road, the prospect of a cold night alone in this unpeopled wilderness, and the possibility of a long, lonely hike in the morning to find help.

I sat in the car, a little forlorn and depressed by my inability to solve my dilemma, even after lifting the hood and looking for loose wires or anything that might explain the DoDo's utter refusal to spring reassuringly to life. And as I sat, I remembered a line from Levi's book: "In this atmosphere permeated by divinity the time passed, while the angels watched over me by night and Giulia's witchcraft by day." He was describing his perception of Basilicata's mystical nuances and his total reliance upon the local Aliano witch, Giulia Venere, who acted as his housekeeper and general protectress

from the daily vicissitudes of his life as a *confinato* (prisoner), where he floated in a metaphysical soup of unexplainable sensations and strangeness.

MY OWN STRANGENESS began half an hour or so later, when dusk was merging into night and the last amber glows of sunset had flickered away over the far western ridges. It certainly wasn't Carlo Levi's Giulia who watched over me on that particular night, but it was definitely a woman, "a woman of the fields," or what the northerners often referred to disparagingly as a *mezzadra* (sharecropper peasant). Not that peasants (locally referred to as *cafoni* or *braccianti*), in the ancient feudal meaning of the term, exist there anymore. And yet in some ways, for the older, now landowning *contadini* (farmers), things hadn't changed all that much in terms of the rhythms and rigor of their lives. On my mountain journey that day I'd seen them in those little rackety *furgoncini* (small vans), on tractors, in tiny three-wheel Ape trucklets, occasionally on *motorini* or perched atop donkeys invariably overburdened with twin wicker panniers full of field tools or huge bundles of wood.

Maybe I dozed off for a few minutes (there wasn't much else I could think of to do), but I awoke with a jolt to find myself staring into one of the most furrowed faces I'd ever seen, in a region renown for the furrowed countenances of its overworked *terroni.* It appeared to be an old woman. Well, I thought it must be a woman because it was wearing large gold earrings and a gold necklace, sort of gypsy style, and the hand tapping on the window had a remarkable number of rings on it.

"*Buona sera,*" I said sleepily and lowered the window.

The woman nodded and smiled a huge, toothless smile. A large wart on her chin, sprouting thick black hairs, wobbled. Her muddy, purple head scarf wafted in a faint breeze, and she began talking at such a furious pace that I couldn't discern a single word. Doubtless one of the many regional dialects in these parts, I thought, as I watched almost hypnotically as froth and bubbles collected at both corners of her mouth. I explained that I was not Italian, and once I'd

pried myself out of the DoDo, I indicated that the engine wouldn't start. I thought I should add that bit in case she was not familiar with all the complexities of today's internal-combustion engines. Admittedly a rather sexist assumption on my part but . . .

She kept on talking, chuckling, and chattering, and then opened the hood and began rubbing her hands over bits and pieces—the distributor, the air manifold, the radiator cap—as if seeing an engine for the very first time. I tried to do a body-language charade indicating that I needed another car to tow me to a garage some- where, but she was still chuckling, touching, and rubbing things. Then she stopped and indicated that I should lower the hood. I started to explain that I didn't think that that was the appropriate thing to do under the circumstances, but she'd have none of it. Lower the hood, her hands indicated, and start the engine.

Oh, this is a treat, I thought. But she seemed pretty adamant, and I had no wish to offend her, so I did as she instructed. I lowered the hood, got back inside the car, turned the ignition switch, and . . . *Voila!* The engine started! A glorious throaty roar of new life and energy. All the little dials were flickering as they should be, the radio was playing, the engine responding beautifully as I pumped the accelerator. Wonderful. How the heck did she do that? Was it a loose wire on one of the battery terminals? Is that what all the touchy-feely stuff had been about? Yet I didn't remember seeing her hands anywhere near the battery. Anyway she'd done the trick, so perhaps it was time for thanks and maybe a gift of a few euros, if she wouldn't be too insulted.

Except, when I got out of the car, having assured myself that the engine was humming along nicely, there was no one around. Nothing. And no sign that anyone had even been there. Just that chill breeze that frilled out from the raggedy forest by the roadside.

Where had the old woman vanished to? She'd been there, as large as life. (Well, not quite large: She had had the traditional diminutive, stumpy figure of older Basilicatans.) But then she was not there. Maybe she's gone into the trees for something, I thought. I peered into the forest, but it was all very dark and tangled. I called

out, *"Scusi, Signora . . . dov'è Lei?"* But there was no response. Nothing but a bird chirp or two and that cold night breeze.

HALF AN HOUR OR SO later that night I finally arrived in Castelmezzano. It was too dark to see much except a dimly lit street and, thankfully, a charming little *pensione* with a flickering restaurant sign. When I'd settled myself inside, I explained to the owner my odd little experience up in the mountains.

There was a long pause and then a sigh. I got the distinct impression that he was not keen on "the local mysteries," as he called them, so at least I thought he'd eliminate any mysteriousness in this particular occurrence. But he didn't. In a rather tired voice he explained that some people just had "the touch." They could put things right, heal things. Usually people, but he'd also heard that it could happen with inanimate things. "Like with your car, I suppose, too."

"So, that's what you think maybe she had? The touch? She brought the DoDo back to life just by touching the engine!?"

"Who knows?" the *pensione* owner said, obviously wanting the conversation to end. "Things happen around here that are not easy to explain. In places like this you just don't know."

"Don't know what?"

"Precisely," he said.

Somewhat dissatisfied with such a nebulous response, I told the story as straightforwardly as I could to the smiling locals gathered around the restaurant bar, with none of the Italian gesticulation-theatrics used normally by locals.

The climax of the car's starting and the woman's vanishing was not greeted with the "wows!" and "amazings!" I had anticipated. In fact, there was just a series of heads nodding sagely and seriously.

"Why are you all nodding?" I asked.

After more silence, one of the men said, "Yes, I know of things like this."

"Like what?" I asked.

"Well, this . . . healing of things . . ." he mumbled ambiguously.

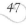

"Yes, of course," I said. "Healing of coughs and headaches and things with potions and philters and tisanes. That still goes on in many places, I suppose. And the power of mystical suggestion—that's a very potent cure sometimes, too. Or even death caused by a curse. . . . But healing car engines!?"

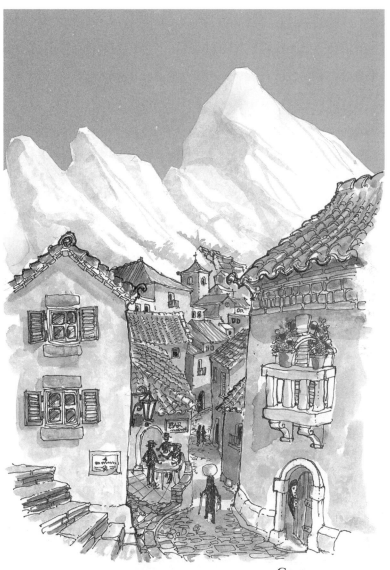

CASTELMEZZANO

There was more silence, until another man gave an elaborate "it happens" shrug and left me just as frustrated as the *pensione* owner had.

"So, none of you is surprised at all?" I asked.

More communal shrugs. A whole bar full of shrugs.

So, I left it. Some things in these wild hills and canyons, I guess, are, as both Levi and Douglas suggested, way beyond rational explanation.

But, as an interesting postscript, I should mention that this bizarre "laying-on of hands" episode provided me with a car that never failed me again.

Of course, I still prefer to think that the old woman just spotted a loose battery wire and fixed it.

Strangeness evolved into utter fantasy the following morning.

I rose from my bed, gave thanks once again to the old woman with the "magic touch," shuffled across the cool, tiled floor of my room, and flung open the shutters onto a scene out of some exotic fairy tale.

I had been looking for this place all my wandering life. Somewhere, sometime, in dreams, I had been there. I had entered a deep, wild country full of shadowed valleys and gorges whose depth could barely be gauged. I had climbed laboriously up ragged, rock-strewn mountainsides so precipitous that looking down was tantamount to vertigo-suicide. I had been told that way up among strange, jagged peaks with great fangs of twisted strata hundreds of feet high I would find a village so melded with the rock and built of the rock and bent and buckled like the rock that I wouldn't know it was there until I was in it. But it would be there. Waiting . . .

And, there it was at last, in a region of soaring white and dramatically eroded peaks, their spires and knife-like profiles slicing the clouds into long transluscent ribbons; a region they called the Lucanian Dolomites. Not as extensive as the Alpine Dolomites of northern Italy, but equally dramatic as they rose abruptly, unexpectedly, out of ancient rounded ranges. Houses, interlocked like Lego blocks, appeared nestled against and in the rock, almost like off-

spring in a kangaroo's pouch. They looked so small and vulnerable in this fantasy landscape, and yet they were tough buildings with thick, bulging stone walls and small windows to resist the wind and the cold that certainly froze the place solid in deep winters. A place that was one of the highest communities in Basilicata, set on an impressive three-thousand-two-hundred-foot ridge. Roofs were of solid stone. Where pantiles were used instead of stone, huge rocks were placed along the eaves to hold them down when the gales came shrieking from the canyons that soared up from the huge gorge of the Caperrino River far below.

There were clusters of houses crammed in under the rocks along a narrow ledge that dropped off into a hazy space only the buzzards would call home. The main street—if it can be called a street—was more like a medieval alley, sinewing across the turbulent contours. I walked down this ever-narrowing passage, under the arched fangs of rock. There was a sudden right-angle bend, and then another, each offering new vistas of peaks and canyons and clusters of buildings clinging like limpets to vertical, bare precipices. This is the kind of place, I thought, that only a madman could have fashioned. A marvelous madman though. A madman who could cram one of the most tightly packed communities I'd ever seen, laced with alleys and houses perched on houses perched on houses, into this bizarre wonderworld of topography that surrealists, even the irrepressible Dali, could never have hoped to conceive.

But there were more surprises to come.

"Have you seen Pietrapertosa yet?" the *pensione* owner asked me after breakfast, happy, I imagined, that I had put aside my search for explanations of the region's strange mysteries and was now fully appreciative of his unique village.

"I've heard of it," I admitted.

"Well, you should. Castelmezzano here is very beautiful, but Pietrapertosa . . ."

FOLLOWING HIS DIRECTIONS, I wound my way out of Castelmezzano, after exhausting my supply of color film on its exotic

charms, and began a long, tortuous ascent higher into the Lucanian Dolomites.

50

He was right. Pietrapertosa, set even more dramatically among the jagged peaks at around four thousand five hundred feet, boasts a record as the highest community in Basilicata. Its name translates as "perforated stone," and indeed the white fangs and peaks there,

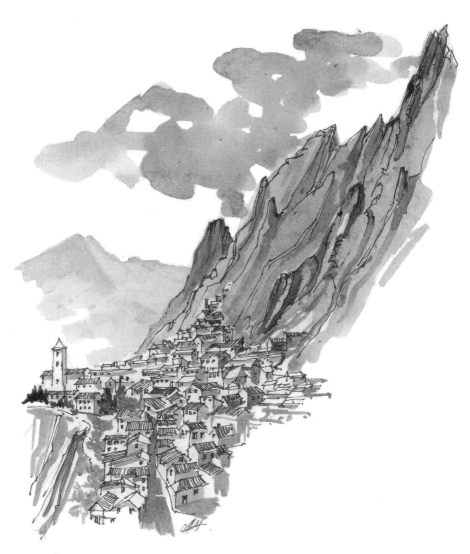

PIETRAPERTOSA

some towering hundreds of feet over the clustered village, were liberally pockmarked with hollows and holes, bared and smoothed by millions of years of erosion and harsh climatic fury.

Like Castelmezzano, the village offered a perfect defensible refuge in the tenth century for invading Saracens, who constructed a fort to guard the gorges, so hidden among the pinnacles of rock that it was hard to spot at first. Even after climbing up through the steep warrenlike alleys of the Saracen's *Rabatana* quarter, I had to reach the top of the ridge before appreciating what a remarkably impenetrable bastion they had created for themselves more than a thousand years ago.

The *Rabatana* was still regarded with some trepidation by people in the lower parts of the village. One elderly man I met at a coffee bar in the old center, adjoining the Church of San Giacomo and a cluster of bold, elegant stone palazzos, half whispered that he still didn't trust the remnant Saracen population living "up there."

"But they came centuries ago," I suggested. "Surely by now . . ."

His response was a slow wink and an index finger drawn from under his left eye slowly down the side of his nose and ending with a quick slash across his throat. Then another slow wink and finally a sideways shrug of his head, with his mouth contorted in a cynical grimace.

I must start to get the hang of these eloquent, say-everything expressions, I thought, and tried to invent my own responsive gesture, combining a wink, an empathetic nod, a smile, and a circled thumb and index finger. He smiled in acknowledgment, so I guess it worked.

I went on to explain to the old man in appalling "Italianish" that I was thinking of making a brief journey across the mountains to Aliano. I had been anxious to begin linking my random Basilicatan experiences with Levi's remote village.

He nodded and told me (I think) that Aliano was a rather strange place and that, as this was my first visit to the province, maybe I should first extend my looping familiarization expedition to include Matera—"a very, very ancient city of caves, the *Sassi.*" Maybe then,

52

after that, he suggested, I might begin to understand the unusual things, the "strangenesses," I would later see and learn about in Aliano. As a final comment, he advised me, with another flurry of descriptive gestures, to avoid all the Albanian villages, such as San Constantino and San Paulo. "Very strange peoples. They still have vendettas—every family has a *Kanun,* a "Book of the Blood," to keep record of killings. Stay away."

I looked at my map and estimated that Matera was an easy three-hour drive at the most from Pietrapertosa. I thanked the elderly man for his advice and told him I'd leave immediately, and that I'd also avoid the Albanian villages (for the moment at least).

He smiled and appeared relieved at my decision.

I was tempted to ask more about the "strangeness" of Aliano but decided that I'd prefer to explore the place on my first visit without a bagload of biases, preconceptions, and myths. A friend of mine in the U.S.A., who also had a home in Italy, had warned me just before I left about "crazy village vendettas" in Basilicata, fueled by ancient prejudices, half-remembered slights, and rivalries, and the endemic ethic that "anyone who's not from our village is either a cheat, a liar, a philanderer, or a werewolf in disguise."

I'll try to retain my innocence and neophyte bliss as long as I possibly can, I told myself as I left Pietrapertosa and curlicued my way down dozens of curves and ridiculous hairpins to the wide, straight main highway along the Basento Valley.

AT FIRST MATERA was a real letdown. Sprawling endlessly across a high ridgetop, the city appeared to consist primarily of ugly, new tower blocks, traffic-clogged streets, and architecturally neutered neighborhoods whose arbitrary layout and tangled inter-sections only served to leave me disoriented and disappointed.

There were plenty of signs pointing the way to the *Sassi,* but every time I thought I'd arrived, there'd be another sign sending me off in another direction totally contrary to the first. Finally, when I was convinced that I was somewhere near the old historic core of Matera (streets suddenly blocked to traffic with Pedestrian Area

notices were a useful hint), I parked the car and decided to walk until I found what I was looking for.

And what I was looking for was pretty amazing: spectacularly deep *gravine* (calcarenite-limestone gorges) pockmarked with ancient Neolithic earthworks and caves dating back to 500 B.C.; medieval hermitages; more than a thousand cave chapels (*chiese rupestri*) rich in Byzantine frescoes, some dating back to the eighth century; and profusions of cave houses dug into the soft, golden bedrock in the two cliffside *Sassi* "amphitheaters" (Barisano and Caveoso). Despite constant invasions by the Greeks, Byzantines, Lombards, Saracens, and Normans, the bizarre *Sassi* communities continued to expand and flourish. The city, one of the world's most ancient settlements, became such a prosperous trading center that in 1663 it was declared the capital of Basilicata, and remained so until the Napoleonic era, when, in 1806, Potenza, way to the north, was selected instead.

Overcrowding and negligence in the two unique *Sassi* districts eventually led to appalling living conditions, with peasants sharing their cave homes with livestock, suffering from the rampant spread of disease, and finally finding a voice of protest in individuals like Carlo Levi. His impassioned writings and speeches led to a special law requiring the forced abandonment of the *Sassi* and the relocation of more than twenty thousand inhabitants.

Levi offers a formidable picture of life in Matera in the 1930s, through the eyes and words of his sister, Luisa, also a physician and social activist. She captures a truly Dantesque vision of squalor and poverty:

> *The houses were open on account of the heat, and as I went by I could see into the caves, whose only light came in through the front doors. Some of them had no entrance but a trapdoor and ladder. In the dark holes with walls cut out of the earth, I saw a few pieces of miserable furniture, beds and some ragged clothes, hanging up to dry. On the floor lay dogs, sheep, goats and pigs. Most families have just one cave to live in, and there they all sleep*

*together; men, women, children and animals. This is how 20,000
people live. . . . the children have the wizened faces of old men,
their bodies reduced by starvation almost to skeletons . . . most of
them had enormous, dilated stomachs, and faces yellow and
worn with malaria.*

Only the intervention of UNESCO in 1993 saved the complete
destruction of these unique places. Today, so I'd read, massive efforts
were under way to restore and rehabilitate the cave dwellings. So suc-
cessful apparently had such initiatives been that *Sassi* houses were
becoming de rigueur among the young and wealthy, and the canyon
dwellings were coming back to life as affluent, fully functioning com-
munities, complete, in many instances, with air-conditioning and all
the modern conveniences of the twenty-first century.

I wandered around a little aimlessly at first, following mislead-
ing signs, and then suddenly everything fell into place. Actually
dropped would be the more appropriate word because as I followed
the slow downhill curve of Via XX Settembre, I landed abruptly and
unexpectedly in the vast Piazza Vittorio Veneto, the great *passeggiata*
meeting place of Matera. Bound by elegant and richly adorned
churches, a stately library and government center, palazzos, and
numerous restaurants, coffee bars, and kiosks, this almost-circular
space is the heart of the old city, focal point of all its great festivals
and processions, and a prime viewing point (at last) of the great
canyonlike bowl containing Sasso Barisano.

From a shaded belvedere I could peer hundreds of feet down
into this amazing bronze-and-cream-colored intensity of ancient
urbanity. Clusters of cave houses, their façades often adorned with
baroque and classic motifs, tumbled in seeming chaos down the face
of the canyon and into the great bowl below. Sinews of alleys and
endless staircases and tunneled streets suggested some order and
logic to all the confusion. However, as I left the bustle and chatter of
the piazza and began an arduous descent down into the *Sassi,* I
quickly realized that such order could really be appreciated only
from the belvedere high above.

I became disoriented. But it didn't matter. The place possessed such a hobbit-land appeal that I wandered, as I had done in Castelmezzano and Pietrapertosa earlier that morning, as if in some kind of surrealist dream. I peered in at the powerful frescoes of the Byzantine chapels, followed serpentine alleys where the façades of the leaning houses almost touched one another, explored dark underground passageways that suddenly emerged into tiny, bright, flower-bedecked piazzas, and gazed up at the golden glories and delicate slender tower of the *duomo*, Matera's great cathedral dating back to 1270 and dedicated to the Madonna della Bruna, a patron saint of the city. I was particularly moved by the Church of Santa Maria di Idris. Carved deep into an enormous, craggy pyramid of golden rock known as Monte Errone, the church had a richly decorated, cool, cryptlike interior adorned with twelfth-century frescoes, whose soft colors glowed almost magically in the half-darkness.

Somehow I edged and nudged my way into the southern *Sassi* bowl, Caveoso, and slowly began to climb up through more echoing tunnels and sinewy staircases to the Via Ridola and the great austere seventeenth-century façade of the Domenico Ridola National Archaeological Museum.

Returning slowly to Piazza Vittorio Veneto, and passing the baroque extravagance of the Church of Purgatory, dripping with grimacing skulls, crossbones, and other all-too-obvious reminders of the fate that awaits us all, I celebrated the fact that I had come full *Sassi*-circle without any mishap. I must admit that all of those endless steps leading out of the bowl had set the old ticker tocking along a little faster than I'd have liked. But I was still alive, breathing (panting actually), and ready for a big, frothy cappuccino and an enormous slab of one of those sumptuous, cream-laden Italian confections I'd seen displayed almost erotically in store windows and coffee bars around the piazza.

As I sat watching the clusters of men and families gathering for their evening *passeggiate* and chats, the lights came on deep down in the *Sassi*, creating a truly fairy-tale tableau of illuminated

architectural exuberance. I then decided that I should stay here a day or two and try to capture the tumult and fantasy of all this in my sketchpad. A definite "must do."

Sketching Matera

The day before had been a frustrating day. My sketch of Matera's ancient *Sassi* dwellings just would not take shape. I had an *idea* of what I thought I wanted to say with the illustration, but the pen and brush resisted, the line was uncertain, vague, and the mood of the sketch was essentially one of vapid blandness with a few gimmicky flourishes I added to make me feel better. But they fooled no one. Certainly not me.

Today is entirely different, and I have no idea why. I'm sketching the same subject, the weather is the same—bright and fresh and cool—and my mood is essentially similar to that of yesterday, if maybe a trifle angst ridden.

I don't like it when sketches refuse to gel. It unnerves me and reminds me of the tenuousness of that vital link between eye, brain, and hand. I guess I suffer from that same deep-lurking dread felt by anyone who tries to create something out of nothing—to fill a blank sheet with words or drawn lines or brushstrokes that communicate something worth saying. That dread of numbness, that dread of the day when nothing comes because the eyes refuse to see, the brain refuses to think or feel, and the poor hand remains poised motionless above the increasingly threatening whiteness of the empty page.

But this morning that specter of doom vanishes as soon as the pen begins moving across the page. Everything seems, as they say, to be "in sync," "in the zone," or even "in the Zen" (irritatingly glib phrases, but when you're there, you certainly know it). And I'm so relieved that I try something I've never done before. I turn on my tiny voice-activated tape recorder and mumble and murmur away to myself, telling myself what I'm seeing, feeling, and trying to express, while my hand scurries across the paper as if it had a life

entirely of its own. All I have to do is look and let the wonder of a hundred little observations work themselves into the page without any self-conscious concern for the niceties of style or composition or technique. All those elements seem to take care of themselves as I stream forth my scattered observations into the tape:

~ Splendid sensations of vast space and aloneness here—these great sunlit stones under a cloudless, deep blue sky. Powerful, sculptural, and yet possessing something of the mysterious, hollowed-out solitude of a Hopper painting.

~ The brutal, muscular surge of the tufa cliffs from the shadowed depths of the Gravina River gorge; they say it's three hundred feet deep, but it feels more like three thousand. The brilliant, antipodean sun dapples, illuminating the cliffs with dark bronze hollows of hundreds of hand-hewn caves and the dazzling patches of peach ochre, where landslides have sliced away sections of strata and revealed its rich, creamy interior.

~ The amazing variety of texture and light falling on flat planes of rock, the gradations of shadow and those enticing niches that appear totally in shade, but when you peer closer, you can see that golden glow of reflected light that seems almost to exude from inside the stone itself.

~ And despite this exuberance and dominance of stone, small violently overgrown patches of grasses and bushes and cacti and even two solitary dwarf palms are all sinewing in snake-like intensity on perches along the bright white and deeply eroded contours of this magnificently gouged-out bedrock gorge.

~ Gradually the cliffs and lower hollows and caves are merging—almost like osmosis—with the first Paleolithic dwellings and then into the eighth- to twelfth-century walls and houses and church façades carved directly into the rock. Then more cubist projections of houses combining traditional block by golden block of carved stones with ancient cave interiors. Then flowing higher into staircases and over-

hangs and arches and tunnels and balustrades carved directly out of the bedrock. Soaring, soaring, higher and higher. Each level a little more sophisticated and finessed than the one below it—a sort of vertical history of form and of man from prehistoric times through early Byzantine cave churches, with their religious wall paintings still intact, and all culminating in that one gloriously slender and simple tower of the twelfth-century cathedral, built on the site of the sixth-century Church of Sant' Eustachio.

~ The whole ancient *Sassi* town seems to be moving, undulating, breathing like a living creature. It combines the immensity and strength of form and outline of Henry Moore with the fluid exuberance of van Gogh. Similar colors to Cézanne's paintings, too, with those more subtle, flickery, restless forms of El Greco, and sudden Fauvist flashes of violent color when a line of washing radiates against the cream beige and golden unity of the *Sassi*. Even the pantile roofs possess a harmony of colors, darker, fire-burned versions of that golden bedrock clay from which they were formed. And as the sun, glittering now like hammered silver, surges brighter and hotter, the whole place begins to vibrate and radiate, and lines swirl and buckle, and the shimmer starts as the cold air from the canyon below rises up to be simmered in the day's new heat.

~ It gets to the point where it's not real anymore. I don't know yet how this sketch will work. I'm trying to give the place form, unity, and structure, and yet it seems to want to disintegrate like a Bacon painting, or even one of those furious Kandinsky "women" works.

~ Now I can feel my hand rejoicing in its freedom, and I hardly dare look at the lines because it may all be an utter mess. But it feels so right and powerful, and I sense the town is looking right at me, talking to me, urging me to celebrate its utter uniqueness, its gloriously chaotic nature, and its wildness of spirit and form. Thing is—can I do it?

I'm finished, at least for the moment. And I'm exhausted in that pleasantly reassuring way when you know that, whatever the outcome, you've had a true experience, a real communion with your subject.

Time for a glass of wine in the piazza.

Thank you, amazing Matera. Your organic forms will always be in my head when anyone speaks of the "growth of a city." And I'll think of—I'll know—one place in the world that actually looks as though it's grown out of the ground like a living thing—from gorge, to carved cliffs, to caves, to houses and churches, up and up to the very pinnacle of that beautiful cathedral tower.

I smiled to myself. The art is always where the heart is. Today was a good sketching day.

Pietro in the Piazza

I decided to celebrate this period of successful image-capturing with a glass of *prosecco* (sparkling wine)—a popular lunchtime aperitif among urbane cityfolk—in the piazza on Via XX Settembre. And that's when I met Pietro. We literally bumped into each other at a coffee bar. The bar was so dark and he so gaunt that I failed to notice him and almost dumped my wine on his long, black overcoat. Fortunately the incident was resolved by laughter, and we strolled together across the piazza to the arcaded belvedere overlooking the *Sassi*.

As we walked, Pietro handed me "a typical piece of Italian propaganda," as he called it. But it didn't look like your normal slipshod political tract. In fact, it was a fine tabloid-size, folded brochure for a "Miro in Matera" exhibition that had just ended. The brochure was filled with reproductions of some of the world-famous artist's most fluid and childlike sketches, a couple of them so off-the-wall loony and light that they seemed to whirligig above the page. I smiled at the infectiousness of Miro's art. This seemed to irritate Pietro.

"No, go to back of this . . . brochure, where the town gives you its propaganda!" he said.

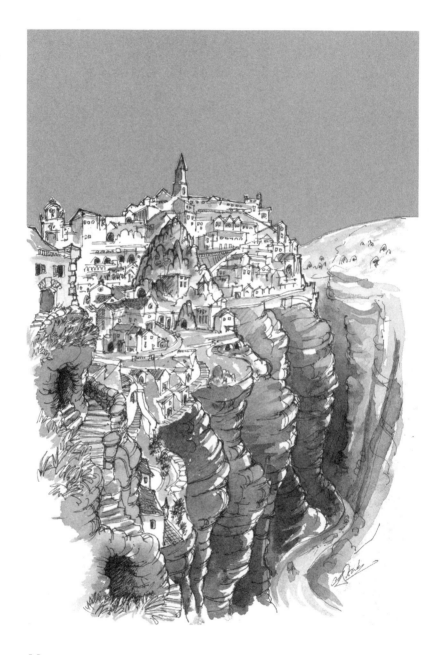

MATERA

I turned the brochure over and found an enchanting piece of Italianish self-promotion that read exactly as follows:

Culture and Matera: An inseparable combination. *This pittoresque town of southern Italy, the origins of which have lost in the mists of time, can justly boast supremacy that derives from uniqueness of its ancient Sassi. This is example of how human settlement can be done inhabited, without interruption, for at least five thousand years. Houses overlook the cobblestones of the same courtyard, incouraging a mutual exchange which is today irretrievably lost in the progressive dehumanization of the modern city. Carlo Levi was inspired to renounce the inhuman conditions in which peasants lived in the south, in his book* Christ Stopped at Eboli. *Today Levi's prose belongs to far-off times. After the declaration of Sassi as world heritage by UNESCO the restoration experience of these old carved cave houses is become a methodological indication of the historical centers of the Mediterranean area. Matera is part of a world that is still in tact, untouched by the follies of contemporary life. But at the same time it is looking towards future.*

"So, what do you think?" Pietro asked.

"Sounds like they're pretty proud and want to improve the old town."

"Improve! That's not improve! They should pull all down! Destroy! This is terrible history of town. I am very ashamed."

"Ashamed?" A voice of protest emerged from a nearby coterie of black-coated elderly gentlemen. The piazza was full of them: all usually neatly dressed and, even during their lively discussions, maintaining their flimsy veneers of carefully nurtured social accretions and gentile behavior. The whole street was a daylong *passeggiata* for such men, culminating in the full-blast evening promenading that was so thick with static groups and slow, oozing-lava flows of stocky, swarthy Materans that it was almost impossible to negotiate a way through them.

Apparently never one for avoiding a good argument, Pietro swung around in true alpha-male fashion to face his diminutive, elderly challenger, who stood eyeball to Pietro's chest, his face blotched red in protest.

"Yes, I am ashamed!" Pietro shouted, swinging his arms operatically to emphasize his dramatic *cri de coeur.* "To think that people are now coming from all over the world to look at this terrible way that we lived. In caves! One tiny wet room for the whole family, plus chickens and goats and pigs and whatever!"

"Stupid!" his stocky challenger rejoined. (There go those fragile veneers of mutual respect, I thought.) "The house, as you call it, was just bedroom. That's all. The street was the house. Everything was done in the street: cooking, eating, looking after the children. Everything."

"That does not change anything. You are missing—"

"Yes, I agree." Another elderly gentleman decided to join the fray, and notched up the noise level a little more. Other groups paused to listen. People began edging closer. Nothing like a grand rhetorical battle to get the Italian blood flowing and the Mezzogiorno sensibilities stimulated.

"Nonsense!" said another, a rather blimpish *bluffeur,* quivering with Materano pride. "The *Sassi* have made Matera famous. Before this, who had ever heard of our city? Not even in Italy."

"That's very true," a fourth entrant to the huddle cried out.

"But what you are forgetting is . . ." rejoined Pietro, trying to reclaim his position as prime spokesman in this rapidly expanding crowd.

Within a few minutes there must have been thirty or so black-coated Materans crammed into the little belvedere *Sassi*-viewing area, and I was being pushed closer and closer to the railing and a vertical tumble of fifty or so feet to the pantile rooftops of the older cave houses below. One surge from this vociferous bunch, and I'd be over the edge.

"What you forget," continued Pietro, who towered above his jostling audience, straining his neck and head even higher, like a

goose in a chicken coop. "What you forget . . ." Still not fully gain-
ing their attention (I could see him thinking of some strikingly stri-
dent phrase that would clinch his self-appointed role as prime
speaker; it finally came to him), he said, "We are *all* still peasants!"

Silence descended like a thick shroud. The men stopped in mid-
gesticulation, and all eyes turned again on Pietro. "Yes," he said,
knowing he had recaptured their attention and maybe scratched off
a cultural scab or two. "Yes, peasants! We are not much different
now from then: Maybe we live in a large cave in the sky in one of
those concrete public housing apartments. Maybe a little hot water
and a tiny pension. But in our hearts, in our heads, in our spirits are
we not still peasants compared with the people in Rome and in
Madrid? Because that is how they still see us! Southern Mezzogiorno
peasants! *Terroni!*"

Pietro's eyes gleamed behind his rimless glasses. His fisted
hands moved with Lenin-like determination and emphasis. He
reminded me of one of Carlo Levi's characters in his huge and
famous painting in the nearby Carlo Levi Center. Unfortunately I
had seen the work only in reproduction (the center being invariably
'closed for renovations'), but it showed Levi's antifascist friends in
full rhetorical swing, preaching their "power to the people" gospel,
which, even today, so infuriates and unnerves the politicians of the
North.

My position against the railing was now even more tenuous. The
crowd was still increasing, jostling, shouting, decrying Pietro's
words as blasphemous or supporting them with raised fists and the
fire of revolution in their eyes. The quiet, methodical, almost som-
nolent pace of the *passeggiata* was gone now. Pietro had become the
focal point of a vehemence that seemed to lie just under the surface
of this normally staid and steady populace.

But sheer survival was my primary focus now. The crush against
the railing was painful and precarious. So, with a flurry of "*Mi scusi,*"
"*permesso,*" and "*attenzione,*" I elbowed and kneed my way through
the throng to the safety of the main piazza.

Pietro was still in full swing. I discovered that my newfound

friend had much gusto and crowd-galvanizing eloquence in him. I watched him a while longer, but the clamor was such that I couldn't understand much of what was being said. Briefly catching his eye as he ranted on, I mouthed, "Bar" and pointed to our previous meeting place across the piazza. And then—with a dual focus that convinced me that he truly was a politician in the making—Pietro gave me a wink and nod of agreement while still holding forth in full *appassionato* flair, flailing his arms like a Mussolini wannabe and apparently loving every crazy second of it.

A quarter of an hour later he finally joined me, his eyes still sparkling with passion and the possibility of new futures for a side of himself that even he seemed surprised by.

"Congratulations, my friend! That was one hell of a show," I gushed.

He grinned in agreement but also dismissed my compliments with a big Italian shrug and a modest *"prego, prego."*

But then, quite touchingly, he descended from his clouds of eloquence and brief glory to a more mundane conversational style, devoid of all florid rhetoric, and smiled at me. *"Grazie. Mille grazie,* David. Now, what were we talking about before?"

I realized once again what a host of characters lurked inside each individual Italian, and how comfortably and easily they seemed to allow all these different, and contrasting, facets of themselves to make brief, and often very memorable, appearances on the stages and in the performances of their daily lives.

Ode to Simplicity and Love

Which leads me to another type of performance, and another insight into the Italian psyche, experienced that same day. If I could craft this little memorable mini-event in poetry, I'd be very happy. But, alas, my poetic skills got stuck at about the same level as my high school piano lessons, barely above scale-playing ability. Possibly unfairly I blame all this on two teachers. The English literature fellow somehow managed to suck out all the marrow of poetic creation

in me and restrict my attempts at composition almost entirely to rhyming pentameters. Any attempt at free-form verse was greeted with ridicule and, on more than one occasion, a hundred punitive thou-shalt-not-type lines to be written out while others enjoyed games of rugby or cricket beyond the classroom windows. As for the piano teacher, the less said the better. She was an unfortunate, dispirited spinster who seemed to hate all young boys, all music, the piano, and anything else associated with the subject. I sensed no love in either teacher for what they supposedly taught, so my interest in both poetry and the piano quickly shriveled too.

All of which has nothing directly to do with the little story I'm about to recount (although there's certainly a moral floating about somewhere—something to do with intensely loving whatever you do). The incident took place at a restaurant I'd just discovered in Matera. A tiny shoebox of a place carved, like so much of the old city, out of the soft golden tufa bedrock and hidden down a couple of flights of stairs off the main piazza. It had half a dozen tables, a large fireplace, rough walls of native rock, and two windows with spectacular vistas across the great bowl of the ancient *Sassi* city.

The maître d' of this modest establishment was the chef's son, and he had the gift of making the simplest of homemade pasta dishes sound so entrancing it was impossible to select one from among them. So I left it to him and his father to serve me whatever they considered to be the best dishes of the day.

On this particular night, after a deliciously rich and tender *orecchiette* ("little ears" pasta) with a *ragu* sauce of ground pork and beef, the chef's son presented me with one of Italy's classic dishes: a fritto misto of deep-fried prawns, small pieces of fish, and calamari. Now, I've enjoyed such a dish many times before, often with a far more varied selection of seafood and with batters ranging from a delicate tempura to bold English ale fish-and-chips-style to American onion-ring crispness. But the fritto misto that night was easily the best. As soon as I bit into the first calamari slice through a crisp golden skin and into a briny, succulent softness, I knew I'd found genius. Calamari are notorious for rapidly developing a tasteless

and rubberized quality that makes eating and swallowing them a most unpleasant chore. But the chef here was obviously a master of the art of maintaining their subtle sea and seafood flavor, soft texture, and ultra-crisp exterior.

After dinner I asked if I could thank the chef and ask him for the recipe for his rendition of the *fritto*. His son led me into a kitchen barely bigger than a bathroom and introduced me to his father. When I asked him for the secret of his perfect fritto misto, he laughed and put all the fancy chefs to shame with a single word, "Simplicity!"

"Three things only," he said. "I buy the freshest baby calamari I can get. I slice them and let them sit in a mix of sea salt, water, and fresh lemon juice. Then I dry them and toss them in durum flour and fry when the oil is just beginning to smoke. And that's all."

"No eggs in the batter?" I asked. "No salt, pepper, or spices?"

He leaned forward, gripped my arms, and said, "Simplicity. Is love for the thing you cook, not how clever you cook. Simplicity is love! And love makes your cooking sing!" (All of which sounds so much better in Italian.)

Meeting the Professor

On the third day I decided it was time to get serious and learn more about the city and Carlo Levi's links with it. I was frustrated at constantly finding Matera's Carlo Levi Center locked up and guarded by officious uniformed characters who seemed to take great delight in telling people to buzz off. So, I decided to seek out the director of the place and tell him what I thought of his off-limits center and his guards. Instead I found myself in a delightful phone conversation with a gracious gentleman, Professor Nicolà Strammiello, who suggested we meet so he could show me around the institution he had founded more than twenty-three years ago.

I saw him approaching long before he spotted me. I couldn't miss him, really. He had a distinct don's way of walking, measured and flowing, with his long, elegant camel's-hair coat wafting cloak-

like around his calves. He looked distinguished, appropriately pro-fessorial, and yet rather jaunty, with his tall, lean frame, trilby hat set at a rakish angle, and bright scarlet tartan-pattern scarf tied like an ascot around his long, ramrod-straight neck.

The Professor moved closer to my bench by the *libreria* (book-store) but he still hadn't seen me. His eyes seemed to move hazily from his meticulously shined shoes to somewhere high above the pantiled rooftops of the *corso*. He looked deep in thought—presum-ably deep professorial thought—and seemed oblivious to the passing scene. Not that there was much scene passing at the time, but he was oblivious to it anyway.

And, as I was about to rise and introduce myself, I experienced a sudden thwack of intense déjà vu.

"Look, look!" something inside me cried out in joy and surprise. "This isn't the Professor at all but someone you used to love more than any other person you were aware of, perhaps even more than your own parents." It was someone I had also lost—abruptly, cruelly—to a sud-den heart attack when he was in his late seventies and I was ten. I'd wept then as I'd never wept before. He had been my special friend, my only real grown-up friend, and I felt it was all so unfair. He was the kindest, gentlest man I'd ever known. We used to talk together, like equals, as we sat eating the delicious tomatoes he grew in his hothouse at the bottom of his meticulously preened garden in Yorkshire.

The Professor was my grandfather! George Herbert Marchant. A serious businessman, director of his own modest copper and bronze foundry (an enterprise that later failed), proud owner of a magnifi-cent Alvis limousine ("next best to a Bentley," he used to insist, "but less showy"), and lover of the good life—good food, good music, and good conversations (even those held with his ever-curious and rather rambunctious grandson). My parents were always begging him to "please stop encouraging the child" when he and I wandered off together to explore the nooks and crannies of his garden or sat side by side, looking at *National Geographic* magazines, his favorite "good read" and, hence, mine at the time. And together we dreamed of faraway places.

"You're putting far too many ideas into David's impressionable little head," my mother would reprimand him. "He now says he wants to spend his life traveling all over the world!" (Ironic, eh?) And my grandfather, who was actually a rather quiet, shy man of gracious manners who rarely raised his soft voice above a melodious, meditative whisper, would smile mischievously, accept the reprimand with a good-natured shrug, and ask, "So, what's for dinner?" or "Have you seen my new roses?" or "Is the wine open yet?"

The image of my grandfather grew stronger as I walked up to the Professor and reached out to shake his hand. That long, gentle face, a little jowly and striated with tiny veins, the slightly purple nose, that mischievous half-smile, those eyes—soft hazel with the faintest haze of blue around the pupils—and then his hand. It was too much. I was trying to express my pleasure at meeting this stranger, and yet I felt as if I were shaking hands with my grandfather, feeling the same silky smoothness of his tissue-thin skin and seeing the delicate veins of his hands showing quite clearly through the almost translucent flesh, his manicured nails, with their mauve-colored auras. And wanting to hug him!

I was so utterly gobsmacked by these bizarre sensations—deep affection, anger at his having left me so abruptly, near tears of relief at seeing him again, joy at that conspiratorial smile of his that seemed to say, "just between us, isn't this a wonderful, zany, beautiful world we live in?" Best of all was that gentle face, with its almost Buddha-like aspect of calm contentment and pleasure at seeing me again after such a long, long time.

Fortunately, I was able to get through the "so very pleased you could spare the time" prelude without hugs or tears or laughter or anything else that might have revealed to this man the odd mix of emotions I was feeling.

The Professor responded just as my grandfather would have done, with a beatific smile, warm, shining eyes, a gracious nod of acknowledgment, and a slow, soft homily about the pleasure being all his and please excuse his English and how nice it was to be outside on such a splendid day of warm sunshine and blue sky.

I had to avert my eyes. The sensations were still too strange and eerie. *This is not Grandpa, stupid!* I told myself, so start thinking and talking about something else before you make a complete idiot of yourself and become a real *scemo* (one of little intelligence) in the middle of Matera's main street.

MATERA MONTAGE

I suggested we stroll to an adjoining terrace overlooking the southerly of the two amphitheater-like *Sassi* districts and began asking him about the history and ongoing restoration of this unique masterpiece of organic "architecture without architects."

And that was the right thing to do, because it got my mind off this beguiling reincarnation and encouraged the Professor to expound on the city and its famous *Sassi* at length, eliminating most of the preconceptions I'd gleaned from careful (or so I thought) research.

No, he told me, in measured, eloquent English, the original cave dwellings on the opposite face of the vast gorge that formed an abrupt, dramatic boundary to the city were not Neolithic, as many claimed, but actually Paleolithic, dating from 10,000 B.C. Matera, he emphasized, is one of the oldest cities in Europe. And no, most of the buildings in the two adjoining bowl-like *Sassi* districts on our side of the gorge were not, in fact, caves, as misleading guidebooks claimed, but freestanding structures built close to, but rarely into, the rock face.

And yes, it was true that some of the present houses were caves with façades added on, but most of the caves had actually been used originally as shelters for religious hermits and as churches, and later as storage areas—*cantine*—for livestock, wines, and preserved vegetables and meats. And no, it was not commonplace in Carlo Levi's day for homes to be occupied by both people *and* livestock. That practice had always been vastly overexaggerated by those wishing to denigrate the Mezzogiorno and deride the way of life of its poorer *terroni* inhabitants.

"Because, you see, you must understand," he said, with full professorial emphasis on the *must*, "Matera has always been a place of great wealth. Just look at our shops, our churches, our museums today. We are not a poor city at all. The whole of that vast empty plateau you see beyond the gorge—we call it *le Murge*—is one of the largest wheat-growing areas in Italy today. And we have always, in history, been an important place for mills and for trading; even the Greeks and Romans traded together here. The Greeks, as I'm sure

you already know, founded a number of important cities along the coasts of Basilicata and Calabria. This was part of Magna Graecia, and today we still have some ruins left at Croton, Sybari—home of those very indulgent Sybarites—Locri, Taranto, Metaponto, and others. The best ruins are at Metaponto—if you can find them! A beautiful temple—you must see. Virgil, Ovid, Pindar the poet, and Horace: they all loved the landscape of the South. And Pythagoras. His school of philosophy was founded in Croton in 531 B.C. And even when the Normans occupied the city in the eleventh century they granted it very special privileges and made it an even more wealthy place."

On he went, this true Matero-phile, demolishing so many of my impressions and cutting to the core of fact with such precision that I felt it was time to forget all about his resemblance to my grandfather and start to challenge some of his professorial authoritativeness . . . delicately, of course. The Professor not only was a gracious man but he also had a mischievous glint in his eye that seemed to invite spirited, but scrupulously polite, debate.

"I understood that Carlo Levi was so incensed by the inhuman living conditions of the Materani down in the *Sassi* that he triggered a whole new attitude toward the problems of the Mezzogiorno," I said as forcefully as I could. "They even say he managed to have much of the area closed and public housing built for the impoverished population. Good housing—well planned, with lots of air and open space."

The Professor smiled, stroked my arm affectionately, gave one of those odd "devil's horns" (*corno*) gestures (a closed fist with index and pinkie fingers extended and wiggled as a protection against "the evil eye"), and said, "Aha! An admirer of Levi, I see. Well, in that case I have something to show you in my center." He pointed down the street to the elegant façade of Palazzo Lanfranchi, a mid–seventeenth-century seminary, part of which was now being used as Matera's Carlo Levi Center.

"Ah, yes, I've been there before, but it's always closed for restoration."

"Ah, yes, the restoration. Of course. A long process."

"How much longer, do you think?"

He leaned forward conspiratorially, gave another one of his wiggling *corno* signs, looked around to make sure there were no eavesdroppers, rubbed his thumb and forefinger together in the universal "it's all about money" gesture, and whispered, "Who can say? You know what I mean? Who can say, eh?" He ended by tapping a finger on his cheek just below his left eye (the popular Italian *furbizia* gesture indicating conspiratorial insights).

But this time, despite the "ongoing restoration," I was able to enter the modest rooms of the center and its small conference hall and library. "And now, the best room of all," said the Professor, leading me by the arm across half-completed flooring into a large cryptlike space and pointing at an enormous series of ten-foot-high painted panels extending over sixty feet along one of the walls.

"So, tell me what you think of this!" he gushed, his eyes twinkling.

And there it was: Carlo Levi's most notorious and skillful artwork, his *Lucania '61*, painted for the Turin "Italia '61" Exposition—a centenary celebration of Italian unity—and regarded by many as one of his most blatantly strident and socially condemning of all his works.

Its impact was overwhelming, so great in fact that I couldn't absorb it all at once. I had to study it segment by segment, guided by the loquacious Professor, whose enthusiasm for this huge masterwork knew no bounds. Many of the finer subtleties and graphic jibes at local politicians and the omnipresent "Luiginis" (Levi's term for "middle-class petty power parasites") were lost on me. However, its ultrarealistic depiction of the appalling living conditions of the *terroni* in Matera and the surrounding hill villages, the furor of outrage and protest by such writer-philosopher-orators as Rocco Scotellaro, one of Levi's closest friends, and the fear and trepidation on the faces of the regional powerbrokers at the possibility of revolution and retribution, all burst from the canvas like riotous explosions. And Levi's choice of colors—from the dark hovels filled with even darker coteries of black-clad widows to the glaring scorch of

the summer sun on the bodies of bone-weary peasants to the vibrant hues of the angry crowds—reflected perfectly the range of moods and powerful actions he intended to portray.

Great art speaks, and this masterwork spoke volumes of almost biblical length and import. I left the room dizzied by the scope and power of the work.

"Coffee, I think," the Professor suggested as we strolled out from the ancient palazzo to a nearby coffee bar and enjoyed espresso and grappa *corretto*. Well, that's not exactly true. The Professor limited himself to a fruit juice; I was the one with the *corretto*. (I always have to be careful when ordering not to confuse a *corretto* with a *cornetto*, which is only a sweet croissant and has far less immediate impact upon the system.) But I felt I needed it. The vividness and horror of Levi's painting—a vicarious journey into Basilicata's heart of darkness—had left me emotionally limp.

"I think you were impressed, eh?" the Professor said, as the *corretto* worked its restorative magic.

"Yes, indeed. But you know, I'm still curious, and the more I listen to people here the more curious I become. As founder and director of the center, what do you feel was Levi's real legacy to this region? What was the true impact of his book, his art, and his later role as a senator in the national government?"

The Professor had obviously been asked the same question many times before but seemed willing to give it a full response. "Why don't we walk in the sunshine? I'll tell you some things that may interest you."

FOR THE NEXT HOUR or so he displayed his full wisdom and insights, and although I'm sure I missed many of the finer points of his rhetoric, some key ideas filtered through that helped me better understand the context and impact of Levi and his beliefs.

Perhaps our greatest problem nowadays, the Professor suggested, is that we have forgotten what a wild, idea-filled ethos existed in the world during the early and middle part of the twentieth century. Great revolutions—in France, Russia, Spain, Italy, and

other countries—revealed new societal possibilities, structures, and power, particularly the enormous power of "the masses," destitute downtrodden peasants, serfs and mass-production factory workers. The two terrible world wars were direct manifestations of the great conflicting "isms" of the day: socialism, communism, nationalism, fascism, and capitalism.

Levi's first, and for many his most powerfully strident, book, *Of Fear and Freedom* (*Paura della Libertà*, 1939), can be truly understood only in the context of this turmoil-filled time of political schisms, revolutions, and wars whose scale of horror and devastation had never been known before.

"Levi saw such battles as conflicts for the very soul of man," the Professor explained. "How to save mankind from the tyranny of petty-power oppression, unending exploitation of the underclasses, revisionist historical manipulation, and the utter corruption that entrenched power brings. He was particularly convinced that the little power men, the middle-class village tyrants, were the worst offenders, prohibiting all kinds of freedom and eliminating the possibilities for the lower classes, the peasants, to lead a civilized existence. He was very adamant when he wrote: 'These tyrants are a physically and ethically degenerated class, incapable of carrying out their functions and living on small robberies of a debased feudal rights tradition.' And Levi was also very critical of the power of the church. He said, 'Man is wandering through an eternal forest, in search of an eternal certainty: a certainty whose price is servitude and death. In such a drying up and shriveling of the soul, every self mutilation is thought to be holy . . . the sacred history of the world is a history of willing servitude.'"

"The church must have considered this outright blasphemy," I said. "Just like the state. Wasn't he equally critical of the over-whelming power of the state?"

"Oh, indeed yes," the Professor said. "He wrote, 'the state requires total slavery—and it commands to believe, to obey. Every individual autonomy, ever act of personal creation is, by its very nature, outside this law, inimical to the state—a sacrilege!'"

"Yes, I remember those words. So, his idea for returning power to the peasants—was that a kind of communism, as many claimed?"

"No, no, it was more complicated than that. Levi was returning to something far more basic—as he said, to 'a history outside the framework of time.' In the *terroni* of Aliano and other parts of the South he saw an ancient peasant civilization (that necropolis they discovered recently near Aliano suggests that this civilization goes back to at least 7000 B.C., beyond the Neolithic Age) suffering 'patient pain and nurtured by very ancient wisdom, outside of history, beyond even progressive reason.' And paradoxically, despite the centuries-long pounding down of these people by malicious pyramidal power structures, he perceived a young world that is still dawning, in which a new type of man was being, or could be, formed. An ancient world and yet one also potentially alive and present in an enlightened new world, the adolescence of centuries ready finally to emerge and play, like butterflies from their cocoons, like new shoots under the bark of trees. Levi saw, 'The Lucania in each one of us—a vital force ready to become fresh form, life, fresh intuitions fighting the entrenched paternal, landowner institutions in this claim for a new reality—new men making an entirely new history. All the Lucanias of the earth meeting the challenges of the future together and "giving a fresh start to history".' "

The Professor's explanations touched a chord. "I remember reading a wonderful passage Levi wrote about his enlightenment in Aliano," I said. "But I'm sure your memory is better than mine."

He smiled, his jowls wobbling with delight. "Yes, yes! He wrote: 'I suddenly realized I loved the peasants and a great feeling of peace entered me. I felt detached from every earthly thing and place, lost in a place far from time and reality. I listened to the silence of the night and felt as if I had all of a sudden penetrated the very heart of the universe. An immense happiness, such as I had never known, swept over me with a flow of understanding and fulfillment.' "

"Yes," I said. "That's the quote. It read almost like St. Paul's conversion on the road to Damascus."

"Yes, a beautiful revelation, beautiful. And Levi gave his life to this vision. All his life."

WHEN WE FINALLY said good-bye (I almost said, "Good-bye, Grandpa" but managed to catch myself just in time), I expressed sincere gratitude for the Professor's insights and opinions before giving his hand a farewell shake.

His smile was still my grandfather's smile, beatific and Buddha-like, and his handshake was firm and unusually long. He looked at me and into me in such a warm and intimate way that I wondered if he sensed a little of my earlier emotional confusion. Then he winked. A definite conspiratorial wink, followed by one of his now-familiar *corno* gestures.

Moments of Introspection

After all these professorial revelations of the Mezzogiorno's plight and Levi's role in attempting to stimulate the emergence of new men making an entirely new history from the downtrodden *terroni* masses, I knew it was now time to head for the source of Levi's visionary insights: Aliano itself. No more of these moth-circling-the-flame meanderings, although I was tempted to journey a little farther to the northeast, into Apulia and the strange land of the *trulli*. These unique, beehive-shaped houses and farms fill the high limestone plateau of *le Murge* around the town of Alberobello, presenting an almost fairy-tale picture of life in a very bizarre corner of Italy. But such a journey I knew would inevitably lead to a longer exploration of nearby Lecce, whose center is a gorgeous golden-hued city-shrine to Italian baroque at its most extravagant. Too much, I told myself. Focus!

From my map I guessed that Aliano was only a two, maybe three hour drive south from Matera, across a topography that appeared to be a lot less tortuous and tangled than the mountain wilderness I'd faced on my drive from Sapri to Castelmezzano.

So, bidding farewell for a while to the intriguing complexities

and strange beauty of the *Sassi,* I left Matera and headed toward the place I hoped would become my—our—new home.

Sweeping down again into the broad Basento Valley and then up the other side into a rounded series of ridges and hollows, I felt a sudden surge of utter freedom. Time, I realized once again, was all mine to do with what I would.

And apparently it was time for a little epiphany. My body tingled with excitement, and the car began to meander erratically on the winding road so I pulled off to the side and parked on the edge of a steep bluff with grand vistas in all directions. And I just sat, still tingling, watching hawks cresting the thermals and sensing the softness of the breezes, like doves' wings against my face. I let my mind wander where it wanted to go, spooling through my life and adventures, relishing the subtle threads that seemed to link all my experiences and that had combined to bring me here, into the heart of Basilicata, perched on the cusp of something wondrous.

I always carry a notebook with me, full of the most enticing quotations from the learned, famous, and celebrated (and others less so) on the raison d'être for travel, the driving force behind (in my case at least) the dementia of endless journeys of discovery. And I find the sheer over-the-top honesty of Mrs. William Beckman in her book *Backsheesh* (1900) irresistible: "In the spirit I shall never revisit lands my eager, willing feet once trod. Travel has ever been . . . a passion so great it seems to me life beyond the grave will not be full or complete unless it be that Eternity means wandering from one fair world to another."

What a blissful idea (and blissfully stated)—that heaven might be a continuum of the joys of travel! Unfortunately, although known by my closest friends for my unbounded optimism, I have never quite been able to convince myself that this might come to pass. It may well be, of course, in which case my wanderings will continue undaunted after my passing into Mrs. Beckman's "fairer worlds." But I've always erred on the side of spiritual caution (not pessimism, I tell myself, but merely a sensible rationale) and have tried to cram into this immediate life, as much randoming, wandering, and peri-

patetic perambulating—whatever you wish to call the way I satisfy my constantly restless nature—as possible. This sense of urgency had been exacerbated by a number of near-death events that, in hindsight, seemed to be regular and necessary reminders of the constant fragility of mortality. So, I didn't waste time. I made no exaggerated assumptions about my longevity and certainly none in terms of afterlife adventures.

Here's another favorite quote from my notebook that set the seal on all my "road less traveled" explorations. And who better to express the idea than the irascible, irresistible Mark Twain: "Your road is everything that a road ought to be . . . and yet you will not stay on it, for the reason that little, seductive, mysterious roads are always branching out from it, and as these curve and hide what is beyond, you cannot resist the temptation to desert your road and explore them."

Ah yes. Those "temptations to desert" still guide most of my journeys, which continue to invite "small epiphanies" (another lovely notebook phrase I picked up somewhere), celebrate serendipity, and generate wonder at whatever marvels may be revealed around the next curve, and all the other ones after that.

And indeed they have done throughout my traveling life, which began at the ripe age of thirty with what was supposed to have been a short sabbatical from a career as an urban planner. I'd intended it merely as an intriguing interlude with Anne of a few months' duration to try to satiate a hunger for adventure and exploration that had been niggling and nudging us both for years.

Now, after thirty years "on the road," I realize that I was obviously seeking far more than satiation, far more than a calming of my restless nature, which would, I thought, allow my original career to continue and flourish, niggle-less. Apparently what I had embarked upon all those years ago was both a yearning for and a celebration of the possibilities of self-exploration, on a "soul-voyage" that continues to this day. I no longer seek satiation of that spirit and the forces that drive it. That spirit will not accept satiation, so I allow it to lead me where it knows it must go.

In hindsight, those three decades now seem so remarkably ordered and logical. Very early on in my sabbatical I realized that it was not merely travel I wanted but rather to share my journeys in as many ways as possible with others through articles, books, illustrations, photography, lectures, interviews, etc. I also found that I had little interest in exploring the more famous haunts of tourist and travelers. I chose instead the hidden, the secretive, the elusive places, which gave rise to books with such titles as *Backroad Journeys*, *Nooks and Crannies*, *Hidden Corners*, and, later, as I found myself taking on the whole globe and writing much longer works, *The World's Secret Places*, *The Back of Beyond*, and *Lost Worlds*.

My new life as a "world-wandering earth gypsy"—a title bestowed upon me by a reviewer of an early book (for herself Anne preferred the more modest "travel-mate")—also began to open up deeper ideas and themes related to travel. Exploration and adventure had obviously become (possibly they always had been) a metaphor for inner exploration and the search for the driving spirit that lurks within each of us. The spirit that nudges us all toward a closer relationship with and celebration of the breadth and multitudinous possibilities of our own protean natures. Walt Whitman insisted that "I contain multitudes" and James Hillman suggests our souls are "a community of many interior persons and each needs nurturing."

I also sensed a need to change the scope of my explorations and add a little more depth to my travels. Rather than giving myself the gift of the whole world and visiting up to twenty "lost worlds" for each book, I realized that I was becoming increasingly intrigued by the wealth of riches to be found in a single place.

I particularly agreed with the writings of Thomas Moore, who suggested:

> *Today many people live the external life exclusively, and when the inner world erupts or stirs, they rush to a therapist or druggist for help. They try to explain profound mythic developments in the language of behavior and experiences. Often they have no idea*

80

*what is happening to them, because they have been so cut off from
the deep self. Their own soul is so alien to them that they are
unaware of what is going on outside the known realm of fact.*

Moore also suggests, "The soul echoes ancient themes common
to all human beings. It is always circling home." But he emphasizes
that excessive soul-searching can lead to "dangerous seriousness"
and that "absence of humor signals a failure in basic humanity." He
senses that life is a divine comedy and that "heartfelt laughter" was
very much a part of "the mystical land before our birth."

In an attempt to combine the subtle, the serious, the sensuous,
and the gloriously silly, I began to unravel all the years of travel
memories, trying to discern larger constructs of comprehension
and richer patterns of experience. And this somewhat unexpected
and certainly intriguing introspection resulted in my sitting in my
little DoDo on that bluff with all its magnificent vistas and cele-
brating the months of surprise, mystery, and delight that lay
ahead.

My work, this book, was not to be a guide, so I had no need to
gather meticulous, tedious data on hotels, inns, and restaurants
(not that there were many in this part of Basilicata) or offer inter-
minable recitations of oft-told histories or describe, with a pseudo-
authoritative air, the trappings and iconic decorations of
ecclesiastical highspots (I didn't see many of those either). Nor was
it to be a sketchy, superficial tale of a fast week's wandering in "hid-
den Italy" for some touristy travel magazine. Instead, for once—for
the first time actually—I had a whole book to write on a single small
region and even primarily on one tiny village in that region. I was
about to give myself, and Anne (when she was finally able to tear
herself away from her teaching responsibilities in Japan), a chance
to meld slowly into village life, to talk, drink, and eat with the resi-
dents, to share their mirth and mysteries, to celebrate their festivals
and fun, and to offer our own little feasts and celebrations in return.
And then ultimately to try to capture this whole kaleidoscopic mon-
tage in words and sketches in a book. This book.

The First Spring

* * *

SLOWLY THIS SUDDEN surge of introspection and expectation simmered down to a warm glow around my shoulders. From my high vantage point, the view was spectacular. A few of H. V. Morton's words, from his delightful book, *A Traveler in Southern Italy*, capture its ambience:

> *Cloud shadows moved across the distant plains and a treeless countryside, golden with stubble in the valleys, golden with ripe winter wheat on the hills. A beautiful gradation of color from golden yellow to brown amber and burnt sienna; . . . There was no sign of life upon this wide landscape save where, far off, catching the sun upon the shoulders and crests of mountains, a gleam of white denoted towns and villages . . . The only movement was a flight of hawks, sometimes high above me, sometimes below in the valleys, gliding upon the air currents. This was the country described by Carlo Levi who wrote the best book of its kind on the south of Italy.*

I looked at my watch, and realized that it was much later in the day than I'd thought. The sun was sinking, pearlescent, and dusk shadows were easing across the vast wheat fields all around me, filling the valleys with the purpling haze of evening.

My schedule-monitoring self began to fret about dinner and a bed for the night, while my gypsy self seemed utterly unconcerned, reminding me that I had a bag of snacks in the back of the car—slices of salami and proscuitto, half a plump round of focaccia, some delicious gorgonzola, a bar of creamy Italian chocolate, and a bottle of Barascolo wine. And what about sleeping? moaned my monitor. What's wrong with the car, and right here? my gypsy responded happily. Just pull up a little higher up this rough track and wake in the morning with one of the finest views in Basilicata.

So that's exactly what I did.

CHAPTER 3

Seeking a Home

A First Visit to Aliano

While I'm often humbled yet energized by the almost-tangible power of wild places, not all explorers of the Mezzogiorno shared my enthusiasm for this relatively undiscovered part of Italy. Shelley, Henry Swinburne, Edward Lear, and others all warned of the dangers there, particularly from rabid forest creatures, brigands, and widespread disease. Perhaps most adamant of all was Augustus Hare, who wrote in 1883:

> The vastness and ugliness of the districts to be traversed, the bareness and filth of the inns, the roughness of the natives, the torment of zanzare (mosquitoes), the terror of earthquakes, the insecurities of the roads from robbers, and the far more serious risk of malaria or typhoid fever from bad water, are natural causes which have hitherto frightened strangers away from the south.

Like Levi's classic works, Anne Cornelisen's powerful books on the region, *Women of the Shadows* and *Torregreca*, had impressed both Anne and I long before we decided to live there. We found

Cornelisen's description of the region a little alarming, but also enticing:

> *The south has always moved me. They suit one another, this bleak land and dour people who see no joy in life, but only an eternal struggle which they cannot win. . . . It is a bare, sepia world. A cruel world of jagged, parched hills, dry river beds, and distant villages where clumps of low houses cling together on the edge of precipices . . . The south is not for the easily discouraged. It is for those who can imagine living in another time . . . in a mirage-world created by light so piercing that it sears the eye.*

As I left my high aerie in the early morning, watching the valley mists move like ancient oceans against the bare hills and ridges, I felt no such trepidation. Just pure elation. From the wide, fertile valley of the (dry) Sauro River, a ridge rose abruptly, dotted with strangely eroded buttes and green-clay gorges that looked recently torn out of the soft, oozy earth. Straggly olive orchards clung to tiny patches of land between the eroded clefts. And way, way up—over one thousand five hundred feet up from the valley road—perched little Aliano, like a craggy half-completed fortress. Upon closer inspection, the fortress turned out to be the high walls of public housing recently built to rehouse residents whose homes had collapsed or were destined to collapse in the next earthquake or landslide—apparently a familiar feature of life in those parts and one that certainly reflected the mood of Cornelisen's description.

I counted twenty-two one-hundred-eighty-degree hairpin bends and a dozen or so additional tight curves on the painfully slow ascent to the village. I'm sure the ever-increasing breadth of views across the rolling green wheat fields and the high, craggy hills beyond must have been spectacular. But I wouldn't know. I was too aware of the fact that most of the twists and turns were densely crowded in by ancient olive groves full of fractured and contorted branches and even more contorted root systems that curled and looped around one another like orgies of serpents. Anything coming

down the narrow road from the village could not be spotted until mid-bend. Ditto anything coming up. Like me.

My little DoDo sputtered and choked in first gear, narrowly missing traumatic interfaces with two donkeys, both bearing on their sides enormous straw pannier baskets crammed with olive-branch prunings (veritable forests themselves); a huge blue *corriera* (bus, the local public transport); one of those rackety three-wheeler Ape trucklets, with a maximum uphill speed of around five m.p.h.; and an old woman on foot who was bearing a voluminous bundle of kindling twigs on her scarved head. The woman was half hidden by a tumult of weeds and brush that overhung the road, and I had to swerve quite dramatically to miss her. The look from her enraged eyes seared through my car window like a laser, and as I continued upward, I wondered if her irate gesticulations were an omen of things to come.

Welcome to Aliano, I whispered to myself. Don't forget all Levi's warnings about the *pagani* strangeness here and the life-and-death power of village witches. As the Professor had told me, despite its Roman name—Praedium Allianum, bestowed on the village in the sixth century A.D. in honor of its owner, Allianus—this was a far more ancient and mysterious place. Possibly more than nine thousand years old, according to the findings at a necropolis near Aliano's sister village, Alianello. Tread lightly.

Having gone to all that trouble of climbing up to the village, the road curled across the top of a narrow ridge offering brief but spectacular mountain vistas in almost every direction and then immediately began a precipitous tumble past forlorn-looking clumps of apartments and shadowy, stepped alleys. Older buildings, some with ancient stone façades, began to close in tightly as the road continued its steep descent. And then, with no warning and in that wonderful way that Italians articulate urban spaces and the "accidental aesthetics" of architecture-without-architects and townscape-without-city-planners, the road flared out at the bottom of the hill into a piazza boasting an elegant circular paving pattern of cobbles and smooth black stones. Across the piazza a church rose up

with whitewashed walls and a sturdy stone tower. Small streets wriggled away in various directions around a couple of prominent palazzos, but the main street, set at a right angle to my descent, was broad, neatly paved, tree lined, and dotted with small stores and coffee bars.

I like the look of this, I thought. I'd expected something a lot tougher and surlier from Levi's descriptions.

But as I drove slowly down the main street in my DoDo, the pavement suddenly appeared to vanish and tumble into a dramatically eroded gorge hundreds of feet deep—the *Fossa del Bersagliere*, according to a small, lopsided sign (which also mentioned that the gorge had been named after an unfortunate soldier who had been thrown to his death here by brigands). The road made a sudden turn to the left by another coffee bar, but the shock of that abrupt precipice remained and increased as I continued my exploration of the town.

The main street had indeed been something of an illusion. Beyond the tightly clustered dwellings I caught glimpses of Aliano's *panorama calanchistico*, vistas of startling precipices studded with ancient cave dwellings. Much of the rest of the village seemed in dire need of repair, although some restoration work was in progress. I noticed a mini piazza (*piazzetta*) with rebuilt stone houses around it and a small new gallery featuring the artwork Levi completed in the village during his 1935–1936 *confino*. Nearby was a small amphitheatre set on the edge of another precipice with dramatic views across more canyons to the south. Farther down, the large house where Levi had endured his *confino* was being restored as a museum, but to judge by the absence of machinery or workers, it seemed to be suffering from the same kind of in-progress lethargy as the Carlo Levi Center in Matera.

Elsewhere, blank windows stared out of cracked and broken walls, buildings leaned drunkenly, and in a lower section of the village two tightly clustered clumps of seemingly abandoned houses— the perfect setting for some werewolf or vampire horror movie—perched precariously on even more vertical precipices. A

sudden shudder of strata would send the walls, the lot, tumbling and shattering into the ghost-colored gorges far below.

The Mezzogiorno is renowned for its natural disasters, most notably the destruction of Pompeii and Herculaneum, near Naples, in A.D. 79, following the ashy eruptions of Vesuvius, and much more recently, the horrendous Messina earthquake in 1908, which killed more than eighty-four thousand people and decimated the cities of Reggio di Calabria, at the tip of Italy's toe, and Messina on Sicily. Aliano suffered its own more modest earthquake in 1980, which explained the battered appearance of many houses, some of which dated from the fourteenth century.

The village bridge had already gone. One night in June 1998, this vital link to the outside world at Sant'Arcangelo in the next valley, the Agri, had collapsed with a great roar. All that was left now was a pathetic attempt at rebuilding—which had apparently been abandoned due to "sliding earth" problems—and a sinewy, footpath-wide track that somehow managed to carry small vehicles at ridiculous grades down to a minor canyon floor and up the other side.

I was beginning to rethink my initial optimism as I backtracked to the main piazza, parked the car, and sat outside one of the coffee bars ruminating over a late morning *caffe latte*. Old, diminutive men with bowed backs stood or sat around the other side of the street watching me warily, and I sensed in the eerie silence Levi's "age old stillness of the peasant world." I opened my notebook and flipped through to find a composite quotation of his descriptions of Aliano:

Archaic traditions aimed at driving back the evil eye revealed themselves in the architecture of the façades of the humble buildings here. Small windows like malicious eyes underlined by frowned eyebrows, consisting of warped moth-eaten chestnut wood lintels, were set on either side of immense arches that create a devilish sneer expression. Staircases grind their teeth formed of broken steps and bestow a grotesque and horrible expression, and are the only true guarantee for chasing away the evil eye and evil spirits. . . . This is a truly animistic architecture with attentive

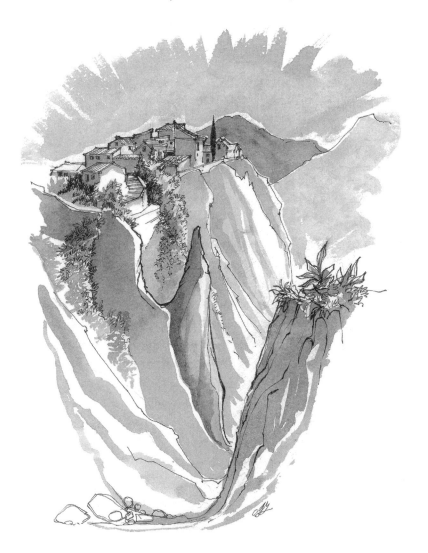

FOSSA DEL BERSAGLIERE—ALIANO

eyes, threatening grim looks; everywhere one feels observed, spied upon and warned.

Levi captures the mood perfectly, and in many ways little seems to have changed today, except for odd clay tablets fixed to walls around the village bearing brief quotations from his book. I also

enjoyed another of his descriptions of these older parts of the village I found in a booklet on the Parco Carlo Levi, one of seventeen "literary" parks established throughout southern Italy to celebrate links with famous writers and also to stimulate local-related economic initiatives:

> *I discovered that closed world, shrouded in black veils, bloody and earthy, that other world where the peasants live . . . bound up in inherited passions . . . faces of primitive solemnity. One old man in touch with forces below the earth could call up spirits. . . . They called themselves "pagani" or heathens (all outsiders were regarded as "Christians") . . . behind their veils the women were like wild beasts. . . . The peasants seemed prey to a sort of madness . . . a subterranean deity, black with shadows of the bowels . . . their Madonna appeared to be a fierce, pitiless, mysterious, ancient earth goddess, the Saturnian mistress of this world. . . . Here there is no definite boundary line between the world of human beings and that of animals or even monsters. And there are many strange creatures at Aliano who have a duel nature. . . . In this region names have a meaning and a magic power. . . . The atmosphere is permeated by divinities . . . everything seems bound up in natural magic. . . . The peasants are not considered human beings (by the landowner-gentry) . . . they have only one color, the color of their sad, sorrowful eyes and their clothes, and it is not a color at all, but rather the darkness of earth and death. . . .*

Powerful stuff. And yet, despite Levi's initial abhorrence of the plight and depths of degradation suffered by the peasants almost as a birthright, his own experience of life here ultimately brought joy and exuberance, as the Professor had described, both by enlightening him and by shaping his views and political activities for the rest of his life.

Yes, but I'm not here to shape political activitism strategies, I thought. I'm here to live happily with Anne, learning, and generally

have a spanking good time dining on all those gorgeous porky products and homemade olive oil and wines and wild game and pasta galore.

"MAY I OFFER YOU a *corretto*?" I heard someone say in very precise English.

I turned and faced a young, clean-shaven man dressed neatly in a dark blue suit and crisp white shirt. He was giving me a most welcoming smile.

"That's very kind of you," I said. "I'll try one of the local grappas."

And that's when things began to change, and my optimism returned. Ironically in my subsequent months there I never again saw this young Italian man, but his spontaneous kindness that day made me realize that despite the strange aura of this remote village, I might find the nurturing warmth of new friendships. After all, no one said the hill villages in Basilicata were cute, squeaky white-clean masterpieces of ethnic aesthetic like their affluent northern counterparts. They are what they are. Ancient bastions of an ancient way of life that has pounded, broken, and decimated homes, families, and communities. And yet they're still here. Bruised and battered but with enough belief in themselves to rebuild, plant trees, and provide benches all the way down main street for the elderly. And they are still lived in by people—a thousand or so in Aliano—who possess enough innate southern hospitality to offer a confused stranger a drink at a coffee bar on a warm morning while he watches the little hunched, black-shrouded widows scurrying about on seemingly ever-urgent missions, donkeys clopping by carrying those now-familiar dual wicker panniers crammed with farming tools, huddles of old, sullenly dignified men deep in animated debate, and old women, sturdy as little trolls, swaying past carrying laundry or bundled faggots of kindling on their heads Arab-fashion.

I was intrigued by the whole timelessness of the place, and the only real disappointment on that particular day was my inability to find anywhere to stay. The village didn't seem to possess even a

modest *pensione,* and there was no place for rent, according to my kind young friend at the coffee bar, who apologized and explained that "Housing here is very precious, and many people still live in very small spaces and they have nowhere for other people. This is not a place that knows many tourists people from away. We are not—how you say?—on the map. But I think it is very nice that you would like to stay. Maybe you could find a small hotel in a nearby town—Stigliano or Accettura—for a few days, and if you will call me at this number I will ask here in the village for you. Maybe something will happen. Maybe we will make something happen."

He paused and ordered two more grappas for us. I tried to pay, but he waggled a long index finger topped with a perfectly manicured fingernail (very different from the stumpy, earth-ravaged hands of the old men here), adamant that he was the host and I was the guest. "We have a little saying in our Alianese dialect," he continued. " *'Chi caminete licchete, chi no restate sicche.'* 'He who looks always finds something to eat; he who stays at home shall never find a bite.' "

And indeed, that's precisely what happened on my second visit to Aliano just before Anne joined me a couple of weeks later.

Accettura and the Mingalones

As the sacred lunch and siesta time eased in at around twelve-thirty P.M., I drove back down those endless *tornanti* from Aliano and through that strange moonscape of eroded canyons and buttes feeling optimistic that somehow, before Anne arrived, I'd find somewhere in the village to live. But the slightly more urgent problem was, where to stay tonight? The previous night, sleeping in the DoDo on that bluff with views that went on forever across a Dakota-like landscape, was just fine. I had slept long and deeply, and would have slept even longer if the dawn chorus hadn't been so gloriously frenzied.

But right now, I decided, I'd prefer a bed and a bathroom, at an inexpensive hotel or *pensione,* in a room with a big terrace and more huge vistas of mountains and gorges. Not much to ask, I thought,

except that I haven't seen a single hotel anywhere in this wild, empty land, since leaving Matera.

Just go and flow with the flow again, suggested my optimist. Something always turns up.

Oh yes, right, mumbled my more pessimistic self. It's already siesta time, so nothing will be open until four o'clock, you're in the middle of all this nowhereness, and you don't even know which town you're heading for.

Oh yes, I do, chirped my optimist. Accettura. I like the sound of the name, and it can't be more than an hour over the Montepiano mountains to the north.

So, Accettura it was. And it did indeed take just less than an hour of fine upland driving across broad three-thousand-foot-high ridges bedecked with fruit and olive orchards and then through the great shadowy oak forests of Bosco Montepiano, where the air was cool and syrupy with mossy woodland aromas.

The trees ended abruptly at another high ridge offering more dramatic vistas. And there, a few hundred feet down the steep slope of a very deep, shadowy valley, sat Accettura, an appealing white, piled pyramid of houses and alleys rising on a rocky butte topped by a sturdy, castlelike church and bathed in brilliant silver-gold afternoon sunlight.

Perfect, I thought. Just the kind of place to relax in for a while if things work out right.

Which they did.

Thanks to Rosa Mingalone.

"SOMETIMES I WISH I were back in Nottin'ham. I really miss England, y'know." The lady's cheerful Italian face sagged a little, and she half-whispered her remarks to me as we emerged together from Accettura's small (very small) supermarket just up from the main piazza. By chance (yes, I know "there are no coincidences") I'd found this smiling middle-aged lady with a great halo of gray-white hair to be a most useful interpreter as I tried to discuss with the owner of the store the different qualities and characteris-

tics of his five different types of proscuitto, all purple-pink and all equally enticing, despite hairy coatings of mold and other odd blemishes and growths, apparently indicators of fine aging.

"You don't wanna pay all that for one of those Parmas; everyone thinks it the best, but I think our local hams are much tastier m'self." She gave me a conspiratorial grin. "Listen, if you're from Yorkshire like what you say, I bet you don't normally pick fancy stuff jus' 'cos it's got fancy prices, now d'you?"

It was most peculiar chatting with this obviously very Italian lady with a fluent grasp of English, an English delivered in an authentic Midlands dialect. And she was right: I didn't and I wouldn't. Then came the clincher.

"'Ow long 'as it been since you had a nice strong cup o' real English tea?"

"Weeks," I said. "No, actually, months."

"So, why don't you come over to our 'ouse and have a cup and meet my 'usband, Giuliano, and taste some of his prosciutto?"

"He makes his own?" I asked, ever hopeful of the authentic experience.

She gave a loud laugh and then covered her mouth as heads turned in the tiny store. "He makes everything 'imself! We've just moved from up by the church to a new home he's just finished so he can be closer to 'is olives and 'is oil and 'is fruit trees and 'is pigs and 'is *cantina* where he cures all 'is sausages and hams and *coppa* and *pancetta* and . . . everything else! Oh, and 'is wines. He loves 'is wines, an' what else?"

She paused and then chuckled. "Oh and 'is bricks. He makes bricks and tiles and all kind of stuff 'imself. The old way. Everybody loves 'is bricks."

I couldn't believe my luck. Had I finally found a haven of home-made *cucina di casa* (*casareccio*) products? The kind of thing that northerners tend to assume is the birthright of just about every family living down in the Mezzogiorno, but which, when you actually get here, you discover is a little rarer than the Armani-Gucci romantics up there would like to think. And increasingly rare every year, too,

as Giuliano made adamantly clear as we all sat sipping Rosa's real English tea in their simply furnished new house, whose exterior was adorned with Giuliano's various types of handmade bricks, cornice mouldings, and pantiles.

Giuliano was a stocky, ball-faced, middle-aged man with prominent teeth (six, to be precise), a stubbly chin, and eyes brimming with energy and enthusiasm. Despite a Notthingham accent, his English was not as extensive as Rosa's, even though they'd left Italy and lived for more than twenty-five years in that city, running a special continental foods store. But what his conversation lacked in eloquence, it made up for in content and scope, and his remarks were usually amplified with self-explanatory gestures, shrugs, winks, and nudges. And certainly his views on today's young generation and their lack of respect for the "old traditions" were eminently clear as he pointed to a very large and elegant funnel-shaped fireplace in the corner of the room.

"Y'see, that's where you see the difference. Those are all my bricks." He pointed proudly to the thin, rustic, rough-cut, salmon-colored bricks that he'd crafted so carefully into a three-sided funnel that met the ceiling in a flurry of his finely detailed miniature fired-clay sculptures of a Madonna and child (of course) and then looser renditions of some of his friends. "You don't see many fireplaces built like that. People use factory bricks because they're cheaper, but they just don't have . . ." at this point he got up and waddled across the room to stroke his creation fondly ". . . this kind of feel and texture. Here, David, c'mon and touch it."

So, there the two of us stood (much to Rosa's amusement) caressing the rough bricks and even the grouting and admiring the subtle variations in color, including the three darker bricks he'd selected as focal features of his fireplace.

"These is very special. There was special minerals in that piece of clay so when they were fired they came sorta volcanic and melted inside the clay like."

And that's how they looked—centers of chocolate fudge–like swirl dotted with air bubbles, neatly framed by salmon pink clay edges.

"C'mon," said Guiliano. "Let me show you som'thin' else."

He was one of these eternally restless types, so I allowed myself to be led and forgot whatever plans I'd made for the rest of the day, which wasn't too difficult, really, as I hadn't any.

As we left the house, Rosa gave another of her hearty laughs and called out, "Watch 'im. You may not be back 'til dinner!" And, as things turned out, she was right. But what a day it became—one of those days you always hope for when you let things happen as they will and just sit back and enjoy the ride.

GIULIANO WAS A FOUNT of knowledge about Accettura and the surrounding countryside, and he provided a rich running commentary as we sinewed along narrow alleys, up and down endless

The First Spring

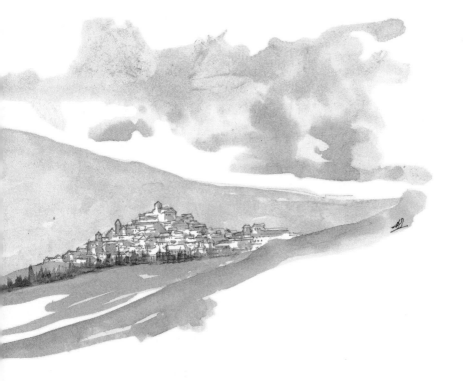
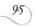

ACCETTURA

steps, moving from piazza to piazza in the intensely bundled and tightly bound little town.

"This is a very old place y'know. They've found things 'round 'bout that go back six thousand years, but our town today was started in the tenth century A.D. And we got many beautiful things: Our big church right on top of t'hill, the *Annunziata*—very old, lovely paintings. We got the Scarrone neighborhood with lotsa big carved doorways and palazzos more n'two hundred years old. We only small with people—maybe two n'half thousand or thereabouts—but we got so much. Lotsa shops, coffee bars, a real big street market every two weeks, a new cinema we just renovated, a communal place for butchering pigs and sheep and cows, olive mills, and lotsa *cantinas* and *tavernas* [a more up-market kind of *cantina*] for makin' and

keepin' wine. Lotsa those. I'll show you mine later. You'll like. Now 'ow 'bout some coffee?"

The man was irrepressible. Maybe not many foreigners visited his little town, but if they did, they couldn't find a more congenial or energetic guide. And when it came to Accettura's famed festivals, Giuliano's eyes gleamed as he described the SanGiuliano celebrations in January, the great Mardi Gras–flavored *Carnevale* in February, the San Rocco di Spagna celebrations in September ("that's a special saint for one of our famous palazzo families"), and the great Madonna di Ermoti celebrations—"The Flower Festival" and the *Festa del Maggio* (May), which he described as "the best thing you'll ever see in Basilicata."

Over our espressos he half-whispered the details, as if sharing some deep and ancient secret. "Every *pagani* know this festival. People come from all over Italy, all over the world, to see this special thing. They say it's been done here for thousands of years as a big fertility celebration. Goes on for days. Thousands of people watching as our lads and those big white oxen bring down a huge oak tree from out of the Montepiano forest. Another bunch carries a holly tree from the Gallipoli forest, with lots of singing and dancing and food. And then—and this is the real *pagani* bit—they marry the two trees by grafting them together and lifting them a hundred feet, m'be more, into the air. And then it all gets real crazy. People shooting guns to knock prizes out of the trees—some others climb right up to the top—and there are processions and choirs and women carrying great *cende* candles on their heads. Supposed to be good for marriage, they say. It's real beautiful. Like I said, the best thing you'll ever see in the whole of the Mezzogiorno!"

Obviously my choice of Accettura had been most fortuitous. Now all I had to do was find a place to stay.

"Oh, thas no problem," Giuliano said, grinning. "You stay at my hotel."

"You own a hotel?"

"Well," he said, chuckling. "It's got my name on it, Hotel SanGiuliano. C'mon, I'll show you. It's a nice place, not so big but

nice rooms, good food, and good people who owns it. I'll see if Massimo's around. He and his dad run it. See, there it is. Right on our big piazza."

And a more enticing place I couldn't have wished for. Set back a little from the cafés and bars around the piazza, the SanGiuliano rose four storeys from the cobbled street, its cream-and-lemon stucco walls gleaming in the late afternoon sun.

"Lovely," I said, and then spotted a large terrace right on the top of the hotel.

"Is that one of the rooms up there, right at the top?" I asked Giuliano.

"I think. We ask. Okay?"

"That's the one I want," I said.

"Okay," Giuliano said, chuckling again.

And very okay it turned out to be. Massimo was inside serving coffee to a couple of locals, and as soon as I saw his young, almost-cherubic round face and bright, genuine smile, and heard his pretty good attempt at an English welcome ("Please come in and have a coffee and very happy to meet."), I knew I'd found the ideal place to settle down for a while.

And, yes, the room at the top with the huge terrace was free, and, yes, the vistas of the Montepiano and Parco Gallipoli forests and ranges all around, plus views over all the town and the main piazza, were magnificent, and, yes, the price was reasonable in the extreme, and, yes, the fine-looking restaurant offered truly authentic and delicious Basilicatan fare.

Once again, laissez-faire luck had worked its magic, and I was a very happy, if slightly weary, traveler.

The Market Fruit Seller

My brief sojourn in Accettura was characterized by a series of minor but memorable occurrences. The first was during one of my almost daily visits to the small covered market in the town.

Dawn, as they often say, tends to creep in. But that particular

morning it arrived in a sudden spectacular fanfare of light, as the ponderous black clouds of night lifted faster than a curtain at a first-night opening on Broadway to reveal a horizon ablaze with color. And there were frantic noises, too: the sound of the market stalls being assembled. In fifteen minutes I was up, showered, dressed, expressly espressoed by Massimo, and out into the piazza heading for my favorite saleslady.

Maria Montemurro seemed so fond of her homegrown fruits and vegetables, which she had displayed neatly in precise pyramids on her small trestle, that selling them, even to people she'd sold them to for decades, seemed to saturate her elderly, wizened face with deep sadness. Every time one of the villagers walked away with a paper bag containing a few of her golden apples or outrageously red tomatoes or one of her enormous, tight-as-a-punching-bag heads of lettuces, she watched them go with a look that a mother might give a beloved boy-child as he left for a new life in some distant land. You could see her almost silently beseeching each customer to return and relinquish their just-made purchases so she could place them lovingly again on her meticulously assembled pyramids.

This time, I told myself, I will be strong. I will not watch her eyes or pay any attention to her expressions of anxiety and sorrow. I will simply buy my apples, a few of those beautiful little, juice-laden tangerines, a cluster of the crispest celery imaginable, and a kilo of vine tomatoes that taste the way tomatoes used to taste when I was a child—sweet, sharp, peppery, and with just the slightest aftertaste of anise.

I was in the process of picking six sun-golden apples from one of her perfectly mounted displays when she started up: "These are all for you? That's too many." I didn't look at her and continued to make my selection. "That one is bruised. See? Look! They're all bruised! Why do you want to buy my bruised apples?"

There were no bruises. Now, onto the tomatoes.

"Too ripe. Try next week. You like them harder."

I wanted to say, "No, these are just fine. Thank you, Maria," but

I was determined not to turn this into a debate or even a mild discussion. I knew what had to be done. The tomatoes were perfect. Now for the lettuce.

"You picked a different kind last time. Why pick this one? You won't like it. It's very bitter. Come again next week."

Lettuce selected. And the celery and the tangerines and for good measure a half kilo of green grapes. I was winning. I could hear Maria's commentary. "Too sour. Too big. They have better ones across the piazza in the store." But it all sounded halfhearted. Almost defeatist. Then she made one last effort, handing me a couple of grapes. "Try." I tried and . . . unfortunately, she was right. They were too sour for my taste. But what to do? Should I be stubborn and insist that they were just fine or should I . . .

Mistake! I looked at her face, and if ever a face said, "Please, leave me something," it was poor little Maria's. I could swear her eyes were watering. So, I surrendered.

"Okay, Maria, you're right. Too sour. I'll wait until next week."

Transformation! Her face lit up like a young child's. She snatched the grapes from me and returned them enthusiastically to the table, almost caressing them in the euphoria of her little victory.

I handed her a twenty-euro note (then twenty dollars).

"Too big. I have no change. See if you have coins. Or you could come back later maybe. I'll look after your bag for you."

It was very kind of her to offer, but I dreaded returning to find all my purchases returned to their respective displays. So, I dug deep into my pocket and pulled out a batch of coins. However, I had only a little over two euros.

"Not enough. You need another euro. Look, why don't you forget the tomatoes?" Maria began.

Not so fast, my tricky fruit-seller lady! There was another two-euro coin deep in my other pocket, and now I had more than enough to buy all my selections. So there.

Maria gave me my change slowly, packed everything into a bag, and said nothing. For a moment she held on to the bag, and then with a sigh she handed it to me across the table.

"Grazie, Maria," I said, but she was already nervously watching

her next customer.

Improvising at the Hotel SanGiuliano

A few days later I received one of those little uplifting boosts that made my Accettura interlude so memorable.

As hotels went, the SanGiuliano was not very large, or grandiose. And though its room heating did not always work effectively, that didn't pose a problem; even though it was early March, the daytime temperature was already in the mid-sixties.

I THINK I was the happiest person in this compact little hill town on the edge of the verdant and mountainous oak forests of the Bosco Montepiano. Certainly I felt a lot happier than those sinister-looking village black widows appeared, wrapped defensively and identically in enormous black shawls and scurrying like beetles across the piazza in their black dresses, black stockings, and black shoes . . . black everything, in fact, including their perpetual shrouds of doom and gloom and the dark looks on their faces. When I or anybody else approached them, they would tighten their shawls around their mouths and chins, Islamic fashion, and glower through suspicious, coal-black eyes. I saw them as black volcanoes—little fiery Etnas—ready to blow at the slightest tectonic nudge of trouble. I had thought that this kind of thing had died out in Italy—this mourning for a spouse that can last for decades and all those deeply entrenched superstitions and *pagani* beliefs, including, around this part of Basilicata, the rumored shape-shifting and other mysterious protean abilities of elderly "sorcerer" women. But, as I was to learn later, ancient traditions had tentacles there, and strangenesses indeed remained.

Fortunately most of the other locals were a sociable lot, always ready for a little gossip 'n' chat over glasses of grappa at the piazza coffee bars. I also happened to make friends with the hotel staff,

particularly the burly chef, Bruno Mastronadi, who bore an uncanny resemblance to America's portly Cajun-cooking celebrity, Paul Prudhome. It became a habit of mine to drop into Bruno's kitchen after the siesta to see what delights he was concocting for that evening's dinner, and inevitably after discussing recipes and unusual local ingredients and the like, we became bosom buddies of the stove.

It was Friday night. Fish night (of course) at the hotel, and Bruno always tried to serve something different along with his more traditional, time-honed recipes. That night he'd managed to acquire an enormous salmon, and he was planning to prepare a rather interesting *misto* of fish, stuffed calamari, octopus, and prawns, served with potato-and-oregano gnocchi. I was particularly impressed by his pile of prawns.

"Too many," he said. "Good price, so I bought too much." He laughed and his big belly shook like Jell-O. And without thinking, I said, "Well, give me half, and I'll cook something up."

He stopped his meticulous filleting of the salmon, looked at me curiously for a moment, laughed, and then, without asking what my intentions were (I didn't know myself), he pointed to the stove, chopping block, and vast array of herbs, spices, vinegars, wines, oils, and liqueurs, and said, "*Va bene.* Help yourself."

And that's precisely what I did. As he continued refining his delectable *misto*, I began to make a reduction of white wine, butter, tarragon, lemon, and garlic. Then I added . . . Well, I won't bother with the details of the recipe because I was improvising like I normally do and can't really remember. I had a flavor in my head that blended the briny freshness of the ocean with the deep flavor of the wine-herb reduction, the sparkle of fresh lemon and local *limonce* liqueur (a splendidly thick, golden, sweet-tart concoction), the slight sweetness from some anise to reinforce the tarragon, the thwack of local Basilicatan hot pepper (*peperoncini*) sauce—which seemed to accompany everything in those parts—and then something not too bold but comforting to act as the "bed" for the purity of the prawns themselves. And since it was still *porcini* season, what better than wafer-thin slivers of

those delectable mushrooms, glazed in their own "sweat" for a few seconds in a searing-hot dry pan, and then added along with a little cream to the sauce, which had been quietly simmering down to a rich consistency and texture.

Bruno and I tested each other's creations, savoring the subtleties we'd both tried to achieve. And then—surprise, surprise—he gave me a palm-tingling high five, and we proceeded to hug each other and slap each other's backs and tell each other that tonight would indeed be a special night for the patrons of the Hotel SanGiuliano.

Modesty should creep in at this point, but, no, let honesty win out. I've had many nights when my "improvising" at home has led to the need for hasty, last-minute culinary overhauls. I was even telling myself as I prepared my impromptu dish that day that if my prawn concoction didn't work out the way I'd hoped, I'd throw in a lot more garlic and cream and tomato paste and call it "Provençale" or something that sounded foreign and mysterious, and hope for the best.

But I'm happy to say that my "Prawns Improv" was happily devoured along with Bruno's splendid salmon-and-seafood misto, and the enthusiastic restaurant crowd even stood and gave us both the honor of a toast, apparently a rather rare occurrence in those parts.

It was one of those nights I shall remember for a long time, along with the next of my Accetturan adventures.

Bricks, Pantiles, and Other Creations

"So, tomorrow then," Massimo told me as I sat drinking my second cappuccino of the morning at his hotel. "Tomorrow morning. Before breakfast. He wants to take us to his kiln and show us how to make pantiles and bricks. Is okay?"

I'd almost forgotten that floating invitation to go and watch the ancient pre-Roman craft of brick- and pantile-making by the only man in the whole of Basilicata who still remembered and used these time-honored and once-revered processes. Giuliano Mingalone.

"Great!" I said. "But why before breakfast?"

"Because Giuliano says he has special breakfast he wants to

cook for us. At his kiln. Not far out of town. Just a little way down in the valley."

A "LITTLE WAY" turned out to be a mile-long hike, and "down" was an almost head-over-heels scramble down the near-vertical sides of a canyon on the outskirts of Accettura, following a *mulattiera* (mule track) that even a mule would have had problems negotiating.

ACCETTURA'S *MAGGIO* FESTIVAL

"Bit too steep for jeep, with all three of us in it," Giuliano said happily as we all met around eight o'clock on a brisk, blue-sky morning and began the tortuous descent.

"You have to walk up and down this track every day?" I asked Giuliano, whose stumpy legs seemed almost to float over the rough stone-and-pothole surface, while I skidded and jarred my way down. Massimo wisely remained in the rear, carefully and adeptly learning from my disconcertingly amateurish performance.

"*Si, si.* No problem. Unless raining. Then is like river here. You gotta go careful then."

I nodded. I've gotta go careful now, I thought, and it hasn't been raining for days. My challenge was to avoid the pockets of dust and loose pebbles that kept trying to trip and pitchfork me headlong into the sinister, shadowy depths of the canyon far below.

Somehow we all arrived at Giuliano's hideaway without traumatic incident, except maybe a little punctured pride in my case. We left the track to continue its tortuous descent and emerged onto a level shelf of pleasant, grassy land bathed in warm early sunshine.

Scattered around the site were piles of packed clay bricks, thousands of them, fired to a delightful medley of ochres, bronzes, golds, and ambers, and standing six feet high or more under tarpaulins and other improvised coverings.

I gasped. "You made all these!?" The enormous piles looked like the equivalent of a year's production at a major brickworks.

"Oh yes," Giuliano said with a satisfied grin. "Sometimes much more down here. Depends when I sell them."

"And how do you get them out?"

"Oh, no problem. We have special truck."

A truck? What kind of vehicle would it take to negotiate that deadly track? And loaded with bricks, too. And I thought, if indeed there is such a truck, why the heck couldn't we have used it this morning and saved me the indignity of that descent and the inevitable trauma of the clamber back up?

But "Ah" was all I said. After all, Giuliano was my host, and he'd

gone to all the trouble of bringing us down here, while carrying a large hessian bag over his shoulder.

"What's in your bag, Giuliano?" I asked.

"Oh, well, first we have breakfast, eh?" he replied with a mischievous grin. He reached into the bag and pulled out a large package wrapped in newspaper and tied with rough string. "What I wanna do for you and Massimo is very common, very old dish. *Ciambutella. Mezzadro* [sharecropper] breakfast. Is best breakfast anywhere. You think so, Massimo?"

Massimo's angelic face beamed in anticipation. "Oh, yes, the best. My father still does sometimes."

"For the hotel guests?" I asked, wondering if I'd missed one of the house specialties of the Hotel SanGiuliano.

"No, no, no. He tried to do once, I think. But maybe taste too different for people from North and other places. This is real Basilicatan dish, so of course we use lots of hot peppers, *peperoncini*. Some people don't like hot peppers at breakfast." He shrugged a very "of course they don't know what they're missing" kind of shrug and then gave one of those knuckle-twisted-in-the-cheek gestures to emphasize that *ciambutella* was an acquired, but unforgettable, taste experience.

"We can make it here? Outside?" I asked while watching Giuliano unpack his parcel. Its contents appeared slowly: eight deep-brown eggs that appeared to have been fresh laid (if bits of earth and feathers on the shells were any indication), a thick slab of purple-red–fleshed *pancetta* (bacon), two red onions, a small bottle of olive oil, four fat homemade sausages, four large tomatoes, two large frying peppers, another small bottle of what I assumed to be Giuliano's special hot pepper *cantina* concoction, a bushy sprig of bright green basil, a two-liter bottle of his strong red wine, and various little paper twists of seasonings. Oh, and the bread: a huge golden-crusted beauty pulled from his bag.

"Okay," he said as he spread everything out by the side of a hole dug in the earth and filled with twigs, small branches, and a couple of arm-thick logs. "First, nice fire, and then we start cook." He

pushed a couple of handfuls of hay and dead leaves under the pile and flicked his ever-present Bic. The flames began immediately sending clouds of pungent blue smoke into the early morning air. Memories of my Boy Scout days curlicued around me like the smoke as I smelled the scorching wood and remembered the thrill I used to get from wrapping primitive flour, water, and salt dough around thin sticks and toasting them to a crisp in the hot embers. I had been amazed then that anything so basic could taste so good. But now I sensed I was about to graduate to a higher appreciation of bonfire cuisine, to the *ciambutella*, the almost mythic dish of the South.

Giuliano wandered off to gather a couple more small logs and his huge cast-iron cooking pan, which he kept hidden in a woodpile nearby. He returned, stroking its smoky-black rotundness. "She has been my best pan since I was boy. My mother gave me when I married Rosa. Nineteen fifty-two. She said all it needs is bit of olive oil to keep her nice and shiny. No, not Rosa, David, the pan! Not too much washing, she told me. She said washing is not nice for iron. Just wipe clean, very clean, and rub in some oil. That's all. She will last forever, she told me. And just look." He proudly held up the ancient pot, veteran of more than fifty years of marriage and alfresco outdoor meals. "Touch, rub her."

Massimo and I rubbed the pan's smooth, oil-glossy flanks and admired its durability. Giuliano was pleased. "She gives special taste to everything. Makes better. Everything I cook."

THE FIRE WAS now roaring splendidly, and we pulled back a little into the cooler air. The thick grass provided a perfect cushion, and the early sun over Montepiano bathed our faces in golden light.

Giuliano started chopping the peppers, onions, and tomatoes into bite-size pieces, dicing the *pancetta* and sausages ("I make these sausages with fennel and peppers," he boasted. "My own recipe"), and arranging all his other ingredients in a half-circle around the fire.

"Okay, so now we go," Giuliano said, carefully pressing his huge pot deep into the fire and pouring in a good half-cup of olive oil.

Before the oil began to smoke, he added the vegetables. They sizzled and spat and quickly began to brown. Then he rolled in the diced *pancetta* and sausage, pulled the pan away from the main heat of the fire, and gently tossed and turned the ingredients for ten minutes or so, letting the sugars slowly caramelize but not burn. The aroma was primitive, earthy, and utterly seductive. My hunger pangs arrived.

"No garlic?" I asked.

"No. I don't like for breakfast. Gives me . . ." Giuliano gave a pseudoburp. He tested a couple of pieces of the meat and seemed satisfied. "Now, some *vino* and some of my sauce . . ." He poured almost half a liter of his deep-red, almost black, wine into the pan and stirred rapidly. Then he added his special pepper sauce, maybe a couple of tablespoons, flecked with tiny pieces of bird's-eye pepper, one of the South's most potent delights. "Add more later," he mumbled half to himself. "Always keep tasting. That's the *segreto*. Keep tasting and testing."

And this he did constantly, with a large, very burnt and chipped wooden spoon, while adding trace amounts of salt and herbs from his paper twists. (I spotted oregano, thyme, and parsley.) The mixture thickened as the wine evaporated, and its aroma was zesty and rich.

"David, you wanna taste?"

I did, and my mouth became firecracker-alive with such a magnificent melding of flavors, enhanced by the zing of those hot peppers, that I knew that given half a chance, I could quite easily have devoured the whole dish.

"Fantastic!" I gushed, as different blendings of flavors bounced around my mouth. Massimo took a spoonful and said nothing at all. He didn't need to. His grin virtually wrapped itself around the back of his head.

"So, eggs now, and then eat!" Giuliano said, pleased once again by our reactions. He cracked the eight eggs straight into the pan, then added a little salt, black pepper, and torn segments of basil leaves. While he slowly stirred and scrambled the succulent mix, Massimo cut huge slices of bread from the crisp-crusted loaf, pulling the knife

toward himself as he held the bread out from his chest, in the traditional, although one would think potentially lethal, fashion.

Giuliano gave himself one more generous spoonful sampling of the creamy *ciambutella* and then pulled the pan off the fire and let it rest on the grass. "We leave coupla minutes. Gets better taste." He reached into his bag for some plastic glasses for the wine and then suddenly mouthed a vehement little Italian epithet ("*Porca putana!*" or something along those lines). "Forks! I forgot forks!"

Massimo, being a country boy himself and well versed in the art of improvisation, leaped up and scampered off to a nearby cluster of thin, bamboo-like reeds. A few quick cuts with his pocketknife and he was back with three foot-long hollow sticks. With another few deft strokes, he fashioned these into two-pronged forks. (I still have mine in my box of Basilicatan souvenirs at home.)

All that remained now was for us to devour the gently steaming creation by forking soft segments of this colorful (green, red, and yellow, with pieces of dark, glistening meat) *mezzadro* masterpiece onto the slabs of fresh-baked bread. We did this with unabashed delight while Giuliano passed around the bottles of olive oil and hot-pepper sauce—"If you like more"—along with brimming glasses of his rich, dark red wine.

Hardly a word was spoken for ten minutes. Only when the last fragments had been mopped up from the pan, moistened by a little olive oil, did we let out one long communal sigh and lay back in the grass like satiated satyrs. I did so knowing that I had just enjoyed one of the finest breakfasts I'd ever had anywhere in the world.

"Jus' one more glass of wine," Giuliano urged. "Daft to take back. Don't forget, '*U'vine iete ulatta di vecchie,*' 'Wine is like milk for old men.' And we're all of us getting older y'know!" So we had that final glass and looked around, glassy eyed and utterly replete, watching butterflies flutter among the wildflowers and the last of the early morning mist, trapped in the deep shadowy canyon below us, melt in the coming heat of the morning.

"So that was *ciambutella*," I mused drowsily, half to myself.

Massimo rubbed his stomach and said quietly, "The best."

GIULIANO

Giuliano smiled, maybe a little complacently, as he indeed should have, and said nothing at all.

At least, not about cooking or *ciambutella*.

Because he was now ready for the next phase of our day together.

"Okay. Let's make pantiles, eh?" he said and trotted off up the grassy slope to a workbench shaded by a couple of ancient olive trees.

"These are my own trees. Two hundred years old. Very nice fruit. I got fifteen more over there, also apple trees, pear trees, and almonds. Good place to work, eh? My clay is just over there," he said, pointing to a large pit of scooped-out earth—pure, moist clay—covered with old, circular straw mats, once used in Accettura's olive mill as part of the crushing process.

"So, what I do is, I get my mold here." Giuliano picked up a one-inch-deep wooden frame in the shape of a parallelogram, approximately eighteen inches long, twelve inches across at the widest point, and six inches at the narrow end. "Then I sprinkle it with this lime powder to stop sticking. Then I scoop up a big load of clay, throw in the mold like this, then I push into the corners to get a good shape

and make sure no air bubbles. If you have air bubbles, it will explode—*boom!*—in the kiln. So, here I press, then take this stick and scrape off extra clay, then press again, then scrape. That's 'bout right. Now I take off mold like this and then I lift the soft clay tile and put on this round wooden log, which gives it right pantile shape. Same shape used by Etruscans, Greeks, Romans—all of 'em. Then I put over here to dry for coupla days and make my next tile. Simple, eh?"

"It's simple, I guess, if you know what you're doing," I said.

"If I gotta good day, I make five hundred pantiles," he said, stroking the smooth glistening clay of his first tile as if it were a woman's thigh, gently and with great feeling. "See how soft it is? Beautiful clay here. Beautiful."

"But five hundred? That sounds like a heavy day's work."

"Well, see you gotta have passion for it. I got passion. This is in my heart. I am fourth generation of tile- and brick-makers in my family. But I'm the bad man." Giuliano paused reflectively. "Y'see, if you compare me to my granddad, I'm the bad one for this job. My granddad spent all his time here. All his time. But I'm not. When I left here and stopped making tiles I was nineteen years old, and when I come back from England, after many, many years, I try it again, but I don't feel so happy about that. My grandfather would smack me—you know what I mean—but, well, for the time now, I'm the best one. Because I'm the only one!" He quickly overcame his brief flirtation with guilt and was laughing again as usual.

"C'mon. C'mon and see my kiln. Is beautiful thing. Over two hundred years old and still beautiful."

Massimo and I followed him past rows of piled bricks and pantiles and down a small grassy slope to the kiln entrance, set into the hillside. The kiln was a massive domed affair of brick and rock-hard clay, about nine feet high, with a great maw of a mouth leading into a dark, wood-smelling interior.

Giuliano pointed to the ten-foot-high piles of twigs and logs by the side of the kiln. "Poplar and oak. Best for burner like this. It's got two levels. I can get six or seven thousand pieces in here, and they cook at a thousand degrees centigrade for up to thirty hours.

Very strong. Not like factory bricks, with salt that comes out when they're used. That's no good. You gotta have passion and respect for what you make. In the thirties, before the war, there were ten, maybe fifteen different people down here making bricks and tiles. It's such a good place for clay. People used to come all the way by donkey from Pietrapertosa [almost ten grueling mountainous miles along near-impassible *mulattiere*] to buy bricks here. But now . . ." He laughed sadly and shrugged. ". . . now is just me. I try to get other peoples interested. But no one want to do this. They don't believe you can make good living doing this. Even the schoolchildren. I invite the teachers to bring them to see old way we did things, but"—another sad shrug—"not interested."

And there he stood—at the entrance to his enormous "burner" surrounded by his piles of bricks and pantiles, thousands upon thousands of them—the last living proponent of a tradition that stretched back way before recorded history. And he knew he was getting older. Soon, despite his obvious passion for this hard and exacting work, his trips down that near-vertical hillside would diminish, and he wouldn't be producing his five hundred tiles a day, and no one would take over at his clay pit or fire up his two-hundred-year-old kiln.

And then people would say, "Whatever happened to those beautiful handmade bricks and those smooth, curved pantiles they used to make around here? What a shame that such traditions are allowed to die out. Something should be done . . . someone should . . ."

But something will not be done. And that elusive "someone" does not exist. And so Giuliano's clay pits and his workbench and his piles of bricks and tiles and his ancient domed kiln—all will disappear into the reedy bamboo clumps. And the tracks down the hill will get washed away and yet another fragment of an ancient heritage will disappear, leaving little else but weeds and vague memories.

And worst of all, Giuliano's skills, knowledge, respect, and passion will all be lost, too. And houses will be built with cheaper, poorer, salt-oozing bricks, and their mass-produced pantiles will

have none of the rainbow range of ochres and golds and bronzes and ambers that make Giuliano's tiles so beautiful and unique.

And the world will be a poorer place with yet another nail hammered into the coffin of lost skills and traditions.

Just a Bottle of *Limonce*

Every day in Accettura my understanding of life and ways in southern Italy increased, and one aspect, one vital law of existence, quickly became blatantly obvious: Patience in Italy is vital to self-preservation.

ONE MINOR but memorable occurrence may serve to illustrate this most important of local aphorisms. I only wanted a small bottle of Basilicata's popular *limonce* (often called *limoncello*), a liqueur that possesses a delightfully rich and authentic lemon flavor with a little extra alcoholic kick to help it down. The *limonce* was not intended for me, although I have been known to partake of the delicious nectar. It was to be a gift to Giuliano for all his kindnesses since my arrival in Accettura, and in particular that wonderful *ciambutella* breakfast at his brick kiln.

I found a bottle of it on the shelf in the small grocery store on the main street, picked it up, and eased my way down the narrow aisle to the checkout counter by the door. There I found a little logjam of ladies. This was rather odd, because when I first came in, only a couple of minutes previously, I could have sworn the place was empty. But now four elderly women were ahead of me. And that's when I began to learn that in Italy, patience is not merely a virtue, but a way of life essential to maintaining one's sanity and survival.

Here, without the slightest exaggeration or authorial embellishment, is how it went.

The first lady, chatting away happily to the other three and in no rush to complete her transaction, decided that one of the items she was purchasing—a large box of Italian Perugia chocolates—needed gift wrapping. She smiled seductively (as only elderly ladies can, conjuring up all their charms) and asked the young man at the

checkout if he could possibly help her, as she had no gift paper at home. He smiled back, equally charmingly, and said, "Of course, no problem," and vanished to find some suitable paper. The chattering continued. Everyone seemed happy to share bits of local news, and only one person on line was getting a little restless: me.

Three minutes or so elapsed before the clerk returned with a sheet of paper smothered in *putti* (cherubs) and garishly pink roses, which delighted the elderly lady. He then left again to find some scissors, returned, and began to cut the paper carefully and wrap the gift . . . only to find that he had no tape. Off he went again, and another minute of chatter among the women ensued. Then he returned, still all smiles, and sealed up the gift.

And I'm thinking, Well, thank goodness *that's* over. Now maybe we can move ahead. But it was not to be. The lady purchasing the chocolates, alas, did not have enough of the old Italian lira to pay in lira or enough of the new euros (only recently introduced and still a novelty, and a nuisance, for almost everyone). So with remarkably complex calculations, at first on a dollar-store calculator that kept giving the same number in sequences of fives no matter what the input was, the clerk fell back on the time-honored paper-and-pencil method. But obviously he'd never completed basic math at school (not surprising, given that the poor high school kids there had to endure a journey of almost an hour each way every day to a distant school to complete their studies, and inevitably many dropped out or became maestros of truancy capers). The minutes crept by, and I wondered if I really needed this stupid bottle of *limonce* at all, but the impartial observer in me was becoming intrigued by the growing complexities of this little transaction.

There then ensued a somewhat confused discussion as to whether the young man had handled the conversion correctly, but finally the elderly lady succumbed, smiled that coquettish smile again, and relinquished her confusing lira-euro mix of coins and notes. Lots of *grazies* and smiles and off she went. Then the next lady in line stepped up only to be stopped by the first one rushing back to explain that she'd forgotten something, which she grabbed from the

shelf—a packet of chocolate cookies—and it became another confusion of lira-euros until finally she left for good.

It appeared as if the next lady would follow on quickly, but at the moment of payment she looked at the package—slices of prosciutto that the young checkout clerk had cut for her in the deli section at the far end of the store (the poor guy seemed to be operating a one-man show here)—and realized that it was inadequate for her needs. Another two hundred grams—sixteen slow slices—had to be cut, which required the young man's leaving the checkout counter and going to the back of the store. We could hear his slicer slicing endlessly, and then finally he returned, smiling, relaxed, mellow as a marshmallow.

At this point I was about to stomp and shout and pour the bottle of *limonce* over somebody's head.

Two more ladies to go. One waited smilingly as the store clerk added up her half dozen items. When he turned to ask her for the money, she gave one of those "Oh, money! Ah, yes of course! You need money" looks and began to fumble through her handbag and pockets, looking for cash. (I mean, you'd think she might have realized that money was usually required to complete these little daily transactions.)

Finally she left. The last lady in line, getting a little impatient herself now, had only two items, and she would have got out of there in thirty seconds or less except . . . suddenly through the door, followed by a retinue of half a dozen beaming and doting ladies, burst a young village wife who apparently had just returned from the hospital in Potenza and had brought with her her newborn baby girl for the approval and adoration of whoever happened to be in the store.

Twenty minutes later I dragged myself from the store clutching my bottle of *limonce* and wondering the repercussions such a sequence of events would have had in an American store. Manic madness and mayhem, no doubt.

In Italy, patience, as I said, is vital to self-preservation.

CHAPTER 4

A Home in Aliano

Maybe I'd been reading a little too much of the renowned physicist Stephen Wolfram's work. Actually *reading* is the wrong word; it's more like a mind-bending, thought-contorting plod through hundreds of tight-knit, tight-print, self-published pages. Not something I would normally do, but in Basilicata reading had once again become a key evening pastime. Anyway, after a decade of writing his seminal work, *A New Kind of Science*, Wolfram claimed to have demolished and reassembled all science and mathematics into a universal operating system based upon "cellular automata" algorithms. No, I didn't understand it either, until he suggested that free will was the result of something called "computational irreducibility," which in layman's terms means that "the only way to know what systems will do is just to turn them on, let them run," and then try to make sense of their unexpected and certainly unpredictable patterns and outcomes. At least, I think that's what he means.

All of which, I guess, is just another way of saying that when faced with a particular dilemma or challenge, it's not a bad idea to try letting the solution emerge all by itself by—once again—just "letting go." It had worked admirably for me in Accettura, so that's precisely what I did when I made a second visit to Aliano looking for a place for Anne and me to put down roots when she finally arrived

from Japan. I was getting increasingly impatient and missing her far too much.

The first time I ventured there, prior to my brief hotel residency in Accettura, I had a pretty good idea of what I wanted to find, only to find that I had found nothing at all. My needs may have been a little too specific, and my Italian in those days (and these days, too) was so god-awful nonsensical that it embarrassed and confused my listeners even more than it did me. Of course matters were made worse when I found myself gabbing away in Spanish, of all things. I was *por favor*-ing, and asking for *café con laiche* rather than cappuccino, and saying *gracias* when I meant *grazie*, and the odd thing was that I never realized I knew that much Spanish to begin with. It had been twelve years since my last visit to Spain, when I was in my "one country behind" tendency and speaking pretty fluent Swahili, and I don't remember picking up much of the local vernacular at all.

So it was a discouraging state of affairs when I settled in Accettura, convinced that my visits to Aliano would continue to be just that, a series of visits.

But on a beautiful afternoon (sparkling blue sky, benign rather than burn-your-bum-off sunshine, and cool perfumed breezes) I decided that as much as I loved Accettura, I'd take another roller-coaster ride to Aliano and try again.

HIS NAME WAS Aldo. I don't think I'd ever met an Italian Aldo before, or since, but he was a charming, slightly nerdy-looking youth who happened to be behind the counter at the second of the three coffee bars on Aliano's *corso*, the Via Roma. His helpful, ingratiating smile made me warm to him immediately, and as he was preparing my cappuccino, I let it drop that I liked Aliano very much and wished I could live there for a while. I didn't expect anything really, particularly after it became clear that his claim to speak a "little" English was utterly without foundation. He spoke none at all. But, when you're in serendipitous mode, you don't think about such things. You just dive in and "let the systems run" in true Wolfram manner.

Something in his understanding of what I expressed in flowery

body language obviously touched a nerve, and his face lit up even more brightly than when I'd first walked in. He abruptly paused in mid–cappuccino-frothing. The machine obviously didn't like such erratic treatment and began spitting and wheezing like an asthmatic harridan. (If you've never seen one of these, watch out.) "Live? Here? In Aliano? You?" At least I think that's what he said.

"Yes. I would like."

Aldo's grin widened, and he was about to pick up the phone behind the counter when I tactfully suggested, by more expressive body language, that I thought his ancient espresso machine was about to explode. "Ah," he said. "*Grazie*," and completed the ritual of cappuccino-making, put the cup down on his side of the counter, and then picked up the phone again. I hadn't the heart to remind him that the coffee was really meant for me because he had gone into a paroxysm of dialing and slamming down the phone and redialing until . . .

"Ah, Don Pierino. Aldo. *Si, si. Per favore . . .*" And the rest became one of those amazing steeplechase-paced Italian monologues that always seem to suggest the speaker is a fully accredited master of the Australian "circular breathing" technique. If you've ever seen an aboriginal playing the didgeridoo for minutes on end without a pause and without any noticeable intake of breath, then you know the technique. Oh, and gestures galore, of course. They seemed to come with the territory there.

My coffee was getting colder and certainly not getting to me, while the conversation was getting faster and more enthusiastic, right to the final "*Grazie, grazie*, Don Pierino." Aldo hung up the phone and then turned to face me with a grin that would have lit up the Rockefeller Center Christmas tree.

"*Bene*. We go. To Don Pierino. Our priest. Very nice man."

And with that he came around the counter, took off his apron, led me out of the door (my coffee obviously now completely forgotten), and locked up the bar. Locked it! Unheard of in Italy. You don't lock up bars during opening hours. But he didn't give it a second thought. Outside, he led me at a strapping pace uphill from the

piazza to a building around the corner from the church that was oddly painted (mud brown and moldy lemon), institutional-looking, and plastered in *manifesti funebri* (Italy's ubiquitous elaborate, black-bordered funeral notices). He rang the intercom, and we were immediately buzzed in. We climbed steep stairs to a tiny office packed with books, papers, Bibles, and hundreds of religious tracts.

And there he sat, the closest thing to a sparkling-eyed, ironic-smiling, leprechaun-faced Irish-Italian priest I'd ever seen. And, as with Aldo, I liked him immediately, especially when he told me in a fair shot of coherent English how much he'd enjoyed his two trips to New York, including to one Bronx neighborhood—he couldn't remember exactly which one—that contained "more Alianese than Aliano."

Don Pierino (Little Peter) Dilenge had been Aliano's priest for more than thirty years. Little did I know when I met him just how much this man would become involved in my life and experiences there. But for the moment, after a few hesitant "Italianish" pleasantries, it was down to business.

"Aldo say you want life in Aliano."

"Yes, very much," I responded enthusiastically, thinking, well, this is certainly far better than my first visit here.

"For how long?"

"Oh, maybe three, maybe four months, or even longer."

He smiled and tapped his fingers along the side of his mouth. "What kind of place you like?"

"Oh, anything really. But a view would be very nice." (Fat chance, I thought, in this cheek-by-jowl little village.) "And not too big. With some furniture and a little kitchen. Very simple, okay?"

More tapping along the side of his mouth and then action. The good don out-Aldoed Aldo in the speed and precision of his movements. Phone in his ear. Numbers rattled off. Silence. Then not. Then another one of those Italian monologues with a few pauses for responses from the other end. And it was all over.

"*Bene.* I think very nice place. Fifty euro a day" (then about fifty dollars).

"Ah, wow! No, thank you, fifty euro is a little too much for me."

"What you say? You say fifty euro?"

"No, *you* said fifty euro."

"No, no, no! I say *fifteen*. One and five." And to reinforce this he wrote the figures on a pad of paper and turned it around for me to look at. "See? One and five. Is all right?"

"Sounds very good. Can I see the place today?"

"Of course. Immediate. Aldo take you. I come five minutes."

And Aldo did precisely that, leading me with his irrepressible grin back to the main piazza, Piazza Roma. And then he waved, left me, and hurried down the street to reopen the bar, with a brief reminder in Italian that I wait for Don Pierino.

"Okay," I shouted back a little uncertainly.

DON PIERINO

But which house was it? They all looked rather fortresslike, except for one three stories up that had a broad flower-filled terrace overlooking the piazza, the town, and, I imagined, the whole of the soaring Pollino Mountain range to the south. "Yeah, right. You should be so lucky," my little defeatist demon muttered. "Prepare yourself for a black basement cave with no natural light and no . . ."

"Ah, Signore David." The voice came from behind me. I turned, and there was Don Pierino, with his leprechaun grin and sparkling eyes, knocking at the door to the very place I'd been looking at.

The defeatist demon was still not convinced. "Well, of course you'll never get the terrace. The owner will have that. You'll be stuck in the back somewhere with no views."

A plump, elderly lady dressed in ritual black and bowing politely to the priest opened the door and greeted us with a smile as sweet as my grandmother's (on my mother's side—my father's mother was not known for her smiles, although, being staunchly Irish, she could produce an exemplary *colcannon* lamb stew that made up for her rather morose attitude toward life).

My demon was vanquished. I loved her at first glance and even more when I approached her to shake her hand and smelled the enticing aroma of warm olive oil, parmesan, and garlic wafting around her.

She led us both inside and up the steep tiled steps. We came to the first landing. "Please let her keep going," I wished. And, God bless her, she did. She kept on going up another two flights to what I calculated was the third floor, the floor with the terrace.

She opened the door and let us into the apartment, which was neatly furnished with huge cupboards of family china and glasses, a TV and stereo, books, even a guitar (at last, maybe I'd be able to revive my once enthusiastic involvement in folksinging), a large fireplace, and a pleasant, bright little kitchen with a gas stove, fridge, and double sink. There was a sparkling-white tile bathroom too, and a large bedroom with a double bed and enormous pieces of that ultra-rococo carved-wood furniture that Italians seemed to

love, teeming with curlicues and floral flourishes and even a couple of cherubs at the headboard below a stately crocheted portrait of the Madonna in a richly gilded baroque frame.

Both the bedroom and the living room had small balconies and spectacular views of Aliano's North Dakota–type scenery to the east. It was an admirable apartment for fifteen euros a day, a truly serendipitous steal. But no large terrace to be found. Shame. I must have miscounted the floors, I thought. But it'll do just fine, and I was about to tell the woman—her name was Giuseppina—that I'd take it, when she opened another door near the entryway to what I assumed would be a storeroom of sorts.

And there was my huge terrace, bedecked in plants and flowers and pepper bushes and flurries of tomatoes; tubs of basil, mint, rosemary, oregano, and other less familiar herbs; a small table for eating; and even a metal-frame bed in case I wanted to sleep outside. And of course, just as I had hoped, those million-dollar vistas across the piazza, down the *corso*, over the whole town and the vast towering magnitude of the Monte Pollino massif itself.

I tried to suppress my enthusiasm—that fifteen euros could quickly have risen to fifty if I had started to dance a jig—but my eyes and my overly flushed face must have spoken volumes, because Giuseppina smiled brilliantly, squeezed my hand, and invited the good don and me down to her apartment on the floor below to seal the deal with a glass of a strong local liqueur known as Amaro Lucana.

Ten minutes later I was alone on my terrace dancing that jig for all the street below to see, and telling myself that this could not possibly have happened in less than half an hour from my arrival at wonderful Aldo's beautiful bar and my introduction to a perfect priest and one of the nicest landladies it had ever been my pleasure to meet.

Oh, and of course, endless gratitude to the wise and ultratalented Mr. Stephen Wolfram for his advice about turning things on and letting them run just to see what happens . . .

Postscript

I suppose I should add, by way of this postscript, that one more lit-tle "what happens?" happened later that evening, and was decidedly less successful. As Aldo was helping me find my new home, he had enthusiastically praised the excellence of the traditional cuisine at his bar's restaurant. Later on in the evening I thought I'd stroll back, thank him again for his assistance, and enjoy one of his dinners. Unfortunately when I arrived at the normal dining time of around eight-thirty, he was not around; a charming young lady with crisply cut short, black hair and shy, smiling eyes was hostess for the evening. I explained why I had come and asked if I could see the dinner menu. Her face immediately changed from a friendly wel-come to a decidedly "*O Dio, no!*" expression as she handed me the menu of five *primi piatti* (pasta dishes) and six *secondi* (meat dishes) and explained that some of the dishes were not available that night. Feeling in a generous spirit, I asked her what were the available options. She blushed and whispered, "Tagliatelle with tomato sauce."

I should have got the hint and returned on another night, but I felt that might somehow detract from my expressing my gratitude to Aldo. So, untruthfully, I told her I wasn't really hungry anyhow so a plate of *tagliatelle* would do just fine. She still had that "Oh, no!" look on her face, but she beckoned me graciously to the upstairs dining room. Later I learned that it was customary in these small hill vil-lages to give a restaurant ample warning of your intended visit if you expected to enjoy anything more than a hastily cooked bowl of pasta. Microwaves, pre-cooked meals, and all those cosmopolitan short-cuts are unknown here.

The upstairs dining area was a large, dark space, empty except for bare tables and chairs and a huge TV set projecting from the wall. The hostess showed me to a table, placed a TV channel-changer in front of me, and vanished into the kitchen at the back of the dining room.

The place was utterly silent. Even the usual chitchat in the bar

downstairs had ceased. I sat and flicked through the channels for fifteen minutes, hoping to find something in English. After all, with England being part of the European Union, I thought there might be some token acknowledgment of the BBC or something like that. There wasn't—only more of those interminable Italian game and quiz shows and one ancient, badly dubbed American movie. I turned the TV off and waited. Eventually the hostess emerged with a bowl of pasta, wished me *Buon appetito,* and asked if I needed anything else. When I said no, that everything looked fine, relief filled her face and she rushed toward the stairs. "So, I go now. Open bar."

A shimmer of alarm scampered down my spine, and I stopped in mid-pasta scoop. "Open? You closed the bar?"

"Of course. I cook. For you."

Oh no! Not again! That was twice in one day that I'd been the cause of the unheard-of necessity of closing that unfortunate bar.

"Look, I'm ever so . . . very . . . sorry. I didn't . . ."

But she was gone, and by the sound of the raised voices that followed her opening the door downstairs, her customers were not at all pleased with her, or with me either.

Sheepishly, I sneaked out of the bar quietly after finishing my meal, leaving a generous tip and vowing never to create such a dilemma again. After all, I was now a resident of Aliano and had already been the cause of far too much havoc.

And this was barely the end of day one.

The *Homo Ibericus* of Aliano

The next day I said farewell to my Accettura friends, promised to visit them as often as I could, and made the tortuous hour-long hairpin curlicue and vertiginous drive back to Aliano, my new home.

Once again I turn to Norman Douglas's 1915 masterwork, *Old Calabria,* for a reaffirmation of my feelings toward, and observation of, the population in this part of Basilicata. Douglas described the men as:

> *whiskered, short and wiry, and of dark complexion. There is that indescribable mark of race in these countrymen; they are different in features and character from the Italians; it is an ascetic, a Spanish type. Your [typical resident] is strangely scornful of luxury and even comfort; a creature of few but well-chosen words, straightforward, indifferent to pain and suffering . . . A note of unworldliness is discoverable in his outlook upon life. Dealing with such men, one feels that they are well disposed not from impulse, but from some dark sense of preordained obligation. Greek and other strains have infused . . . a more smiling exterior; but the groundwork of the whole remains that old homo ibericus of austere gentlemanliness.*

Douglas also points out another little quirk in the nature of the Basilicatan populace.

> *. . . it is your duty to show, above all things, that you are not scemo—witless, soft-headed—the unforgivable sin in the south. You may be a forger or cut-throat—why not? It is a vocation like any other, a vocation for men. But whoever cannot take care of him-self . . . is not to be trusted, in any walk of life; he is of no account; he is no man.*

I had read this brief summation of Basilicatan male characteristics a few days before finding my new home in Aliano, so I felt just a trifle self-conscious when I finally arrived in the village and prepared to unload my possessions—suitcases, boxes, plastic grocery bags, etc.—from my packed-to-the-gills mini DoDo (definitely a "toy car" by American standards).

I had parked as close to the house as possible, right in the Piazza Roma, the center of the village. The audience of octogenarians (I now referred to them affectionately as "octos") was already in place along the benches around the war memorial and on a remarkable number of additional benches lining both sides of Via Roma. It seemed as if the whole street had been set up for permanent the-

atrical performances, which is what daily life in Aliano turned out
to be.

It would be embarrassing to list precisely the number and range
of ridiculously clumsy antics, faux pas, and little stupidities on my
part that characterized the first half hour of my arrival there and the
moving of my possessions and supplies to my third-floor aerie. At
one point I wondered if I should postpone the whole process until
well after midnight, when most of my audience would have retired to
bed. But telling myself that "one more trip should just about do it,"
I lumbered backward and forward the few yards from my car to the
house under the watchful and increasingly bemused gaze of my
homo ibericus audience. They doubtless decided quite quickly, and
understandably, that I was a prime example of a foreign *scemo*, and
somebody who would be likely to present them with countless other
inadequacies as amusing diversions during their long days of dally-
ing and dozing around the piazza.

A chaotic first few minutes extended to a full half hour of
snapped suitcase handles; torn plastic bags disgorging bottles of
olives and peppers and *funghi* (mushrooms) in slippery oil; a
dropped camera and film spooling all over the cobblestones; lock-
ing myself out of the car; chipping the edge of the marble step to the
house with a particularly hard corner of one of the suitcases; reveal-
ing the entire contents of my wallet—credit cards, cash, personal
photographs, and all those scraps of paper and receipts that I kept
for no good reason—which blew all over the piazza in a sudden, per-
nicious evening gust; and finally, my grand climax: locking my
landlady out of her own house, which required a full family chorus
of "*Eh, Signore, Signore!*" and door-pounding before I realized my
gaffe.

By my count I created a *brutta figura* more than half a dozen
times!

To think of these calamities any further would bring instant
apoplexy. I can only hope that writing them down as a confession of
my temporary incompetence in front of that critical audience will
dissipate further recall. And I also hope that the gentlemanly spirit

of my fellow villagers will enable them to forgive the inadequacies of this *straniero* (foreigner), if not entirely to forget them.

They say that most people in the village are known not by their real names, but by nicknames often gained after some notable stupid or certainly memorable event in their lives. I dread to think what mine might be. And of course, as true *homo ibericus* gentlemen, the villagers in Aliano would never tell, and I shall therefore never know.

Waiting for a Train

Day seven was much, much better.

At last, Anne is on her way, flying into Rome from England and thence by train to Basilicata. At long last!

I WAS AT the train station right on time the following morning to pick her up . . . if you could call it a train station. More like a non-architectural afterthought. A token, aid-funded, pantile, breeze-block and stucco structure flung together as a gesture of the North's recognition that even the Mezzogiornese might need access to a train or two, although rarely (I could imagine them sniggering) to go anywhere north of Naples.

The station stood alone in the broad, sun-soaked valley. The air was thick and stagnant. You'd think that with all those mountains around there'd have been some kind of breeze, token proof that cold air flows down and hot air up. But no tokens today. Just pure unseasonable southern Italian torridity. A wham of heat that just keeps on whamming.

I looked at my watch. Fifteen minutes to go. I'd made good time down the endless switchbacks from the village. My adrenaline was pumping. My heart, if not exactly pounding, was certainly racing along at an abnormal pace of excitement and expectancy. It had been too long since I'd seen her. I reprimanded myself for not being more persuasive in my attempts to lure her there earlier away from all those onerous teaching responsibilities in Japan. But then her

mother was ill in Yorkshire, and she'd wanted to stay in England longer.

I too had wondered if I should have left Italy for a while and returned to Yorkshire to be with the family, but Anne had insisted that there was nothing I could do and that she would soon be joining me as planned.

So, here I am waiting in the middle of this empty valley in the shade of a shed, watching long looping lines of ants do whatever ants do so incessantly, and thinking of the fun and feasts that await us over the next few days back at the village. Massimo is gathering a small circle of friends and promises me "one of the best meals you and Anne will have in Basilicata." Rosa and Guiliano are also offering a family extravaganza "better 'n' Christmas and Easter lumped together."

And there it is. Way, way up the line is a hazy, gray shape getting closer. There's no sound at first, just heat and flies and emptiness. But then I hear it. A tinkling and clinking in the rails getting deeper and louder as this modest little train (only four carriages) wobbles and rumbles to a halt in the middle of all this nowhereness.

She'll have far too many bags as usual. Fortunately the car is parked right next to the tracks. And she'll get all embarrassed when I give her one of my bear hugs in front of all the other passengers.

But I don't see any passengers. The train looks empty. So, why has it stopped? Maybe it is an obligatory stop, because it's now starting to roll again and no doors have opened and there's no sign of Anne.

No Anne. It takes a few seconds for that fact to sink into my overheated, befuddled brain. I peer into the carriages as they move away, but all the seats are empty. Well, maybe there's another train expected. I check the rain-stained, sun-bleached timetable and find that, no, except for a very early train at six thirty-two A.M., this is the only train until a much later night train. I can feel the sweat running down my forehead. Cold sweat. I check my watch, read my notes made the last time we talked a couple of days ago. *London, Heathrow, to Rome. Train from Rome, arriving here at 5:20 p.m.* Plenty of time to get to the station from the airport. Well, maybe the flight was delayed. I never thought to check. How stupid! So that's what I

should do, I decide. Back on the highway, find a phone at the first gas station, call British Air. No, better still: Call Anne's sister, Susan, in England. She'll probably know where Anne is, or if there's been a delay. Yes, that's right! That's what I'll do. Some stupid mix-up. Some typical traveler's confusion. I bet she'll be smiling at my exasperation.

I've never been very good at "systems"—things that require neat dovetailing of plans and schedules. They rarely seem to work. At least not for me. But this time I'll surprise her and just laugh the whole thing off. Like I did on the first occasion we met in our late teens, when we worked in the same office and she watched me with eagle eyes (or was it a humorous glint?) as I signed in that I'd arrived at the office earlier than I actually had . . . but that's another, long story. For once, I'll be a mature adult used to handling crises like this with a cool, detached Zen-like demeanor, and humor too. A Yorkshireman can always find something amusing in any situation. And these two Yorkshire folk, born—believe it or not—on the same day in the same year, in Yorkshire towns only seven miles apart, and now married partners for over thirty-five years, will have a real laugh at it all together. So that's it. Find a phone. Fast.

Fortunately, inspiration struck, even in the midst of all that mental anguish, confusion, and fantasizing.

Forget England. Forget the airline company. Just call Rosa. Of course! Anne has her number in case of emergencies or, in this case, what looks like a typical Italian botch-up of itineraries, timetables, schedules . . . and my dreams. (A couple of days previously I really had a bizarre, ultraromantic Bogart-and-Bergman—tinged dream of me hairpinning across the wild ridges and ranges and descending into a broad, empty valley to greet my beloved at a godforsaken little, stucco-peeling railroad station in the middle of nowhere and our dissolving into a welter of hugs and kisses and whispered sweet-nothings and vows of never being apart so long ever again.)

Rosa, calm and stoic as ever, told me that, yes, Anne had called, and the train had left on time, but that there had been some kind of mix-up of station names and locations and that she'd finally

emerged at another middle-of-nowhere station way down the Basilicatan coast, at Metaponto.

"How long ago was all this?" I asked.

"Oh, 'bout an hour ago," Rosa said laconically.

"So, where is she now?"

"Well, she waited a long while for you at the station and then she got a taxi."

"A taxi?! From Metaponto? Where to?"

"To Aliano."

"From Metaponto!? That's fifty miles away!"

"Well, she didn't know what else to do. At Metaponto there was no one around, and she said she was getting a bit nervous so . . ."

So much for my dreams of starry-eyed reunions in the wilds of the Basento Valley.

"So, she's on her way to Aliano?"

"Likely she'll be there already."

"But she doesn't know where I live. She hasn't got a key. There'll be no one around to meet her."

"Ah, she'll be fine, David," Rosa said encouragingly. "Aliano's only a tiny place, and your friends'll look after her just fine."

And how right good old reliable Rosa was. Once again, I swirled my way back through all the ridges and ranges, roaring like a rally driver on the twists, turns, and tortuous grades and soaring up the final twenty-two *tornanti* to my precipice-perched village. And, there she was, there was my darlin'—as I skidded to a dusty halt by the church—being escorted around the piazza by a coterie of locals, most notably Don Pierino himself, proudly pointing out the nuances of Alianese architecture, with Giuseppina and her two sons all smiling and chatting with Anne in ripe Alianese dialect (which sounds nothing like Italian), and Anne nodding and responding in her usual warm way, as if she understood every word, and beaming that beautiful smile of hers. And then waving at me like a schoolgirl and scampering across the cobblestones to greet me—just as I'd imagined—with hugs and kisses. And I was thinking, We really shouldn't be doing this in front of my friends and all the octos and

the black widows (looking askance as usual at the slightest outward demonstration of affection). But, the hell with it! Anne's safe, she's happy, she's radiant . . . and she's here. At last!

The rest of the evening faded into a blissful blur, the two of us well lubricated with wines, liqueurs, bountiful snacks provided by my, and now our, new friends. In fact, the next few days were a moveable feast of fun, frivolity, and endless indulgence with our dreams come true, well and truly manifested in glorious, rainbow technicolor.

A Sense of Settling In

A few days later Anne and I were on the terrace whimsically watching the village go about its morning rituals when we heard the fishman's cry. It was ten A.M. on a Friday, and once again he was right on time, his gruff voice echoing through the streets and rolling across Piazza Roma. The village glowed with warm early sunshine, and the octos were already in their places, by the war memorial and on their preferred benches all the way down Via Roma. There they sat, their trilbies and flat *copolla* caps carefully set on their invariably bald heads, walking sticks at their sides, and jackets fastened against a cooler-than-usual morning breeze that gusted up from the *fossa* and the wild *calanchi* gorges.

The magnificent outline of the Pollino range was on full display. No haze at all this morning. The air was sparkling and crisp, and all the broken ridges and shattered volcanic cones and the great rounded bulk of Pollino herself—like an enormous ball of rising bread dough—seemed almost close enough for an afternoon stroll.

We crossed our terrace to the railing, which was lined with the now-familiar pots of herbs, hot peppers, and tomato plants, and peered down onto the piazza to see precisely where the fishman had parked his small, white van today. And there he was, busy with three black widows and a young girl, whose large straw basket he was filling with an amazing array of the sea's delights. We could see Giuseppina strolling across to take her turn in line. I'd better get

down there, I thought. His selection seemed a little on the meager side that particular Friday.

A couple of old men looked up. No matter how timorously we walked about our terrace, someone always seemed to spot us and to mumble something to all the others, who then looked up as well. Then we'd exchange *Buon giornos* and brief analyses of the weather and endless friendly waves. This time was no different. "*Buon giorno!*" we called out, and almost in unison they responded, a couple tipping their hats. And they informed us that it was, indeed, a *bella giornata*, and we agreed and pointed to the blue sky and at the swifts completing their morning insect-gobbling swoops (very useful, those swifts, keeping our streets free of irritating biters), and then to the fishman, indicating that I'd be coming down to do my Friday-morning fish shopping. And they all smiled, maybe even chuckled a bit at the odd idea of a man buying fish, or buying anything in the way of domestic supplies—very much a woman's job in that village. They'd even chuckled when, before Anne's arrival, I emerged from the general store almost on a daily basis with my little plastic bag of eggs and wine and paper towels and, always, my morning fix of those two hundred grams of sweet, succulent, melt-in-the-mouth slices of *prosciutto crudo*. (Despite Rosa's advice, I always chose the Parma ham. The other brands just didn't taste as rich and winey.) But I think it was a well-meaning chuckle. After all, I was a foreigner, and who could explain the follies and foibles of foreigners?

A very pleasant sensation rippled through me that particular Friday morning. I suddenly realized that I didn't feel very foreign at all anymore. I sensed that I had adjusted to the daily rituals and rhythms of the village, which now felt, well, like home, I guess. Even my Italian had progressed to the point where I could hold simple conversations and indicate to the grocer and greengrocer the items I needed, and appreciate the various types of bread produced each day by the *forno*, which opened at around six-thirty with the most salivating aromas wafting in our bedroom window. I had even begun to understand a little of the furious early morning political debates

between the younger men at Bar Capriccio, where I usually had a sensually frothy cappuccino topped with a heap of powdered chocolate at around eight o'clock. If it was warm, I'd sit outside for a while on one of the bar's blue-plastic garden chairs, watching the village wake up and checking off the daily rhythms of activities that were now becoming so seductively familiar.

I would note the same half dozen or so black widows entering the church for ten minutes of genuflecting at one of the four candle-bedecked shrines; the dogs starting their hour-long paroxysms of barking; the big, blue public bus arriving at seven-thirty and leaving promptly at seven forty-five; the crack and rattle and blast of those mini-tractors barely bigger than a boy's peddle-power racing car; at least two, sometimes four, mules, all with dual wicker panniers, with their owners sitting cheerfully astride their bowed backs on their way to the small fields and olive groves far below the village, among the *calanchi* canyons.

Often, if I worked at my trestle table on the terrace, I would continue to keep an eye on all the other regular rituals—the women chatting at the shop doorways or on van Gogh–styled rattan-seated chairs outside their homes, but never on the street benches. (That was very much a male domain, and rarely did male and female mingle in public, except during the evening family *passeggiata*. No matter what their age or marital status.)

As the sun moved higher, the coffee bar at the end of the street overlooking the *fossa* and the broad Pollino panorama would become an increasingly popular meeting place for belligerent card playing and the exchange of daily gossip that seemed a source of endless intrigue for the octos. Younger men would also stop by in their little battered Fiats and Renaults and those creaking three-wheeler Ape creations that, I was told with great pride by one owner, could get over fifty kilometers to one liter of gas, even on the riotously uphill lanes of the village and the hairpin roads that linked Aliano to the outside world.

Few people seemed to walk much beyond that bar. A handful might stroll to the pine-shaded overlook a hundred yards farther

down, by the dark, severe bust of Carlo Levi. Here they would lean for a while against the railing or peer down at the abrupt vertical drop of the *fossa*, edged by those strangely eroded pillars of "clay earth," which you'd think would have been washed away eons ago, but in fact still seemed almost identical to those painted there by Carlo Levi in 1935. And then, after a brief glance at the "old town," with its densely packed walls perched precariously on towering bluffs, and maybe a hawking spit into the shadowy depths of the *fossa*, they'd slowly saunter back to the bar and treat themselves to more thimblefuls of caffeine-concentrated espresso washed down with small glasses of grappa, anise, or *limonce*, or anything else with a bit of a kick to it.

I needed a kick myself, if I was going to get a decent run at the fishman's boxes of sardines, fresh anchovies, eels, plaice, mussels, calamari (three different kinds), octopii, and big, pink *gamberi* (prawns, my favorite, despite their price of fifty euro cents a piece). But then I reminded myself, it's costing us only forty dollars a day tops to live here. Fifteen dollars a day rent for our splendid apartment with everything included, ten dollars tops for food and drink, ten dollars for the hired car, and another five thrown in for whatever we might need. So, I told myself, go ahead, treat yourselves, just as you did last week.

I scampered downstairs and strolled out into the sunshine, and that wonderful sense of being a part of all this filled me with a deep joy. I smiled and waved and *Buon giorno*-ed everyone. I smiled at the church, with its constant chiming of the hour (the deep bell) and quarter hour (the high bell) and its insistent clanging for the two Sunday services at noon and seven o'clock, and even more insistently for its weekday seven-o'clock services. These weekday services were less popular and a constant source of frustration for poor Don Pierino, who told me in his beguiling singsong manner that, "Even after thirty years, I still can't get them to take these weekday services seriously. Unless there's some kind of calamity—a bad storm that's created landslides, or a little earthquake, or if we've had a couple more "passings" than usual, or when it's close to the grape

vendemmia or the olive harvest—they just don't seem to see the significance of non-Sunday services. Of course I always get the same 'loyal ones' " (his polite reference, no doubt, to his devoted coterie of ever-anxious black widows) "but with the others, particularly the young ones, it's usually hopeless!"

He scowled, then looked a little confused by his failure, and finally, as he always did, he gave that enticing leprechaun's chuckle that made me realize that, all in all, things weren't too bad in Aliano, and certainly no worse than in some of the other outlying hill villages of his diocese, where church attendance had to be engendered by threats of godly vengeance and images of eternal damnation in the searing flames of hell. "I don't really go much for that kind of thing," his gentle eyes seemed to say.

Don Pierino seemed happy with his village and his flock, as later

VIEW FROM OUR ALIANO TERRACE

conversations proved. He appeared to accept and enjoy its slow, steady ways—the gradual emptying of the streets after one o'clock, when the shutters came down at the shops for the long lunch and siesta; their rattling back up again around four or five, when the benches filled up once more and the piazza echoed with cup-clinks and endless chats from the coffee bars.

Around six in the evening the tractors came clattering home from the fields, along with the weary mules, and the evening *passeggiata* would begin around seven (nothing quite so formal and lengthy as the ones I'd enjoyed in Matera and Sapri, but a pleasant enough village-type communal stroll). Of course the old men usually enjoyed sitting more than strolling, and the young men studiously gave the impression of ignoring the primped and frilled young women, and drivers stopped in the middle of the street to

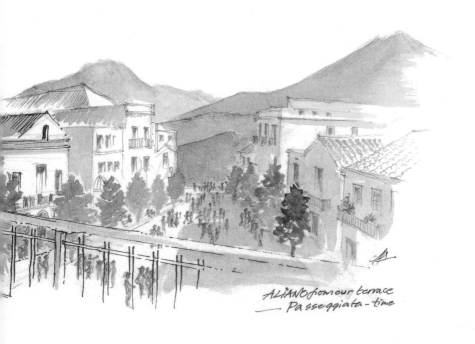

ALIANO from our terrace
___ Passeggiata-time

greet passersby or talk to other drivers, and the swifts arrived again in their cloudlike swoopings to clear the air of mosquitoes. Then, as dinnertime approached, there came a slow quieting of the whole place, with just a few grappa-drinkers propping up the bars, and night settling over the village as the moon moved slowly over the *campanile* of the church.

"SO, THE SAME, is it, Signor David?" It was my turn with the fishman. "Your *gamberi*? Like last week? Maybe also you try some of my big calamari? And these little anchovies? Very, very good. Very fresh. Sweet, too. You can cook in olive oil with cilantro and garlic. So *gooood!*"

I usually took his advice and always ended up with far more than I needed. "But what the heck," my indulgent chef-self invariably insisted. "He only comes once a week."

We'd overspent at the Thursday street market too. But there again, that only rolled into town every two weeks. And when you're living in such an isolated place you've got to make sure you're fully stocked up. I mean, who knows? You might decide to throw an impromptu party for your newfound friends here to thank them for all their many and oh-so-appreciated kindnesses. Or if that freezer of ours in the top half of the refrigerator could ever be made to work, I'd really cook up a storm and produce a week's worth of dinners in one go, and save myself a lot of time for more writing and sketching.

And that was another thing: my cooking. When it got around that not only did I cook our food but that I actually enjoyed cooking, even to the point of discussing recipes with the local ladies—well, that was a bit too much for some of the elderly male benchwarmers to digest. But eventually they seemed to accept this quirk of mine, write it off as another foreign fetish, and continue to greet me (occasionally with sympathetic glances at Anne for having to put up with such a bizarre husband) as if I'd been a long-time resident of this remote and enticing place.

Which is precisely the feeling I had on that lovely spring morning as I strolled back to our aerie overlooking the piazza, parcels of

fish and seafood all neatly wrapped, thinking that maybe we'd try the fishman's recipe with those fresh anchovies for our dinner that evening.

Maybe I'll Stay an *Americano*

But feeling like a long-term resident didn't necessarily mean that everyone else in the village shared my sentiment. I learned this a couple of weeks after our arrival.

"SOMETIMES," as my mother used to tell me, "things are best just left alone."

Now this is my Yorkshire mother speaking. Born and raised in the land of the famous pudding, the coalfields (at least before the Thatcher wipeout of the mines), the steel mills, the Yorkshire Dales, and the home of England's finest beers—Samuel Smith's and Tetley's. And of course, source of the Yorkshire dialect, so indecipherable to outsiders that only a few of its meaty aphorisms are understood—most notably "weer theer's muck, theer's brass," and the typically dismissive phrase that pretty well sums up a Yorkshireman's view of the rest of the world: "neether nowt n' summat," or, put in the Queen's vernacular, "not particularly memorable."

Yorkshire, England, is where I was born. And despite the fact that I've spent well over half my life far outside its borders, primarily in and around New York but on occasion just about everywhere else in the world, I still regard myself very much as a Yorkshireman—born and bred and proud of it "until I'm good an' dead an' six foot under," as an uncle of mine used to say with irritating regularity.

So, as you might understand, it came as some surprise when I realized that my Aliano neighbors had failed to grasp the geographical niceties of my origins and often referred to me, both overtly and covertly, as "*il Americano.*" And it wasn't as though nobody had shown curiosity about my place of birth. Usually the second or third

question from anybody I met, after asking my opinion on the weather or confirming that I was, indeed, well and happy and enjoying myself in Aliano, was, "And where are you from?" And I would gladly explain about Yorkshire, England—where it was in relation to London and how the weather there was far inferior to the balmy blue skies of Basilicata and how the wines (Yorkshire doesn't produce many) were not even a patch on Basilicata's magnificent Aglianico del Vulture vintages. And then I would smile, hoping I'd been sufficiently complimentary. And they would nod and smile and invariably end the brief interrogation with a satisfied, "*Bene, bene. Americano. Bene.*"

"No, no," I would reply, "Not *Americano. Inglese.*"

And they would nod and smile again, but as I turned to leave after a polite *Buon giorno, Buona sera, Va bene, Ciao,* or *Arrivederci*—depending on the hour and the individual and the mood—I would invariably hear a quietly whispered "*Americano*" as I walked away, and see them nodding knowingly to anyone else who happened to be around in a "he can't fool me" kind of way.

So I gave up. If they wanted to call me an *Americano,* I thought, then so be it. And I guess, in many ways, I was, after all those years we'd lived in New York and all those tens of thousands of miles backroading together around one of the world's most scenic and mesmerizing nations and writing books and endless articles on America's hidden delights.

"You know, David, it's possibly a good idea to stay an American anyway," Giacomo (a bar friend) suggested to me over a cappuccino as I told him about this little local misconception.

"Really?" I said. "And why's that? What's wrong with trying to tell them about Yorkshire?"

"Well," Giacomo said hesitantly (he invariably spoke hesitantly, as if his evolution from questing adolescence to mature middle-age was incomplete), "First, it may be a little confusing to them. They might think Yorkshire is your country, and as they've never heard of it and can tell you're speaking English, they find it easier to think of you as an American. After all, America's virtually our second home.

Almost every Italian family has someone who lives in America. It's been that way since the late 1800s. And that's what they call people who return from living abroad, even if they didn't live in America! So, in a way, they're seeing you as part of our extended family, eh? And that's nice, no?"

I nodded, remembering Don Pierino's remarks that there were more Alianese in the Bronx than there ever had been in Aliano itself.

"Okay," I said. "That's fine. It doesn't really matter anyway."

"And then . . ." Obviously Giacomo hadn't finished. "*Scusi*, but maybe I should tell you something else." He seemed almost embarrassed.

"About what?"

"Well, you see, during the war . . ."

"Which one?"

"The last one."

"Ah," I said. "You mean the fact that the English were fighting the Italians?"

"No, no, not that."

"Because the Americans were there, too, you know. Britain and America were allies."

"No, no. Of course. I know that. Let me explain."

"Sorry, I just thought . . ."

"No, that's okay. Everyone understands about that . . . ah, difficult time. No, it's something else. And it may not be true. Who knows these things? Everything gets so exaggerated."

"So, tell me."

"Well, it seems there were some stories about our prisoners. Italian soldiers in North Africa. Many were caught by the British and sent away in ships to England."

"Yes. I'd heard that. But I thought we treated them well. Not like the German camps. Or the Japanese."

". . . and to Scotland. Yes. Like you say, most were treated very well. Hardly prisoners at all, really. They often helped out on the local farms. And even got paid, too. Because so many of the young

Scottish men were away at the war. Some even decided to stay there after the war. Married nice Scottish girls and settled down. They said Scotland was very beautiful except for maybe . . ."

"The weather."

"Except for the weather and . . ." Again, that hesitancy.

"And what?"

"Well, except for the Scottish men. The older 'whisky men,' they called them. They were quite wild, I think. Always fighting . . . and things."

"Really?"

"Oh, yes. I think so. Because y'see, some of our men, the prisoners, after the war, did not come back. Could not be found."

"You mean they'd escaped?"

"No, I don't think so."

"So, what happened to them?"

"Well . . ." said Giacomo very slowly. "We . . . they . . . the people around here think that maybe they were . . . well, you know Italian men, even prisoners, they have . . . a way with the ladies, you know. And they say Scotland is very wild. And the Scots men getting very drunk a lot . . . well, maybe, you know . . . some of the ladies felt a little lonely and also sorry for the prisoners and maybe they were having . . ." And then came one of those exquisite Italian gestures that suggested so eloquently and passionately what a less-cultured individual, a Yorkshireman like me, for example, might bluntly describe as "having hot times in the highland heather." They would refer to such an occurrence more delicately as a *piccola avventura* (a little affair).

"Ah," I said.

"Yes," he said.

"So, some of them never came back?"

"Yes, this is what they say. Of course . . ."

"And they never found them?"

"No. I don't think so. Those Scotsmen, you know. Very wild peoples. Maybe when they found out about their women . . ."

"Ah," I said.

"Yes," he said. "They say the earth there—what do you call it— 'peat,' I think. They say it is very deep there in Scotland."

There was a long pause. I ordered a couple of double grappas for us both, and we waited in silence until they arrived.

"You know, Giacomo, I think you're right," I said.

"How so?" he said. Although he already knew. He'd once tried to explain *la perfida Albione*, the disdain Italians have for certain kinds of Britishers, especially those football hooligans.

"Maybe I'll just stay an *Americano* for a while."

"*Bene*," said Giacomo. "Very good idea."

So we toasted my new honorary citizenship.

An Interesting Question of Etiquette

There were other minor embarrassments, or certainly "questions of etiquette," to be sorted out in our early days in the village. I remember one occasion in particular. I had just emerged from the Aliano church. No, I hadn't just attended the whole of the noontime Sunday mass, but enough of the last few minutes to confirm that the pleasant-sounding choir that echoed in the street outside consisted, in fact, of a dozen or so well-scrubbed, Sunday-best angelic faces and was not some prerecorded cassette tape. It was reassuring to know that, in this tight-knit village of peasant-heritage pensioners, there were enough nubiles around to provide at least the well-intentioned nucleus of a real, live chorus. And a guitarist, too. Far cheaper, no doubt, than an organ and certainly more likely to attract a younger crowd . . . although apparently not young enough: out of the fifty or so in the congregation—not bad for a *pagani* community of a thousand or so individuals—only a mere ten could be classified as youths.

After the service was over I smiled and nodded at the ever-smiling Don Pierino and emerged into the bright one-o'clock sunshine. Rather than go immediately to my terrace for our lunch, I thought I'd spend a while in the sun on the old men's perch by the war memorial at the side of the church. The memorial has a rather

interesting, very contemporary-style statue of what I thought were the two Marys holding the slumped, lifeless body of Christ. A classic subject, I thought, until I noticed that this particular Christ was dressed in what looked like army-issue boots and tight military-cut trousers, with a well-stocked ammunition belt around his waist. Now that's something you don't see every day, even on a war memorial, I was thinking to myself, when a charming little girl with long, black hair and bright, hazel eyes, dressed in pristine Sunday white, nudged me and gave me an utterly disarming smile.

"Oh, *ciao*," I said, surprised and charmed by her precociousness.

"*Ciao*," she said. She was pointing enthusiastically up at our terrace and, presumably, saying nice things about it, although I wasn't sure what. I nodded, smiled, agreed equally enthusiastically with whatever she was saying, and just stood there, beguiled by all her excitement.

She waved and danced off, and I sat down on the marble bench by the statue and watched the rest of the congregation fan out across Piazza Roma. After a couple of minutes, I noticed someone waving from the terrace below mine. Giuseppina's terrace. It was the little girl, still bubbling with excitement. I smiled again and was about to return her wave when I noticed Giuseppina herself, in her Sunday black (which looked remarkably similar to her weekday black), hanging up her washing to flutter in the breezes that wafted up the Via Roma from the cliffs of the *fossa*. She'd obviously already done the sheets and pillowcases and all that mundane stuff, and was now onto what one might call the personals. And an awful lot of personals there were, too. And unusually large and lacy personals—black Victoria's Secret–style—obviously not the personals of her small and perky daughter who occasionally visited her. And it was obvious that Giuseppina knew that the little girl, presumably her granddaughter, was waving at me at this rather, well, personal moment.

Giuseppina had obviously decided to ignore me at what was obviously an intimate interlude for her. So what should I do? Should I wave back and let Giuseppina know I'd seen a full in-your-face

display of her unusually frilly lingerie, or should I pretend I hadn't noticed the wave or?

And then out came Don Pierino, walking from the church toward his apartment high up by the "other" church. He looked up and saw Giuseppina adding yet more personals to a now very impressive line, and he scowled. Which is hardly surprising, as apparently he had just given a homily about inadequate church attendance and here was one of his more faithful parishioners in one of the most prominent houses in the village hanging out her smalls for all to see when she should have been genuflecting and "amen"-ing with the rest of the congregation. What could I do but restrain my amusement, pretend I'd noticed none of this, slide off the bench, and slink away to the solace of the shadows by Bar Centrale where I ordered a double espresso and a large grappa, which I think in the circumstances was possibly the correct thing to do. Etiquette-wise.

Postscript

Ah, the righteous justice of retribution. Slow, but certain. And I was certainly given my comeuppance a couple of weeks later, when Anne decided, on a brilliant blue-sky day, that it was a good opportunity to wash and hang out a few of *my* intimates: half a dozen or so pairs of underpants. Nothing so unusual in that, I thought, except for the fact that we'd overlooked their somewhat colorful characteristics; rainbow-hued might be the appropriate term. They were a gift from Anne as a protest against my normally subdued range of outer attire colors of browns and olives and bronzes and dark blues (manly I thought. She didn't).

So, there they all were, hung up on the line above Giuseppina's terrace. I was at the bar for my morning cappuccino when I noticed a group of octos in the piazza pointing up at my scarlet, bright green, and polka-dot blue personals and having a hearty chuckle at my expense.

I decided not to return home immediately. In fact, it was almost an hour later when I finally scurried back. The sun had slid its way

westward a little and the octos had moved, as they always did, to the sunnier corner of the pizza, well away from my door. And as I'd forgotten to take a book or a magazine to the bar, it had been a long, tedious hour indeed. Certainly enough time for me to empathize fully with Giuseppina's predicament and vow never to write about such things again . . . and also to buy myself some less flamboyant personals next time I visited Matera's Carrefour hypermarket.

Once I'd explained my predicament, Anne did not object. She just smiled her classic maternal smile and nodded knowingly.

An Impromptu Street Party

Once in a while, a potentially embarrassing incident can lead to an interlude of delightful—and, in this case, decadent—spontaneity.

One afternoon, a couple of weeks after Anne's arrival, I was exploring the lower half of Aliano around the house where Carlo Levi had been kept during his *confino*. Like so many of the older hill towns in the region, this part of the village had grown almost organically out of a soaring vertical-sided butte, making it look as if it had been there since well before Christ's arrival on earth (not that he would have noticed since, according to Carlo Levi, he never got this far). The place felt abandoned. Doors were padlocked and windows shuttered. The alleys, barely wide enough for a donkey, echoed to the sound of my boots and nothing else. I decided that this must be either another Aliano-regeneration project or a complete abandonment, which I was to learn later was not an uncommon occurrence in the region.

Then I heard a door creak open on what sounded like huge and ancient un-oiled hinges. I paused. I could hear someone climbing, painfully slowly, down a series of ancient steps. There were grunts and moans and the clack of a walking stick. And then she appeared: another one of those small, hunched women shrouded in black widow's weeds. She was carrying an empty five-liter bottle on her head (not an uncommon sight in Aliano). She turned and saw me, and for a moment I thought I was going to be the cause of her imme-

diate demise because she reared up to her full, unbent four-and-a-half-foot height, and almost fell over backward.

"*Scusi, scusi,*" I said. "*Buon giorno.*"

Her face spectrummed through half a dozen conflicting expressions and ended in a grin as she patted her heart and finally wished me a wheezy "*buon giorno,*" too, before scurrying off with her bottle wobbling precariously on her head.

I wandered on and, by coincidence or not, ended up five minutes or so later back in the same alley, approached from the other end, and once again had one of those heart-attack–inducing encounters with the old lady. And again she started laughing and patting her chest.

I noticed that her bottle was now almost full of transparent, crystal-bright liquid. "Aha!" I said. "Aqua? Or grappa?"

Her laughter increased, and between alarmingly short breaths she whispered, "*Grappa . . . un po . . . per la famiglia . . .*"

"Aha," I said. "*Si, si.*"

Then she did a most peculiar thing. From a pocket deep in the folds of her black shroud she pulled out a grubby shot glass and gestured for me to try her grappa.

What could I do? "Of course. *Bene,*" I said. "*Grazie.*"

She handed me the glass, poured me out a generous sample of her grappa, and indicated that I should be a man and drink it in one gulp. I would have preferred to sip it, but she was laughingly insistent. "*No, no. Beva, beva!*"

So, I drank and I was about to hand the glass back with thanks when the white lightning hit with the force of, well, lightning. "*Whooaahh!*" I think I shouted, or some equally inane exclamation. "*Jeeeez!*"

The old woman's laughter increased to the point where I was convinced, in the throes of my agony, that both of us were about to die on the spot.

Doors suddenly opened (so much for my theory that this was an abandoned section of the village) and faces peered down onto the alley from windows as I clutched the lintel post of a doorway and

continued my wheezing, while the old woman collapsed on a set of steps and laughed until her face was awash in tears.

Anyway, to cut to the quick: That silly little incident led to an impromptu street party as people emerged, glasses appeared from nowhere, and everyone lolled about the alley for half an hour or more sipping samples of the still-laughing lady's remarkably potent moonshine.

It turned out to be an unexpectedly pleasurable, and unusually short, afternoon.

An *Accortezza* Interlude

Another unexpected and most pleasurable event occurred a few days later. Anne and I had been invited back to Accettura, an offer we readily accepted, as we were missing our friends there. It began with an offhand remark from Caterina, a feisty young neighbor of the Mingalones, whom I'd met briefly at one of Rosa's long lunches a few weeks back. "My friend Giusella is very *accorta* [very knowing] about the old ways of cooking," she'd told me. "Very *tradizionale.*"

"I'd love to watch her cook," I said.

"I will ask. I'm sure it will be all right. She is very proud of her cooking. Many of her dishes she learned from her grandmother a long, long time ago. Before she was married. And now she's about eighty, I think, and she says she has changed nothing."

"Do you know if she has ever written her recipes down?"

Caterina gave a horsey snort. "I don't think! Maybe, but I don't think. She is a real *quanto basta* cook; 'when there's enough, there's enough' kind of cooking. Like so many older Basilicatan peoples. Recipes are for . . ." she scoffed a little, "young girls, new wives, people who don't really know how to cook by feel, by taste, by heart! You understand?"

"Sure. I understand."

"So, I will try to arrange and telephone you, okay?"

That was fine with me. One of my favorite pastimes, other than

WOMAN IN "LOWER" ALIANO

cooking in my own kitchen, was watching other people cook. Particularly the *accorti quanto basta* types.

THAT'S HOW I came to be sitting at a thick and much-used oak table in a small, simply equipped kitchen in a tiny stone cottage on the southern edge of Accettura, up near the cemetery. Giusella had given the nod to Caterina, and I had arrived at her house one morning to watch her prepare one of her favorite dishes for a family gathering to take place in a couple of days. Anne had been invited too, but she had decided that as I was the cook in the family, her time would be better spent catching up on the latest village sagas with Rosa.

Caterina had warned me: "Giusella is very nice old lady, but she does not speak English. Actually, she doesn't speak much to anybody, not even her husband, Toni. Or me! And I'm one of her best friends."

"That's okay," I said. "I'll just sit quietly and watch and take notes. I'll learn all I need from just watching, I hope."

Note-taking turned out to be a little difficult, because Giusella asked me if I'd like to help and I, of course, said yes. So, rather than scribbling in my pad, I found myself dicing carrots, celery, and onions. Giusella watched me out of the corner of one of her wrinkled eyes. The other eye was watching something else. She had a pronounced squint, which, along with a thin, small figure barely five feet high and an old furrowed face, gave her a rather witchy appearance.

The dish she was preparing was something very *classico Basilicata—stufato di cinghiale* (wild boar stew). The boar came courtesy of her son, who had a local reputation as a fine (legal) hunter, and the vegetables—in fact, all the other ingredients, including her homemade vinegar and grappa—came from her small garden or her cellar of stored wonders.

Already I was reminded of something Rosa had once told me about the essence of good *casareccio* (home kitchen) food. "Most of the best dishes here come out of our poverty. They are usually quite simple to prepare and inexpensive. What makes them special is the unusual mix of ingredients compared with other parts of Italy, like Abruzzo, Lombardy, Campania, and the Veneto. Oh, and the freshness and homemade goodness of everything and of course all that slow cooking and the stirring and the tasting."

Giusella had already marinated about two pounds of cubed pieces of shoulder boar—usually essential, as boar is tasty but tough meat—in an aromatic mix of homemade extra-virgin olive oil, lemon juice, thyme, parsley, garlic, and savory. She said that one day of marinating was essential, but two or three were better, to make the meat "tender like butter."

Soon we were ready for the stove. Giusella worked without meas-

uring devices, demonstrating a true *quanto basta* flair, sauteing my diced carrots, celery, and onions in olive oil, then adding the pieces of marinated boar to brown before pouring in about a half cup of her own red-wine vinegar and a cup of her homemade tomato sauce—canning homemade sauce was a major event in September for most families— and letting everything reduce down to a thick, almost caramelized consistency. Then in went a couple of cups of Toni's homemade Montepulciano grape wine (bold, feisty, and almost black in color); about half a cup of the marinade mix (Why not? . . . it's got all those lovely meat juices in it); a fistful of fresh thyme, parsley, and savory; a hefty dose of that Basilicatan hot *peperoncini* mix made from her own peppers; and a couple of large bay leaves. And for the moment, that seemed to be that. She adjusted the heat to a slow simmer, gave the stew a good stir, then covered the pan partially and sat down with a sigh and a slight smile of satisfaction.

And then she was up again, back at the stove to set a large pot of water to boil. I wondered if this was part of the recipe, but it soon became apparent that she had other delights in mind.

Like lunch.

I hadn't expected it, but there she was, boiling her homemade, thumb-pressed "little ears" (*orecchiette*) pasta, slowly simmering a mysterious concoction she had pulled out of the fridge, and slicing great chunks of golden bread off an enormous domed loaf.

In minutes we were sitting together devouring one of the most delicious pasta dishes I'd had so far in Basilicata: *orecchiette al dente* tossed in a hot sauce of olive oil, garlic, chopped anchovies, salted capers, small pieces of black olives, and homemade unsalted tomato sauce with basil and parsley. And, as a little finesse, sprinklings of fresh, pan-roasted bread crumbs piqued with her own crushed and very spicy *peperoncini* concoction and sprinkled with grated parmesan cheese.

Caterina had been right: Giusella wasn't much of a conversationalist, but what the lunch lacked in dialogue was certainly made up for with her redolent Basilicatan specialty washed down with tumblers of Toni's strong red wine.

* * *

THE *STUFATO* WAS still slow-cooking when I stepped outside to enjoy a cigar in the sunshine on a raised terrace overlooking Giusella's tiny garden.

Finally, after a gentle simmer for two hours or so, Giusella declared the dish almost ready and called me in for the final touches. And unusual ones they were. She tested the sauce for seasoning, as she had been doing constantly, and nodded with satisfaction. Then she pulled from the cupboard a big bottle of grappa and poured in a good half cup of that fiery liquor along with the juice of a whole squeezed lemon and a few drops of sweet, nutty *vin santo*, a popular after-dinner tipple.

Ten minutes later, after a final simmer to blend these two new and unexpected flavors, reduce the sauce, and take one last lip-smacking taste of the thick aromatic stew—now a deep, rich bronze color—Giusella scooped up a ladle of the *stufato* and poured it into a soup dish for me. "That's your *secondo* for lunch," she said with a crackling laugh (her first since my arrival, which gave her witchy face quite a girlish glimmer).

I won't belabor this little tale with more exuberant adjectives and exclamations of excellence. Suffice to say, I left Giusella's little house convinced, once again, that the process of cooking is indeed a minor miracle. And that people like Giusella are the true miracle-makers, worthy of culinary sainthood in *cucina di casa* paradise.

And if there isn't such a heavenly place, I would be honored to propose it to whichever higher powers might be listening. And I would remind them that cooking, the real *casareccio casa* cooking, is not about technique or flamboyance or fancy gimmicks or elaborate kitchen gadgets. It's about wholesome goodness—so good you must have more—and about caring and love. Love for the ingredients, love for the often long processes of preparation, and, most important, love for those you invite to your table. It's love in its most traditional, tangible, and delectable guise.

So, thank you, silent Giusella. Your love is in your creations, and

they speak volumes. I tried to tell her this in my still-appalling Italian, and she, in return, offered her final farewell as I left: *"Ca vo'campà quante campete u'cele e la terra."* I didn't understand the significance of these words at the time, but I quoted a somewhat garbled version of them to Caterina a couple of days later when I told her of my morning of culinary education Accettura-style in Giusella's kitchen.

"She said *that* to you!?" Caterina said, gasping.

"Why? Yes. Is it bad?"

"Bad!? No, no, no, it's good, very good. It is like a blessing. She said to you: 'May you live as long as the sky and earth shall last.' "

"She said that to me?"

"Yes. That is a great compliment. A wonderful thing to say. She must have really liked you."

"I don't know. She didn't talk very much."

"Ah well," Caterina said with a wise little wink, " *'L'amacizia si mantenete, quanne u'stiauvuechie, vate e venete.'* 'You keep friends by giving gifts for the gifts you receive.' "

"But I didn't give her any gifts."

"Well, she must have thought you did."

And then I remembered another local saying offered by an elderly man I'd been talking to the previous week at Caffé Capriccio in Aliano. He was a fountain of information on the village, but at the end of our long chat he laughingly said, " *'Nu vecchie decite ca tenite nuuantanove anne e ancore s'avita 'mparà.'* 'Even when I'm ninety-nine years old I'll still have so much to learn.' "

In these wild, mystery-filled mountains of Basilicata, I felt the same way. But then again, I reminded myself, we've only been here for a few short weeks and our plans were changing. Why not give ourselves a whole year, we wondered? That would mean three more seasons yet to go, which seemed a most enticing prospect . . .

Summer

CRACO GHOST VILLAGE

Introduction

"The summer was at its dreary pinnacle; the sun seemed to have come to a stop straight overhead and the clayey land was split by the burning heat. . . . A continual wind dried up men's bodies, and the days went by monotonously under the pitiless light."

CARLO LEVI

The less said about summer, the better.

It is not pleasant. It is hammer-and-anvil hot. It is a good time not to be here, and as the soporific, suffocating temperatures soar, and the *afa* (sultry weather) increases, the locals vanish too, at least those entitled to official vacation time. Life in the towns and villages of Basilicata grinds to a standstill as Italians rush, lemming-like, to *il mare*. The lidos along the flat, heat-hazed Metaponto Coast are crammed with bronzing bodies packed sardinelike in regimented rows of deck chairs, sunshades, and lounge beds. The time-honored daily rituals—sun-bathing, cream-and-lotion spreading; occasional sea dipping; candy-gloss and gelato-gorging; *bambino*-bussing; long *pranzi* (lunches); endless beach-blanket chattering and child-watching; *bagnino* (lifeguard) and near-naked *ragazze* (girl) admiring—fill the days nicely. Such activities are as neat and predictable as the fresh-cut fruits offered by beach-boy vendors, whose bronzed bodies titillate the ladies and bring out that deep-seated machismo lurking in the soul of every Mamma-pampered, forever-tan Italian male. All in all, not an enticing prospect, especially if one adds the unwanted panhandling by *emarginati* and *drogati* (social outcasts and drug addicts). So, recognizing the need to visit family in England, Anne and I left for

a while and avoided at least the "dreary pinnacle" of that season of sear and shrivel.

Upon our return in early September we asked our friends how they'd managed during the hell time, and we were met with furrowed brows and frustrated expressions that seemed to say, "Why even think of reminding us?" So we stopped asking and assumed that nothing much had occurred during our absence other than pure stoical, day-by-day existence and a constant search for relief from that notorious southern sun. No one contradicted our assumption.

And thus we resumed our lives in Aliano in the waning heat of that long and unusually hot summer.

CHAPTER 5

Mood Shifts

Some Tourists Come to Town

When we returned to Aliano, tourist season—not that Basilicata has much in the way of tourists—was still rolling its multitudes across Italy, and our little village was about to experience a brief (very brief) touristic interlude.

IT WAS A BRILLIANT, brazen evening. The swifts were out as usual, swiftly wiping out mosquitoes and everything else that might intrude on our enjoyment of the sensual slipping-down of the sun, the approach of a predinner calm, and Aliano's gentle and informal *passeggiata*. I was at my table on the terrace, also as usual, watching the colors deepening over Pollino and wrapping up a useful afternoon of writing, with a couple of sketches thrown in when the mood struck.

I thought I'd stroll down to the *fossa*, have a sip or two of one of those obscure Italian liqueurs at Café Rosa, and then return home to cook us dinner, a dish I hadn't quite decided on yet. Something spicy. Possibly tomatoes eaten raw with a little olive oil, basil, fresh-ground black pepper, and thin slices of *mozzarella di bufala*, one of our favorite of the regional specialties. Maybe I'd make that the

antipasto and add some slices of Accettura *caciocavallo* cheese, reated from the milk of a special local breed of white cows.

And then a bus arrived. Not one of the usual blue public buses that rattled their way up and down the *tornanti* three times a day to and from the main square. This was something much more souped up, with flashy logos and brilliant rainbowed paintwork that almost put the evening sun to shame. And it was full of faces, a most unusual sight. The public buses were invariably near empty, to the point where one wondered why they even bothered to run them. Except that this was Basilicata, the new oil-rich, but still job-poor, Basilicata, a place with a future, maybe, and certainly one to be treated with a little more respect than in previous years when it was regarded, accurately I guess, as very much the back of beyond.

Anyway, in rolled this remarkably colorful, ultrasophisticated luxury tourist coach, its occupants' faces gazing outward in bewildered fashion. It pulled up in front of the church, its back end taking up a substantial part of the Piazza Roma.

The old men by the war memorial and on the benches down Via Roma stared in disbelief. Tourists? At this time of day? In the tail-end of the season? Even at the peak of summer, Aliano was way off the traditional tourist routes, although, over the last few years there had been a growing "cultural tourism" interest in its links with Carlo Levi and in its ancient and strange traditions. But in mid-September?

The octos rose up, hats adjusted and walking sticks rampant, and waited with curious bemusement to see what would happen next.

A bunch of rather weary, *tornanti*-tossed, summer-clad visitors slowly emerged from the dark-windowed interior of the bus and blinked in the bright early evening light. They all milled around an attractive female guide, who was explaining, I assumed, why they were there and what they should be looking for and at.

". . . in twelve minutes," I heard her say in English.

I had missed most of the early commentary, but definitely heard that last bit. I was quickly off the terrace and down into the

piazza in record time and standing with the octos listening to the guide's fragmented pitch about peasants, regional poverty, and Carlo Levi.

"This is the church he described in his book," she told them, "but there's no time to see the museum." And then came her reminder: "Don't forget, we've got only twelve minutes. Please be back in time. We have to be in Potenza for dinner."

Potenza! That's quite a drive, I wanted to tell them. Your guts will be so twisted and tortured by the *tornanti* that you'll never eat dinner tonight.

But they were already off, cameras flashing at the old men posing—yes, posing—for cute "character" pictures, and then vanishing up the side streets behind the church.

I followed one young couple into the store across from the bakery. Anne had reminded me on the way down to the piazza that we needed eggs, and as I was selecting each one carefully from a large bowl full of fresh-laid beauties, I heard the most bizarre exchange in a regal-toned Oxford English accent.

"Oh, no, no, darling, no please," came the enticing whisper from the female.

"Why not? You love it!"

"Oh, well, all right," she said, giggling. "But do it now, quickly, before I change my mind."

"I know you want some just as much as I do."

"Yes! I know I shouldn't. But I really do. Please. Now!"—followed by mutual giggles and then silence.

I peeped around the aisle, hoping to catch a glimpse of some energetically erotic antics performed by the two obviously highly charged tourists among the piled packets of dried pasta and beans. But regrettably, the scene was dismally anticlimactic: She was merely devouring a bar of dark Perugia chocolate, and he was in the process of unpeeling a hazelnut-crumble.

Outside I saw a group of more elderly visitors behaving far less demonstratively. There were strolling slowly down Via Roma to the *fossa* and Café Rosa, mingling with the *briscola* card players (vehe-

mently cursing and table-thumping) and the younger men lolling against the railing, ultracool in the face of this invasion of plump matrons and hairy-kneed retirees.

I wandered closer and instantly recognized their accents: that wonderful, in-your-face, "you don't fool me, mate" Yorkshire dialect, complete with "luvs" and "Ah'll 'ave a pint, George," and the ladies' "Well, I never . . ." murmurings.

"Evenin'," I said to a huddle of them staring blankly up the street toward my house and obviously wondering why they were there and what they should do next.

"Evenin', lad," said one elderly gentleman (so elderly I couldn't take offense at the "lad" bit. In fact, it rather lifted my spirits). "You one of our lot?"

"No, no. I live here. Up at t' top end of the street. Just by t' church." (How easily that strange northern England vernacular emerged with barely a second's hesitation.)

He looked at me quizzically and nudged the lady next to him, his wife, I presumed. "Gladys. Lad 'ere lives 'ere. An' 'e's a Yorkshire lad bi' sounds o' it."

"I am Yorkshire," I said. "Born in Castleford, near Leeds."

"Tha's kiddin'," he said.

"No. No kiddin'. Ah'm a Yorkshire lad and I'm livin' 'ere for a bit. Lovely spot. So, what are you lot doin' in these parts then?"

"Don't ask me, lad. We're on this 'ere archaeological trip. Greek and Roman remains and all. Some Etruscan stuff, too. They said we were comin' up to see this 'ere village. Somethin' 'bout a fella wrote a book 'bout all the weird goin's-on roundabout."

Another man stepped forward. He was a lean, tall, ascetic gentleman with an aristocratic bearing, dressed immaculately in a safari-type outfit, but he immediately destroyed the image he gave by addressing me in the broadest of Lancashire accents. "'E's talkin' 'bout that Jewish chap . . . what's 'is name . . ."

"Carlo Levi."

"Right. That's 'im."

"Have you read his book?" I asked. How pleasant it would be, I

thought, to share a few musings about the man whose words and sentiments had lured Anne and me there in the first place.

"They gave us some stuff but, to be reet honest, I 'aven't read it yet."

"Oh," I said.

"Well," he said, "Best be gettin' back to t' bus. She only gi'us a few minutes."

"Seems a rather short stay."

"Aye, well. These trips are all like that, you see. Y' come in, gerra few photies and you're off again. 'Ardly time for a pint an' a trip to t' loo . . . 's all a bit daft, really."

We strolled up Via Roma together back to the gleaming, multi-color coach, bathed in the last scarlet flare of a very dramatic sunset.

"So you live 'ere then?" the man from Lancashire asked.

"Yes. That house there right in front of you, with the terrace. Great place. Fantastic views."

"What for?" he asked. "You on 'oliday?"

"No, I'm a writer. My wife and I are doing a book on this area."

He stopped abruptly and gave me a long, withering look. "You . . ." He seemed at a loss for words. He looked at the house, then at me again, and then spun around to take in the huge purpling vista of Pollino and the wild *calanchi* landscape and all the tight-knit charms of the little village.

"You **** jammy bugger!"

I laughed out loud. It had been years since I'd heard those north-ern "street" words.

"It's not a bad place, is it?" I said rhetorically.

He stared at me again, chuckled, scratched his balding head, and then said: "Not bad!? It's bloody champion, mate. Tha's got some reet gumption finding summat like that. Do me no enda good to stay 'ere for a bit an' stop all this 'arf cocked runnin' around! All this lovely eatin' 'n' drinkin' 'n' loungin' about . . ." (the last bit added with envy tinged by a distinct touch of Anglo-Saxon disdain at overt hedonism).

"Yes, I bet it would," I said.

There was a long pause, and then he turned to me with a laugh and added, "Aw, sod off!"

I think he meant it kindly, even though Yorkshiremen and Lancashiremen rarely see eye to eye about anything.

Then they were gone. The guide did a quick head count, smiled at me and the coterie of villagers gathered around the bus, still gaping vacuously, and pulled the coach door shut.

In a short while all was quiet again. The shadows were deepening. The old men were returning to their benches. Dogs were barking. Coffee cups clinked in the bars. And all was as it had been a quarter of an hour before.

I returned to our terrace to watch the moon rise. Anne and I toasted our little village with glasses of chilled *sambuca*, and I wished I could have shared a bit of all this with my north of England visitors. They looked as if they could have done with some slowdown and silence.

It's a strange life, I thought. This organized-trip type of tourism. Never did quite understand it.

In Carlo Levi's Prison

After the tourists' hasty departure, I realized that, although I knew the Levi Museum and the new gallery of his artworks well, there was one place in the village I hadn't yet explored: his place of confinement, his prison.

WHEN HE WAS first brought to Aliano by the police in 1935, Levi was left to find his own lodgings. Of his first option he wrote that he was, "closed in one room, in a world apart, where the peasant lives out his motionless civilization on barren ground in remote poverty, and in the presence of death . . . The air was black with thousands of flies, and other thousands covered the wall . . . I felt I had fallen from the sky, like a stone into a dark pond."

But eventually he was offered another house:

by far the most impressive structure in the whole village. From the outside it looked decidedly gloomy with its blackened wall, narrow barred windows and all the marks of long neglect. It had been the home of a titled family which had gone away long ago; then it had served as a barracks for the carabinieri, and the filth and squalor of the walls inside still bore witness to its military occupation. Strips of plaster and cobwebs hung down from the gilded and painted ceiling and stalks of gray grass had pushed up through the cracks in the tiles. As we went from room to room, we were greeted by a quick, furtive sound like that of frightened animals running for shelter. . . . I threw open a French window and went out onto the balcony . . . when I stepped out of the darkness I was blinded by the sudden dazzling light. Below me lay a ravine . . . and infinite wastes of white clay, with no sign of human life upon them, shimmering in the sunlight as far as the eye could see until they seemed to melt away into a white sky. Not a single shadow broke the monotony of this sea on which the sun beat down from overhead . . . how could I manage to live in this noble ruin overlooking the bottomless sadness of this desolate countryside. But my new home had the advantage of being at the lower end of the village, out of sight of the mayor and his acolytes; I should be able to take a walk without running at every step into the same people and the same conversation.

And yet, Levi wrote later, that "in spite of my work . . . the days went by with the most dismal monotony, in this death-like existence, where there was neither time, nor love nor liberty."

Things worsened for him in the approaching winter:

The wind came up in cold spirals from the ravines . . . went straight through a man's bone and roared away down the tunnel-like paths. There were long, heavy rains . . . the clay was beginning to break up and slide slowly down the hillsides, a gray torrent of earth in a liquefied world. . . . I had a choice between freezing and weeping . . . as the world just beyond my door

melted away in the rain. Then came the snow . . . a stillness and a silence thicker than before settled down around the lonely mountain wastes. I gazed into the wind-swept grayness, as if I had lost all my senses and slipped out of time into the wastes of eternity from which there was no return.

But, of course, he did return to the world, and spent much of the rest of his life struggling to deal with "the problem of the south." But even Levi, for all his fame and adulation, realized the intractability of the national government and its northern bias.

And the same empty rhetoric continues today—elaborate schemes and dreams for the South rarely backed by fiscal investment or the vision to see things through, or truly believe in a new future for this maltreated land. Ever strident in his political beliefs, Levi emphasized the need for "autonomous or self-governing rural communities. This is the only form of government which can solve in our time the problems of the south."

Anne and I had become close to this man and his ideals. They coincided to some extent with our own tendencies toward a "gentle anarchy" and the way in which we tried to live our own lives. It's an approach that attempts to encourage self-expression and the widest form of self- (or rather selves) exploration, because I believe we are all far more multifaceted and creative than we ever give ourselves credit for. Even though it may be highly unfashionable in our increasingly homogenized world, I still support the concept of the Renaissance man and celebrate individuals like Levi, whose "multiself" facets included that of scholar, writer, journalist, publisher, doctor, artist, and politician. And even when Mussolini and his cohorts dispatched Levi to his *confino* in Aliano, he overcame the angst of his lonely prison at the southern tip of the village in his little hot-cold room, produced a remarkable portfolio of artwork, and wrote his classic tale, which has as much impact today as it did when it was first published in 1945.

* * *

So FINALLY I went down to the edge of the village to explore Levi's prison.

I had intended to do this as soon as I arrived in Aliano, but the place was being (very slowly) restored and was littered with Keep Out and Danger signs. I guess I could have talked my way in—the workers seemed such an amicable bunch—but something restrained me. Maybe I wasn't quite ready to stand in the small room overlooking those vast panoramas, which to me were a daily delight, and try to see them through Levi's eyes as "the bottomless sadness of a desolate countryside."

I came one lunchtime, after the sacred hour of twelve-thirty, when everything comes to a sonorous halt and silence reigns until at least four o'clock. No one was around. The workers had left for their long lunch and siesta, the gate was open, and despite the profusion of freshly mortared cobblestones and piles of detritus everywhere, I tiptoed to the staircase leading up to the front of the house and edged myself into its shadowy gloom.

It was very quiet. Unnervingly so. There was no breeze spiraling up from the *calanchi* and no scurryings of cats and dogs. There were just dark, empty rooms—cold despite the hot air outside—and a disarray of broken tiles, torn plaster walls, little mounds of broken pottery, and an ancient fireplace with at least six different-colored layers of paint on its chipped surface. I stopped and picked up a piece of pottery, part of a jug handle. Nothing fancy, just crude red clay. Should I keep it? Was it something that might have been around when Levi lived there? I was tempted. I felt I needed some tangible link with the man, something more than my dog-eared copy of his book. However, like an honorable archaeologist, I placed it back on its dusty little pile. Silly, maybe—no doubt it would be thrown out with all the other piles eventually—but, I thought, the only thing I'm here for is to stand in the room, to experience where he lived. Not to pilfer souvenirs.

And there it was: At the front of the house, with two tiny windows overlooking the vast Pollino panorama. There was nothing in the room beyond more piles of sweepings on the floor and a pencil

scrawl with an arrow on the wall, presumably written by one of the workers as an indication of the key room in the house. It read: LEVI.

I'm not sure how long I stood there peering at the view and trying to feel Levi's presence in that claustrophobic space—maybe only a few minutes—but suddenly I sensed that I was not alone. No, it was not another "dark side" incident, although when I turned and looked at the person standing there—a wizened old man in his lopsided *coppola* cap, his ragged neck scarf, and a jacket so tattered and frayed it looked like the shaggy hair of some wild animal—it felt like that.

"*Buon giorno,*" I said.

He grunted and nodded, staring at me out of a pair of dark, deepset eyes edged by flurries of wrinkles and furrows.

"Levi?" he asked.

"*Si,*" I said. "Levi."

The old man's face broke into a grin that set more wrinkles and furrows undulating around his nose and mouth.

"A good man. *Buon uomo virile,*" he said.

I nodded. Damn it, I thought. If only Giuseppe, one of my invaluable village interpreters, were here we could have a decent conversation, and then maybe I'd learn more about the man we'd followed all this way from America and Japan. True, Levi would now be over a hundred years old, if he were still alive, so this man would have been a child, but . . . who knows?

However, before he ambled off, the old man did say something that I managed to capture on my tape. He didn't speak for long, which is odd in this village of natural-born orators always gesticulating. "Because they have so many nationalities down here," Giuseppe had once told me, "so many conquests, they were all once foreigners to one another. So, body talk was very necessary between the races."

I asked one of Giuseppina's sons to translate my recording and this is what he thought the old man was saying to me: "Before Doctor Carlo Levi came here as a prisoner, no one cared about us. We were called animals. *Pagani* peasants, *terroni, cafoni.* But he looked after

us; he cared for my mother when she was very sick. And before he left, he told us, 'You will never be forgotten again.' And he was very truthful man, and although we are still poor, we all now own our own land and we can eat and smoke and be with our own families in our own houses. He made us into men, not beasts. He made us proud to be Alianese."

MAN AT CARLO LEVI HOUSE

This should be part of Levi's epitaph on the new burial plot they've just rebuilt for him up at the cemetery, where his original, simple, headstone reads: *Carlo Levi 12.11.1902–4.1.1975.*

It should say so much more.

What Was It Really Like?

Although Levi's book offers a remarkable and, most locals agree, accurate depiction of life in Aliano in the 1930s, I was always curious to learn more.

"So, you really want to know what it was like before the war?" Felicia de Lorenzo had a deep, throaty laugh, and it echoed around her tiny one-room house.

"It would help. I get lots of little bits of information, but I'd like to know how things looked, what it all felt like, what happened on a normal day. And I'd like to hear it from somebody who was actually here, in Aliano, fifty, sixty years ago, and who can still remember the details."

"Well, I have very good memory. But I don't always like to think about things in the past. And maybe you won't like to hear . . ."

"Just tell me whatever you wish," I said. "I'd like to get a sense of how things have changed in the village." I nudged Gino, my young interpreter for the day, and asked him to translate as accurately as he could. I didn't want to miss anything.

Felicia's enticing laugh tumbled out again. It somehow combined an irrepressible sense of fun with deeper touches of sadness, melancholy, and maybe even a little anger at the poignancy of her memories. Her eyes were looking right at me, coal black but with diamond-sharp flashes. Although she was well over eighty (she wouldn't tell me her exact age), I sensed that her faculties were resolutely intact and that, despite all her ironic humor, she saw the world, and me, in a highly focused, no-nonsense way. She had removed her black scarf to reveal a wavy flow of hazel hair flecked with silver strands.

Her face was sun scorched to an earthy bronze, and her skin was wrinkled like old parchment but in such a way that she always seemed to carry a slight smile as if everything around her was a source of gentle, unmalicious amusement. Her eye creases tilted upward in scimitar-curve laugh lines and crinkled tightly when she grinned, which she did as soon as I used the word *change.*

"Change!" she half shouted, her wrinkles chasing each other across her face. "What change!? Look at my house! One room. Still one room. Just like it was then, so long ago."

"But there are no pigs here! Or cows. Or a dozen other family members living here with you." I thought I'd test her humor tolerance. Some residents refuse even to discuss the days when a single room there served as a repository for an entire extended family, a coterie of farm animals and equipment, and a year's worth of homemade olive oil, wine, cheese, and pig products. Not to mention the shadowy corner for a bucket toilet, a baking-fire that filled the often chimney-less room with acrid smoke, and a "matrimonial bed" that occupied most of the available space and under which the animals made their flea- and dung-littered home for much of the year.

Even back in the thirties, when conditions throughout Italy were marginal at best, Carlo Levi was shocked by what he found in Basilicata and most particularly in Aliano:

> *In these dark holes . . . I saw a few pieces of miserable furni-*
> *ture, beds, and some ragged clothes hanging up to dry. On the*
> *floor lay dogs, sheep, goats and pigs. Most families have just one*
> *room to live in and there they sleep all together; men, women,*
> *children and animals . . . in the dust and heat, amid the flies. I*
> *have never in all my life seen such a picture of poverty.*

Fortunately Felicia laughed at my remarks. I felt relieved. Maybe I could now delve a little deeper without offending her. She had been around ten or so when Carlo Levi was *confinato* here. I told Gino that's where I'd like her to start.

"I've just read in Carlo Levi's book what the living conditions were like in the thirties."

"Ah, Carlo Levi. Yes. The good doctor . . ."

"Do you remember him?"

"Not very much. I was young." (She still had no intention of revealing her precise age.) "But my mother thought he was very good man. He helped many peoples, she said. And she told me he once painted me and my sister . . . a proper portrait."

"Did you ever see the painting?"

"Oh, no. My mother said he kept all his paintings locked away. People called him a real artist, and he wanted to have a big show of his paintings after . . ."

"After he was freed from here?"

"Yes, I suppose so. After the . . . sadness."

I'd heard many euphemisms for the war and the domination of Mussolini and his fascist fanatics. But "sadness" was a new one.

"So you don't remember meeting him?"

"I don't know. Maybe I said 'hello.' He was always walking about. He lived down the hill in the big house."

"Yes. I've been there. It must have been a fine house then."

"Oh, yes. Once it was the best in our village. I think his life was not so bad. He had windows and a view. A beautiful view."

"And you?"

Another thwack of laughter made her body shake. "Me? Well, I think we had one window in our one room. A window looking into the street and the house across. That's all. And we had all the things Doctor Levi described in his book: diseases like typhoid, too many people, animals, fleas, and far too little food. Always too little food."

"So, what did you eat?"

She gave me a long quizzical look before replying. "Listen to me. I will tell you the things you want to know, but you must remember one thing: Looking back now, life then seems to be very bad, but when I was little, everybody lived the same way, ate the same things—bread with a little olive oil, maybe a little cheese, some pasta, bits of meat one time a week. It was not much, but we didn't know different. My mother used to say we didn't know how lucky we were because we had things like bread every day and her tomato sauce for spreading, and if you had pigs, you always had some salami or sausage. She told us there were many times when she was young that she and her family had lived *arrangiandosi*; (getting by) only on *insalata di campo*—wild greens of *radicchio*, *ginestrella*, *rapa*, *asparagi*, *selvatici*, and many other things from the fields, and onions and garlic and soups made out of moldy bread . . ."

I kept quiet. She seemed to be lost in silence for a while, wrapped in her own reverie. Finally she resumed: "And people said things. Bad things. They say we lived like animals. In caves. No toilets. No sewers. No water. You had to walk right to the bottom of the village to the fountain and carry buckets and pots back on your head. They said we didn't wash. Everything was covered with flies and fleas. There was malaria, typhoid, and strange fevers. People dying, all the time. Particularly the children. Every day someone seemed to die on our street. . . ."

"So, what they said was correct?"

Felicia paused again. Obviously not all her memories were bad ones. Despite appalling conditions by today's standards, life there

had continued and had contained its own precious pleasures, laughter, jokes, pranks, even love and romance, amid all the ceaseless crowding of people, swaddled babies rocking in small rope hammocks hung from the ceiling, the constant crush of animals, and an almost total lack of any kind of personal space or privacy.

"Yes, I suppose it is. And even today we still have many of the same problems: poor housing for lots of people, poor weather and crop prices, young people leaving so no one to work the fields, higher and higher costs for things, for everything. And corruption—even here in this small village. And of course, taxes, always more taxes! Ah, *la vita è così* [that's life]. But . . . well, I like to remember the good things, too."

"Can you tell me some?"

More silence and ruminating. Then suddenly Felicia's face brightened, and the laugh lines around her eyes crinkled again. "Well, I remember me, my sister Gina, and my two brothers all cuddling together in bed with our mother when it was cold. And she was always warm. So warm, like a big thick blanket. It was so cozy and safe. We never wanted to get out of bed. Oh, and the baby lambs: When they came in the spring we used to play with them and take them for walks with bits of string around their necks. And playing in the street, too. All of us young ones, with mothers sitting outside in the shade watching us and chatting and laughing. The whole street was like one big room for us all. In the warm times everyone was outside. We only went inside for eating and sleeping. Sometimes only sleeping. And the pizza bread! Not like today, with all kinds of stuff piled on it. This was just leftover pieces of dough our baker cooked with a bit of tomato sauce spread over it and maybe a few gratings of cheese. And we ate it warm, rubbed with garlic and hot peppers . . . and, oh, it was so good. One of the best tastes. And my mother's *orecchiette*, little pieces of pasta dough she pressed with her thumb into tiny cup shapes that she filled with hot tomato sauce—her special *conserva di pomodoro*—and our own olive oil, a lovely bright green color. That was so, so very good."

"Sounds delicious," I said. And I knew it was. We'd made the

same dish a few times in our apartment, and we'd learned, over and over again, how little it takes to create a fine, filling meal without meat or any fancy accompaniments . . . except maybe a little parmesan cheese and some of that palate-scorching Alianese hot *peperoncini* sauce to add piquancy and a definitive palate-punch.

"Oh yes, it was, it was," she said. And then slowly and with many pauses, she continued to describe the small, happier details of her early life, emphasizing the bonds of affection and love among family members, their endurance in the face of regular onslaughts of misfortune—the shared sorrow of a child's passing or the death of a grandparent—but also their deep belief that a far better life awaited them in the hereafter. She told me of the joy of gift-giving at Christmas and other festivals: not store-bought gifts—there was rarely any money for such luxuries, she empha-sized—but small items they all secretly crafted themselves, like stuffed balls of cloth with silly painted faces, small stick figures carved out of bits of old olive branches, bonnets made with shards of old cloth, cut and stitched with colored threads and ribbons. And a special favorite of Felicia's: fragments of a broken mirror she'd once found, which she pressed into balls of moist red clay and decorated around with small colored stones she'd picked up along one of the village paths and then left to bake rock-hard in the scorching summer sun. "Everybody loved those," she said, her eyes watering a little. "So simple to make but so pretty. They were all over our home. And I gave them to all my friends. I still have one . . ." She looked around her one-room house but couldn't seem to remember where it was. ". . . somewhere."

THERE WAS SO much more to learn about Felicia's life: her schooling, her work, her romances and marriage, her life as a wife, mother, and grandmother.

"Please come back," she told me. "You make me remember some nice things. Oh, and things really are a little better today," she said with one of her warm smiles. "You have to learn to live, you know, with what you have around you. Otherwise you'll never

be happy. It may not be much compared . . . to other people, but my mother used to tell us all, 'Happy thoughts make happy people.' "

When I left her tiny home, promising to see her again, I carried her simple reminder with me, deciding that our world desperately needed all the Felicias it could find.

Two Hundred Dollars in Thirteen Uneasy Steps

Despite Felicia's optimism, some things in the South still seem to be entrenched in ancient and obscure rituals. Particularly things bureaucratic—anything that involved endless paperwork or protracted "power-pyramid" procedures. Like obtaining cash—a simple operation nowadays, in most places with ATMs and the like. But when it came to items like traveler's checks, one had to be prepared for a laborious multistep fandango of farce and occasional fury.

I WAS OUT of cash once again, and at the one bank in Stigliano that seemed to be open, the cash machine was broken. Or something like that: There was a long notice taped to the front of it and covering the slot where you put your card in, so I guessed it was broken. But why all the verbiage? Well, I reminded myself, this is Italy, and loquaciousness is the name of the game here . . . except inside the bank itself, where the staff spoke in terse,

FELICIA

monosyllabic phrases and made you feel like customers were the last thing they wanted inside their elaborately baroqued bastion.

And that was Step One: getting inside. I thought I'd stepped into some kind of revolving door, but once I was in the glass cylinder, the sliding door closed quickly behind me and I found myself being stared at like a goldfish in a bowl by video cameras and a very officious, overuniformed young man, who, scowling furiously, looked me up and down—presumably to discern where I had hidden my Uzi automatic. (I certainly was left in no doubt where his was.) Then he nodded and pressed some hidden button. The inner glass door whizzed open, and I left the cylinder and entered the bank itself.

Step Two: Another uniform, demanding (I think) precisely what I wanted in his bank. I waved my traveler's checks in his face. He took them from me, looked at them scrupulously, held them up to the light, and appeared very suspicious. "They're American Express," I said, assuming the revered name would transform his attitude into one of fawning subjugation. Unfortunately, it seemed to have just the opposite effect. He handed them back to me with two fingertips, holding them like a fish that had been out of the ocean for far too long. He pointed to a cubicle. I looked longingly at the counter, but I guessed I had to visit the cubicle first.

Step Three: An empty, very small, very tidy cubicle—so tidy, in fact, it looked as if no one had ever worked in it—but definitely empty. I peered back at the uniform and he nodded serenely. Apparently this was where I was supposed to be. So I stood and stood and then thought, there's one chair in here, so I might as well use it. And just as I was lowering myself onto its cushioned seat, in walked an elderly man immaculately dressed as only elderly Italian men can dress. He stopped abruptly and looked at me in amazement. "*Ah, mi scusi,*" I said, and immediately stood back up. Obviously it was his chair. "*Prego,*" he said very slowly and disdainfully, and brushed the chair's seat carefully before sitting down and extending an elegantly manicured hand.

I gave him the traveler's checks. "Two, please. I'd like to cash two hundred-dollar checks, please."

Just like the Uzi-wielding security guard, he gave the checks a very detailed analysis. I felt sorry for American Express. They'd gone to so much trouble to make their checks look utterly foolproof and forge-proof, with little holograms and watermarks and all kinds of fancy colors and shiny bits, and yet this fellow obviously thought that I might be trying to pull a fast one on him. He examined them as meticulously as Berenson would have his beloved Renaissance artworks for the slightest sign of artifice or forgery.

Eventually he seemed satisfied, so I pulled out my pen and started to countersign them.

"No, no, no!"

Apparently I was not supposed to countersign yet. He seemed most upset, again. I was obviously making his day very difficult. He pulled a long form out of a drawer and said in petulant English, "Fill, please."

I looked at the form. It was worse than an IRS tax sheet, and of course all in Italian.

"I don't read Italian," I said.

He'd obviously had this problem before, and I gathered he hadn't enjoyed the experience. He sighed resignedly and then with an extended manicured index finger, led me from line to line.

"Last name here. First name here," etc. I think I had to fill in at least twenty different items of information, some of them so personal that at one point I almost rebelled. "Why do you possibly want to know my mother's birth date?"

"Please, fill in," he said in an utterly weary voice. I couldn't remember the year, so I invented it.

He checked my responses, again with that suspicious grimace, and finally dragged out a large, red stamp and stamped each of the four copies.

Again I prepared to sign the checks.

I could have sworn he was chuckling with glee behind that stoic, bureaucratic façade when he made it clear that I had now graduated to . . .

Step Four: I had to sign them somewhere else. At the counter.

And the queue was long, except it wasn't really a queue at all but rather a typical Italian huddle of first-off-the-line-wins contenders. My reluctance to involve myself in queue-jumping meant that it was fifteen minutes before I reached the counter to find . . .

Step Five: My counter clerk rapidly disappearing out of his seat. I looked at the other clerks, but they were either involved with customers or taking one of those gesticulate-and-shout breaks that no one interrupted or would ever dream of interrupting.

Six minutes, and still no clerk. Then I saw my elegant form-man passing by. I gave him one of those "what the heck is going on here?" gestures. (I was being very Italian—spread arms, open palms, open mouth, and raised eyebrows.) He completely ignored me.

Finally the clerk returned with no explanation or apology—in fact, he looked at me as if *I'd* kept *him* waiting. I showed him the two hundred-dollar traveler's checks and said, "I sign, right?"

He nodded wearily, but at least I was finally able to sign.

He studied the countersignature and then my signature on the form, and then he peered at my original signature. Perhaps in my haste and frustration at the whole process, I had penned a signature that was not identical to the original, but I was fed up. "Look, I've been here for almost forty minutes," I said. "Will you please just give me the money?"

He obviously didn't understand the words, but he got the meaning. It didn't work. Hence the final eight steps.

Step Six: Clerk goes off to have someone else verify the signature. (Guess who? Of course. The man with the manicure.)

Step Seven: Clerk returns but seems to have lost the latest dollar/euro rate sheet. Goes off again.

Step Eight: Laborious calculations on a dollar-store calculator that appeared to keep giving him different answers each time.

Step Nine: Clerk finally decides that three consecutive and identical figures must be right. Fills in yet another form with the figures. Opens up cash drawer.

Step Ten: Clerk counts out cash. Interrupted by phone call. One

of those very verbose calls. Loses count with talking. Stops counting and just talks.

Step Eleven: Clerk puts phone down. (It was obviously a woman. He looked quite starry-eyed.) Starts the recount.

Step Twelve: Clerk pushes money out under grill. At last! I don't even bother to check the cash. I just turn and walk away (run, actually).

Step Thirteen: Clerk calls me back and points to yet one more piece of paper, my receipt. I look at him very intensely, and I trust that he has no doubt whatsoever as to where I am willing him to shove that final little bit of paper.

But wait. There weren't thirteen steps; there were actually fourteen. I forgot to mention the power cut (somewhere between steps six and nine). Admittedly a very brief one. Less than ten seconds. But enough to cast the whole bank into a cavelike gloom before the lights turned back on automatically. Unfortunately, the computers did not. Maybe they hadn't heard of surge protectors or backup batteries in Italy. So there the computers sat, dozens of identical gray-plastic boxes, utterly impotent, with their little blank screens as black as the mood that had suddenly descended on tellers and customers alike. And it was obvious that this was a regular occurrence. Far too regular, by the look on everyone's faces. But the exasperating thing was that nobody seemed to know what to do next except throw their arms up in frustration and start lighting cigarettes. Apparently a computer blackout negated all the No Smoking signs pinned to the walls. At least for the staff. I noticed the Uzi-toting guard stride to a young male customer in line, who was just about to flick his Bic and light a rather wrinkled cigarette he'd pulled from behind his ear, and order him to desist. The young man pointed out that the tellers were all puffing away like burgeoning Bogarts, but his appeal sort of faded away as he noticed the guard's itchy trigger finger.

I think it took about twenty minutes before a laborious rebooting was performed, and the system began to move on again in its tediously officious way. I was beyond the limits of patience when I

left and had to resist the urge to kick my way past the guard and the cameras and through the fancy security doors. When I finally emerged back into the soothing sunshine, a well-dressed man who had also just left the bank turned to me with a grin and asked in eloquent English what I thought of the Italian banking system.

I said I found it hard to believe that customers had the tolerance and stoicism for that kind of bureaucratese nonsense.

"Ah," he said, smiling even wider, "We Italians have a different concept of time, I think. We always assume that things will take far longer than one expects. And so long as we have someone to talk to, the time passes pleasantly, eh?"

"I don't see much of that kind of attitude on your roads!" I responded, thinking of the *autostrada* racing-tracks and the up-your-rear-end antics of frantic drivers on *tornanti* mountain roads everywhere.

"Yes, so true. But driving is another matter. That is an expression of . . . how should I say politely? . . . a man's *man-ness*. Which is very different from the situation in a bank."

"But your banks all look so efficient: computers everywhere and enough security to protect the Queen of England's crown jewels."

My elegant informant paused for thought and then offered another telling insight into the "Italian Way." "It's all a front, you see. Front, *figura*, is so very important. Even when everything is chaos you must have lots of papers and rubber stamps and signatures. Sometimes I watch the old ladies picking up their pensions. A simple job, eh? But in Italy it can be like taking out a mortgage! All front y'see."

He paused again, and it was obvious he was trying to think of a final riposte, one of the philosophical aphorisms with which Italians loved to round off their conversations. "But of course we all know this. And we all do it. And we know too" (that sly touching-of-the-cheek-below-the-left-eye gesture that meant so much in Italy) "that all this fancy security and paper-pushing is just a front to divert attention from the truth: The real 'organization' is not what you see but what you don't see. And the real crime, for which there is no

security, takes place much higher up" (he pointed heavenward, but I don't think he was talking about eternal powers) "at the top. Far away from all this nonsense at the bank counter. In the quiet places, particularly in poor Calabria, with the 'Ndrangheta. So greedy. Far worse than the Sicilian Mafia. And then also of course in the old palazzos and clubs. And on the golf courses that you never see, and in the beautiful, large villas hidden behind all those trees . . .

He gave a final chuckle before bidding me farewell. "And in Italy, as you know, we have a very lot of trees."

A Dawdle Day

These occasional tangles with Italian bureaucracy can leave me exhausted and in urgent need of a do-nothing respite, a period of calm and quiet introspection and contemplation.

NORMALLY I CONSIDER myself a master of the day's momentum. I'm a lover of things-to-do lists and a celebrator of check marks, each signaling a task performed, an aim achieved—all small, but satisfying, indications of organized movement and intent, reflecting a continuum of new tasks and new challenges.

Anne doesn't share my list-lust, my daily litanies of perceived progress. She has a remarkable knack of getting things done without the structured formality of lists and checks. She carries each day's regimen in her head and seems to accomplish just as much as I do. And on the rare occasions when she "just forgets" to do something, her rationale is that it obviously couldn't have been that important a task in the first place. Nothing that couldn't wait until tomorrow. Or beyond . . .

As with many nuances of our married life, we celebrate our differences and our diverse ways of doing things. Anne smiles and tolerates my little lists (and even the rare "list of lists" when my life gets really overhectic); I nod understandingly when she admits to an overlooked obligation, because I know that everything needing to be done will eventually get done.

But some days are different. These are the days when I allow myself to float, "list-less" (and listlessly), freed from the constraints of all those little reminders that usually give my life a sense of organization and accomplishment.

Such diversions from my strictures and structures usually come about spontaneously and in response to some sudden urge to lose myself in a "dawdle-day" mode, whether it be a long, rambling walk or drive, a flurry of painting or experimental photography, or a sudden surge of cooking, which can produce the occasional bizarre "improv" dinner.

A day like today, for example, when Anne wanted to spend some time with friends in Accettura and I felt like doing absolutely nothing at all. I usually blame such urges for indolence on things like the traveler's check fiasco or similar frustrating confrontations with local "petty tyrant" rituals. And I attempt to justify such desires by convincing myself that even when we try to do "nothing" we're invariably doing something and thus contributing to our mental well-being, our imagination, our aesthetic sensibilities, or our overall sense of physical relaxation and spiritual nourishment.

Of course, it's not always easy, despite all the tedious tirades of modern-day gurus and New Age enthusiasts, just to flip a switch in our heads, turn off our restless, wriggling minds, and exist, thought-lessly, in the limbo of meditative nothingness.

But some days—a day like this one, for example, when the dawn comes slowly, in rainbow richness—seem to carry within them an enticing balm so calming that you just surrender to the wonder of being alive, the gift of mellow perceptions, and a peace so all-encompassing that, for a while, you know you need no more than this.

This being a perfumed breeze, barely perceptible, that eases in over the rooftops of our little village, quietly announcing a new morning. The low horizontal layers of light over Montepiano ease from mauve-lemon to salmon pink to a slash of scarlet, and finally into a lush, plush gold. The sun flows up over the bare hills by

Stigliano and Cirigliano and gilds the eastern face of the church tower, the edges of the roof pantiles, chipped, cracked and moss-flecked, and the ancient, peeling stucco walls of the houses. There the houses stand, released once more from the anonymity of the night, bold and bulged with age and the weight of their massive stones that have stood for centuries, somehow resisting all the insults of earthquakes, sudden landslides (an all-too-common occurrence in these Basilicatan hill villages), and the violent vicissitudes of storms and hurricanes hurling their fury across the Pollino ranges to the west.

On this particular day the village feels solid and enduring as dawn merges into morning. I become totally aware, once again, of all the little scurrying rituals of its daily awakening, the salivary aromas wafting up to my terrace from the bakery across the piazza, the viscerally strong coffee and cappuccino aromas from the bar next door, the slurred movement of sleepy feet and donkey hooves, the skim of a bicycle or two, a few early morning "octos" lighting their first cigarettes of the day, and the smoke, blue with honeyed curlicues, coiling upward past still-shuttered windows and tiny laundry-drying terraces laced with strands of brilliant red peppers, crisping over the days in the crackling-dry mountain air.

We breakfast together at our table on the terrace, dunking our golden-crusted rolls into our coffees, as the new warmth of early morning strokes our backs and shoulders and makes our scalps tingle with anticipation. It's going to be a beautiful, cloud-free day again, for the fourth time this week. The light is crystal, polishing everything and making the mountains appear so close they're virtually breakfast guests. And while Anne drives off to see our friends, I know I'm going to do little more than let the day, almost erotically, have its way with me. My beckoning lists will remain in the living room, untouched and irrelevant on this morning of slowly moving shadows and cubist patterns of brilliant light—a morning where the early dawn pastels of Monet merge slowly into the bold Cézanne-like structurings of mountains, forests, and sinewed valleys. And then, as the light intensifies and the heat

shimmers the air, and you feel you're seeing everything through a diaphanous sheen of waterfalling colors, a van Gogh vibrancy emerges. Buildings, tiles, chimneys, the lines of laundry, those strings of peppers, nearby fruit and olive trees, and even the herbed pots on our terrace, undulate with intensity, as if being brushstroked with inspired urgency and visionary fervor onto a canvas filled with writhing forms—alive, vital, and totally tangible. A reality so spirited that, for a while, nothing else seems to exist and time passes without seeming to pass at all.

I'm enveloped in a warm cloak of peace and utter contentment. Ideas, dreams, and possibilities, released from the mind's secret places, rise like champagne bubbles into mellow consciousness. And my eye moves slowly, panning like a camera lens from the broad vista of high ranges, the shadowy *calanchi* canyons, and the last remnant of night mists over the distant sea, to zoom into a single white daisy set perkily amid an explosion of daisies in a pot by the terrace railing. I can see the faint veins in each petal descending in graceful arcs to the mounded central cluster of the bee-luring stamen. The green of the ragged stem leaves, frilled and lacy like Italian parsley, intensify the whiteness of the flower as it moves enticingly in the faintest of breezes.

And nearby is our large terra-cotta container of basil—an exuberant burst of aromatic greenery thrusting hundreds of gentle, curving leaves into the morning air. I stroll over and pick one, and the day comes alive in a rush of anise-tinged freshness. I tear off a small piece of the leaf and let it rest on my tongue. At first there's a little hesitancy, as if the herb is reluctant to release its richness, and then, *pow!* All my taste buds rise in grateful unison to savor the rush of flavor, my saliva glands pumping riotously to saturate every nook and cranny of my mouth with the intensity of that gloriously aromatic plant.

No matter how much we pluck its bounty for our salads, pastas, and pesto, our basil plant seems to surge back almost overnight. It will offer itself abundantly and consistently well into December—so we have been assured—when the first frosts bite. And even then, we hear, it will fight back, throwing out hosts of tiny new leaves as if to

say, "Take everything I have and keep my memory alive in your sauces and dinners until I reawaken in the spring."

So, I know what's for lunch now. Hot, steaming *tagliatelle* dribbled with Giuseppina's homemade olive oil, black pepper, and parmesan, and tossed with torn basil leaves and thick segments of vine-fresh tomatoes purchased yesterday from Edenfruit, our favorite (only) greengrocer in the village, just below our terrace. And maybe a little sparkling wine. Why not! The day is shot anyway already, with all this delicious hedonism. Possibly that Malvasia made by Giuliano's cousin, which I've been saving for something special. A day like today, for example. A day that flows on, leading my eyes and senses on a slow journey over rooftops and chimneys to the fortresslike battlements of the church tower and the patterned granite and marble stones of the piazza, and then outward, across the cliffs and precipices at the edge of the village to the hazy enormities of the mountain and ridge landscape beyond.

TIME PASSES SLOWLY and easily. I doze, read in snippets, and pause to see what new nuances of color and form present themselves. I watch the sun, with its constantly changing play of light and shade, make its slow arc over the village, shaping the now-familiar daily rituals, silences, and siestas of its people. It entices birds to sing and then to cease singing in the stunning heat of the afternoon, and then to revive their choruses and swoopings over the rooftops as it begins to sink and lose its fire.

Shadows lengthen and change color. As the Impressionists— particularly Manet, Monet, Bonnard, and of course my beloved van Gogh—knew well enough, shadows are rarely if ever gray, even on the dullest of days. There are subtle violets and deep olives in their dun tones. And on days like this, the shadows almost sparkle with color—mauves, dark scarlets, rich ochres and bronzes, and deep, majestically glowing purples. You don't always notice them at first, particularly as the buildings and landscapes are still vibrant with luscious deepening hues and brilliant-shafted highlights of reflected late afternoon amber. But if you focus your eyes on the

shadows, looking away occasionally to increase the contrast, the range and intensity of their colors are as vivid and rich as those of the sun-bathed flanks of the buildings and the hills all around.

But the real beauty, the real magic, comes during that half-hour period when shadow and light, mystery and majesty, begin their enticing mingling into dusk: a marriage of half shades and haziness when the edges of things begin to soften and merge, and a world, recently crisp and stridently full of hard-edged forms reinforced by blocks and barricades of shadow, now becomes a far gentler, soft-focus place. A unity of graduated tones, from the deepest of blues to the lightest of lemons. The day is now passing into the nuptials of night (now there's a phrase you don't dream up every day), but it does so with such grace and subtlety that I barely notice the changes. Until it's almost dark, and a chill swish of night air closes in like a curtain. When Anne finally returns from Accettura the last band of scarlet is dimming to a dark bronze across the Pollino range and flecking the fleecy feathers of high cirrus clouds.

I hear our car (yes, it's still that little Lancia DoDo with its distinct exhaust prattle) roll down the hill to our parking space by the church. I say "our" space because, through some unspoken tradition of village courtesy, the space I'd found to park the car that first day I arrived months ago had somehow remained ours, except when some outsider, oblivious to local customs, claimed it as his own for a few disconcerting hours. And even then I'd invariably see that the half dozen or so octos, who always sat nearby along the low church wall, were in a quandary, uncertain whether or not to reprimand the outsider and request the prompt removal of his car. Usually they agreed, through heated debate on a "not" vote, but I was always touched by their constant concern. Although no words were ever spoken, I felt they had accepted both of us as a small part of the village community.

It's a pleasantly reassuring, and still surprising, realization.

I LEAVE the terrace, focal point of my daylong dawdling reveries, and go to greet Anne.

"Had a good day?" she asks, with her "Thank God I'm home after all those bends" smile of relief.

"Great!" I say, dreading her inevitable follow-on question.

"So, what have you been doing all this time?"

There's an uncomfortable pause, and I think, What the heck? She understands all my odd little quirks. Mostly.

"Well, to be honest, absolutely nothing. A little reading, but mainly just looking and thinking. And not much of the thinking bit either."

"Ah, that's wonderful!" she says and obviously means it, exhibiting once again the serenity of her list-less life. "You really should do it more often."

The Bagpipe Man

A day or two following my "dawdle-day" something happened that reminded me once again why this little "lost world" had become ever more enticing to both of us in all its nuances, strangenesses, and "dark side" undertones.

I SHOULD START by admitting that I have no idea at all if this story is true. Some of these bar tales, especially after one grappa too many and a bloodstream full of blast-your-socks-off, thimble-sized espresso shots, can start to verge away from what you might call the carefully annotated facts of a well-researched, journalistic-type story. But I was told by my interpreter-of-the-day, Enrico, that the story certainly had the smack of authenticity. Enrico was a lively lad just back from Naples University to visit his family for a long festival of something-or-other (how the Alianese seemed to love those festivals that no one else in the Catholic world had ever seemed to have heard of), and he actually said, in reference to the storyteller, "This guy's cool," which I guess means anything you want it to mean.

I think though that he was a little skeptical at first of Giorgio Continanza's story, even though he had been brought up on Aliano's thick and ancient brew of *incanti* (strange enchantments), supersti-

tions, local witches, healers, and fears of the dark, demon-laced supernatural. According to Carlo Levi, such emotions were entrenched and irrevocably imprinted on the psyches of local peasants and even in the minds of village dons, politicos (*podestà*), priests, and those notorious "sequestrators of property in lieu of tax payments"—petty officials who plagued the poorer populace in the thirties and, according to some disgruntled locals, still do today. And on every possible occasion and in every way imaginable, these dark tales perpetuated all the peasants' deepest fears and dreads.

But Enrico was taking his role seriously, despite whatever skepticism he may have harbored initially, and tried to give me an accurate translation of Giorgio's strange little story.

"This is not something from years ago," Giorgio said by way of introduction as we all sat or stood at the bar by the *fossa*. "This happened only a few months ago. In Oliveto Lucano, over by Parco Galipoli. And I was there."

On a recent backroad "randoming" drive I had come across this extremely well-hidden little hill village, tucked into the forest-shrouded slopes of the high mountainous Gallipoli wilderness. I stopped to ask directions, which were given erroneously, and I think intentionally erroneously, by some of the strangest-looking inhabitants of the region it had ever been my displeasure to meet. If anything weird or witchy were to happen, Oliveto Lucano would be a most appropriate setting, a true place of the ancient *Lucano dei pagani*—the spirit of pagan Lucano.

"It was November," Giorgio continued. "Everything was very nice. Sunshine, but not too hot. I was visiting a cousin of mine. On my father's side. And we were sitting in the piazza at Oliveto enjoying a bottle of his wine. Not a very good wine, but it had been a bad year. For all of us."

The audience, gathered around us at the bar, nodded knowingly. The previous year it had been a bad year for grapes in our part of Basilicata, too, and the problem with bad years was that, because you generally drank only your own wine, you'd be stuck with five or six hundred liters of acidic, vinegary rubbish for a whole twelve months

until the next crop. Or until you'd adjusted its flavor by *lavoro*, otherwise known as "favorable mixing." No one ever admits to such activities, of course, although the local *vinai* (vintners) claim that all commercial wines are invariably well *lavorato*, and they rarely, if ever, drink anything they didn't create and age themselves. But from what I've learned, it's a common, if unspoken, local practice to balance out what might be called the unfortunate and fickle follies of fate and climate.

"So we were sitting and talking," Giorgio continued. "His son was getting married in a few months, and he was not very happy with the bride." Enrico tried to translate the particular words used in reference to the bride, but couldn't. I think "roving eye" was the expression he was looking for. "So, we were trying to think how things could be changed when we heard a very strange noise. It was something I remember as a boy, but I haven't heard it since then. It was—can any of you guess?" he asked his audience as he warmed to his own tale. "It was one of our Lucanian bagpipes, a very old *zampogna*. Not the small Calabrian type. This was the big one with that deep sound. Like an engine. A growling sound. And then the higher pipes on top of that. You remember?" A few older men nodded their heads slowly. Maybe they remembered. Such pipes are now museum pieces and rarely, if ever, seen or used in Basilicata. Or anywhere else for that matter.

"Anyway, the sound was coming up the hill into the piazza. A very unusual sound. And then suddenly this man, a total stranger, appears, walking very slowly, like he was at a funeral, and playing these pipes. Huge pipes. Almost as big as him. They were very dark. Some kind of animal skin with hair on it. Possibly the skin of the *cinghiale* [boar]. And he was dark, too. Dressed in black with a black cap and a long black jacket, almost like a coat."

"Why was he in the village?" someone in the audience asked.

"No one knows. There was no festival. The circus had been months ago. So everyone in the piazza—there must have been a dozen or so of us—just sat and wondered what was happening. Then . . ." Giorgio paused for a hefty swig of grappa (a feat I have yet

to accomplish with any semblance of flair or panache; I'm still an insipid sipper) and continued. "Then he came to the center of the piazza and just kept playing. Not a nice tune. Sort of like a funeral march. And we sat, and he played on and on, and people were coming out to see what that strange sound was. Women came and children too. And he kept on playing. Very sad music, not nice at all. And then he stopped and took off his cap and went around the piazza wanting money. Can you believe it! Money! For that racket!"

The bar audience had now grown. Even the young girl at the espresso machine had come from around the counter to join us. Giorgio's tale was obviously unusual, and he was certainly worth listening to if you had nothing particularly interesting to do except sip coffee and grappa and watch the clouds massing ominously over Pollino and say things like, "I see there are clouds again over Pollino . . ." I was entranced by our storyteller's fingers. They were long and delicate, like those of a concert pianist, and seemed to have an unusual knack of capturing the mood and pace of his tale. As his voice rose, so would his fingers; as it descended to a growly whisper they would turn downward and flutter; in moments of emphasis they would suddenly point outward at the audience like those of an orchestra conductor commanding a dramatic drumroll. Quite fascinating. Almost hypnotic.

"So, nobody gave him anything. A few even got up to leave. But the man just stood there. All in black. His face dark, too. Like one of our local Albanians" (a few knowing nods in the audience at this point). "Then he put his cap on again and went back to the middle of the piazza, pumped up his bagpipe, and this time he played something very different. Very nice, in fact. Much lighter. And people started smiling. So, he kept playing for quite a while and then stopped again, took off his cap, and went around the piazza for a second time. But still no one gave him anything. You know the people in Oliveto Lucano. Real *maliziosi* (mean). They don't like to part with money, for anything!"

Heads nodded again, and Giorgio's audience pressed in closer. "Now, he obviously didn't like this, and we thought he would go

away, but he didn't. He went back to the middle of the piazza, put his cap back on, pumped up his pipes again, and this time started playing dancing tunes, silly tunes like the old *pastorale* for children. And then something very strange. We were just sitting there, and children started coming out of the houses and the little streets and they all began dancing. Childish stuff. Like a game. Girls and boys. And the man started dancing, too, even though the bagpipes were so big. And he began dancing around the piazza, and people started clapping to the tune, and more children came, and they all were dancing around him. And for a while it was very nice, and I think if he'd taken off his cap again, even the Oliveto Lucanans would have given him some money this time!"

"But then . . ." Giorgio's voice deepened, and people clustered in closer. "But then it all became very strange. Some clouds came over the mountain—very dark clouds, like for a storm—and they blocked out the sun. And a wind started. A cold winter wind. Coming out of the pines in the forest. And everything got very dark. But the children didn't seem to notice. They just kept coming into the piazza and dancing and following the man around and around until . . ." Another grappa swig for Giorgio, which emptied his glass. The girl rushed forward and took it into the bar for a refill. The audience was utterly quiet now: not even a dog barking in the street (a most unusual occurrence) and none of those irritating crackling little tractorettes either. Just silence. Giorgio knew he had captured his listeners, and he began to relish his role as a village storyteller, a true local *narratore delle fiabe.*

"Until . . . he began to lead the children out of the piazza. Some of the old men laughed and laughed even more as the man turned around and made a 'be quiet' sign to them, as if he wanted them to be part of a game. So everyone just sat there, giggling, as the man danced out of the piazza with the children, maybe twenty or more of them dancing after him. And you could hear his pipes, all the happy tunes now, and the children singing to his tunes. I could hear them skipping and jumping on the cobblestones. We all could. And I was thinking, when is he going to come back and collect his money. I had

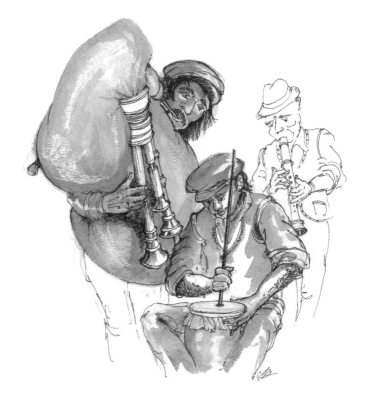

TRADITIONAL BAGPIPE BAND

a euro all ready for him. He was strange but he'd livened up that miserable old place."

More grappa for Giorgio. And more utter silence.

"And then it all became very odd. The music had been fading, and we were thinking he would lead them around the church and then back into the piazza but then we realized that there wasn't any more music . . . and there weren't any children either. . . ."

Giorgio's pauses were becoming more theatrical, and his gulps of firewater grappa more substantial. And yet, as I looked at him, even though I didn't know him at all, it seemed that it was not all theater. There was something in his eyes that appeared disturbed. Even a little fearful.

"So, then there was nothing. Just this cold wind out of the forest and the black clouds and no sun. And it really was cold. Almost like the middle of winter. And people started looking around, and the women were calling their children's names. The men stood up, and the women were suddenly running across the piazza and around the corner. I could hear their shouts, and then their voices got higher and higher. They were frightened, really frightened. Screaming, some of them. I could hear their cries echoing as they ran uphill in the narrow alleys behind the piazza, looking for their children. We followed, of course. Everyone left the piazza. But it was so strange. There was no sign of them anywhere . . . no sounds of the pipes. Nothing. Just that blackness over everything."

Giorgio paused. He was obviously moved himself by the memory. His audience waited, giving him time to sip his grappa again, until someone asked the inevitable: "So, what happened? What happened to the children?"

Giorgio blinked and coughed and began again, a little more slowly: "It was very, very odd. We'd all gone running around trying to find the bagpipe man and the children. We looked everywhere, but there was no sign of them. So one by one we all came back to the piazza and . . ."

Giorgio's audience couldn't wait. "And what?!" they cried almost in unison.

"Well," Giorgio said, "they were all there. Every one of them. No bagpipe man, but all the children, lined up like for a school parade or something. Just standing. Not smiling or anything. Just standing. Waiting."

"For what!?" someone asked.

"We never found out. Everyone was hugging the children and asking them what had happened and where had they been, but they just kind of stood there and said nothing. Like some kind of . . . trance or something."

There was silence. I don't think I'd ever heard the bar so silent. Until Giorgio started again in a hushed voice. "The only thing we got was when one of the boys came over to the mayor, who had rushed

out to join us when we came back to the piazza, and handed him a piece of paper. Just a small piece."

Giorgio's audience was now reaching the exasperation point: "And what was *on* the ****** piece of paper?" asked one, after a tense pause, and else everyone nodded.

"Nothing much. It just said, 'I will see you all again.' "

"That's all?" another asked.

"That's all," Giorgio said with a shrug.

"And the man with the bagpipes? Where was he?" a third asked.

"Who knows? Disappeared into the forest, I suppose, just like a *mago* [magician]," Giorgio said in an unusually quiet voice, and then he slowly drained his third glass of grappa and waited, unsmilingly, for a fourth to be brought by the now goggle-eyed espresso-machine girl.

Giorgio's audience remained still and silent for quite a long while, and—maybe it was just my imagination—but I could have sworn that the breezes up from the *calanchi* had turned colder. Much colder.

Chapter 6

Celebrations

A Little Education on Education

Our circle of friends in and around Aliano grew, not so much by our own initiative, but rather thanks to the diligence and direct empathetic involvement of our village priest—the make-things-happen maestro who had found our home for us. In addition to organizing Aliano's many religious festivals and celebrations, Don Pierino was truly a persistent, if occasionally forgetful, network-creator.

"You really must meet Sebastiano Villani, Director of Education in Stigliano and the headmaster of our school," he urged (for the fifth time now) when I met him by chance in Edenfruit. (Actually he gave Sebastiano's full, impressively official title in Italian: *Dirigente Scolastico dell'Istituto Comprensivo*). The two ladies running the store, standing together surrounded by enormous latticework sacks of field-fresh onions and new potatoes, nodded enthusiastically. Doubtless their children attended his school.

"I will arrange for you, okay?" the good don said.

"Fine, great, thank you," I said. But what I was really thinking was, Why is it taking you so long!?

"Oh, and he speaks English very good," the don emphasized.

Ah, at last, another kindred spirit, at least in terms of lan-

guage . . . but, as it turned out, also in terms of our mutual interest in and admiration of Carlo Levi.

"I CAN'T THANK Levi enough for making me a reformist teacher and a headmaster," Sebastiano Villani told me emphatically as he led Anne and me around his school in Aliano, tucked away up the hill with glorious mountain vistas out of every window. Although Sebastiano was in his late forties, his round, pleasant face possessed an almost childlike aura of enthusiasm and glee, and his eyes glowed with energy and excitement whatever the subject under discussion . . . but particularly so if it happened to be Levi. Sebastiano had read all Levi's books, had studied his philosophy when he was a teenager, and had been inspired, even at that early age, to ensure that the future form of education in local schools around Stigliano, and particularly in Aliano, would never be allowed to sink to the miserable, pathetically redundant methods that characterized the typical teacher's approach in the 1930s.

"Let me read you what Levi wrote. I'm sure you've seen this, but just listen: 'The teacher [Don Luigi Magalone, also the mayor and brother of Donna Caterina] was exercising his teaching function. He was sitting on a balcony just off the classroom and having a smoke. He had a long cane in his hand, and, without moving from his chair, he restored order within by striking through the window with astonishing accuracy at the heads or hands of such boys as had taken advantage of his absence to make a rumpus.' "

Sebastiano held up his finger in a "please wait" gesture, rumpled through the well-worn pages of his copy of Levi's book, and then continued. " 'The children were gifted with insight, a thirst for learning . . . but they learned precious little at school with the inspiration of Don Luigi's cane, cigars, and patriotic speeches; although attendance was obligatory they came out as illiterate as when they went in . . . yet no teacher could have asked for more eager pupils.'

"It was almost like a vision when I read this, a calling, you could say," said this utterly dedicated, yet high-spirited and often very

humorous man who had no reservations whatsoever about his chosen course in life. "Well, maybe just a few," he said, laughing and making his thick, salt-and-pepper moustache jiggle, Groucho Marx–style. "I get so very tired of all the regulations. Endless regulations. And always new ones coming and confusing things. And the crazy thing is, all our schools are now autonomous. There's not supposed to be a lot of government involvement. 'You are free to set your own courses,' they tell us, but then they keep inventing new regulations. It's absolutely crazy!"

Sebastiano's grasp of English was refreshingly extensive, and he knew precisely which words to use to make his points. There was no judicious mincing, no mundane platitudes or bureaucratic obfuscation that, as he said vehemently, "many headmasters use to avoid their responsibilities or to try to explain why nothing gets done and nothing really changes."

Sebastiano was a true catalyst of change—making class sizes small and intimate, ensuring that his schools were models of creative stimuli and high achievement—and, more recently, a leading Italian proponent of information technology, arranging video conferencing, online courses for his teachers, and Internet and video link-ups between schools and students all around the world. He also coordinated the publication of lively newsletters for professionals and children, dealing with a vast array of topics, all generously reinforced with illustrations, photographs, and charts.

He picked up a copy of his international newsletter for schoolchildren, *Our Neighbors.* "Listen to this letter we printed from a child in Greece. It was sent on the Internet to us. He explains about his grandfather's grape harvest, which is very similar to ours. So, it helps create a link between our two countries:

> *I am at my grandfather's vineyard to harvest grapes. This is the first year we harvest grape since the years before the vines were so little that they could not produce grapes. We take the fruit boxes. My grandfather cuts the beautiful bunch of grapes and puts them in the boxes. As soon as I learn how to cut the bunches I take*

the scissors and start cutting. It's much fun to harvest grapes and sometimes I eat some even if my hands are dirty. When it gets late and there are only a few vines to harvest, we have to cut the bunches as soon as we can and at last we fill the boxes. Then we get back to our country village and in our garage we squash the grapes by hand because there aren't many. It has been a very interesting thing to harvest our grapes.

"The key for our young students is cultural change," Sebastiano said, his eyes gleaming with a missionary's fervor. "That's the only way to help them to progress. Learning to speak English properly, in conversation and discussion, is very important because their future will be based upon conversation and communication. All around the world. Of course that must be reinforced with ways to expand the South, our poor Mezzogiorno, economically." Sebastiano's eyes glazed. "Sometimes . . . sometimes I wish I could do more. But I am only a teacher. I can help change attitudes but . . . I cannot provide the factories."

"You have a hard job," I said.

"Of course it's hard work," he said, his beaming face showing no signs of the stress he claimed plagued the life of anyone who tried to "make a difference."

"But you look pretty happy to me," I said.

"Of course I'm happy. I'm doing what I always dreamed I'd do. And I'm annoying the people I should be annoying—the ones Levi described as the people to whom change is always a threat no matter what benefits it might bring. You see, there are, particularly in Italy, two kinds of people" he said. "The first are the peasants—and I don't mean peasants in the old *terroni* or *mezzadri* (sharecroppers) sense; I mean in a positive sense, the ones who work hard and get things done and produce useful goods for other people."

"And the second?"

"The second are all those "little power people"—Levi's 'Don Luigis'—the ones who grab and hold on to their little bits of control and authority, often given as a favor by some *gens* group—that's

what we call our 'old-boy networks' over here—and who achieve nothing of any real value. They work as little as possible, like our *statali* [government] employees, who can retire before they're even fifty on full and generous, index-linked pensions and are renowned for their useless paper-shuffling, their hour-long coffee breaks, and not coming back to work after the *siesta* because they've got only a thirty-five-hour—even less, really—workweek. Levi called them 'middle-class village tyrants' when talking about Aliano and the Mezzogiorno. He wrote, 'They live off petty thievery and the bastardized tradition of feudal rights and under Fascism this middle class took over and identified itself with the power of the state.' "

"Yes," I said. "Levi got pretty outspoken in that last section of his book."

"Outspoken!? He was advocating revolution—*colpo di stato*—at least in Mussolini's eyes. He demanded 'a new kind of state which must be renewed from top to bottom, to remove the unbridgeable gulf between the individual and the state.' And he was correct. It's still an enormous problem today, particularly in our South, and I believe some kind of self-governing autonomy is vital. Similar to what we're supposed to have in our schools."

"Surely, though, there are more than two main groups? What about the very rich and the huge landowners and the big power guys and . . ."

"Oh, yes. Of course. But Levi simplified things, mainly to show that most people fall into those two categories he described. And the hard work and production of the peasants is so often made difficult or impossible by the stupidity and complacency of the second group."

"Yeah. I guess that happens all over the world."

"Possibly. But in Italy it is worse because we do nothing about it. As a teacher I see it all the time. I only hope I can help make things a little better for our next generation."

"I'm sure you—"

"—will? Well, maybe. Who knows? But I have good teachers

working with me. In fact, you will meet some of them. I will arrange."

"Absolutely. Fine. Wonderful," I said as I felt our little network of links and attachments growing. And once again, all thanks to our good and loyal friend, Don Pierino.

Dinner at Donna Caterina's *Palazzo*

In the same way that serendipity seemed to shape our "dawdle-days," it also brought spontaneous, and invariably enticing, sur-prises. Especially when Sebastiano was involved, following up on his promise to introduce us to some of his teacher-friends.

THERE WAS A KNOCK on our door. Well, actually, it was more like a persistent rattle, which we ignored at first, thinking that someone had left the door to the street open and an errant breeze had billowed its way up four flights of stairs. But a second and more persistent series of rattles made me realize that this was no errant breeze but the odd sound that Giuseppina made when she was standing outside our apartment door trying to gain entrance.

Why she just didn't knock in the normal manner eluded me. Maybe she thought rattling was more polite. Anyhow, there she stood on the shadowy stairs, holding out her cellular telephone (almost everyone in the village used cell phones due to the utter unreliability of the one Telecom Italia public phone way up on the windy top of the hill). Giuseppina was obviously in the middle of lunch, to judge by her insistent chewing and by the bits of cheese stuck to her upper lip. I invited her in. "No, no," she said, pointed to her still masticating mouth, and thrust the phone into my hand. Then, before returning downstairs and indicating that I could return the phone when I had finished, she mumbled, "Sebastiano." And I said, "Who else!?" but she didn't seem very amused this time. On the other occasions she'd had to make the climb up to our apart-ment with the phone and announce, "Sebastiano," she had at least smiled.

I tried to suggest to Sebastiano that maybe we shouldn't continue the habit of communicating in this way, making poor Giuseppina climb the stairs every time, but he laughed in a kind of smug manner and suddenly I remembered that he was Giuseppina's boss! (Giuseppina did occasional cleaning at one of his two Aliano schools.) So, I thought, Hey, I'm just the middleman in this little arrangement. Let them sort it out.

"So, David, are you two doing anything tonight?" Sebastiano asked.

I hated to admit that we weren't doing anything except looking forward to a quiet evening together.

"So, how would you like to have dinner in the *palazzo* off Via Roma, where Don Luigi and Donna Caterina used to live. You remember? He was the mayor—the little dictator—and the village teacher when Levi was here. He was a man with an amazing ability for self-deception. And she was his sister, a very clever and powerful woman. It might be interesting for you to see where they lived. It's quite an important place."

Despite our previous plans for gentle indolence and at-home indulgence, this sounded like an excellent idea. Anne agreed. So, I said, "Excellent idea."

"Good. We, Rocchina—my wife—and I, will pick you up about seven o'clock. I think you'll like the people who live there now. Giuseppina, the same name as your landlady, is one of my teachers, and her husband, Bruno, is a farmer. They make all their own foods. And Giuseppina is a very, very good cook!"

"Okay," I said. "See you at seven."

So, seven o'clock came and I was sitting in my neatly pressed trousers with my clean shirt, wind-dried on the terrace after a good scrub, and recently polished shoes. Anne looked immaculate despite the fact that she had brought barely half a suitcase of clothes with her. And there was that rattle at the door again. Funny, I thought, Sebastiano normally rings the intercom buzzer to be let in. Well, maybe the outer door was left open.

I walked to the door saying, "Ah, Sebastiano, you're right on

time . . ." but it was Giuseppina again, holding out her cell phone and not smiling at all. "Sebastiano," she grunted, thrusting the phone into my hand, and then vanished down the stairs before I could even mumble apologies or thanks.

"Hi, Sebastiano," I said "Boy, you're really giving Giuseppina some hearty exercise on all these steps." This delicate rebuke seemed to float right over his head.

"David. Very sorry. Some school things. We'll be late. Okay? About eight o'clock. Okay?"

"Okay. See you at eight."

This time, I thought, I really have got to make amends to Giuseppina, otherwise our landlady-tenant relationship is likely to become a little bruised.

Fortunately, I had a small, but expensive, box of Perugia chocolates in the fridge. I'd bought it on a whim as a gift in reserve. The box was in the shape of a heart, with roses on it and a pretty pink ribbon and bow. Perfect, I thought. Anne agreed. So, I carried the chocolates and phone downstairs, knocked on Giuseppina's door, and was shown into her small, cozy living room. This time she was smiling. She had just risen from her armchair by the fireplace. A half-knitted something-or-other in funereal gray and black lay on a side table.

"Ah, you're knitting," I said.

"Yes, for my son. For Gianfranco." She grinned sheepishly but was obviously pleased I'd noticed her handiwork. "He good man."

"Yes, yes, he is," I agreed. Gianfranco had helped fix a number of small unworkables in our apartment, and I was hopeful that someday he might even get around to repairing our TV, too. Not that we expected to gain much by watching the five all-Italian channels, but the ludicrous game shows, with their flouncings of (for no reason we could understand) near-naked beauties might be good for a chuckle over dinner with Anne.

Giuseppina was a perfect hostess. There was no sign of any frustration over Sebastiano's incessant telephone calls. Instead she had me sit in her chair by the fire, served me a glass of that dark but

enticingly aromatic Amaro Lucano liqueur, and pulled out her bulging file of family photographs (we'd looked at it twice before, but she'd obviously forgotten). She reminisced about the achievements of her now-grown offspring and their voluminous families, and ended up almost weeping as she pointed to her late husband's photograph on the fireplace mantel. She whispered, half to herself, "So young, so young to leave us . . . only sixty-three," as she had done twice before on prior visits. But I found her devotion and her constant wearing of black somehow very touching. Hers seemed to be not one of those decades-long ritualistic mournings but something still real and obviously traumatic. I could see the hurt: a sort of confused sadness tinged with a sense of injustice. "So very young," she said again.

Fortunately the chocolates seemed to cheer her up, even though we had to go through the "Oh no, no, no, no," "Oh yes, yes, yes, yes" routine before she finally opened the beguilingly decorated box and offered me one. And then she kept insisting that if there was anything I needed, I only had to ask, and that she was so sorry about the TV set (it had been carried from our apartment for repairs and now sat in a corner of her living room, like something in disgrace, its black screen turned toward the wall), and did I need any washing or sewing done?"

When Sebastiano finally arrived we were still making conversation, or at least communicating quite happily in bitty "Italianish" helped along as usual with lots of gestures, smiles, and shrugs . . . and glasses of that pungent liqueur.

Sebastiano smiled benevolently upon this scene of pleasant domesticity, and then, bless him, apologized most arduously for making so many calls to me. And Giuseppina said, "Oh no, no," anything she could do to help. . . .

So, that was a nice little resolution of things, and I knew that at least Sebastiano's next few calls would be dealt with pleasantly, with no more frowns on Giuseppina's part.

The rest of the evening went splendidly, too. The other Giuseppina and her husband, Bruno—she a plump, bubbling,

ALIANO ALLEY

laughter-filled lady, and he a very loquacious farmer with a stern weather-worn face that kept cracking open into warm, ironic smiles—were both generous and amusing hosts. And although poor Sebastiano had to act as interpreter once again, he accepted his now-familiar role graciously as we blazed our way through a gargantuan dinner in a cozy cryptlike kitchen and dining room in the lower part of Donna Caterina's palazzo.

Once again I hesitate to describe all the gustatory delights of that evening, but I'm sure there are many who share my enthusiasm for exotic—especially home-produced exotic—fare. And presumably

there are also others who share my maxim: "Eat to enjoy and not to undertake a constant fiber-cholesterol-carbo-calorie–counting guilt-trip." So here we go again: We began with a platter of sprawling antipasto—wafer-thin slices of home-cured *coppa* ham rolled around basil leaves and shavings of pecorino cheese; six different kinds of green and black olives; and wedges of a warm, pungently aromatic cheese-and-mushroom *frittata*. This was followed by brimming bowls of *farfalle* ("little butterfly" pasta) in a rich mushroom, tomato, and ham-stock sauce. Then came a *secondo* course of grilled pork chops doused in a garlic, parsley, and pepper sauce, with *al dente* slices of grilled zucchine, followed by a savory salad of four different "field greens."

There was a brief lull, and then in rolled the desserts—a huge pumpkin-shaped cake stuffed with ricotta and chocolate (appropriately called a "pumpkin") and squares of a deceptively simple-looking sponge cake so richly redolent of fresh lemons and lemon zest that you could swear you were actually eating whole, sweetened lemons.

Fresh fruit followed, as it invariably does in Italy—a help-yourself bowl of unpeeled oranges still with their leaves on, kiwi fruit (a very popular fruit there), bananas, and strange, elongated pears resembling—no kidding—male genitalia! The immortal triad. These both Giuseppina and Rocchina seemed to take great delight in peeling and then slicing deftly into munchable chunks.

And then of course came the inevitable chocolates, grappa, *limonce*, brandy, and final glasses of Bruno's homemade red wine. Like most of the wines we'd tasted in other homes, it possessed that strong, fruity thickness of flavor and texture that seemed to be a hallmark of Basilicatan country wines. We'd actually brought a gift of wine, a rather expensive Aglianico del Vulture, which Giuseppina accepted with a kind of condescending half smile, saying, "Oh, thank you both, but we'll be drinking our own wine, if that's all right with you"—a not unusual occurrence in southern Italian homes. A tour around the palazzo was suggested, to walk off this three-hour marathon meal. We readily accepted, wondering where the grand

rooms might be hidden. And they were indeed hidden. The whole structure was a maze of narrow, low-ceilinged staircases that emerged suddenly onto broad landings and hotel-like corridors of bedrooms and sitting rooms and a splendid dining room obviously used only for special family gatherings.

I was trying to recollect Levi's description of this house in his book, and back at the apartment I found it. First came his revealing portrait of Donna Caterina Magalone Cuscianna herself (Levi didn't have much time for her "petty tyrant" brother and mayor, Don Luigi, who gets short shrift): "Donna Caterina was an active and imaginative woman, and she, in reality ran the village. She was more intelligent and stronger-willed than her brother and she knew that she could do with him what she wanted as long as she left him an appearance of authority." Unfortunately, Levi was a little sparse in his description of their palazzo: "She welcomed me very cordially at the door and led me into the drawing room, simply furnished with gee-gaws strewn around; cushions with a clown design and stuffed dolls." Bruno and Giuseppina's own furnishings could hardly be described as "simple." They obviously liked their comforts—stereos, TVs, big stuffed chairs and elegant cabinets of fine dinnerware and crystal glasses. It was obviously a house they enjoyed living in.

Back in their small and cozy kitchen–dining room, conversation inevitably turned to Levi, whom Giuseppina and Bruno had met there in 1974, a year before he died. "He sat in that same chair that you're sitting in," Bruno told me proudly. But apparently he was rather ill at the time so the meal had been a little more modest than ours.

"What was he really like?" Anne asked. This was a constant question of ours.

Giuseppina and Bruno were both full of admiration for the man, and their effusive descriptions included: "very big and gracious"; "very intelligent and a good conversationalist"; "a lovely smile"; "a very kind man"; "he obviously cared very much for the people here."

But oddly, when we got around to discussing the impact of his

books and his role as a senator in the national government, the mood seemed to darken a little. Although Giuseppina and Bruno took great pains to emphasize, "What can one man do, after all, in a country like ours?" it was obvious they had few illusions about the changes, or lack of them, that had resulted from Levi's writings and actions.

"Nothing much has changed," both agreed. "Look at Aliano. Do you think much looks different?" they asked us.

Anne gave what I hoped was a balanced response. "Well, the old parts certainly don't show much sign of change, but there's a lot of new public housing higher up the hill. That certainly wasn't here in the thirties. And from the homes we've been invited into, we see plenty of new bathrooms and kitchens and TVs and new furniture, and definitely no pigs or chickens living inside anymore!"

Anne obviously hoped that this last remark would generate a smile from Giuseppina and Bruno, but both were determined to minimize the significance of such details. "Well, of course the whole country has improved in ways like that, but . . ." and then it came, as we suspected it would . . . "this is still the South, and the North is the North, and whatever things may have got better here, have got much, much better up there. So, we're still the same as we were in that way. No real changes. No real industry that lasts. Young people have to go north to find work, the whole place is mainly old people now."

Okay, I thought. I've heard all this before and I can see what they're getting at, so let's shift the emphasis a little to Levi's "dark side" perceptions.

Not much better there either. They both insisted vehemently (maybe a little too vehemently, I wondered) that it was "all in his imagination." There are no witches, no werewolves, no shape-shifters or dual-natured people in Aliano—none of those things, they both insisted. And, as far as they could tell, they said, there never had been. These things were all part of the myth of the South. Something for the northerners to giggle about. "We were, are, normal people here. Same as anybody else. Just not so rich," said Giuseppina sternly, her face losing its rotund jollity for a moment.

"Except for Giulio," Bruno said with a sly smile.

"Aha! He's not normal. Not right in the head," Giuseppina snapped.

"What happened to Giulio?" I asked.

Bruno pulled a dog-eared copy of Levi's book from a shelf by the fire. Interesting, I thought. Despite their dismissal of many of Levi's ideas, they keep his book so close at hand.

"You remember that thing about the devil," Bruno said, searching for the passage. "Ah, here it is. This is what Levi wrote: 'One night, an old man coming back from Gaglianello, felt a strange weariness all over him that forced him to sit down on the steps of a little chapel. He found it impossible to stand up and walk again. Something did not allow him to. The night was dark but from the ravine a beastly voice called him by name. It was the devil, there, among the dead, who barred the way.' "

"I remember that passage," I said. "But what's that got to do with Giulio?"

Bruno laughed. "Well, he claimed that exactly the same thing happened to him up by the cemetery. Only a few months ago he came running down the hill to the piazza shouting that the devil was after him!"

"Stupid, drunk old fool!" Giuseppina said.

"I'm not so sure," Bruno said mysteriously. "I could tell you . . ."

"Bruno! Enough," Giuseppina said in a voice that did not encourage a response.

". . . lots of tales too about our little *monachicchi*—our mischievous hobgoblins—who love to mess things about a lot and wear big red hoods and . . ."

"Bruno!"

I wanted to see Giuseppina smile again, so I decided we'd asked enough questions. I was tempted to mention that we'd recently heard that there was indeed a witch in the village. Not a fantasy witch but someone with "extraordinary powers" whom the older villagers at least seemed to regard with great respect . . . and fear. But I suspected that this might just open another Pandora's box.

Sebastiano's gentle shake of his head confirmed that we'd probably pushed the subject far enough for now. We respected his puckish insight and wisdom and nodded in agreement.

We focused again on the liqueur and the grappa and on lighter tales of village life and gossipy goings-on, and the evening ended with us all chuckling over the inane antics of local politicians and the endless schemes and dreams of our local, ever-ambitious, ever-visionary priest, Don Pierino. And finally a toast to increased prosperity and happiness for all of us.

"COME BACK ANYTIME you want—both of you!" Bruno insisted as we all waddled a little unsteadily to the door. "Even for a bath, if you wish!" (We'd admired his elegant bathroom and mammoth tub and moaned about our own miserable shower.)

And who knew? We might just do that. Because I suspect they didn't tell us all they knew about our strange little adopted village.

"Methinks they did protest too much," Anne mused before we both fell into a deep, food-fuzzy sleep.

Three Markets, a Funeral, but No Wedding

The next day brought far more lighthearted experiences (at first . . .).

"YOU CAN ALWAYS tell when the Thursday market is coming," Vincenzo Uno (my nickname for him) moaned in his little general store on Via Roma. Of course his face was invariably set in a perpetual moan-mode, so it was very hard to tell the difference. (Vincenzo Due, his assistant, maintained his perpetual, all's-right-with-the-world smile.) "People spend less. For two, three days they buy just the basics. No luxuries. Not even *prosciutto crudo* or fancy shampoos. They're waiting to see what all those *maliziosi* peddlers will bring."

Well, if these men are peddlers I thought, they must be a modern market kind. No more donkeys with panniers packed to their wicker brims there, or those little three-wheeled Ape contraptions pow-

ered by souped-up lawn-mower engines, where goods were once displayed on the rear flatbeds. Today they arrived in the early morning in large, custom-made vans, which become instant stalls, complete with awnings, storerooms, dozing places (in case the selling got a little slow or the sun a little too scorching), and even, in a couple I noticed, traveling kitchens and mini offices for cash- and record-keeping. They were set up from the top of the hill, where Giorgio Amorosi kept his vast winter woodpile, and all along its steep curve for a quarter mile or so, ending virtually in Piazza Roma. On a particularly busy market day, I counted more than thirty vans nose to tail down the hill, with just enough room left for the occasional big blue *corriera* to squeeze through.

By nine o'clock, with the aroma of coffee and warm baking bread wafting past the church, the hill was a jostling swirl and jumble of black widows, eager children, modern mothers with fancy hairdos, and young girls in their most curvacious jeans and peek-a-boo halter tops, which seemed to be the rage all over the world. There were a few men too, but they seemed to prefer the role of spectator or occasional advisor to a wife or relative if they felt that the *malizia* were not bargaining in good faith. I heard one old man dismiss the whole elaborate market as *merdaio* (literally "a shit heap"), another as a *mercato di bestiame* (cattle market). Whispered phrases like "*È un ladro!*" ("He's a thief!") floated about.

If you had ready cash—*contante*—bargaining was all part of the fun. This was unheard of in stores, where those little price stickers were gospel and no one would ever think of questioning the equanimity of the storekeeper (especially Vincenzo Uno). But at the market it was a real free-for-all. A skeptical "*Quanto costa?*" ("How much?") was all it took to get the ball rolling.

There were a couple of things I wanted to buy, but I thought I'd watch the wily techniques of the black widows first. And they were good. Very good. Maybe it was something in the Arabic-Saracen bloodlines that ran through these remote villages, but those ladies would start at around forty percent of the asking price and rarely agree on anything above sixty percent. And what an Aladdin's cave of

China-produced goodies were on display there! Everything from hundreds of fake Rolex watches, fake cellular phones (why?), fake diamond rings, and fake leather handbags; to cheap perfumes, flick-knives, clocks, radios, and kid's toys galore; to pellet guns with remarkably authentic-looking Walther-style designs; to nonstick pans by the hundreds; to mountains of duvets, sheets, and towels; to acres of jeans in every imaginable rip-off hue and style; to hunting vests and jackets; to enormous aluminum pots, which, if I understood one lady correctly, were for "boiling pigs." (They certainly seemed big enough for most of the local pigs I'd seen, which appeared to me to be a little on the scrawny side. Aliano apparently had yet to discover the advantages of the Vietnamese pot-bellied pig, which had enough meat to feed a large family for a year.)

But I did notice a couple of interesting things in this open-air bargain-basement bonanza. First, other than a few items of bottled fruits and pickles and *produzione propria* (home produced) items, no one seemed to be selling the regular, daily grocery goods found in village stores—a wise political move. Nor were there any second-hand clothes, which had been a prime feature of two other, smaller day-markets I'd visited in villages even more remote than Aliano. Obviously our little village was now regarded as possessing a more discerning class of clientele—certainly a notch or two up from the Carlo Levi days. And a clientele, too, who obviously had a serious desire for fresh, new, gleaming-white and sensually black *indumenti intimi* (intimate garments), with a heavy emphasis on *reggiseni* (bras) and *mutandine* (panties). I don't think I'd ever seen such enormous piled displays anywhere—great snowy peaks of them, with at least four stalls that sold nothing else. And very democratic they were in their range—from the gargantuan, corsetlike contraptions, with elaborate elasticated sides, to the most dainty (but not over-daring, you understand, this is definitely not thong and crotchless, un-Catholic country) little lingerie creations. And what was so fascinating was the delightfully intimate way the rough-looking peddlers would discuss all the particular highlights and nuances of each kind of bra or panty with their whispering female customers—and at

great length, too, if they sensed a likely sale. Also, maybe because of their tactfully nuanced approach and their obvious willingness to give each lady their fully focused attention, I saw little sign of the raucous bargaining antics over all those made-in-China products.

Finally I decided to enter the fray myself—no, not for ladies' panties—feeling fewer qualms about bargaining once I'd observed the black widows' techniques. Ask the peddler's price, name your own price, scowl or shrug (preferably both) at its rejection, start to walk away, then be called back for renegotiation, and finally arrive at a suitable compromise that saved face for both contenders and ended in smiles and winks of mutual admiration for a deal well done.

The only thing was, when I finally reached the piazza and the door to our home, I realized that I'd amassed far more than I needed to equip the little house. Why had I agreed to buy *six* tea towels for a knockdown price when I needed only two, which even at full price would have saved me six euro? And that five-euro Walther-look-alike pellet pistol? What exactly did I have in mind for that? And the wok-shaped Teflon pan? Why would I possibly need that when there were four Teflon pans already in the house, and I didn't have any of the necessary wherewithals to prepare a Chinese dinner anyway! (They weren't big on oyster sauce, sesame oil, hoisin, and black-bean paste in Aliano, for some odd reason.) And as for that penknife . . . true, it was only three euro and had a beautifully polished rosewood handle, but it was plastic! Well, it certainly *looked* like rosewood, and anyway, the peddler had come down from six euro. . . .

Markets are sneaky things. I think Vincenzo Uno and I were both relieved when the peddlers vanished after lunch and left us two weeks of normal, everyday, buy-just-what-you-need, set-price shopping. Vincenzo Due, of course, was still smiling his beatific smile, seemingly oblivious to all the angst and minutiae of village life.

BUT GIULIANO had other ideas about markets.

"Try to come over to Accettura next Tuesday," he told me on the phone in his typically enthusiastic manner. "It's our biggest market

of the year. All the way down the hill. Much bigger than Aliano. And there's a second one, too, same day, just outside town. Very interest. Market for animals. All farmers and shepherds. Very much fun for you and Anne, I think."

"Okay," I said a little hesitantly, having had my fill of markets for a while.

"And I think there's funeral, too. You said you want to see funeral. Local funeral."

"Oh, really? Well in that case . . ."

"And wedding, same time."

"On a Tuesday? Sounds like an odd day for a wedding."

"No, no. Is special day. Good day for weddings. Okay?"

Giuliano's special days were not always as "special" as he claimed. But I loved the man and his unstoppable lust for the good life, even in these penurious, peasant-heritage hills.

"We'll be there," I promised. "See you for espresso and *corretto*."

"Okay. Good. *Va bene*," he said, and I could almost hear him smiling his big toothless smile.

I WAS IN ACCETTURA at ten-thirty A.M. the following Tuesday, trying to find a place to park the car. Anne decided that it was her turn for a "dawdle-day" on our terrace. She gently reminded me that our tiny home was for once adequately stocked with "market things" and that I should try to be merely a spectator. I agreed but checked my wallet for euros, just in case.

I'd never seen the little town so crowded, so I decided to wiggle my convoluted way through the inane, serpentine back streets, hoping to find a space to park on the far side of the town, on the San Mauro Forte Road. I finally found one—almost a quarter-mile walk back to the main piazza, where the market was in full swing despite the threat of rain.

I never did find Giuliano that day. Rosa thought he'd gone down to his kiln "to make some more of them blinkin' bricks." (Ah, how I loved her wonderful Nottingham-England-Italian accent.) "Come for lunch anyroad, seein' as you're 'ere."

I accepted her invitation and set off to explore this remarkable market. Just as Giuliano had promised, it wound its way up both sides of the main road into the second, higher piazza and on and on to the top end of the town by the two roadside bars. The bars were the favorite spots of Accettura's octos, who sat and played cards all day long in the spring, summer, and fall in that perfect sun trap offering fine vistas of Bosco Montepiano, Parco Gallipoli, and the Lucanian Dolomites—views of which you could never tire.

The peddlers in Accettura had the same custom-designed, instant-stall vans I'd seen at Aliano, but there were many more of them here—at least eighty—offering a much broader array of delights (no four-foot-high piles of panties). This was far more serious stuff, and as *vendemmia* time would soon be approaching, there were all the necessary tools for wine-making: mountains of huge plastic *cassette* (boxes) for the grape harvest; great six-hundred-liter plastic vats for the first-run pressing; cascades of fifty-five-liter demijohns in "faux-wicker" (plastic) baskets; mounds of vicious-looking secateurs for cutting the vine stalks; wooden rakes for stirring the wine must; and elaborate, engine-powered and manual *macchine per macinare*, into which the grapes were fed for crushing.

There were even offerings of olive harvest necessities, although the harvest wasn't until December or January: hundreds of cans and plastic containers for oil storage; acres of bright blue and green nets; and three-legged *tramalli* (stepladders) of all sizes for the farmers who still shook the olive trees to release the fruit onto ground-spread nets rather than using the far more arduous, but locally preferred, hand-picking process.

"You can always tell the difference in the oil," I'd been told by Giuliano. "Lazy olive-harvesting oil is like lead; mine is like liquid gold because I pick every fruit by the hand." He was meticulous in everything he did, despite his seemingly casual attitude toward life in general. When it came to harvesting grapes, olives, or tomatoes or to making his wine, his oil, or his September tomato *conserva di pomodoro* (actually, exclusively Rosa's job), or creating his beloved

sausages and salamis, something I had yet to see, he certainly had no time for "bending the edges" (cutting corners). His grand "day of the pig" was to be early in the new year. His supply of this year's salamis had almost run out, as he was notorious for giving away his popular porky creations to family, friends, and neighbors—and even to outsiders like Anne and me, whom he happened "to 'ave takin' a shine to," as Rosa had told me.

The rest of the market ran the gamut from the familiar—household knickknacks; pans; cheese graters; towels; curtains; rip-off tapes and CDs; cheap electric gizmos and gadgets; cushions, pillows, and duvets; winter jackets, coats, and shoes (at least ten shoe-and-boot stalls); and jeans, jeans, jeans—to the more exotic—huge brass cowbells over eighteen inches high; small sheep and goat bells; beautifully carved shepherd sticks; flat caps and trilbies (even a few felt Tyrol-styled hats with high peaks, narrow brims, and pheasant-feather trim); enormous Chinese butchering cleavers heavy enough to decapitate a bull with one stroke; beautiful German butchering knives; and, a particular oddity at one stall, a line of eighteen-inch-high Madonna statuettes "guaranteed to make real tears" (an intriguing and popular characteristic of many church Madonnas in the South).

I enjoyed a delicious, if hasty, early lunch at Rosa's: a traditional Basilicatan soupy mix of pasta with lentils accompanied by wafer-crisp, deep-fried zucchini blossoms stuffed with a succulent mix of homemade cream cheese, eggs, and basil, and, as a separate course, fresh, briefly blanched French beans tossed in Rosa's rich home-made olive oil. Rosa always seemed perfectly happy to cook in fits and starts, depending on who happened to be hungry at the time, possibly a throwback to when she and Giuliano ran their own restaurant way up in the *Bosco*. I thanked her with a kiss, a hug, and a box of Swiss chocolates I'd picked up at one of the stalls, and scurried off to see the animal market just outside town.

I REALLY SHOULDN'T have rushed my lunch. While Giuliano had been right about the colorful array of farmers and *pas-*

tori (shepherds) gathered at the roadside near a patch of open ground (occupied entirely by one extremely morose mule), I saw nothing in the way of marketing. Each of the sixty or so participants seemed perfectly happy to be there, chatting, swapping gesticulative gossip, and telling their tall *passatella* (time-passing tales—an age-old "roasting" game of eloquently insulting your friends but making it sound like a series of compliments), their deeply tanned, wrinkle-etched faces smiling and laughing. But nothing else was happening. I tried to discover if I was too early or too late for the show, but all I got in the way of an answer were cheerful shrugs and those ubiquitous "who knows?" gestures. So I waited . . . and waited. But beyond a sudden roar of mutual laughter when a young man tried to mount the mule and was quickly tossed off by the suddenly energized and obviously highly indignant creature, nothing whatsoever occurred. No pigs or horses or oxen were lugged up or down the hill for auction on the grassy patch. I began to suspect it was just all another excuse for more friendly banter and that Italian daily essential: pressing the flesh.

I gave up and returned to the town to inquire about the funeral. Once again I was met with shrugs and gestures of helpless uncertainty, until one elderly woman told me, "That's tomorrow. How can you have a funeral when there's a market on? They have to walk all the way down from the church." She pointed up at the fortresslike bulk of the Church of San Giuliano, perched atop the highest point in town. "And then up this street here where the market is, and up, up, up to the cemetery on top of that hill over there." She pointed to the second high point of the village, at its opposite end, up by the soccer field. Then she laughed: "Who told you it was today?" I decided not to mention Giuliano's name. "Well, whoever it was must be a little crazy, eh?"

I nodded in silent agreement. He can be, I thought, but his heart's in the right place.

"So, tomorrow? The funeral?"

She nodded sadly. "*Si*. A good man, too. And not so old. Only eighty-seven."

"What time do you think?"

"Oh, around five o'clock, I suppose. Maybe."

Always that 'maybe.'

So, I was at the cemetery around five o'clock the next day, having driven the fifty-minute serpentine route once again along the end-lessly hairpinning roads from Aliano. But I was obviously too early. I suppose I could have gone to the church and joined in the mile-long hike down the hill and then up again, but I decided to explore the graveyard instead.

It was not my first such venture. In fact, since my arrival in Italy, I'd wandered around a dozen or more cemeteries, and I was impressed by their stately similarities. Accettura's possessed a

PASTORI SHEPHERD

compact, high-walled village-like enclave on a hilltop with fine views for "*i cari morticelli*" ("the dear little dead people") and their families, who often made weekly pilgrimages to talk (I mean really *talk*) to their departed.

"Ah, how we Italians love our cemeteries," Massimo had once told me. "You should see these places on *I Morti*—the Day of the Dead. More crowded than a football stadium. And flowers every-where. Millions of chrysanthemums. A great tradition."

The "village" element was most evident in the cemetery in the elaborate, houselike tombs, with their steeply pitched roofs, ornate wrought-iron doors, tier after tier of coffins inside encased by ele-gant, engraved marble slabs, a small altar with a crucifix, flowers (plastic or otherwise), and lots of little flickering electric lights to suggest eternal concern and prayers for the peace of the departed. On either side of the narrow central space, a chair or two might be set up in case family members wanted to carry on an extended con-versation with their beloved's mortal remains.

And occasionally—as in Accettura—some of these family vaults, usually with the family name proudly displayed on the pediment above the door lintel—had other vaults, far older and mustier, below the marble or ornate tile floors of the main "house of tiered tombs." I peered through the old rusted doors of one untended, disheveled vault, whose floor had been pulled up to reveal a stone staircase descending into the shadowy depths of the earth. There I could just make out another set of at least eight tiered tombs, barely visible in the gloomy maw. I saw a date chiseled in stone: 1775. A shiver skittered down my backbone to my toes. Two of the tombs had been broken into. I couldn't see what lay inside; I had no desire to. The illusion of those secure, untrammeled resting places—beautifully serene with their white-marble interiors and boldly invincible with their sturdy stone-and-stucco construc-tion—suddenly disappeared . . . and I saw them for what they really were: piles of coffins and rotting corpses housed in fancy sheds on which fortunes had been spent, often by families unable to afford much in the way of a home for themselves. And why?

Well, I imagined to gloss over the hard reality of death and create a make-believe world steeped in righteous religiosity and the sanctimony of sweet sorrow.

At least the far more modest earthen graves—free plots for the poor—that filled the central part of the Accettura cemetery, were shaded by ancient, black-and-green cypress trees, and thus acknowledged the more basic dust-to-dust reality of death.

But the graves I found hardest to stomach were the rows and rows of burial-box *loculi* (niches—five-by-five feet openings and a good seven feet deep) racked up in square honeycomb-like structures, often twenty or more feet high, like the drawers one used to see in pharmacists' shops (and still evident in Chinese herbalists). One of the nicknames for these odd structures, seen throughout Italy and indeed much of Europe, was *fornetti* or "little ovens." (Having lived in Japan for a while, I spotted a remarkable resemblance to those only-in-Japan "sleeping capsules" in that country's unique, space-age hotels.) The idea was simple. You slid in the coffin, sealed up the opening tightly, and, on the front, put a couple of those flickering electric lights and an engraved panel, usually with a porcelain-etched photograph of the occupant—often an unflattering portrait, the only photograph available often being the dour, don't-smile portrait taken for the obligatory Italian identity card. The wealthier residents invariably resided in the bottom tiers, easily accessible to loyal family members. The tiers higher up could be reached only by rickety ladders, and so were invariably occupied by less affluent tenants.

Usually the *loculi* were rather quiet, somber places despite, or maybe because of, all those tiers of white marble and robotic flickering bulbs. But not today. At least not for one *loculo* perched high up near the top of one of the structures.

I was just about to move on to explore more of the elegant family tombs when a black-clad widow, thin to the point of emaciation, limped up, grabbed a ladder lying on the ground, hoisted it in the air, and rested it against a burial slot four tiers up at the top of the *loculi* structure. She proceeded to climb its creaking rungs with a

sense of urgency and purpose quite contrary to her diminutive, seemingly frail frame. And then, with barely time for a nice "How are you in there?" to the occupant, she started hammering away on the *loculo* with a gnarled fist and shouting at the marble plaque (complete with finely chiseled inscription, porcelain photograph, and flickering lights) as if trying to gain immediate access.

This is perhaps something I don't need to watch, I thought, and was just about to make my escape when an elderly couple, elegantly dressed and walking arm in arm, emerged from behind a nearby tomb.

They heard all the noise, saw the flailing arms of the black widow, and smiled benignly.

I was a little concerned for her, particularly as I could now hear gulpy sobs echoing against the marble wall in between her more strident orations.

"*Scusi,*" I said to the elderly couple. "Do you think that lady is okay?"

Their smiles remained fixed and benign. "Oh, no, no, she's fine," they tried to reassure me. "She always comes here. For over ten years, I think."

"But why all the tears? She seems very upset."

"Of course, I think maybe she is. This is the tomb of her husband, and unfortunately he left most of his money to . . . how you say . . . his . . . other lady. Not to her."

"Oh."

"Yes. It's sad, isn't it?" They nodded sympathetically, still smiling.

"But all that shouting? She must have been very angry."

"Oh yes, I'm sure. But also, he was always a little deaf." the man said.

I could think of no response, polite or otherwise. They both smiled at me again, with a polite *buon giorno*, and moved on, blissfully unaware of the irony of their remark.

So I moved on too and continued mooching around this typically neat, manicured walled cemetery, admiring the wonderful roll-off-the-tongue names of the local families—Bartilucci, Cherubino,

Lobosco, Barberito, Sansone, Belamonte, Mastronadi, Montemurro—when from way outside the tree-shaded sanctuary came the sound of a band. A brass band. The funeral! I'd almost forgotten.

I scampered around the towering tomb houses and out of the main gate to see the first part of the funeral procession approaching the top of the long, long hill out of Accettura. First came a large wagon, so smothered in wreaths and piles of bouquets that I could hardly make out its shape. Then came the hearse—a huge, old, black Mercedes polished to a brand-new sparkling shine—followed by a fifteen-piece uniformed brass band led by half a dozen lovely young girls playing piccolos and clarinets. They were reinforced by tall young men with trumpets and horns, backed up by three burly giants "serpentined"—actually they looked as if they were being strangled—by enormous, snakelike euphonia with great, gleaming, three-foot-in-diameter horns emitting a bellowing brass rhythm line, along with a single drummer, almost invisible behind his huge, resounding instrument.

It was a most impressive display, and doubtless an occasion for great pride among the family, relatives, and friends—scores of them—who followed the hearse to the cemetery entrance, basking in the societal "face," the *bella figura*, that such an elaborate procession must be giving them.

But at that point everything came to a rather confused halt. The coffin was lifted out and carried by the funeral directors through the gate and into a small side chapel. The band immediately stopped playing and, without a glance at the coffin or the mourners, put down their instruments, stripped off their elegant blue, brass-buttoned jackets, and began waving them about like cooling fans while lighting up cigarettes and joking among themselves. After all, it had been a long, steep, and doubtless sweaty slog up the hill, and what with their death marches and dirges, they'd had little chance to breathe normally for the last hour or so.

A few key family members walked behind the coffin to the chapel. The rest of the mourners (I counted over sixty) either milled around by the gate or stood in clusters chattering, apparently uncer-

tain of the next steps in the funeral protocol. But unperturbed—knowing things would sort themselves out, in the Italian way.

They stood and stood. The chapel door was closed, and nothing much seemed to be happening. So, I thought I'd follow them later and went off again to continue exploring the extravagant family tombs.

When I returned, after maybe fifteen minutes, there was no one around except a cemetery maintenance man.

"*Per favore, Signore. Dove sono . . . ?*" I asked with the appropriate Italian gestures for "Where the heck has everybody gone?"

He grunted and pointed to the top end of the cemetery. While I was following his directions, who should pass me, limping angrily toward the cemetery gate, but the black-clad widow of the errant (and deaf) husband. I offered a quiet "*Buon giorno,*" but she was talking to herself so intensely and furiously that I don't think she even noticed me.

Eventually I found the funeral party, but not as I had expected to find them—standing with heads bowed as the priest gave his homily about dust and ashes and hope for the hereafter. Instead, they were more like a group of bystanders at an accident scene, chatting together, laughing softly, and all trying to peer into the shadowy maw of the family vault. I couldn't see what was going on inside, but I could certainly hear sounds, the oddest sounds: of hammers and trowels scraping on marble, and drills, and the gruff and growly comments of men—workmen, I assumed—doing something very messy and laborious.

Of course. They were sealing up the deceased in one of the coffin niches. But the sounds were anything but reverential and muted. I'm sure I heard epithets of a most vulgar kind as the men struggled to slide in and cement over the thick and very hefty seven-foot-long solid-marble inscription plaque. Oddly, no one seemed to mind the unholy racket. In fact a couple of the mourners seemed to be shouting out suggestions to the workmen, which were greeted with more grunts and epithets. And I was thinking, this doesn't feel like a funeral at all, but more like a crowd watching, as they invariably do,

the arduous and always fascinating antics of laborers at a construction site.

Very strange, I thought. Why can't all this noise and activity and swearing go on after the mourners have left, suitably muted and moved by a dignified pastoral farewell and blessing for the deceased. But, once again, I reminded myself, this is Italy.

LATER IN THE EVENING, safely back in Aliano after the hairpinning heights, I called Giuliano to tell him about my day and to thank him for letting me know about the two markets and the funeral (despite their being on two separate days).

"Oh, by the way," I added, maybe a little perniciously, "I thought you said there was supposed to be a wedding, too."

"Wedding?" I could hear Giuliano's mental cogs churning. I guess after a day in clay beds and hanging around a thousand-degree-centigrade brick-and-tile kiln, you can't be expected to remember everything you said a couple of days back. "Ah, wedding. Yes, yes . . ."

"Yes?"

"Yes. Next week. Okay? I call and tell you when. Okay? Very big wedding. Okay?"

"Okay. Thanks, Giuliano."

"Va bene."

"Va bene, Giuliano."

So for the moment it was three markets, a funeral, and, thus far, no wedding. But who knew what my friend might come up with the following week.

Finally a Wedding (or at Least Part of One . . .)

Actually nothing happened the next week. Guiliano had got the date wrong again or something. I never found out. However, I did finally get to see a wedding a while later. It was utterly by chance, and I'm still not exactly sure who the couple, or the families, were except that they were long-time friends of good old Massimo, another maestro

of making things happen . . . and as it turned out once again, messing things up, too.

It all began one afternoon in Accettura. A Friday afternoon, to be precise, when Anne had left with a couple of friends from Aliano for a weekend of shopping in Matera. (It was my turn to remind her that our little house had no need for more "things," but somehow the message got lost in a flurry of farewell hugs.) I'd popped into the Hotel SanGiuliano for lunch, and Massimo approached me in the midst of a fine *linguine alle vongole*, the rich garlic clam sauce with succulent fat whole clams that was one of his *specialite di casa*.

"Ah, David. What are you doing tomorrow?"

"No plans really. So far."

"So you want to come to wedding?"

"Massimo, you're not getting married!?"

For some reason he found the idea utterly hilarious, but when he'd recovered his equilibrium, he explained, "No, no, no, thank you. My friend is. Near Sapri. His wedding. Tomorrow. Saturday morning at ten o'clock."

"In Sapri?"

"Yes, near Sapri. Is not so far. You have been Sapri before I think. So, you leave after lunch today and you be there in Sapri in two, two and a half hours. Okay? You come?"

"Sure. I'd love to," I said, amazed at my speedy decision-making.

"Okay. So, you stay at Hotel Tirreno tonight in Sapri. You like Tirreno, right? You stayed there when you first arrived to here I think."

"Oh, yes. Very nice hotel, so long as I can have my room over-looking the beach and the *passeggiata*. That's where I stayed when I first arrived in Italy."

"No problem. I call for you. They friends of mine. So, listen. I pick you up nine o'clock, after breakfast tomorrow. Is okay? And please tell Anne to come too if she wants. I am sure she will enjoy very much."

I explained that Anne was in the process of spending a hefty slice of our annual budget at Matera's vast Carrefour hypermarket.

"Ah," he said tactfully, "maybe she buy nice present for you."

"Maybe." I said, maybe a little morosely.

He gave me one of his irrepressible giggles. "And you always saying to me I should get wifed!"

So that's how I came to make a delightfully dramatic late-afternoon drive over the soaring Monte Sirino range and down from Lagonegro (supposedly the home of Leonardo da Vinci's *Mona Lisa* model) to balmy Sapri, lazily sprawled around its sandy bay, to attend my first Basilicatan wedding.

PROMPTLY AT TEN O'CLOCK the next morning Massimo arrived at my hotel . . . an hour late of course.

"Sorry, sorry. I am late. Look, you follow me, okay? We go first to the house of groom, which is custom, and then you follow me again to church. Okay?"

"Okay," I said, looking with concern at his exhausted face, bloodshot eyes, and stubbly, unshaven chin. "Are you all right?"

He gave another one of his endearing giggles. "Oh, yes, I am very fine. There was party last night. For a few friends. Men friends. We were all at school together. It was a lot to eat. Too much. And drink. Also too much, I think . . . and too late. No sleep."

I was glad I'd not been invited. If the normally sparkling-faced Massimo looked like this after an all-night bacchanal, they'd have been carting me off to the local hospital, or worse.

Things went smoothly. At least at first. Despite Massimo's typically Italian maniacal driving, I managed to keep up and join him and a coterie of male friends at the groom's parents' house. Most of them looked even worse for the wear than Massimo, but they still seemed able to keep up that spirited, nonstop, semi-monologue continuum that purports to be conversation in Italy. I nodded and smiled and understood almost nothing. But whatever they were talking about certainly seemed to be weighty and of the utmost significance. Of course, every conversation over here sounds like that.

Even discussions of such mundane subjects as the weather invariably end up as flamboyant mutual demonstrations of oratorical and gesticulative overkill.

At a prearranged signal, there was a mad dash to the cars, Indy 500–style, and we were all off again—careening around tortuously narrow turns, soaring over mountain ridges, swirling down into tight little valleys. We scared the life out of the aging occupants of the villages through which we roared, ribbons flying from car aerials, hands waving, horns blaring. Dogs scattered and fists were raised at us in protest. (Or maybe the villagers were just bidding the groom a happy life. Who knows?).

And then we were there, cars screeching to a halt in a school parking lot by the arched entryway to one of the most charming, fairy-tale villages I'd ever seen on the Sapri coast, overlooking the coast from a remarkably high precipice around which rooks floated like expectant vultures.

The numbers in the wedding party quickly grew as we all threaded our way down winding alleys between stone houses bedecked with ornate balconies, potted plants, and dangling planters exploding with flowers. Villagers nodded and smiled as we finally arrived at the quaint piazza by a castlelike church. Apparently it indeed once was the castle chapel, although most of the castle is now a vast breezy terrace with spectacular views of the sea, mountains, and velvety green foothills dotted with scores of whitewashed farmhouses.

In typical Italian "hurry, hurry, wait, wait" fashion, we'd done the hurrying bit so now we waited in a merry mood around the church steps.

I felt a little out of it because of the language barrier, until a young man, tall and shy, sidestepped over to me and asked haltingly, "Are you from English?"

"Yes," I said. "From England."

There was a long pause and then he asked, "Have you met Bon Jovi?"

Now that was an entirely new conversation starter! I wished·I

could have said "yes," but I said, "No." He gave a disappointed "oh" and wandered off.

The groom was standing with Massimo and his friends at the top of the church steps looking as nervous as a fox backed into a corner by baying hounds, unless it was merely the last twitches of *delirium tremens* from the nightlong festivities with his former school buddies. I was particularly struck by his eyes—all three of them! Two were wide open in an expression approaching "terrified." (Maybe he was wondering if his wife-to-be had changed her mind and made a mad dash for the wild forested mountains behind us.) The third eye, right in the center of his forehead, seemed to be closed and a little on the purplish side—doubtless the result of some boys-will-be-boys antics of the night before.

Finally, the bride came down the winding alley—looking radiant in her flowing white gown and halolike camellia-laced headdress—followed by her retinue of young bridesmaids and a remarkable number of family members. After counting more than seventy I gave up. Looking at the snug interior of the church, I wondered how we were all going to fit inside it.

Somehow we did. More than two hundred of us. Crammed and jostled onto hard, narrow pews or, for most, against walls or pillars or anywhere else we could find.

While the day outside was comfortably warm, the church rapidly reached the point of claustrophobic tropic torpor. And that was *before* they closed the doors. Which may not have been so bad if this had been one of those relatively brief Anglican ceremonies, which would have had us all back outside and breathing freely again in little more than half an hour. But not this time. Not at this wedding. Someone had commissioned a full-blown, pull-out-all-the-Catholic-stops service with a large local choir, a toned-down rock band for odd and frequent musical interludes, and a loquacious priest who ranted on for an almost forty-minute sermon. He began benignly and warmly enough, but ended shrieking hell and damnation on couples who did not reproduce fast enough (and other equally intolerable and un-Catholic sins). And as the heat and stale air intensified, then came all

the sittings, standings, and kneelings and the repeating of long Catholic litanies, and finally, an endless wafer-and-wine communion for just about everybody in the congregation. Except me. I stayed as long as I could—certainly for the joining of hands and the kiss and everything—but as soon as possible I was outside, gagging for breath, sucking in the fresh air like a sweet nectar, and wondering where the wedding breakfast was to be held.

Massimo had said he'd managed to get me invited, although I felt a little like a gate-crasher. But, hey, after all the effort I'd made just to be there and add my cheers and well-wishes to everyone else's—even though I still had no idea who anybody was, least of all the bride and groom—I decided I deserved some kind of liquid and gustatory compensation.

OF COURSE, THAT'S not how things worked out. How could they? After all, this was a Massimo-organized event, and as I was to learn many times during our stay in Basilicata, Massimo's "arrangements" existed solely in his own imagination.

Once the ceremony had ended and the photographs had been taken and the happy crowd had marched back down the alleys of the picturesque village (I still didn't have any idea where we were), I followed Massimo's hastily whispered instructions. Which were: "Follow us. Don't go with other cars. We go faster way."

And indeed it was faster. A lot faster. So quick that I lost Massimo's car in a maze of backroads with forks and dead ends and everything else to confuse a neophyte explorer of that wild mountainous terrain.

I had not been told where they were going for what Massimo had described as "a big, big dinner, you won't believe!" And I couldn't ask anybody because first, there wasn't anybody around to ask, and second, I wouldn't have understood the reply anyway.

So there I was, lost in that primitive tangle of unsigned (and in some instances unpaved) lanes deep in a vast forest in the midst of seemingly endless mountains, with this mantra hammering away in my head, "Massimo, this time you're a dead man!"

A Day of Delicious Delights

After my long drive back from the wedding fiasco and Anne's bag-and-box–laden return from her Matera splurge, we thought we would enjoy another one of our more relaxing days: a chance to cook and read or maybe a stroll around the village at *passeggiata* time. Or maybe not. After all, the weather was in moribund mood. The tail end of summer had produced dreary, gray doldrums for the last couple of weeks, the intervals of balmy blue were rare, and there was a distinct early-fall chill in the air.

So an "in day" it was to be.

Until the door rattled. Not exactly a knock, but Giuseppina's odd way of shaking the door to indicate her presence with, as usual, her cell phone and Sebastiano at the other end.

"David, I have someone I think you two should meet."

"When?" (I wasn't really in the mood, so I may have been a little abrupt in my response.)

"Today, if is all right. I am not at school today."

"Who?"

"A very interesting man. A potter. But not like Giuliano. Not tiles and bricks and things. Things for the house. Plates, jugs, these things."

"Where does he live?"

"In Stigliano. Not far from my house. Can you come over about two o'clock?"

"Hold on," I said and consulted the oracle.

"Okay," Anne said with smiling enthusiasm. "We don't have any other plans."

"Excuse me," I reminded her, "this was supposed to be an "in day'."

"Oh, we can do that tomorrow. And if the weather doesn't change, maybe for the rest of the week . . . or month," she said, mumbling the last bit as a rebuke to the strange, depressing climate of the last few days.

"Okay, Sebastiano. Sounds like a great idea. We'll be at your place by two o'clock."

"Good. *Ciao.*"

"*Ciao.*"

So much for our "in day." But, as it happened, this particular day turned again into one of those magical potpourris of delicious and unexpected delights.

FIRST IT WAS our loaf. The previous evening we'd taken a small plastic bag of chopped-up leftovers from our kitchen to our baker across the piazza. I seem to remember we'd included garlic, parsley, bits of four different cheeses, prosciutto, salami and *soppressata* fragments, and sun-dried tomatoes, all mixed with a little oregano, basil, and marjoram. Maybe some bits of anchovy, too, from the dregs of Anne's version of Caesar salad dressing from the evening before.

We'd discussed with the baker what size and shape of loaf we wanted with all our tidbits mixed in, and I'd suggested the eighteen-inch–diameter donut-shaped loaf that was one of his specialties. Of course we knew that this was a complete waste of time because, just as on other occasions, it would turn out to be the same one-foot–diameter, circular pielike loafs cooked in a special pan with all our ingredients spread in a layer in the center of the bread. And that's exactly what it was. But what made it so enticing this time was the baker's wife, a tiny and very huggable, gnomelike lady with sparking eyes. With a distinct blush—an unusual sight in a seventy-year-old person—she asked if she might have a tiny taste of the strange bread she'd been baking for us on and off for weeks. We were delighted. Using the cleaver-like knife she handed me, I cut her and her husband two generous wedges, and a third for her sprightly young counter assistant, whose fresh, country grin had brightened so many of my early mornings.

As they all began to munch on their slices, I cut thin slices for Anne and myself, and we all stood like wine connoisseurs at a tasting—nibbling, chewing, and savoring the rich tastes and aromas from the still-warm bread. And smiling. The little shop was suddenly full of smiles—honest ones, I think—as our three co-conspirators in creative baking all agreed that the flavor was *superbo.*

Anne and I praised their skill at baking and the selection of the appropriate shape (despite our request for the ultra-large donut); they praised our selection of ingredients and the finely chopped mix we had given them. But despite this warm aura of mutual admiration, when I asked the husband-and-wife team if they thought such a loaf would be popular with the villagers, they shook their heads sadly. The young girl also shrugged eloquently as if to say, "What can you do in a place where the old ways are as rigid as the sequences of a Catholic mass?"

"But you all seemed to be enjoying it. Why wouldn't other people in the village enjoy it?"

There was a flurried exchange of eye contact and unspoken debate until the lady baker explained, "We only have twelve different kinds of bread." This really wasn't an explanation at all, more like an apology for the constricting regimentation of old traditions.

Well, I thought as we left the bakery, at least those three enjoyed it. And it was definitely one of our best. Something about the mix of the tiny warm pieces of prosciutto and salami with those four cheeses and just the slightest hint of anchovy, garlic, and basil had given it a rather unique character.

We looked forward to enjoying more of our creation when we returned to the house. But we never got that far. As we were approaching our door, a plump gentleman in a long, black cashmere coat, red scarf, and perky black *coppola* cap strolled across the piazza with a determined air and held out his hand.

"*Buon giorno.* Hello. How are you? 'Scuse me for interrupting, but I am Alberto Garambone."

"Ah," I said, having no idea who Alberto Garambone was except that, with his plump, smiling face, fat moustache, and bright, shining eyes, he seemed the kind of person it might be fun to get to know.

"Yes. I am the son of the *Americano.* You remember from Carlo Levi's book? He had lived much of the time in America. The one who owns this palazzo." Alberto was pointing at the large, stately, and a little aloof, house by the post office, which, since I'd arrived, had

always been shuttered and empty. I'd often been curious about this place but had never seen anyone enter or leave. So far it had been a rather splendid mystery.

"Oh, really? The *Americano*'s home. Of course. I remember it well. Levi described its elaborately carved door and lots of geranium pots on the balcony."

"Yes, you are correct," said Alberto, with a cheek-bulging grin. "You know his book well."

I smiled and nodded. I should. I was into my ninth read, and in places the text was barely decipherable in a blizzard of my notes and underlinings.

"Maybe you would like to see inside?"

"Yes, indeed, we would. When?"

"Well, now," Alberto said, his happy grin widening. His face reminded me of that of an equally plump British actor who always played the character role of a well-meaning Dr. Watson–type bumbler. I still can't remember his name.

"Fine," we said.

And so off we all went across the piazza. Alberto unlocked the huge, brown doors of the palazzo, with their elegant carvings of cherubic faces. They opened onto a steep staircase leading to the upper living floors. As soon as Alberto opened the doors to the kitchen and "informal" dining area, I knew we'd stepped through a time warp and back to the early 1940s. An ancient but immaculate white-enameled wood-burning cooking stove had pride of place against the far wall near a glass-door cupboard filled with delicate porcelain dinnerware. The table, with elegantly carved legs, was set for one. "I sometimes stay here overnight, but I live in Grassano. Maybe you would like to visit me there? Grassano is very famous for its *passatella* games. Maybe you and your wife would find interest."

We murmured agreement but were distracted by the tour of this museum-like mansion, with its elegant formal dining room, over-stuffed armchairs, lacy crochet covers on all flat surfaces, and tall, windup gramophone. ("It still works beautifully," Alberto said proudly.) Melodramatic Victorian-spirited paintings in elegant

frames hung on the walls, including one of those "Monarch of the Scottish Glens" works of a majestically antlered stag standing proudly atop a highland peak. (These had once been almost obligatory accoutrements in British homes, including my grandfather's house in Yorkshire.)

The upstairs bedrooms were classic forties, too, with washbasins and jugs, an enormous polished-steel (or zinc?) bed with a most flamboyantly scrolled headboard, and more large artworks. The corridor led to an expansive terrace with spectacular vistas to the east across the valleys and foothills toward Stigliano.

"I would so much like to make this into an official bed-and-breakfast," Alberto said a little hesitantly. "You think?"

"I think—with a few changes and some repainting—it would make a great B and B," I said. "When will you open it?"

"Ah," Alberto murmured sadly, a sound I'd heard so often before when ambitious plans were discussed there. "That's the problem. Too much paperwork . . . permissions . . . the mayor, the police . . ."

"For a two-room bed-and-breakfast? Why all the bureaucracy?"

Alberto nodded, smiled sadly, and shrugged. "This is Italy," he said.

"But everyone I've talked to agrees that the only real future for a place like Aliano is in "cultural tourism," linked to Levi and the whole spirit of Basilicata. I'd like to think they would be pleased to have some B and Bs in the village. There's nowhere for people to stay here at all!"

Alberto continued shrugging and shaking his head. "I know, I know. You are so right. It's the only way. But . . ."

I waited for the coda. We actually spoke the words together: "This is Italy."

Outside again, we bid farewell to yet another newfound Levi enthusiast and promised to visit him in Grassano.

"You will both come for big lunch. Then I will show you *passatella* games in the bars. Very interesting, very crazy!"

"Excellent. We'll look forward to that."

* * *

BACK AT THE HOUSE, Anne made the morning fire to counteract the strange late-summer chill. She's a far better fire-maker than I. Something to do with the way her dad taught her to build diagonal layered stacking and spaces for the flames to "breathe." I tend to cram everything in, light a couple of fire-starters, and hope for the best. Which means there's rarely a "best" and usually a frustrated me blaming wet wood, lousy newsprint that won't burn, or bunged-up chimneys.

"Could be, darlin', could be," Anne usually responds as she sets about remaking the whole thing after my pathetic efforts, and invariably ensures that the fire lasts throughout the day and well into the evening.

We chuckled over our little adventures in the bakery and with Alberto as we munched on the remaining fragments of our special bread.

"You know it's market day today," she said, and I remembered that market day was indeed every second Thursday.

"Great," I said. "We've got time before Sebastiano. Let's go and see how massive the piles of panties are this time."

"You're so crude," she reprimanded me, but laughed when I indicated with elaborate arm gestures that one pile at last month's market had been more than four feet high.

A while later we were walking up the long hill past the twenty or so market vans with their cooking pots and huge casserole dishes, China-made trinkets galore, cheap curtains and clothes and duvets, and a couple of delivery trucks packed with cheeses, hams, and sausages.

And unexpected delights began again. The peddlers seemed to be in the mood for generous bargaining, so we ended up with a few bags of things we really didn't need—"couldn't resist the price" type of household goodies. And also a bag of enormous plate-size fresh *funghi prataioli* (meadow mushrooms) free of charge. We still have no idea why. We had only smiled pleasantly at the Buddha-bellied

salesman whose van was packed with large boxes brimming with these just-picked wonders, and he'd smiled back . . . and next thing we knew, Anne was presented with a bag full of these delicious items. Doubtless, if I hadn't been around, she would have bussed both his red, shining cheeks for his kindness. As it was we all just shook hands and vowed always to buy our fresh *funghi* from him, despite the frowns of dismay this would generate if our local green-grocer ever found out, which she might, given that her store was directly below our terrace. (She seemed to regard us as part of her extended family, sharing the daily gossip with us in exuberant torrents of local dialect, none of which we understood.)

Back home we selected two of the largest *funghi*—both more than eight inches across—doused them in raw egg and heartily seasoned flour, and sautéed them into succulent mushroom steaks, liberally sprinkled with fresh grated parmesan cheese and served for an early lunch with the remaining fragments of our special bread.

Normally we would relax a little after lunch, but not this time. "Oh, damn!" I said. "My hair. I forgot. I've got to get it cut before we see Sebastiano. These side pieces are beginning to make me look like Einstein on a really bad hair day."

Anne was silent but smiled with catlike complacency. She'd been urging me to have a haircut for the past two weeks. So, before the village closed for the "sacred time," I scampered across the piazza to the local barber, who I'd been told was far younger and more "modern" than other nearby barbers and who actually listened to your requests regarding styling. I even had the correct word for a trim (*taglio*) written down along with *poco*, which usually means "a little." And, delight of delights, for five euros he applied his tonsorial skills masterfully, giving me the perfect trim—even though I had to listen to a litany of complaints about his latest girlfriend, which ended with a dramatic tirade when he denounced her for having had the audacity to use another hairdresser for her last perm. I commiserated as best I could and escaped before my own hair became the recipient of his macho-misery flailings with scissors rampant.

Finally we were off to Stigliano to meet Sebastiano and the

STIGLIANO POTTER

potter. And when we arrived, who should also turn up but Giuliano, in his familiar *coppola* cap. We stood together in the small, pot-crammed studio watching Michele Rasulo, a *ceramista artistica*, create intricate little flared pots, wine jugs, and olive oil decanters on his electric-powered wheel. I could have watched for hours this magical transformation of crude misshapen gray balls of clay into finely articulated fluted jugs and bowls. Giuliano, whose primary skill was the creation of his handmade bricks and pantiles, and more recently little souvenir-type animals for children (another one of his dozen or so ongoing projects), watched in awe, too.

Michele showed us his kiln crammed with just-fired items, all now salmon pink and ready for his vigorous hand-painting with decorative borders and sprightly cockerels sporting flared blue tails, and other equally convincing birds created by four or five min-

imalistic brushstrokes. Almost Japanese in the freshness of the flourishes.

Maybe it was our smiles and exuberant praise, but we all walked away with personally signed gifts—olive oil and balsamic vinegar holders and a special pot for *olio piccante* (a redolent, throat-scorching mix of extra-virgin olive oil and *peperoncini*, that ubiqui-tous Basilicatan seasoning mix).

Not far from the pottery, we met a young man, a friend of Sebastiano's, who invited us in for a "little coffee," which we all readily accepted. As the young man flung open his *cantina* doors, we discovered that a full bacchanalian Italian family lunch was in progress. At least four generations were seated all together at a long table spread with salads, pasta, mounds of golden bread, wine bot-tles everywhere, and two huge casseroles of steaming pork stew, richly spiced with *peperoncini* (of course), anise, and big chunks of the same type of mushrooms Anne and I had been given as a gift ear-lier that day. So a "little coffee" actually turned out to be wine, stew, bread, fruit, grappa, and then finally the coffee.

The family seemed to enjoy our intrusion, and we certainly rel-ished their hospitality. Then Sebastiano said he'd like to show us one more little delight before we all collapsed into a wine- and grappa-induced stupor.

And so it was that we met yet another friend of his, a man who had been a potter before his recent retirement. After a little prompting from Sebastiano, he asked if we would be interested in seeing his foot-powered potter's wheel, which he kept "in storage" just outside town. Five minutes later we were all standing on a bare patch of land with amazing vistas across the Stigliano hills and even as far as the Mediterranean Sea, way in the distance near Metaponto. Close by stood a junk pile of discarded bricks and beams and old cement blocks. The potter, who bore a striking resemblance to Anthony Quinn in his *Zorba* role, pushed his way into a riot of weeds and straggly bushes and slowly pulled out an ancient and dilapidated four-foot-high contraption built out of wooden planks and metal disks. Daintily for a man of his bulk, he eased himself into

the "seat" (a triangular slab of board) and proceeded to spin a three-foot-wide circular wooden plate with his right foot, which turned a one-foot-wide potter's wheel. And with his hands crafting and sculpting nothing but air, he proceeded to show us how, in the days when he was a local professional potter, he used to create huge jugs, bowls, casserole dishes, and Greek-influenced amphora. The delicacy of his hands and fingers was such that we could almost see these finely shaped objects emerging from the nonexistent clay. Giuliano stood silently (a most unusual occurrence) watching those fingers with a childlike intensity. The potter seemed to forget we were there. His foot moved with a drumlike beat as the wheels turned and his invisible creations emerged in his mind and in his heart.

And, as if in celebration of this moment on this wild hillside with all these amazing vistas, the sun, which had been cloudbound all day, slowly emerged through a tear in the gray, bathing the whole scene in a regal light of amber and gold.

CHAPTER 7

Strangenesses

The Basilicatan Way of Death

The funeral earlier in the month had piqued my curiosity about some of the more unusual aspects of what I could refer to only as "the Basilicatan Way of Death." So, along with my young and faithful interpreter-friend, Gino, I set out to find someone who could enhance my still-neophyte understanding of local mores and customs.

"IT WAS DIFFERENT from village to village all around here. We were like separate kingdoms then. Fifty years or more ago. The idea of 'Italy' being one country was still strange. We all spoke different *dialetti*. Sometimes even different parts of a village would speak differently. Sometimes there was an Albanian part or a Saracen *rabatana*, and then it was very difficult to understand anything. So, one place would treat the death of a loved one one way and another place another way. But . . ."

Giulia Colucci paused and lowered her wrinkled face, foxy lean and wrapped tightly in a dusty black scarf. A little tighter and a little more cloth around the mouth and eyes and you'd have had an Islamic *burqa*. And this was the way our conversation went: Sudden

deluges of recollections and information followed by long reflective silences, sometimes accompanied by moist eyes or even tears as her memories jostled and her brow became more deeply furrowed, and sometimes a gentle chuckle to herself. And, once in a while, her gnarled fingers would reach out to touch mine, followed by a quick squeeze—an indication, I think, that she was surprised and pleased that anyone would take an interest in her, her life, or her memories. Oh, and very rarely, came a sudden outburst of cackling, hoarse laughter as a particularly amusing memory popped into her mind. I could tell she relished the richness of her recollection and was eager to express its often rather risqué humor. But this time her "but" obviously preceded a serious series of thoughts and memories, and Gino and I gave her all the time she needed to put them into words

"In those days it was hard," she eventually began again. "Very hard. Today is much easier. The women now often refuse to do all the things that were once expected. If they lose a husband they even think about finding another. We didn't do that. It was not the right thing to do. 'One husband forever into eternity,' the priests would tell us, and we never really thought about it. There was no choice. Everyone watched you to make sure you did everything right. Your mourning, years and years of deep mourning . . . lutto . . . everything in black—scarf, cardigan, skirt, blouse, stockings, slippers, even black underwear, intimi."

"What did you actually have to do?" I asked, wanting to understand just how onerous these "black widow" obligations once were (and still were, if the odd habits of some of the Aliano widows were anything to go by). I'd seen some signs of the enduring strangeness and intensity of a death in the family in nearby Cirigliano a while back. I could still feel the shivers of doom and dread that scampered up and down my spine that day in those narrow, shadowy alleys. Echoes of howling and wailing, seemingly ceaseless, had pursued me as I tried to wriggle my way out of the intense maze around the village's ancient defense tower. The sight of twenty or more black-shrouded women raising their skinny, vein-etched arms in unison and releasing their eerie, ear-scratching screams and shrieks of

sorrow into the chill morning air was something I would carry with me to my own grave. And yet, even in the apparent intensity of all that collective emotion, I had seen flickers of ironic, Monty Python–esque humor. One old woman had stopped in mid-scream to kneel and hug a child who kept pulling at her long, black widow's weeds; another had a fit of coughing and couldn't hold her screech, so she stopped, cleared her throat with a gutteral rasp, and spat a great blob of phlegm over the terrace of the room where the dear departed lay and onto the cobbled street below; two other women, obviously exhausted by all their wailing, moved decorously to the end of the terrace and began chatting and smiling together as if they'd just met on the street on the way to the store.

While there had obviously been enormous sorrow and genuine despair in that house, I had begun to see a distinct structure in the public demonstrations of "formal" grief by some of the women, whom I felt had been invited more for their enduring howling and head-clawing abilities than for their close relationship to the deceased.

Giulia eventually began to answer my question. "Well, after the wake, *veglia,* and the funeral, the real mourning began. Years and years of it. The first two or three months were the worst. You had to stay in the house all the time, without any fire or any cooking. The family or your friends were supposed to shop for you and bring you food. You couldn't play the radio or TV, but," Giulia added with a sly grin, "if you did, you did it very quietly and turned them off if any-body came near your door. And you wore black clothes and a black scarf all the time. Inside the house even. Sometimes it was so like a prison that you began to wonder what was worse. Dying or being left to live like this. My mother used to describe it, the way we had to live, as 'dust delayed.' You could do nothing except cry in your house—and make sure other people outside could hear you cry—and go to church. For at least one year, sometimes two—depending on what your village said was correct—you became almost invisible. No visiting, no joining in the *feste* and processions, not even a family wedding or baptism—unless you got a special dispensation from the

priest. Even after five years you could still do very little. Wearing the black, all black, was still expected, and no jewelry or anything fancy was allowed, nothing to show that you might have forgotten your dead spouse. And this could go on and on—it often did—for more than ten years. Sometimes until you died."

When I finally left Giulia a while later, I had developed a new respect for all those aged "black widows" I saw every day bearing their ritualistic burdens of perpetual mourning. This once-obligatory lot in life is described so powerfully by Anne Cornelisen in her book *Torregreca*, in which she likens these women to "human snails as they shrank deeper into the shells of their shawls." However, it was also a constant reminder to me of the all-encompassing "silent endurance" of today's *terroni*, still bowed and bound by the ancient ways of Basilicata.

Soft Porn and Pasta

Death, love, emotional tirades, scandalous gossip, and infrequent moments of calm all seemed part of the daily collage of existence in these tight-knit, clannish hill villages. But food was undoubtedly the great bonding factor that nurtured and focused family life—that intricate cat's cradle of unspoken links and loyalties requiring obligatory mutual gatherings at least once and usually twice a day, no matter what emotional turmoil or angst serpentined through sibling and parental relationships. Sit, talk, drink, argue, eat, and love were the laws of familial longevity and endurance. And television. Watching television seemed to be another prime requisite of daily life, as we learned on many occasions, most memorably when we'd been invited to dinner at friends of Sebastiano's.

"OOPS, THERE SHE GOES again! Wow, she's big. *Grossa!*" Antonio, the father, ogled the television screen briefly as he sucked up long strands of *fettuccine* doused in a decadently rich sauce of *porcini*, parmesan, black pepper, and cream.

Televisions are a ubiquitous fact of Italian life. They're always

on—in bars, in restaurants, and invariably in homes, no matter how small or modest. "Oh, it's just noise," Antonio's wife said, shrugging to display her utter indifference to the oddest mélange of hyper-emotive soaps, game shows, quiz competitions, endlessly talking heads, dubbed American movies bursting with bad language and street gore galore, and a whole menu of *colpo grosso* (soft porn) shows, which seem to generate huge ratings even though no one we met ever admitted to watching them. But then, when she thought no one would notice, her eyes strayed to the screen and between generous mouthfuls of pasta and fat, iron-crusted *crostini* (toast) dipped into a rich mix of olive oil, balsamic vinegar, and garlic, she would gaze hypnotically at the oddest images. We found we couldn't resist either, particularly when, as the *secondi* platters of *saltimbocca* and salad were being served by our generous and talented hostess, a cluster of four "ordinary housewives," apparently selected at random from a raucous audience, stripped off a garment whenever they failed to answer general knowledge trivia questions correctly.

Anne and I had no idea what kind of questions had been asked, but they must have been awfully difficult because the failure rate was remarkably high. Skirts, blouses, shoes, stockings, and ultimately bras and slips were shed with unseemly enthusiasm and regularity as the quiz master chortled and two fine, young specimens of scantily clad Italian womanhood feigned mock surprise and giggling embarrassment.

The closer the contestants came to utter nudity, and began some kind of cavorting dance with one another, the more the dinner guests tried to pretend to be indifferent to the proceedings. In fact, two of Antonio's married sons, sitting across the table from us, never once turned to look at the screen. We were beginning to admire their stoicism when we realized that their eyes seemed to be glued to a point immediately above our left shoulders. We turned and, lo, there in the large mirror hanging on the wall behind us, was a perfect reflection of the TV picture in all its promiscuous glory.

Not surprisingly the conversation was a little stilted until the show ended. Then an almost audible sigh echoed around the table

(disappointment, relief, frustration, envy, or maybe all of the above?) and someone brought up the subject of Mona Pozzi.

Anne and I had never heard of her, but she was obviously the focus of familiar heated debate. Antonio's wife kindly filled me in on the details, as voices around the table rose and tempers flared. Miss Pozzi, who, in 1994, died at the very young age of thirty-three from a liver ailment, had for years been Italy's reigning porn star. For many people she had also been a focus in the debate over that national dichotomy in male attitudes toward women—the eternal battle between lust and love, carnality and concerted worship, whore queens and Madonnas, torrid love slaves and the ultimate figure of reverence in Italy, the matronly matriarch of the family, the eternal and adored (especially by spoiled sons) mother figure.

Over grappa and fresh fruit (tiny, gorgeously sweet *mandarini* being the highlight of the night), opinions raged.

"She was a true individual. She knew who she wanted to be," Antonio said.

The rest of the family offered alternative interpretations and comments on Pozzi's significance:

"A harlot! Nothing but a vulgar, money-hungry harlot."

"She would have made a fine politician."

"Didn't she run for office once?"

"She was so polite. Her manner was almost old-fashioned."

"Everyone loved her—Fellini, Dino Ricci, DiCrescenzo . . ."

"Did you ever see her movies? Filthy! Obscene!"

"She came from a good Catholic family. Her father was a respected nuclear scientist."

"Michelangelo would have loved to paint her."

"I liked her TV ads, for those cookies with the chocolate middle. Very respectable and nice."

"She confessed in the end and was blessed by the Church."

"She asked for no fuss at her funeral. She wanted her ashes to be scattered on the ocean. Very simple, very pure."

"But she had those horrible sex-talk telephone lines."

"Yes, but she gave all the proceeds to cancer research."

And so on. All the schizophrenia of Italian sex versus love: Madonna and beloved Mother versus lusty maiden and licentious vamp. It was almost an anticlimax when, as the grappa continued its rounds, another show started. This time it was tantalizing vignettes of nice ladies doing rather daring and naughty things in woods and up dark alleys in Naples, or somewhere equally gritty. All eyes slid surreptitiously back to the TV screen while the conversation reverted to polite, friendly, no-brainer chitchat, hopping happily from cliché to platitude and back again, all about absolutely nothing at all at just another one of those typical, everyday, Basilicatan family gatherings.

Craco—An Experience in Natural Magic

There are many strange creatures here who have a dual nature . . .
CARLO LEVI

The enticements of mystery and magic are woven so naturally into Basilicatan lifeways and perceptions that they also become part of typical, everyday events, and no one really pays them much heed. Except those who experience them directly. Like me. But not Anne. She preferred to bask in what she called "the normal, everyday life of Aliano" and found my "dark side" excursions a little too macabre, if not verging on maniacal. Fortunately, after more than thirty years of marriage we had learned to celebrate our different interests in a laissez-faire manner, buoyed by mutual, if occasionally quizzical, affection. Although, in this particular instance, I did wonder if Anne's reticence might have a been wiser, and certainly safer, life-maintenance policy.

AND IN ADDITION TO heeding Anne's warnings about my dabblings in the region's strange and mysterious heritage, I should have read Levi's text even more carefully. I had marked the one-line passage on "dual natures" in my much-marked copy of his book, but I must have been so distracted or intrigued by the idea of Aliano's

population possessing protean, shape-shifting abilities that I
skipped over the context of one of Levi's brief and surprising state-
ments.

So, to clarify things for this next odd tale, let me provide an
extended Levi quotation that might suggest the framework for yet
another bizarre adventure into Basilicata's dark side:

> There is nothing strange in the fact that there were dragons in
> these parts in the Middle Ages. . . . Nor would it be strange if
> dragons were to appear again today. . . . Anything is possible
> here where the ancient deities of the shepherds, the ram and the
> lamb, run every day over the familiar paths, and there is no defi-
> nite boundary line between the world of human beings and that
> of animals or even monsters. . . . To the peasants everything has
> a double meaning. The cow-woman, the werewolf, the lion-
> baron, and the goat-devil are only notorious and striking exam-
> ples. People, trees, animals, even objects and words have a double
> life. And in the peasants' world there is no room for reason, reli-
> gion and history. There is no room for religion, because to them
> everything participates in divinity, everything is actively, not
> merely symbolically, divine. . . . Everything is bound up in natu-
> ral magic. Even the ceremonies of the church become pagan rites
> celebrating the existence of inanimate things, which the peasants
> endow with a soul, and the innumerable earthly divinities of the
> village.

My experience of this "natural magic" all began on a long drive back
to Aliano from Matera, after one of my rare indulgences in the
enticements of that intriguing cave city, and more specifically in the
vast gourmet delights of its Carrefour hypermarket. I took a differ-
ent series of backroads this time, a looping route past the prominent
hill towns of Pisticci and San Mauro Forte. And another town, too: a
dark and remote place, silhouetted dramatically against a purpling
evening sky, high on a hill striated with precipices rising hundreds
of feet from the lower foothills. And, unlike the other places I'd

passed in the gathering twilight, there were no lights to be seen there. Not a solitary flicker from the tightly packed houses that clung to the vertiginous hilltop like clusters of mussels on a pier post. No streetlamps, no glows from windows. Nothing.

Most odd, I thought. But I was getting used to things unexplainable in this region, and I almost forgot about the place until I was talking with a friend of Massimo's in Accettura a week or so later and happened to mention the unusual route I'd found through the back country on my return journey from Matera. I remembered that strange little dark and lightless village and asked Massimo's friend what it might be.

"Near Pisticci, maybe, ten miles or so to the west? On the Stigliano road?"

"Yes, that's about right."

"That's Craco."

"Oh, okay. I just wondered. It seemed a little odd. There were no lights there or anything. No sign of life at all."

"Of course there were no lights or life. It's abandoned! *Fantasme.* It's a ghost village."

"Really? Abandoned? The whole place? Everybody just left?"

"Oh, yes. And very quickly, too. They built a new village in the valley."

"Why so quickly?"

"Well . . ." My informant hesitated just a moment too long, enough to make me more curious. "Well, they say it was because of landslides. The village is built on a very steep rock, and things kept falling off."

"Looked pretty intact to me. Although I couldn't see too clearly. The sun was down and it was getting dark."

He looked at me with a rather concerned frown. "You didn't go into the place?"

"Oh no. It was too dark, and I wanted to get home."

"Ah," he said, obviously relieved about something. "Good."

"But I plan on going back and looking around. I don't think I've ever seen a totally abandoned hill town before."

"Why do you want to go back? Why?" His voice rose a pitch or two. He sounded concerned, almost protective.

"Why? Because I'm curious."

I didn't know Massimo's friend very well. In fact, I hadn't even remembered his name. But the way he reached out and touched my arm suggested a nuance of bosom-buddyness. "Listen. Maybe that's not such a good thing for you to do, you know?"

"Why? What's wrong with the place?"

Another hesitant pause. This was getting interesting.

"Well, maybe it can be dangerous."

"Dangerous? How?"

"Well, buildings falling down, things collapsing. No one has lived there since over forty years so there are no repairs, or anything. It's a dangerous place. Why not go and visit Pisticci instead. It's nearby and a very interesting place. It's got . . ."

Our conversation meandered off into other areas, and then we both went down to the Hotel SanGiuliano to see Massimo for one of his superb, wood-fired–oven pizzas.

But I didn't forget that bizarre conversation. I felt as if Massimo's friend had wanted to tell me more. However, as happened so often in those parts, if there was any suggestion of strangeness in the subject under discussion, normal eloquent rhetorical flourishes ceased and people became noticeably uncomfortable and embarrassed, and nudged the dialogue in different directions.

My little Basilicata guidebook, one of the D'Agostini Touring Atlases given out at tourist information offices—if you're lucky enough to find one open or a rare copy in English—was also unusually devoid of background or factoids on Craco. It read:

CRACO (391 meters.) A totally deserted ghost-town of medieval origin. The old village had to be abandoned by the population after 1963 following a number of landslides. Still standing are a tower of the castle and the old baroque church of San Nicolà. Twenty brigands were shot in front of the church in 1862, as strong rebuke to the ruling class, too lenient in its repression.

CRACO

Usually the D'Agostino guidebooks are generous to the point of loquacious overkill in their descriptive details and litanies of architectural and religious heritages. But this was all they offered on Craco. And in other guidebooks of a more general nature, there was no mention of the town at all, despite the fact that it had been

used as a backdrop for many of the scenes in Rosi's film of Levi's book.

A perfect place for an afternoon jaunt with camera and sketch-pad, I thought. Maybe I could get up to the old baroque church where the brigands were shot or even to the castle tower that had stood out so dramatically when I first saw the place that dark evening.

So, off I went, hoping I might bring back some interesting tid-bits of information and calm the obvious concerns of Massimo's friend. "Dangerous," he'd said! Well, we'd just see about that . . .

IT WAS A WARM and beautiful blue-sky day, and along my meandering back-road drive I saw other all-white hill towns perched or sprawled across mountain peaks and ridges.

And then I spotted Craco, looming up to the south like some Tolkienesque fantasy. An ideal setting, I mused, for one the *Lord of the Rings* sequels. But as I drew closer, the place began to lose some of its fairy-tale charm, taking on a distinctly haunted appearance. A skeletal aspect. The broken walls of collapsed buildings reared up like bare, brittle bones and windows peered out at me like empty eye sockets in a catacomb of ancient, earth-stained skulls. There were no gleaming glass panes or brightly painted shutters to soften their vacant stares. And there were no doors either, so doorways gaped like empty, fleshless mouths, some twisted and leaning in agonized maws beneath massive stone lintels, where the deserted houses had buckled through neglect or the collapse of supporting structures.

Well, I guess I can see why people might be a bit leery of the place, I thought. Particularly at night, under a bright moon, when I could imagine it took on quite a ghostly character. But, I reminded myself, it's brilliant sunshine today and it looks like there are still alleys and steps intact so I should be able to get to the church at the top of the precipice and maybe even as far as the castle tower.

I parked in a vast field of rubble beneath the village. Remains of a once finely cobbled road led up to a broad broken flight of steps that climbed to a broad terrace—perhaps the remains of the main *corso* and *passeggiata* piazza.

The silence was intense. I started to climb. Even though I could feel slight breezes around me, there were no trees to reflect their presence in motion and sound. In fact, there was little vegetation of any kind, merely pockets of summer-brittle grasses and stunted scrub, much of it bleached white by the scorching late-summer sun.

I continued climbing up rubbly remnants of steps to the terrace and found it to be the forecourt of what once must have been an unusually elegant palazzo with huge windows of Palladian proportions, elegant wrought-iron balconies, and massively arched doorways . . . with no doors. An obvious invitation to enter, which of course I immediately accepted.

The lower floors seemed to contain mostly rooms of a mundane nature—storage *cantine*, a large kitchen with an enormous fireplace and even a few battered pans lying on its broken floor, and other eerie, dungeonlike spaces, small, cramped, and musty.

I followed what seemed to be the once-elegant main stairway to an upper level of a very different nature. This was obviously the living quarters of the palazzo's *padronale* and his family, and while in a state of miserable disrepair—its ornately tiled floors strewn with rubble, walls cracked, and balconies half-collapsed—I could tell that it had once housed a family of very substantial means. There were massive baronial fireplaces, some still framed in carved stone, remnants of elegant wood-paneling, and, most striking of all, exquisite hand-painted plasterwork on the ceilings and upper portions of the tall, once-refined rooms. The paintings suggested a life of luxury and amplitude, depicting garlands of exotic flowers, plump, smiling cherubs floating in pale blue skies, and bacchanalian profusions of fat fruit, huge fish, haunches of meat and game galore—pheasant, deer, hare, and boar.

I was particularly intrigued by the artist's rendering, high above a broken but once exquisite mantelpiece, of a boar's head. While the other depictions of animals, fowl, and fish were masterfully done, there was something unusually realistic about this particular boar. It seemed to project forward beyond the other images, and as I moved about the room its head seemed to grow larger and more three

dimensional. When I focused on it and stared harder, it receded, but when I shifted my position and turned quickly to look at it again, it appeared to protrude like a taxidermist's re-creation of an actual head, complete with fierce incisor teeth and a bristled hide so well detailed that it looked almost tactile.

Remarkable work, I thought. And then I peered even closer. Something about the boar's face seemed different now. Less animalistic and, well, more familiar. Those bright, intelligent, but cruel eyes and that half-smiling sneer of a mouth were, in the half-light of the room, almost humanoid.

Stupid idea, I told myself. A trick of light or a clever bit of artistic license. But I'll take a photo, I thought, and see how it appears on film. Only the camera wouldn't function. My big, fat, complicated Canon, with its almost embarrassingly long zoom lens, refused to work, despite every indication that the battery was fully charged and everything else in order. When I pressed the shutter button, nothing happened. No reassuring click or whirr of the winding mechanism. I gave it a little knock with my fist (a common and effective solution, I'd found, to many mechanical and electrical problems), but still nothing.

With a final frustrated glance at the boar's head, now looking more human faced than ever in the darkening room, I turned to leave but . . .

Why the darkening? I wondered. It had been quite bright when I entered the palazzo only ten minutes or so before. I walked to the window and peered out. There was my answer: The sky had indeed darkened, quite ominously, and what had been a perfect blue sky was now increasingly blotted out by huge banks of cumulus clouds, rolling in like invading galleons from the Pollino range. They must have been on their way here when I arrived, I told myself. I just failed to notice them on the western horizon.

It was now too gloomy to see much more in the palazzo, so I retraced my steps to the broad, marble-paved terrace and decided I'd better start climbing up through the alleys if I was to get to the church and the site of the brigands' execution before the weather changed.

I began clambering up steeply stepped passageways littered with broken bricks, stones, and pantiles from the half-collapsed houses that closed in tighter and tighter. Compared with the spacious luxury of the palazzo, these were miserable little hovels, single-roomed, cavelike dwellings crammed together with almost no windows, tiny one-log–capacity fireplaces, and no bathroom facilities of any kind. It was not a pretty picture of eighteenth- and nineteenth-century community life, despite the romantic silhouette of the hill village from the distance.

It was a frustrating climb, too. Alleys ended without warning in sudden shadowy culs-du-sac; stairways had collapsed entirely in places so I had to find other alleys. And it was getting darker and colder. I realized I was becoming increasingly lost in a labyrinth of twisting, sinewy streets, some barely more than a body's length in width and so contorted that I couldn't see any landmarks—the church or the castle tower or anything else I could recognize.

And then came the first few drops of rain.

This was not working out at all the way I had planned. All I had on was a cotton shirt, jeans, and sandals, and I had no desire to be drenched to the bone in one of Basilicata's notoriously fickle and furious rainstorms.

The hell with it, I thought. I'm getting nowhere except lost, so why don't I just go back the way I've come and try again another day? After all, it's not a long drive from Aliano.

And what should come next, of course, was indeed one of Basilicata's notoriously fickle and furious rainstorms accompanied by seething winds, which seemingly sprang out of nowhere and were suddenly howling around me, tearing up the alleys and across the half-collapsed rooftops like shrieking banshees.

One moment, a few warm drops; the next, a deluge.

I began to hurry back down the increasingly slippery marble steps, but I'd forgotten the way back and kept running into dead-ends or places where I had to climb higher to find another alley going downhill. And all the time the downpour was growing stronger and louder. . . .

"Find shelter!" I yelled aloud (an occasional odd habit of mine, this talking to myself).

Fortunately, I spotted a half-open door to one of those dreadful one-room houses. I pushed it open, jumped inside, and closed it tightly against the rain, which was now flailing in wet sheetlike deluges up and down the alleys.

The thick door jerked and rattled against the power of the storm, but I managed to keep it almost closed. "Geez!" I shouted aloud again. "This is ridiculous!"

I'm not exactly sure of the next sequence of events. It all happened so quickly. One moment I was inside, out of the rain, and the next I was . . . outside again, petrified! Something behind me in the blackness of that pitch-black house had been moving. There was a strange shuffling on the floor, then a sort of scratching sound, like claws on hard stone. Almost leaping out of my sodden clothing, I flung the door open, hurled myself back out into the pounding rain, and ran down steps and more steps, oblivious to my skidding and sliding on their lethally slippery cobblestone.

At least I was going downhill, I thought. I turned and saw nothing. Whatever it was in that hovel was not coming after me, so I slowed my pace. Directly ahead and below me I saw the roof of the palazzo. As I grew closer I noticed a small building projecting from its side, and this time there was no door so if anything was lurking inside . . .

But there was nothing lurking. At least nothing you would call animate. So I flung myself inside, away from the rain, and stood heaving and panting like a hog in heat, which, as it turned out, is rather an appropriate metaphor for what happened next.

It seems that I had inadvertently sought shelter in the family tomb of the palazzo *padroni*. I could have let out another yelp and run like hell once again, but I didn't. I was tired of running and tired of being terrified. So I stood my ground and looked around with the cool gaze of an amateur anthropologist. I allowed myself to be impressed by the majesty of the memorials to past generations of *padronale*, and by the meticulous nature of the carved inscrip-

tions, and by those strange porcelain-etched photographs that are used throughout Italy to ensure realistic remembrance of generations past. And I was thinking, what a cozy collective setup they once had here, with the living occupants enjoying the sumptuousness of their lives in that ornately decorated palazzo and their deceased loved ones nestled in dusty peace right next door in this cozy chapel tomb, and . . .

Then I noticed one particular photograph, larger than all the others and set apart on its own inscribed tablet. And I recognized it, him, immediately. (Now you'll think, this poor fellow's gone a little crazy what with the storm and all that running and the scratching thing in that pitch-black little hovel, and more running—but all I can do is tell you what I saw clearly and unambiguously.)

It was the face of the boar. Not a boar in actuality, of course. It was a man's face—his head, shoulders, collar, tie, and huge, bristly head of hair—but it was also the face of the boar. The same startling eyes and obviously unusually large teeth as displayed in the sinister half-smiling sneer of the boar's mouth. No doubt whatsoever about it.

And if you don't believe me, all I can do is invite you to go see for yourself. But tread cautiously. There are creatures lurking in that malevolent place—shape-shifting boars or otherwise—and the palazzo, along with much of the rest of Craco, is dangerously unsafe. So, once again, *caveat emptor* (which is a phrase I must learn to heed more often in my spontaneous rambles). Another apt phrase, and one I've always rather treasured, is, "The world of the imagination is the only one worth living," although I guess I should consider discarding that one.

Things Elemental

Our simple life in Aliano occasionally made us introspective and encouraged us to reevaluate our other existences, in New York and Japan.

Someone once asked us: "Why, of all places to live in the South, did you choose a place like Aliano?" Actually, a number of people

asked that question, back in England and the States, when we described the kind of "back to basics" life we were living there. Others who asked it were Italian. For example, my grandfather's doppelganger, Professor Nicolà Strammiello, founder of Matera's Carlo Levi Center. He had looked down his prominent, aristocratic nose with a mischievous glint in his eye, given one of his hasty, devil's horns finger gestures, and said, "And it's where Don Pierino lives, too!" (I never found out the real reason for his odd sentiments toward my favorite priest.)

We usually managed to offer a pretty convincing rationale, putting heavy emphasis on the significance of our living where Carlo Levi had been imprisoned and the importance of feeling, up close and personal, some of the emotions and even terrors he'd experienced in what was, and still is, a very tough, unadorned, unpretty, worn-down kind of place.

But once in a while, after rambles through nearby villages more aesthetically appealing and generously infrastructured—places like Guardia, Accettura, Corletto, Stigliano, San Mauro Forte, and even tiny Cirigliano, perched perkily on its rocky puy, tight, twistily mysterious and artistically appealing—we would ask ourselves, "So, why Aliano?"

And we realized that something about Aliano's utterly unassuming and unselfconscious spirit appealed to both of us in the same way that Giuseppina's house, with its splendid terrace, had lured me in despite the fact that nothing about it, beyond the magnificent vistas, reflected the slightest iota of our own tastes in furnishings or our delight in gadgets, climate-control, diversionary amusements like our video library, a fine sound system, a well-designed and equipped kitchen, and space, lots and lots of good old American domestic space.

Our home in Aliano was cramped, invariably too cold or too hot, and devoid of a TV or a decent stereo system. It possessed an inadequate hot-water system, a kitchen stove with two malfunctioning burners, a non-operative oven, and a bed that creaked and groaned like a dying elephant. The lighting system, consisting of high, cen-

trally placed, low-watt bulbs that, until we supplemented them with a few inexpensive market-bought table lamps, produced a form of illumination so depressingly Hopper-like that we named them "suicide sockets."

And yet, we both loved the place. And if we had to be away for more than a few days, we yearned to be back, happily cursing the stove and the erratic shower and the long, laborious climb up from the street, and the constantly clanging church bells across the piazza, and the barking dogs outside the window, and the toe-numbing chill of the tile floors in the early morning, and the fact that we could never cook Yorkshire puddings or cakes or pies or soufflés in our nonfunctioning oven.

I wondered if I was in some kind of masochistic mode or some bizarre male-menopause interlude or perhaps seeking to return to my Yorkshire childhood, when, from what I can remember of our little home among the coalfields and "muckstack" slagheaps, conditions were not much better than in Aliano.

But then, looking back over our married life, Anne and I reminded ourselves that despite our over-large upstate New York home and our smaller, but delightful rented house in Japan, we'd also spent years living together out of VW campers (we later upgraded to a twenty-foot-long Winnebago motor home), rented places (well over twenty, ranging from the barely tolerable to the outrageously sumptuous), and other homes were loaned occasionally by kind colleagues, who, intrigued but also concerned by our gypsy ways, possibly felt that they should offer some form of "get real" respite for their two erratic world-wandering friends.

"Isn't it time you had a real home of your own?" some would suggest with well-intentioned earnestness. "After all," one architect friend reminded me, "you were once an urban planner. You appreciate the pleasures of fine design and the joy of sensitively articulated spaces. Surely you can't keep on living in vans?"

I remember trying to explain that we found something deeply satisfying in condensing our lives and our needs into a compact, ingeniously designed traveling box. "You get rid of all the super-

fluities," I'd said. "You only have what you really need. You become . . . elemental, in practice and in spirit."

And how valid I realized that off-the-cuff remark was when, years later, we did in fact (somewhat nervously) buy our first home in the United States, and found that in no time at all the place was packed to the rafters with . . . stuff. Unbelievable amounts of superfluous stuff that we'd never needed before but that now suddenly somehow seemed vital to our daily existence. A sort of Peter Principle of clutter: Stuff tends to fill to the space you have.

But thinking again about Aliano I realized how significant that word *elemental* had become for us. For that's what we found there: a space small enough to ensure that we surrounded ourselves only with things that were truly of value in a village where superfluity, materialism, exhibitionism, and a "he who dies with the most toys, wins" attitude were not, and had never been, options.

Most homes we visited in Aliano were masterpieces of minimalism. A few even consisted, as they had for centuries, of a single tile— or flagstone-floor room—some barely bigger than a twenty-foot-long motor home—with bed, table and straight-backed chairs, a small stove and sink, a fireplace (sometimes), a well-used armchair (rarely more than one), an ancient wardrobe and chest of drawers, maybe a TV, and a tiny screened-off bathroom. The only items of decoration were invariably limited to framed religious icons (with a distinct bias toward the late Padre Pio of Pietrelcina famous for his recurring *stigmata* [wounds] and now a saint), a few family photographs, and a nailed-up calendar usually adorned with kittens. The last item always struck us as rather odd, given that the Alianese were not particularly fond of house pets, possibly because in the old days they had to share their single-room houses with a menagerie of farm animals.

Even where an Aliano home boasted additional bedrooms and maybe a larger bathroom, the same hard-edged, no-frills minimalism persisted. Little attempt was made to soften the spectral gloom of the rooms. Low-wattage bulbs, often of the fluorescent kind, were used, producing that dreary, autopsy-room light. And in some of the farmhouses we visited, the living space often contained a beguiling

mix of basic domestic necessities—piled sacks of animal feed and fertilizer underneath clusters of homemade salami, prosciutto, and pancetta dangling from cobwebby rafters, alongside earth-encrusted collections of farm implements—all in the same living room. At one farm in particular, a flagstone in the floor of the main (only) room was lifted to reveal a basement byre filled with a jostle of cows, sheep, and goats, all of whom turned to look at us with baleful eyes as we peered down from above.

But, similar to New Age productions of Shakespearean plays featuring minimalist stage sets, such homey spaces were quickly transformed into intense, vital theaters of life. Characters entered, conversations began, laughter rose, flamboyant gesturing flared, voices clashed and collided, and emotions ran the gamut from ribald to ripe affection to rhetorical excess and climaxes of emotional release that far out-Olivier-ed Olivier and even surpassed the gilded gushings of Gielgud.

Shakespeare would have indeed felt perfectly at home in such a medieval morass of familial affection and endless squabbles and bawling babies and sauces and stews bubbling on the stove and the day- and nightlong dramas of human beings hacking out their conjoined lives with such edgy intensity that the primitive stage "set" in which Alianese lived everyday lives faded into utter insignificance. In fact, anything more elaborate or self-consciously fussy would have detracted from that drama. Elegant drapes, chintzy accoutrements, elaborate displays of family china, or excessive concern over matched dinner sets or fine crystal, would have created a distinct sense of dislocation and discomfort.

So, "elemental" my dear Watson, was the key in and around Aliano. And what were a few chipped cups and mismatched odds and ends of cutlery, when the food was rich, filling, and generous, the wine homemade and strong, the *bruschetta* dripping with homemade olive oil or creamy chicken-liver paté or melted pecorino cheese, and the spirit of affection and camaraderie so intense and all consuming that nothing else seemed to be of any real importance whatsoever.

And that was what Aliano offered in abundance. We felt ourselves fortunate and indeed honored to be able to participate in such a rich and spirit-nurturing stew of human sentiment, conviviality, and love. "The good life" was indeed alive and well here in abundance, despite all the modest trappings.

And for the moment, we had no plans to live anywhere else.

An Afternoon with Angelo

Especially when good old serendipity kept rolling in, offering unexpected diversions and delights. This was merely one little example, but a most memorable one . . . It all began with a picture I just couldn't resist. Normally I was very careful about the way I used my cameras. After all, I wasn't a snap-happy tourist on a point-shoot-and-run package-trip schedule. I lived here, and, while admittedly I was prying into the affairs and activities of the locals, I did my best not to make that too obvious. I put up a front of polite but casual indifference, used my smallest camera where a shot was vital, or ask permesso if I felt I had to be a little more blatant about the whole thing.

Which it wasn't hard to be if I happened to be lugging around my huge Canon, with its embarrassingly phallic telescopic lens. But that's all I had with me in the car that afternoon as I spiraled down the tornanti through Alianello, on my way to the supermarket at Sant' Arcangelo and to make a few phone calls. The public phone in Aliano was, as usual, nonoperative.

I was overdoing the Monte Carlo rally bit on some of the bends, convinced that I had the road to myself, and that's how I almost ended up bumper-to-backside with the rear end of a very old and bedraggled mule—complete with dual wicker panniers, three huge, yellow-plastic cassette used for the grape harvest—and the rather alarmed elderly gentleman in an earth-splattered flat coppola cap and old leather vest, perched atop his faithful steed.

I suppose I could have just carried on as would most other "why the hell are you on my road?" Italian drivers, but something about the look of disgruntled alarm in the old man's face made me pull

over, turn off the engine, and walk over to offer my apologies. (And while you're at it, suggested my little avid photographer, you might just as well take your camera along.)

And that's how I came to meet Angelo Guarino. We shook hands—his as rough, twisted and gnarled as an olive tree trunk, mine white and sponge-soft as usual. His forehead was furrowed like dark, lumpy rows of newly ploughed earth. I made my apologies and he gracefully dismissed them with a shrug and a smile. I admired his mule and the strong wicker weave of his ancient panniers. Angelo asked me if I had a cigarette. I said no, I don't use them, but if he'd like a cigar instead . . . He nodded enthusiastically, so I pulled one out of my vest pocket. (Yes, like my beloved grandfather, I'm an unapologetic cigar smoker, one who staunchly supports Mark Twain's maxim that "Smoking a cigar provides the best of all inspiration." But, of course, I carefully limit my consumption, as did the renowned Mr. Twain: "I smoke in moderation—only one cigar at a time.") Angelo's deep-set eagle-eyes, hooded, wary, and darkly shaded by his *coppola*, seemed to glow with irrepressed surprise and delight. He accepted the cigar tentatively, as if afraid his hard *contadino* hands might break such a delicate creation. The Cuban seed (Dominican-produced) wrapper, encased in the six-inch-long, glossy cellophane tube, glowed a deep bronze in the bright sun. Angelo fumbled to open it and then eventually extracted the cigar slowly, lifting it to his nose to smell its rich, toasty aroma. I asked if he'd like to smoke it now, and it was perfectly obvious by his toothless grin that he would. So I pulled out my lighter and, as he sucked vigorously, I lit the tip as gently as I could, despite the fact it was wobbling backward and forward in his saliva-dripping mouth. His eyes crossed slightly as he tried to focus on the tip of this obviously unfamiliar object and keep it still.

Finally it was done, and he began to draw the smoke deeply into his mouth as tradition decreed, and then onward straight into his lungs, as if he were smoking one of those tiny and very mild Basilicatan cigarettes. I was about to discourage him from doing this—there's an awful lot of smoke in one puff from a cigar, and most

people, myself definitely included, could no more inhale on one of these fine creations than eat a plate of boiled ox eyeballs. But apparently it didn't seem to faze Angelo in the least. Either he had lungs of steel or had endured a lifetime of breathing in the rich, winter smoke of burning oak and olive logs in a house whose chimney was, more than likely, either a loose tile in the roof or even something designed to *discourage* evacuation of smoke and heat. (As one *contadino* put it to me concisely, "Why have a chimney? I'm the one that needs the heat, not the sky!") And so Angelo puffed and inhaled and puffed again, and I thought that it was the ideal moment to ask if he minded my taking a photograph of him on his donkey enjoying the fruits of some tobacco farm in the remote Dominican Republic. He seemed delighted by the idea, and so I clicked away as he sat, upright and kingly, in his ancient saddle, which consisted primarily of a squashed pile of old olive-harvest burlap sacks.

When I paused to put a new roll of film in the camera, he asked if I enjoyed the wine of Alianello. I replied that I didn't know, having never sampled any.

"Oh, *Santa patata!*" (Holy potato! a wacky local expression) he exclaimed, with a widening grin revealing his pink gums and large purple tongue. "Maybe then you would like to sample some of mine."

Hazy recollections of the rest of that afternoon include my first introduction to the delights of wining and dining in a *Sassi*-like cave (*grotta* or *cantina*) hacked out from the soft tufa rock beneath the prominent crag on which the partially abandoned village of Alianello Vecchio somehow still perches. Antonio called the ghostly remnants a *paese sperduto* (a god-forsaken place), and there was certainly something Craco-like and sinister in its broken walls and weed-clogged alleys.

The approach to Angelo's cave was precarious, even in a totally sober state. At least it was for me. Angelo tied his donkey to a tree by the road and then scurried off along a narrow rock ledge littered with loose stones, exhibiting the agility of a sure-footed goat, and pausing once in a while to look back at me as I followed with the pace

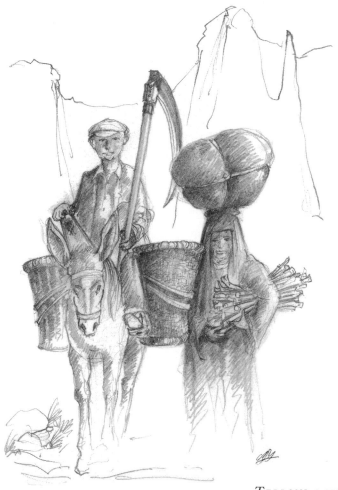

TERRONI COUPLE

and timidity of a turtle. If I stared hard at the rock face of the cliff I felt reasonably safe, but once my eyes strayed—as of course they did—to the edge of the three-foot wide path and the vertical drop of more than two hundred feet that lay beyond its eroded and very fragile-looking edge, my legs immediately developed the shakes and my pace slowed to a geriatric shuffle.

"Very old path. A real *sentiero*," Angelo called out, I think by way of encouragement, to assure me that for generations the path had

withstood the ravages of time and the torrid climate and provided safe access to all the numerous caves scattered along its length. I nodded, but couldn't quite seem to share his nonchalance. A rock suddenly shot out from under my right foot and sent me skidding toward the drop. The rock tumbled over the edge, and it was a long time before I heard it hit the earth far below. I backed up even closer to the cliff, using its occasional protrusions as handholds. I knew Angelo was smiling—maybe even sneering at my overcautiousness—but I decided not to look at him and kept my eyes fixed firmly on the path and the cliff. I wanted no more loose rocks. All I wanted, needed, was a glass of that wine of his to steady my nerves. Which it must have done, as I seem to remember, after our pleasant interlude together, strolling back along the same path with a confidence and braggadocio that were altogether lacking on my outward journey.

Eventually we arrived at an overhang in the cliff face and an ancient wooden door set tightly in the rock. The door was padlocked with the kind of enormous contraption they doubtless once used to lock up castle dungeons. Angelo's key was equally enormous—more than six inches long, very thick, and very rusted. Lock and key were joined, but for a while it appeared neither would submit to the other. Angelo spat, cursed, waggled the key, and thumped the lock with his fist.

"Very old lock," he explained unnecessarily. "Very strong."

Finally, with a series of deep rasps and grinds, something gave and the lock opened. Angelo pushed the thick, weather-gouged door inward.

Daylight dappled the ancient walls of the hand-hollowed cave. As my eyes grew accustomed to the half-gloom, I spotted the marks of whatever chipping instrument—something like an adze perhaps— had been used to gouge out the interior. Although the space was not particularly large compared with the *Sassi* in Matera—a little over six feet high and maybe nine feet deep—it must have required enormous effort to complete the task. Whoever had undertaken the work had obviously been a methodical, practical, and even artistic man.

The chiseled marks in the tufa were even and regular, and they caught the light in a rather pleasing manner. Depending on the angle of the cut, some facets were bathed in the full golden sheen of the sun while others glowed in various hues of bronze, amber, and ochre. There were shelves, too, cut right out of the rock, and hollowed areas for storage, which Angelo had used to good effect. On some rested small tools and boxes of nails and screws; on others sat various household items—plates, cups, and glasses—that suggested that he occasionally used the cave as a kind of vacation apartment. It seemed to be the ideal place, like one of those local shepherds' *baracche* (huts)—a place to escape the intensity of the tight-knit village high above at the top of the cliff and enjoy a little solitary peace on a shelf of land boasting splendid vistas across the Sant' Arcangelo Valley and the vast purple-blue Calabrian ranges beyond.

Other objects made the cave feel distinctly domesticated—a metal-frame bed covered with a thin mattress and an old raglike blanket; a couple of rough-hewn stools; flurries of red peppers hanging to dry on strings attached to hooks pounded into the rock ceiling; half a dozen very moldy salamis dangling alongside strings of garlic, onions, and even tomatoes, which had wizened themselves into tiny, leathery, burgundy-red skeletons of their once-ripe plumpness; and four fat, golden globes of homemade pecorino cheese. And then the wine: Four, three-foot-high wooden barrels and six fifty-five-liter glass demijohns, each with its small tap at the base for pouring.

IT WASN'T LONG before our sampling began. Angelo pulled the two stools into the doorway by the path so we could enjoy the breezes and views while we sipped his brews.

The oldest was a three-year vintage Montepulciano—dark, rich, and thick, with a strong bouquet and an enduring taste that moved from tart to a coy sweetness at the end. The youngest was this year's production of a Sangiovese—more modest in flavor but with a bright fruitiness that made it seem effervescent as it bounced along the tongue.

Between glasses he served slices of one of his salamis, which, once the mold and skin had been removed, had a deliciously pungent, salt-and–hot pepper flavor that seemed to grow deeper the longer you chewed, especially if you added pinches of the chili pepper and dried tomato that Angelo had crumbled onto a plate from the strings of them dangling from the ceiling. Oh, and some of his olives, too. Beautiful dark green creatures he'd marinated for weeks in an olive oil, vinegar, wine, garlic, and a hot pepper mix and served in an old cracked bowl with such panache and pride that you'd have thought he was offering the finest Beluga caviar. And around the edge of the bowl, he placed chunks of aged *pecorino stagionato*, gamey with its rich aroma of sheep's milk, but creamy sweet when it melted in your mouth.

Fortunately, and coincidentally, Angelo had spent a few years working in England, not far from Nottingham, where Rosa and Giuliano once had their shop. While his memory of the language had faded somewhat, as the afternoon eased along, we still managed to chat in wispy strands of English about his life and his family.

The cave had been carved out of the rock by his great-grandfather, and although Angelo insisted that it had been used as a wine and curing *cantina* for a long time, I wondered if it had once also been a dwelling, as was the case with many places like this around Basilicata. I was tempted to ask but was unwilling to risk our new companionship by prying into things that might be embarrassing to him or, worse still, might make him suffer any *brutta figura* (loss of face)—a real no-no in these parts if you valued an enduring friendship.

Under the convoluted, and often corrupt, land reforms of the sixties, Angelo's father had been able to convert his *mezzadro* (sharecropper) status into that of a landowner of seven hectares of arable earth, olive trees, and a small vineyard, now defunct. (Angelo purchased the grapes to make his wine from other larger local vintners.)

I asked Angelo how he felt things had changed since the feudal "quagmire days" of the notorious *mezzadria* system, when, on a

whim, powerful landlords might increase their fifty-percent share of all crops grown by their peasant tenants to sixty or even eighty percent.

"Well, I suppose some will tell you things are much better now. But I don't think too much has changed, really. Maybe worse now in some ways. Less people work the land now. The old men, like me" (he laughed a deep, throaty laugh, spitting out bits of olive and cheese), "we can't do too much. And the young men . . . well, they won't. They go away. You know old story. In past they go to America or Australia. Now today that's not so easy, so they go to the North— Bologna, Milano, or Germany. Even England for some."

"So at least the education system, the schools, may have trained them for a better life."

"*Porca Madonna! Dio Cristo!*" he exclaimed. "What education?! Most of them go to do building or house-painting or stupid kinda work. No security. No pension. Some find government jobs, but only if they have many *raccomandazione* [recommendations]. And you know what they think of recommendations from Basilicata? They think we still animals down here. Even though now we own our own houses and our land, and now many of us have cars, TVs, refrigerators, all these things. Just like up in the North. But they still think we all *pagani, terroni, mezzadri*. So . . ." Angelo gave an enormous, sad shrug and took a long slurp of his wine. "So, what can you do? In our world down here much has changed, but it has not made so much difference I think . . ."

The breezes were warm and playful. Grasses rasped and the sun was hot, but not unbearable. A strange halo of haze slowly revolved around Pollino's huge, rounded summit. Elsewhere the sky was azure blue and cloudless.

I asked Angelo to tell me what life was like when he was a child. His eyes glazed over and he sighed. He was silent for a while, then spoke quietly: "It's little things I remember most. Everyone was farming then—husbands and wives—all working on small pieces of land, sometimes a long walk from the village. So that's what we all did, and you didn't think about it. But the little things . . . like the

foccaccia, warm from the bakery with garlic and little bits of tomato on top. We almost lived on that. We dipped it into our own olive oil. It was beautiful. And pasta. Lots of pasta. Maybe a little meat—salami, rabbit, lamb, even *cinghiale* —on weekends, but mainly pasta with olive oil and the *conserva di pomodoro* my mother made. A beautiful sauce with garlic and basil and little pieces of fennel. That gave special taste. Different from what others made. I could always tell hers. Sometimes my grandmother brought her own sauce, but it was just tomatoes and salt. You had to add things to make it good to eat. I think our home, my mother, had the best *cucina di casa* [home kitchen] in Alianello. All the family used to wait for her to shout, '*Andiamo a tavola!*' ['Come to the table!']"

Another long silence. I decided not to interrupt. He would tell me things if and when he was ready. And then suddenly he laughed, his wrinkles undulating across his face like things moving under his skin. "Oh, the toilets! I forgot. We had those great chamber pots—*zio peppes* they were called or, if you are polite, *vasi da notte.* There was always argument about who should carry those outside when they were full and pour the stuff down the ditch. And we all lived in one room, you know. Eight of us. With a small *cantina* at the side for the mule, pig, chickens, three cats, maybe four, and rabbits. We tried to keep six rabbits but sometimes we got very hungry and . . . well, we might only have two or three then. But, oh, they tasted so good in my mother's wine-and-pepper sauce, and then she would curse at all the washing-up which she had to do in large bowl using sand and ashes from the fire. She kept soap for *real* washing—clothes and things like that. Soap was very expensive. Some people made their own soap from pig fat after they killed the pig and hung all the salamis. But they used lye in it, and it was dangerous. If they got the mix wrong it could burn your skin and your eyes. And now today when I go into our local store in Aliano, although it's very small, I see two dozen, maybe more, types of soap and detergent and washing-up liquids . . . and all so cheap too!"

Angelo laughed, a deep, warm, rumbly sound that echoed back into the cave. "Yes, it's all so crazy! Once we had almost nothing—

and not so long ago either—and now we've all got these new things in the stores. And all the TVs, too. My grandmother used to refuse to watch. She said the Pope should ban TV—all those naked women and stupid, rude shows and all the bad news about a world full of sin and evil things. She was very angry. And very strong. Like most women here. They say the men are the head of the house—the *capo della casa*—but . . . well, maybe that's what the women like us to think. But I don't think so. The young children worship their mothers like Madonnas, but as they grow up they see that she's tough, too. Like my wife, Maria. She can be very sweet and kind, but she's also very good at keeping all our affairs organized and looking after our money. There's not very much, but she makes sure we use it carefully and save some."

He paused, nodded, and smiled to himself, lost for a while in some pleasant reverie about his domestic life. Then he was off again. "Once we had five bad years here in a row, crazy times: The hot winds, *levante* and *libeccio*, burned up the olives, the *grandine* [hail] flattened the wheat, the grapes got some kind of fungus, and most of our house crops—tomatoes, onions, zucchine, and things— were lost. But somehow Maria looked after the children and also went out and got jobs, little things: sewing, cleaning, teaching music. And she made sure we got through okay until things were better. And she never complained or got angry like some of the other women—real bitches, some of them. Hard, crude, always cursing, and shrieking."

Another long, introspective pause. Then Angelo continued quietly. "I thank God I am lucky to marry my Maria. And she always say to me, 'We've had all our bad luck. Things can only get better now for us.' And she was right. They always did. And when we look after another small farm, she work with me in the fields until our fifth child came. A bad birth . . ." Angelo paused. Obviously his memories hurt. "I thought I'd lose her, Maria. Baby came the wrong way. There wasn't time to get her to Potenza, to the hospital, so everything was done at home like all the others. And you know . . ." He paused again. "She never cried once. She . . . just bit into the

blanket until it was all over. Not a single cry of pain. She knew that was the old way it should be: no cries. Although it was very, very bad for her."

This time the silence went on longer than usual, so I poured us both another glass of his Montepulciano and decided I had to say something: "A toast, Angelo. You're very lucky to have such a fine wife, so let's drink to your Maria!" And we did, almost draining our glasses in one gulp. "And to you, too, Angelo, to a fine winemaker, genius of the art of salami-creation, and master of olive marinades."

". . . And very happy man, too," Angelo added with a big grin. "Why?"

"Because although we are not rich peoples, we are *autonomi*—our own bosses—not *dipendenti* [employed workers]. Also we don't have two much *sotto le stelle* [stress] in our lives. And, of course, I am also happy because my wife lets me come here and drink and eat and talk to peoples . . . good peoples."

"Thanks, Angelo. I owe you another cigar."

He turned and gave me a quizzical grin. "Eh! Who say I was talking 'bout you!?"

Our wine-daft laughter echoed in the cave behind us, rolled over the edge of the cliff, and drifted off in the direction of Pollino's hazy halo and the beginning of a lovely, luminescent sunset.

Freedom Is the Absence of Choice . . . or Not

Between these sudden spontaneous happenings, the simplicity and slow, steady pace of daily life here encouraged moments of reflection, so bear with me on this story. We're taking a little diversion, but I promise we'll soon return to Aliano.

ONE OF MY FATHER'S unrequited ambitions in his later life was to write a book with the title *This Freedom*. He mentioned it many times with a wistful look in his eyes, usually after he'd closed up his grocery store in the small village where we lived on the fringe of the once-great Yorkshire coalfields. He would slam the door tightly

shut, turn the lock with a sigh, and climb the stairs for a "quick wash" (he was very fond of that word "quick": quick drive, quick nap, quick lunch, quick cup of tea). Then, without a scintilla of quickness in it, he would go into our lounge above the garage, sit at his old upright Steinway piano, and play Beethoven's Moonlight Sonata or some gorgeous Debussy prelude or fragments of Chopin or Mozart or even parts of a Bach concerto, with all the grace and touch of a concert-hall maestro.

My father's life had not been particularly easy. Born to a rather poor Catholic family of Irish descent with younger siblings galore, he'd seen his beloved elder brother die a terribly slow death from lung-destroying mustard gas at the end of World War II. Later he played the piano for silent movies at local picture houses to boost the meager family budget. He rarely saw his father, my grandfather, who was a popular world-touring, music-hall performer, billed as "Yorkshire's Own Harry Lauder," from whose apparent successes the family rarely benefited financially. But Dad persevered at the piano, and his talents were recognized by a local mill owner, who adored the classics and who encouraged my father to take the scholarship exam for the London School of Music.

My father passed, the mill owner offered to support him financially during his studies in London, and for once the world looked very rosy . . . until a series of sudden calamities in the family, including a sudden marriage for one of the other brothers, made Dad suddenly responsible for supporting his mother and younger sisters. London and a life of music and concert-hall recitals were now out of the question. He became an engineering draftsman briefly and then an insurance salesman until, not long after he married, he was posted to the British Air Force in Australia in World War II.

Four long years later, he returned home a very different man, according to my mother. He was frustrated and disillusioned by the disasters of war, and by the loss of his job at the insurance company, a job supposedly "held in trust" until the war's end.

So, he became a shopkeeper. "It may not be much, but at least it's all ours," I remember his saying when he showed my sister and

me our new home. His face showed a mix of emotion: pride in his independence and "freedom," but I also remember seeing tears in his eyes. Music still coursed through his veins. The lost opportunity of his youth still rankled, dangling as a constant reminder, like a rotten carrot on the end of a broken stick.

I think that's when his idea for the book *This Freedom* may have germinated. He was nonplussed to put it politely—disgusted may be more accurate—by all the rallying cries for "Freedom!" during the sixties and seventies. And it didn't help much for him to watch me enjoying my own wild, roller-coaster ride on through that gloriously anarchistic era of Dylan Thomas, Brendan Behan, John Osborne, the Beatles, Jimi Hendrix, Bob Dylan, and Joan Baez—all those bold, "break all the rules," "get out of the way if you can't lend a hand," "make love not war," role models.

"Freedom isn't free," he would say during one of our infrequent "serious chats." "It requires rigorous discipline. Without discipline there's only indulgence, hedonism, selfishness, anarchy, and ultimately self-destruction."

"But, Dad," I would try to explain, "I'm just trying to find out who I am first and what my options are. Discipline can come later, when I've made some basic choices, when I have a clearer idea of where I'm going and what I want to do with the rest of my life."

And that's when he came out with that ancient saying: "True freedom is the absence of choice."

I gagged. "And you believe that?!" I said.

To give him his due, he patiently tried to explain the deeper implications of what sounded like such an obvious oxymoron. He placed particular emphasis on the Orthodox Jewish Hasidim who, because they devoutly followed their more than six hundred rules of daily life, which encompassed the most intimate of personal activities, claimed to release themselves from the constant natter-chatter of petty choices and find abundant time and freedom to focus on the higher, Talmudic aspects of their existence. And then he became more personal. "I reached a point where I had no job and, because of my age, not much chance of getting one. So, the only 'choice' I

could see was really no choice at all. I had to find a way of becoming my own boss in order to support us all. So, that's what I did. And insofar as it may have been a choice, it's the best one I ever made. And now, although it's not always been an easy job, I feel I've got all the freedom I want and need." Which brings me back to Aliano and most of the other hill villages in this once-forgotten, subsistence-economy part of Basilicata.

Watching the octos day after day happily chatting away with friends they've known since they were kids, and who all once worked similar small patches of land among the *calanchi* buttes, with their handfuls of olive trees and fruit trees and vines, I wondered if they ever saw life as having any choices in it whatso-ever. I actually brought the subject up one evening with a group of local friends and was greeted with deep, throaty guffaws of amusement and astonishment. And the essence of their general reply was that, except for those who'd emigrated to America, they never had any choices as *contadini*. The land was their birthright. For better or worse—usually worse—it was all they had, and they held on to it with the tenaciousness of those vicious Basilicatan shepherd dogs.

And it didn't seem to bother them one bit. The hardscrabble life they'd lived, the fickle fortune of harvests, the same meager diet of pasta and homemade tomato sauce for years on end, the searing summer heat, and those frigid winters had given them few, if any, personal choices. And yet, as one of them explained with a broad grin, their "freedom from choices" had given them great pride in *"tengo una famiglia"* ("I support a family"), a tight and loyal circle of friends, the joy of grandchildren and even great-grandchildren, a village they loved to live in, and enough resources—given the more generous government support nowadays—to live in reasonable comfort in their own homes, surrounded by all the things they loved and treasured. Oh, and one of them said, ". . . and a place already picked out for my final rest in the village cemetery, with views across this beautiful land, this *'stro paese* (place of true rurality) I've known and walked on and worked in since birth."

Another joined in, "Could anyone even with all the 'freedom' and 'choices' in the world ask for much more than that?"

A third decided to bring the whole discussion to an end with an appropriate Italian aphorism, which, in Alianese dialect, was almost incomprehensible. But I remember reading it somewhere: *Chi si accontenta, gode,* which translates roughly as, "He who accepts, enjoys."

Of course Carlo Levi saw it all a little differently. He regarded the feudal-like conditions back in the 1930s and the hard and endless servitude of the *terroni* as an insult to the essence of humanity in each individual. He saw what appeared to be the ever-constricting cycles of power and control perpetuated by almost instinctive fear at all levels. He perceived how the fear of mortality and the cruel vicissitudes of fortune among the peasants had led to the creation of ever more oppressive systems of church, state, and landowner control. And as such systems became more dominant and signs of revolt were perceived among the peasants, the systems themselves felt fear and tightened their rules, laws, and punishments . . . which in turn created even more fear among the peasants, and on and on: a doomward spiral for which mass revolution and total reformation were, according to Levi at least, the only solutions. Others in the village had similar views, too, and one man in particular seemed to enjoy expounding eloquently on Levi's themes, along with an enticing array of other matters of local import.

Banks, Butterflies, and Bewitchings

"Well, I certainly think he's still there!" Giuseppe D'Elia said with a little bank manager's chuckle, which was most appropriate because that's what this open-faced, polite, and witty gentleman was: the *Direttore della Succursale* (branch manager) *del Banco Popolare del Materano* in Aliano, which is hidden away, for some odd reason, up in the narrow alleys near the school.

"Who?" I asked. Our conversation had taken so many intriguing twists and turns, thankfully in English, that I wasn't sure exactly which of my questions he was now answering.

"Christ!" he said. "He's still stuck in Eboli! I don't think he ever really reached down here." he said, and chuckled again. His bright lemon tie, decorated with tiny blue butterflies, bobbed about as his large chest bounced happily. I couldn't help laughing at his gentle blasphemy.

"I'm not sure Don Pierino would agree," Anne said.

"Ah, the good Don Pierino. A fine man. He really cares for the Alianese. He loves them."

"And tries to bring about changes, too," I suggested. "It's not just pomp and prestige with him. His new olive mill, for example . . ."

"Yes, yes, very true." Giuseppe nodded enthusiastically, his butterflies fluttering again. "But he has a hard job. Things change so very slowly here. All the old things, the strange things, are still around, you know."

"You mean Levi's tales of witchcrafts and werewolves?"

"Oh, yes, very much so. Levi was not making these things up. He was recording fact, everything accurate and . . ." He paused in mid-sentence and seemed to be considering the efficacy of his next remark. "And, well, we still have one. Here."

"One what?"

"A *strega*, a witch." He followed this announcement with a quick *corno*, that curled "horned fist" with outstretched index and little finger used so often by superstitious southerners to ward off evil.

"A real witch! Are you joking? I've heard stories, but I thought people were just exaggerating."

"No, no. Not about that kind of thing. They are serious. I'm serious. Her name is Maria. A little elderly lady. She lives just around the corner. I have talked with her many times, and she's quite happy to tell you that she's a witch. That's what she told me the first time I met her. 'Welcome to Aliano,' she said to me when I arrived here. 'I'm a witch.' "

We didn't know whether to laugh. But we decided to play along. "So, could you introduce her to us?"

"Of course I will, if you wish. She would be very happy, I think," he said, chuckling again.

"We would like that," I said. Anne smiled and discreetly rolled her eyes.

"How about . . . Wednesday?"

"Fine. But why Wednesday?"

"I think that's her day off from witching." He burst out laughing again, and this time his butterflies almost seemed to be flying off his tie.

"Ah, you're joking," Anne said.

"No, I'm sorry. No. Truly. I think you might both find her very interesting. I will arrange this for you. If you come around midday. That should be a good time, I think."

"Well, thanks," I said hesitantly, thinking, 'Well, let's see how far he wants to carry this.' "And now back to the economy . . ."

Despite the fact that we knew he had at least two other clients waiting to see him, we chatted away for another half hour about the Alianese economy ("Very depressing. No young people stay here. They all want *stracittà* [city life]. They don't like the old *nostro paese* [rural life]); the Mezzogiorno economy ("What economy? Where are all the promises? Where is all the money?"); the changes since Carlo Levi's book ("I don't think so. Not too much"); the difference between the North and South ("Two very different places. In the South we are different culture. Many invasions. A mix of many peoples. Two separate countries. We are considered 'black.' Too many small towns and a bourbon and feudal mentality"); Aliano's isolation from other towns ("Very alone. 'The solitary man is not a man,' and Aliano is very much solitude. All we have here is *passatella* and card games to pass the time").

We enjoyed talking to Giuseppe. He combined humor with intelligence and a deep empathy for the problems of the South. "I think about it a lot," he said, "when I drive to and from work every day."

"You live where? In Stigliano?" Anne asked.

"Oh, no! In Salerno."

"Salerno! But that's hours away."

"Almost two hours," he said. "Each way." He shrugged. "But it is only for a short time, I think. The director told me only for one year."

"And how long have you been here?"

"Almost two years."

"So when . . . ?"

Giuseppe gave one of those shrugs of bureaucratic resignation. "I hope very soon, but maybe not."

"What else do you think about on your long journeys home?"

"Ah, well, I learn things—lessons—on cassette tapes. Also I play good music . . . and I think of pasta!"

"Pasta?"

"Yes. I am what you might call a pasta-nut, a true *pastasciuttaro!*" More chuckles and butterflies flying.

"So, which are your favorite kinds?" Anne asked, curious about the scores of different shapes and sizes of pasta we kept seeing in the local stores. "Other than the normal spaghetti and rigatoni and fettuccine?"

"Ah, well, that is very difficult. You see it all depends on the accompaniment. Each pasta, I think, has its own perfect accompaniment. You have to balance the two, even though pasta is basically the same mixture of flour and water and sometimes eggs. Each one 'tastes' different. It's very strange but logical. Would you drink wine from an egg cup? Or whiskey from a beer glass? Each type of pasta must be balanced differently or it does not taste right."

"Well, tell us a few of your favorites."

I was glad I had the tape running, because what we got was the most amazing encyclopedic recitation of pasta names and descriptions we'd ever had from anyone in Italy. The man was a walking menu. When we transcribed the tape we counted descriptions of at least thirty variants. Here is just a sampling of some of the more obscure ones:

"Okay, there's *rosmarini*, like long, thin rice; *corallini* and *paternostini lisci*, very small macaroni; *tempestine*, like Moroccan couscous; *stelline*, like little stars; *angelini*, like tiny halos; *fiocchetti*, very small *orecchiette*; *cocciolini*, like small *gnocchi*; *lumachini*, like tiny snail shells; *casarecce*, like hand-twisted strips; *tripoline* and *mafaldine*, strands with frilly edges like sheets of lasagna; and—definitely

one of my favorites to eat with rich sauces—*pipe rigate*, like little cups. Is that enough, do you think?"

"Amazing!" I said. "I don't think I've heard of any of those!"

"Ah, there are so many more," he said, chuckling and salivating at the thought of all those multitudinous varieties. "Like," and then he started again, "*semi di mellone, acini di pepe, mezzani, elicoidali, gomiti, liste, trofie . . .*"

"Okay! I believe you. I'm convinced. You're definitely an expert pasta-nut, Giuseppe. Congratulations."

"Thank you," he said. And I think he was genuinely pleased at the compliment.

"So," I said. "We will see you on Wednesday and meet your witch."

"Yes. That will be very excellent."

"And maybe you would join Anne and me for dinner that evening before your long drive home."

He paused and consulted his diary. "Yes. Thank you. I would very much enjoy that."

And that's how we left things. Until the day of the witch, the following Wednesday.

ONLY THINGS DIDN'T quite work out that way.

Giuseppe was not around on the following Wednesday. The bank teller mumbled some garbled response to my query, which I didn't understand, but I sensed that something urgent had taken my new-found friend, and link to the darker world of Aliano witches and other things, far away from the bank.

Smiling at the teller to suggest I understood completely, I left a note for Giuseppe asking him to call me whenever convenient so we could arrange to continue our explorations together.

But he never called. For weeks there was silence, so we let the matter fade, until one strange night, the night of . . .

The Curse

"Behind their veils the women were like wild beasts."

CARLO LEVI

Now I'm not suggesting this odd occurrence was in any way related to Maria or our plans to be introduced to her by Giuseppe the bank manager. But, still, it made us wonder. And although there's something sinister in the elderly, wizened widows of Aliano, shrouded completely in black, day after day and year after year, they seemed no different from any other "black widows" I'd noticed in the hill towns all around Aliano. They went about their daily rounds, doing whatever they did, scurrying hither and thither, carrying little bags or large objects (often on their heads), rarely pausing to talk to anyone, and certainly not to the men. Occasionally I would see two or three by a doorway whispering and glancing around as if constantly seeking affirmation of whatever dark, intrigue-filled tales they told one another in their secretive huddles. In church they would sit together too, in tight, black, rooklike clusters, on specific, carefully guarded pews. But mostly they seemed to prefer their solitude and the silence of the shadows.

Until the *vipera* (viper) spirit strikes . . .

Late one dark evening I was returning home from the bakery (our vital village resource that often stayed open until ten o'clock) and had just placed the key in the lock when a spine-clutching shriek echoed up an adjoining alley. A black cat by my doorway heard it and rocketed off in the opposite direction, as if chased by one of those ferociously fanged shepherd dogs. I looked around. The few octos who were still gesticulating and orating at one another on the benches down by the Bar Capriccio seemed not to have heard anything. Maybe, I thought, it's just another poor animal being booted out of the house. (Pets were usually banned from the houses and left to fend for themselves on the chilly streets.)

But it was not an animal. At least, not any animal species I recognized, although the sounds that came up the dark alley could

hardly be called human either. They consisted of hissings and grunts and a fusillade of vicious, high-pitched words that rattled like machine-gun fire against the cold stone walls.

I tiptoed as quietly as I could on the cobbles down to the corner and very slowly peered around into an even narrower and darker cul-de-sac. And at the far end, barely illuminated by the dim light of a half-open door, stood one of the village's old black-shrouded women. She was very bent but was using her cane not as a support but rather as a sword, or even a witch's stick, as she spat and hissed in a venomous manner—her neck extended, her left arm outstretched with all her fingers spread apart—at the head of a half-visible figure crouched behind a door.

At first her noises seemed like the jumbled racket of intense anger or hatred. But as I listened, fixed to the spot and with no intention of intruding further, I detected rhythms in her chilling tirade—like a violent incantation: a spell, a curse.

There was little or no sound beyond low grunts and growls from the person in the house. At one point the door almost closed, but the woman in black stabbed at it with her cane, so it remained ajar as her ceaseless torrent of viciousness continued.

I expected all the doors and shutters in the alley to open. Surely others must have been disturbed by that eerie and frenetic monologue. But nothing. No lights. No opening of doors. Just that one door.

And then that, too, was suddenly slammed shut.

But the woman continued: hissing, spitting, and now banging furiously on the door with her cane in a rapid tattoo, beating in time to that same sequence of violent words and sounds.

The lights inside the house were switched off, and the street was now almost entirely dark . . . but light enough for me to see the old woman suddenly stop her tirade and turn, with remarkable agility, in my direction. I immediately pulled back behind the corner, dreading her approach. Surely she couldn't have seen me? How could she sense I was even there?

There was nothing now but silence. I wanted to run, but my feet,

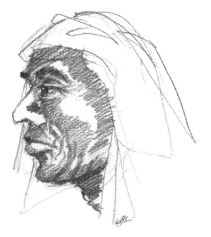

ELDERLY VILLAGE WOMAN

almost as in one of those dreamlike scenarios where your body refuses to do as it is bid, remained rooted to the cobblestones.

After more silence I very slowly peered around the corner again and into the blackness. And there was nothing. No one was there. This seemed most peculiar. The alley was a dead end, so there was nowhere for the woman in black to go except past my hiding place.

But no one came. And there were no more sounds. Just that deep, somber silence. And that night-shroud of utter Conradian blackness.

Autumn

MISSANELLO

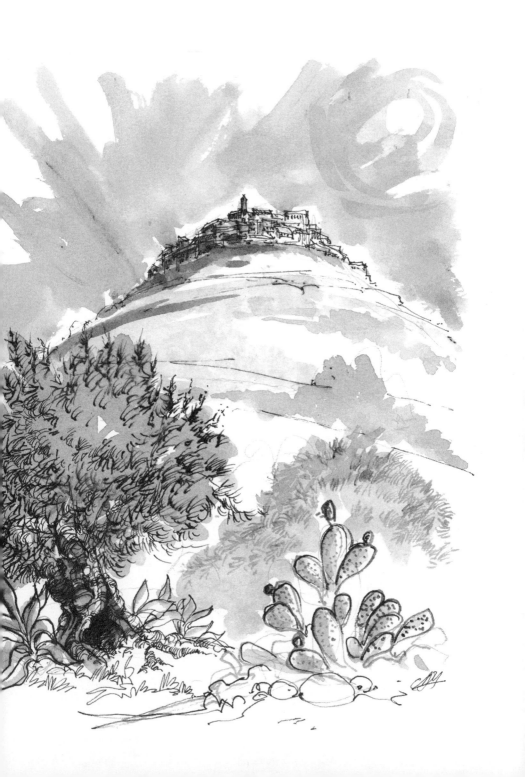

INTRODUCTION

Despite the fact that Keats's "Ode to Autumn" reflected romantic English scenes, his lilting line "Season of mists and mellow fruitfulness" could apply, this year at least, to our remote, mountainous corner of Basilicata just as well as it did to that beloved poet's bucolic vales and dales of Somerset.

This is surprising, given the strident Italian summer of storms and searing heat and a prognosis for the upcoming season verging on the utterly pessimistic. Our friends predicted a mediocre *vendemmia* (grape harvest) in October, a dearth of wild mushrooms and chestnuts to pick and wild boar to hunt in November, meager fruit production, and, worse of all, a pathetic olive harvest late in the year or early next year. Not an enticing prospect for the months ahead. Autumn was usually a time of abundance and even a little taste of affluence for those *contadini* who were able to harvest more than enough for themselves and their families and and have surplus fruit, grapes, and olives to sell to their friends or in the piazza marketplace.

As it turned out, the prognosis was a little overpessimistic, certainly as far as the *vendemmia* was concerned. Much of Italy did indeed experience mediocre-to-plain awful harvests, and the government decreed that 2002 would certainly not be a banner year for

fine vintages or wealthy vintners. But our part of Basilicata seemed to escape the widespread misfortunes of the North. Despite a sudden, virus-driven destruction of the ripe tomatoes, which in September were reduced to black mush overnight in many gardens and farms (alas, no two hundred liters of homemade *conserva di pomodoro* per family this year), the grapes swelled to plump, rot-free, juice-filled maturity and produced far better wines than expected, much to the surprise and delight of all our friends. And of Anne and me too, whose almost daily burden it was to sample and splurge on new vintages to the point where water became a rarity. (Ah, the sweet suffering and sacrifice of authentically dutiful research . . .)

CHAPTER 8

Rhythms and Rites

An Unexpected Supper with the Famiglia Spagna

Who are all these people? I wondered, as I strolled into Massimo's hotel in Accettura one Saturday evening and realized that the small lobby bar was packed with a crowd of Americans talking at one another in that uniquely excitable "lemme tell ya" manner that seemed to be a hallmark of stateside camaraderie. And then one of them, recognizing a fellow *straniero* (foreigner), almost pinned me to the wall with an enthusiastic "How ya doin. Good to see ya."

We'd barely introduced ourselves before the American launched into his tale. "Believe me, you've never seen a barbecue like the one we had this afternoon. Lemme tell ya, Dan—It's Dan, right?"

"Actually, no, it's David. Or Dave if you—"

"Right, so, like I'm saying, Dan, they get this massive stand with a grill and big logs on it and they burn the logs until they're red-hot and the embers fall down through the grate. Then they shovel up the hot embers and put them on another grate, and the meat goes over this second grate so the flames never touch what they barbecue. Only the heat from the embers, ya see. Flames are a real no-no. And, believe me, this was the most beautiful meat you've ever tasted. No burning. No charring. They cooked all kinds of stuff: lamb's liver,

lamb chops, chicken, pork, not *porchetta* (suckling pig), but nice, big, juicy strips. And all that, mind you, came after a massive *antipasto* of homemade pecorino cheese, handmade from their own sheep's milk, mozzarella from their own cows, fried peppers that crackled and crumbled in your mouth like real tasty potato chips, lots of *prosciutto crudo* and salamis and mortadella—the genuine stuff with crushed peppers in it—and wine, rivers of real good red wine, all homemade, so much it still makes my stomach groan just to think about it."

Who is this guy? I was thinking. And what is he talking about?

Then all the Americans suddenly moved into the adjoining dining room, and I sort of got carried along in the rush. Even after we'd sat down the man was still talking enthusiastically at me as if he'd known me for years, describing in colorful detail all the nuances of the afternoon's bacchanal while taking great mouthfuls of the hotel's excellent steaming-hot, four-cheese pizza topped with proscuitto and salami.

"And to think if we'd just kept paying the taxes, we could still have had all this," chirped the young man seated next to me at the table. "The 1806 palazzo in the square outside, the huge farm, that country palazzo, our own chapel and coat of arms, our own saint, San Rocco Famiglia Spagna, and even our own town procession, the one we saw today for our own special saint!"

"Don't even talk like that!" snapped the older man who was still giving me a saliva-producing description of his barbecue experience. "My father, Emilio Spagna, lived in that palazzo, but he left here in 1892 and made it clear he never intended to return or claim any of our Spagna inheritance. And he never did. So, don't even start thinking like that."

The young man accepted the reprimand with a wry grin. "Those Accettura Spagnas were sure worried though at first, weren't they, at the barbecue?"

The older man pulled away in exasperation and shrugged his shoulders at the rest of the gathering in a kind of "what the hell do I do with this kid?" gesture. I turned to Massimo, who, as usual, was

patroling about as master of ceremonies at his hotel. "Who are all these people?" I whispered. In typical generous American fashion they had invited me to join them in their "light supper" of endless pizzas and wine, and I still had no real idea who they were.

"Ah, very important family," Massimo whispered to me solemnly. "The American Spagna side of the family. Originally from Spain, in the 1600s, I think. The other part of the family, the Accettura part, owns the large palazzo with the big green door just above the piazza, by the big statue, and also a big farm outside town. But most of the family live in Potenza. Very important people. Judges, politicians, doctors. The procession today all through town—I am very sorry, David, I forgot to tell you—was to honor San Rocco of the Famiglia Spagna, who protects people from plagues and other nasty things. They keep him in their own special chapel inside their palazzo that is very beautiful."

"Fascinating," I said. "So these are all Spagnas here tonight?"

"Yes, they're all part of this same big Spagna family. These people are from all over America—Florida, New York, Pennsylvania—all over. And they come to meet their relatives who still live here in the palazzo and at the farm. And I think they're having good time, eh?"

Yes, indeed. A very good time. Brothers, cousins, sons, daughters, grandchildren, and in-laws: twenty or more of them in the dining room all devouring Massimo's superb pizzas baked in his wood-fired oven and knocking back countless flagons of Massimo's homemade plonk. And despite their enormous barbecue lunch, they were still looking fresh and frisky and fascinated by their new-found history.

Ben Spagna, the tanned, silver-haired gentleman who had described the unusual barbecuing technique he'd witnessed that afternoon, produced an enormous hand-drawn family tree he'd been given by one of the Accettura Spagnas. "This guy—I forget his name—he's a doctor. One of my cousins, I guess. He musta spent weeks, months, researching all this. Look, that's the date the palazzo was built. Eighteen hundred and six. And there's my grandfather's birth, in 1841, and my father's in 1872 and . . . look! This is me and

my wife, Betty, in this box here." Betty was a demure, smiling lady who sat quietly next to Ben as he enthused about his newfound Italian family. She occasionally pulled out her enormous Nikon with professional speed-drive and mega-flash to photograph the antics of this increasingly boisterous reunion.

"She's really into photography," Ben said.

Betty smiled demurely.

"She's won a heck of lots of prizes, too, in North Carolina, where we live. Got some published too."

Betty continued smiling and maybe blushing a little.

"Anyway, like I was saying, these Spagnas—the Accettura side of our family—seem to be doing all right. Big new farmhouse. Plenty of land. Olives all over the place. Animals. You know, a real farm."

"And they could all have been ours if we'd just kept paying the taxes . . ." mumbled the young man again, obviously intent on niggling Ben.

"I've told you. That's enough of that," snapped Ben.

Betty smiled, demurely again. And then, when she spotted my camera, a far more modest version of her own mammoth creature, she decided that was enough of all this demure stuff and started asking me questions about my own photography. And, as is often the case, it turned out that we shared similar interests and we even knew the same New Jersey neighborhoods where Ben's father had done "pretty damn well" in real estate until he lost it all in the 1929 crash and died "a man of much more modest means" in 1949.

And I thought, isn't it strange how once again the great circles and spirals of coincidences keep conjuring up serendipitous meetings of this kind. Here am I, thirteen thousand miles from our home (for the moment) in Japan, and discussing the New Jersey Palisades, even down to specific apartment towers along Boulevard East, where Anne and I once lived in our New York period and enjoyed spectacular vistas over Manhattan—views that insular Manhattanites rarely saw because they hardly ever left the city, except for hedonistic weekends in the Hamptons and other upmarket havens. They certainly wouldn't tell anybody if they ever slipped under the Hudson

into no-no New Jersey territory. And here's this family gathered to-gether from all over the United States, meeting in a kind of roots search with another branch of the family—the Italian side, which happens to be one of the lynchpins of Accettura, a remote hill town in the middle of nowhere, and who can trace their Spanish roots back into the 1600s, when they left Spain after losing some battle or other and sought refuge in this mountain

Spagna family crest

wilderness. And today there'd been a big procession (and one I'd missed owing to Massimo's forgetfulness) for their very own patron saint whom they kept locked up in their very own chapel in their very own palazzo, which just happened to be one of the largest houses in Accettura.

And to think that I wasn't even going to stop off at Massimo's hotel that evening. I'd had a long wearisome drive to Potenza, where I'd tried to get excited about the remnants of that old hilltop city but couldn't, and then had been served one of the worst lunches it had ever been my displeasure to eat in southern Italy, in a restaurant that was supposed to be one of the city's finest.

All in all it had not been a memorable day, and I'd been looking forward to getting back for a *sambuca* on the terrace with Anne. But then the day was transformed as I was lured into this friendly family gathering to devour pizza and drink heartily of good country wine.

As I've said before, there's an awful lot to be said for serendipity and for just letting things take their own natural course. You just never know what will pop up next.

The Cowboys Who Couldn't

What popped up next was a minor, but intriguing little event that reflected a very appealing feature of life here: the enthusiasm exhibited by villagers for festivals, fairs, "special events," and anything else with life, fun, food, wine, and endlessly gregarious, gossip-laden social mingling.

Massimo was a remarkable, if not always reliable, source of information on such events and would invariably call us up a day or two in advance with his "David, Anne, you've got to come and see . . ."

On this particular occasion, it was supposed to be some kind of cowboy rodeo roundup display for local Basilicatans, who didn't get much of that kind of thing in the normal course of their lives. According to Massimo, it was to be held at a recently created public recreational area high up in the magnificent forest of Parco Gallipoli, west of Accettura. It wasn't too far west, according to the map, but it certainly seemed a long way after countless hairpin turns and curlicues on an increasingly dramatic drive to the top of the ridge where the event was planned. Massimo had insisted that it was "only just a short way" out of town. But with his eternal optimism and his categorization of every event and experience—no matter how overwhelming or traumatic or grueling—as an "only just" experience, we should have reckoned on a longer, more arduous drive.

But we were glad we'd come. The views across the forested mountains to the dragon-teeth peaks and arêtes of the Lucanian Dolomites, five falcon-flying miles across the valleys to the west, were well worth the challenging drive. Massimo had insisted we get there before the crowds, by three at the latest. Even allowing for his tendency to exaggerate, we arrived at four and still found nobody around and a lot of empty tent booths with nothing in them. Eventually we located the bar Massimo had told us he'd be running, but of course there was no sign of our friend. The only people around were a bunch of surly men huddled in a corner under a pall of cigarette smoke, dealing cards and looking for all the world like a

remnant of Pancho Villa's army who'd decided to play hooky for the day. I guess it was their American West gear that gave such a distinct impression—high-heeled cowboy boots, tight jeans, massive decorated belts, and large brimmed Western-style hats verging on south-of-the-border Mexican size.

"Are we too late for the rodeo, or whatever it is?" I asked in appalling Italianish. They paused briefly in their *slam-bang-dunk* card game and gave us a collective "who the hell are these crazy dudes interrupting our game and let's plug 'em full o' lead just to see 'em die real slow" kind of look. From a mumbled response that emerged after what you might call an "icy silence," we gathered that the event had not even started. Great, I thought. There goes another afternoon wasted following up on another of Massimo's suggestions. And then in came a burly, overweight character—obviously the boss of the show—dressed even more elaborately Tex-Mex than the others. He was bawling into a cell phone and spitting out the obviously distasteful residue like tobacco juice. From fragments, we gathered that, along with half a dozen other imminent catastrophes, one of the trucks carrying the bulls for the rodeo hadn't arrived. After that, it was all over. Another hour later and there was still no Massimo, no audience, and no cattle.

The "boss" was rapidly approaching apoplexy, but he decided that he and his cowboys (*butteri*, I think he called them—a rather soft-sounding name for these surly hands) had at least better smooth out the sand in the stockade pen created for the event. So they all gathered around an ancient Land Rover, alongside some tall and appealing female cowgirl groupies with long dyed-blonde hair, ornate vests, jeans they must have been poured into, and ultra high-heeled cowboy boots. The boss had found some kind of ancient, rusty sand smoother, or whatever they call those heavy cast-iron contraptions, but couldn't find chains to attach it to the Land Rover. Eventually they used rope, which, after two circuits of the stockade, broke and broke again and broke again, until someone found some tougher rope.

Then along came another member of the cast—a very un-Western-

looking young man in a baseball cap worn backward. In a high-pitched, whiny voice, he pointed out, with hysterically flailing gestures, that the sand smoother hadn't been adjusted right and had churned up dozens, actually hundreds, of fist-size rocks, which of course were anathema to both horse and rider when one was doing rodeo antics and cow-tying and bull-riding and the like. The young man was in a maniacal mood, hurling stones out of the stockade, which only seemed to unearth more stones, and bawling at the Pancho Villa guys to pull their ****** out of their ***** and start cleaning up the other rocks, which looked like at least a day's work to us.

It was now past seven, and there was still no sign of anyone turning up to watch the event. The sun was going down, so we gave up. We took one last loving look at the gloriously golden fangs of the Lucanian Dolomites, tried to decide precisely how we would lynch Massimo this time, and set off down those enervating and endless series of loops and bends again, playing Willie Nelson's "On the Road Again" at full blast to soothe our own frustrated cowboy spirits.

Vito's *Vendemmia*

The mood changed dramatically the next day. I knew we'd struck gold when we asked Vito Montemurro about the October grape harvest, the traditional Basilicatan *vendemmia*. His gray eyes suddenly sparkled, and he lifted his heavy, seventy-five-year-old frame straighter in his favorite fireside chair. Even his head, huge and bone dense, which usually appeared too large for him to hold upright, rose in sprightly fashion.

Our conversation had been a little slow over the last half hour or so, partly due to the pasta and wine lunch (far too much of Vito's strong red wine) and partly because it was really time for a little afternoon siesta. But the mention of vines and grapes had lifted the sleepy stupor that filled the room even after a couple of those small but intensely strong Italian espresso coffees, liquid caffeine basically, with a taste that demanded attention and respect and

seemed to say with each sip, "You've never really experienced coffee before this!"

"A wonderful time!" Vito began, "Best time of the year. Everyone came to help. We all knew when the grapes were ready, not by taste or color—deep almost purple skins that feel hard with the pressure of the juices inside—but when you crush them in your palm and let the juices dribble off and then curl your fingers into your palm, if they stick it meant the sugar is ready. Then women do a big break- fast. Lots of coffee. Big glasses of grappa. Big slices of bread. Maybe eggs mixed with sliced peppers, sweet ones and hot ones. Just right to get you started."

Vito paused and asked his wife, Laura, a dumpling-plump bun- dle of warm domesticity, for a glass of grappa. She gave him a repri- manding smile but poured one anyway. (Anne and I politely refused ours. The wine had been enough.) Then he was off again. "So, up we go to the vineyard on the hillside—Paolo, Nicolà, Giovanni, little Giuseppe, and all Carmela's children, all the family. Everyone car- ried a big straw *paniera* (basket) with a strong handle, and a pair of clipping shears. Paolo would drive his truck with huge *bigonce* (tubs) and then it would start. Everybody following the *paniere* and Carmela's children, running about carrying the full ones up to the *bigonce* and handing out empty ones."

"Soon . . ." Vito paused and took a generous tipple of his 150- proof grappa, ". . . very soon there's juice everywhere—in the bas- kets, over your hands and clothes. And the smell of ripe fruit, ah! What a smell in the early morning. When the *bigonce* were full Paolo would drive them to the crushing barn and the vats, where Carmela and Laura would start crushing them with thick wooden poles, like big clubs. Paolo then took the empty *bigonce* back to the vineyard, and they'd get filled up again, and on and on until lunchtime. Everybody was exhausted so the women brought out a real *pranzo* (lunch) of pasta and prosciutto and *pancetta* and those big loaves of bread—really big loaves, a meter wide—you don't see anymore now, and of course lots of wine. Oh, it was all so good."

Vito seemed to be lost in his own reverie. No one said anything.

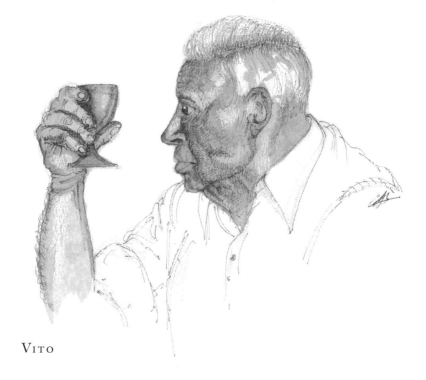

VITO

He sipped the last of his grappa and began again: "Then, after lunch, a little siesta. Not too long though. And back to the vines for more grape-clipping and filling *paniere* and *bigonce* and crushing in the barn. And that wonderful smell! It was like the juice wanted to turn into wine right there. The air would make you drunk, and the sun was hot, and everybody was covered in juices and laughing, and the children throwing grapes and covering their faces and heads with juice and skins and . . ."

Vito paused again. The memory seemed too poignant for him to continue. His face and body sagged a little, and he said softly, almost in a whisper, "Such good, good times. The family all together. All the other families helping, and then that magnificent *cena* dinner at night, when we'd all washed and sat down to all those big *antipasti* plates filled with our own cheeses, artichokes, tomatoes, and big, fat sausages full of garlic and fennel and big bowls of *penne* with porcini

mushrooms, the best ones, and tiny, crunchy pieces of ham cooked in dark sugar with a sprinkling of thick, thirty-year-old *aceto balsamico tradizionale*, and *saltimbocca*, and big cauldrons of goat stew sometimes, and if we were lucky with our hunting, *cinghiale* steaks, or even, on very special occasions, *porchetta* (roast suckling pig) with lots of rosemary and garlic! Ah, such good, good times."

Laura could see he was struggling to control his tears and she came and stood behind him, stroking the massive shoulders of her *capo della casa* (man of the house). She finished the story for him, quietly. "Yes, they were good times. But now our vineyards are all gone." Then she laughed. "But at least we are still here and a lot of our family . . . and still many, many good friends."

"And our old wines." Vito added with a moist-eyed grin.

"Yes, still a few of those left in our *cantina*," Laura said, giving her husband a huge hug.

At Last Giuliano's Own *Vendemmia*

Slowly we were beginning to understand and celebrate the larger rhythms of life that gave structure and richness to each of the seasons there. After Vito's brief introduction to the subtleties of the grape harvest came one of the richest times of all for almost everyone in those remote hill villages: the great fall grape harvest and wine-making rituals. A real ancient, time-honored *vendemmia*.

"ONCE I USED TO have my own *vigneto* [vineyard]," Giuliano said with a wry, slightly sad look on his face. "But now I don't. And normal, in the past, when I didn't 'ave my own vines, I got grapes out of Sicily. Real beautiful fruit. Montepulciano grapes. And I made my own wine. I always do that. You can't trust all that stuff in shops. It's best do it yourself and make your own *vino d'uva* (wine made entirely from grapes without commercial additives). Like most people around here, like my cousin Salvatore. I use his grapes now. Very nice. Mainly Sangiovese and a few Malvasia for

sweet wines. He's got vineyard near San Mauro Forte. And we're cutting tomorrow. Why don't you come along, help out, an' 'ave a good fun time with us?"

I had every intention of helping and having a good time. Truly I had. Giuliano said they'd be starting around nine o'clock and should go on until around lunchtime. "And then I guess we'll all have a nice *merenda* [picnic] in the vineyard," I prompted. "With wine and cheeses and salamis and maybe even a large *pranzo* with roast chickens and boiled beef . . ."

"Oh, no, no. Sorry, David. None of that. This is small vineyard. We'll be finished by noon, so we all come back and have lunch at my 'ouse."

"Oh, okay," I said. Rosa's cooking, I thought, would be more than adequate consolation for the absence of a *pranzo* and even a *cena*, the huge, traditional, postpicking celebration dinner.

AT AROUND TEN O'CLOCK I was at San Mauro Forte, in the lush green foothills covered with olive orchards and vineyards, with my head spinning once again from all the hairpin curves of the drive from Aliano. I walked from the gateway to the vineyard, where Giuliano's truck was parked, and then through the high rows of vines, with their hundreds of fat, dew-moist *grappoli* (clusters) of deep-purple grapes, to where I heard voices.

"Hello," I called out.

"Ah, David. *Buon giorno!* Come on. Have a glass of *vino* with us."

"Great," I said and emerged upon a timeless scene of half a dozen weary, juice-splattered grape pickers sitting in the shade under an arbor of apple and bay laurel trees, treating themselves to a tipple or two before launching again into the back- and neck-straining work, especially in vineyards with those *pergola* (arbor) arrangements of vines strung on wires between narrow wooden or stone pillars. Like this one.

"Not too much for me," I said to Giuliano as he sloshed deep red wine from a label-less bottle into a chipped cup. "I've got work to do."

Giuliano gave me one of his endearing, almost-toothless chor-

tles. "Ah, well, y' see, David. There's not so much work to do because . . . we're finished!"

"Finished!? You said it would take until midday, and it's only . . . ten-fifteen!"

"Yes, azright. But you see my cousin here, Salvatore—Salvatore meet David, and David, this is his wife, Carmela. You see, this is their vineyard, and they invited some extra friends, so it got done much faster. So . . ." That oh-so-Italian "what's to be done" shrug once again.

"Well, I can't leave here without filling at least one *cassetta.*"

Giuliano winked at his cousin, who smiled and nodded and agreed to show me the subtle art of secateur use and where to cut the grape bunch stems and how to lay each cluster carefully in the *cassetta* (alas, not the romantic old-fashioned wicker *canestra* kind, but the more practical, modern, square, yellow-plastic box type). The trick was to do it gently, without bursting the grapes—so fat and juicy you could tell they were just dying to ferment themselves into their true earthly manifestation—bold, deep-red, country wine.

It was a short but interesting education. The *cassetta* was soon filled with its fifty-odd pounds of gorgeous-looking fruit, and I carried it to join the dozens of other brimming yellow boxes all ready to be taken off in Giuliano's truck, divided up between the families, and then crushed for the initial fermentation in their separate *cantine.* In Giuliano's case, his garage. Salvatore gave me a quick rundown on the productivity of his small, less-than-two-acre vineyard. "We should get around twenty-five *quintali*—each quintale is a hundred kilos—so that's around twenty-five hundred kilos, over five thousand pounds, with around sixty to seventy liters of wine for every *quintale.* So, what's that?"

"Around seventeen hundred liters or so," I said. "I think."

"*Si. Corretto.* Seventeen hundred. Maybe a little less. But enough to keep our families happy for another year, eh?"

"Was that your wine I just drank?" I asked.

"Why, of course," Salvatore said, surprised by the idea that we would drink anything else while on his land.

"Then I think your family should be very happy!"

"Ah, yes, *bene, grazie.* You must have some bottles of my new wine when it's ready."

I nodded an enthusiastic "yes" and decided not to tell him that I'd already placed my order for a couple dozen of Giuliano's brew, too.

LATER IN THE AFTERNOON I was standing outside Giuliano's *cantina* with Rosa, Donato, their son-in-law, and Vito, their son, a strappingly large young man in his mid-twenties with Giuliano's big grin and Rosa's cautious eyes. Giuliano emerged from the *cantina,* proudly pushing out what looked like a enamel-plated, wheel-less wheelbarrow with a lawn mower–type engine attached to it and a screwdriver-mincing device that ran along the bottom of a V-shaped container. "My *macchina da macinare,*" he said proudly. "The best grape crusher in Accettura!"

"The only one in Accettura," Rosa mumbled. "And it's a real noisy."

"Oh, yes, the only one like this in town," Giuliano said.

"How do the other winemakers do their crushing then?" I asked. "With their feet?"

"No, no. Not anymore. They have something like this, but they have to work it by hand. Not so good that way. This much better."

He was obviously very proud of his *macchina* and kept stroking its cream, green, and red enamel-coated flanks and emphasizing once again that it was the "only one like this in Accettura."

Close by stood forty yellow *cassette* stacked five high and full of those gleaming purple Sangiovese grapes.

"Okay! So, *va bene.* Let's go!" Giuliano said and flicked the On switch, immediately filling the narrow street where he lived, right across from his large garage *cantina,* with a cacophonous racket.

The *macchina* was linked by a long, transparent hose to a Jacuzzi-size plastic vat in the center of Giuliano's *cantina*—large enough to hold the six hundred and fifty to seven hundred liters of

wine he hoped to extract from the thousand kilos of grapes waiting in the *cassette* outside.

Donato carried the first *cassetta* to the *macchina* and slowly poured in the bunches of grapes. With a roar, some crackling and spitting, and a very slushy-mushy sound, the screw-mincer churned the grapes into pulp in seconds, sending the juice, skins, pits, and pulp through the hose and into the vat at a remarkable speed. The larger stalks flew out the back end of the *macchina*. A second *cassetta* followed quickly, and then a third. The time-honored process of wine making was finally under way. The great vintage of 2002 was about to emerge. Giuliano looked very happy, scurrying about up and down a stepladder among his dangling strings of air-dried red *peperoncini* to check on the rapidly filling vat and then outside again to advise the others on the pace of grape-pouring from the *cassette*.

Already the rich aroma of grape juice and pulp was emerging from the *cantina* and mingling with the din in the street and the ever-growing piles of stalks, which Vito kept whisking away in emptied *cassette*.

When we were about halfway through the pile of forty boxes, Giuliano beckoned me inside. "This is best bit," he said, chuckling. "Now we find out what kinda wine we gonna get this year." He placed what looked like a large thermometer into a narrow glass cylinder of just-pressed grape juice that stood on an old upturned wine cask. "This measures grape sugar. Tells you strength of your wine."

We both watched as the little measuring device bobbed in the juice, then slowly steadied itself, and finally remained still. Giuliano peered intently at the numerical etchings on its glass surface and then let out a great, "Yesss! Look, David! Look! Twenty-three sugar content. That's about fifteen-percent-strength wine. Very good. When it's finished we'll lose maybe one percent. So we have thirteen point five to fourteen percent wine. A good year. Very good year!"

This was rather surprising, as most vintners had been bemoaning the lousy summer and forecasting mediocre vintages at best for

the year. In fact, throughout Italy, 2002 was generally considered to be a poor year for wine, but in this little part of Basilicata, things looked far more promising.

The *macchina* continued its roaring and squirting and pulping. I climbed the ladder to watch the juice and fruit pouring in and the thick, red, aromatic scum moving slowly across the rising surface of the juice.

"So, what happens after this?" I asked Giuliano.

"Is very simple. I leave this juice here for eight or ten days, depending, to ferment and then I drain off the wine—our *vino buono*—the "free run" wine. And then to get more wine we use the *torchio* [press]." He pointed to a sinister-looking, circular, vertically slatted device bound by steel hoops in the corner with a huge double-handled screw for tightening the press. Vivid images of the Spanish Inquisition came to mind. This machine was used to squeeze all the juices from the skins and fruit. "That's big, messy job. Takes me whole day sometime just for three hundred liters or so. Anyhow, and then it goes into my *barili* [barrels, often oak, but in his case metal] and these *damigiane* [demijohn] bottles over there in the back room, to age and ferment just a little bit more. And then, in three or four months, we come in each day and pour some from one of the big *damigiane* into liter bottles and we start to drink and enjoy it!"

"And what happens to all that sludge, the skins and whatever in the *torchio*?" I asked.

"We call that the *mosto*," Giuliano told me. "Well, some people add water and make a kind of weak wine—maybe five to six percent— with a little fermentation and an extra squeeze. It's called *strizzo*. You have to drink that right now. It doesn't last."

"And then?"

"Well, in the old days you could take the *mosto*—like giant fruit-cake—and distill it to make grappa. Some peoples still do. It's not hard, but it's not legal. It's very *controindicato*. I use for pig feed or *vigneto* [fertilizer]."

"Fantastic. At last I think I'm beginning to understand the

homestyle wine-making process. But are there any little additional tricks you use? Your wine's got such a deep rich body?"

"Well . . ." he hesitated a little and then gave one of those "oh what the heck" kind of shrugs. "Well, there is one little thing. Rosa and I usually take about thirty liters of the wine before we bottle it— about five percent of total, no more—and put it in big pan and boil it down on the stove in the 'ouse to about fifteen liters. Then we let it

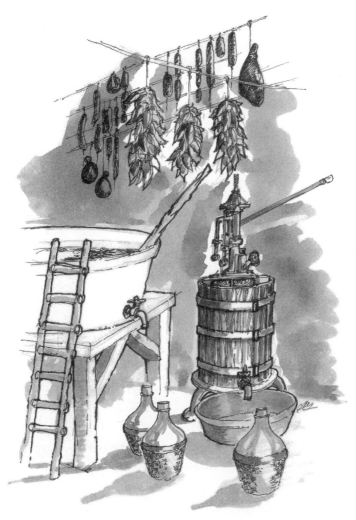

GIULIANO'S *VENDEMMIA* EQUIPMENT

cool and pour it back into the big container of wine, the six hundred liters, stir it up and . . . well, that's all. It helps give a little extra body. A bit more flavor."

"Interesting idea," I said, wondering how this little innovation would be regarded by the great vintners of Bordeaux and Burgundy.

"'S'my own idea," Giuliano said, grinning his irascible grin.

I COULD HEAR THE same grin over the phone when I called him ten days later.

"So, it's today, Giuliano, day ten? The *torchio* begins?"

He responded with one of his chortling chuckles and reminded me that he'd said "about" ten days.

"So, when should I come over then?"

"Say three days? We let everything sit and ferment bit more for another three days, and then you come. Saturday. Good day for *torchio*. Vito is 'ere and maybe Donato too."

"And Rosa?"

"Ah, Rosa, she always 'ere."

"And me? What's my job?"

"And you. Yes. You wanna help too? Good. Then just sit and watch and drink my wine, eh?"

"We'll all sit and drink your wine. As usual."

"*Va bene.* See you Saturday. 'Bout ten o'clock."

I WAS THERE promptly this time (unlike the *vendemmia* at Salvatore's vineyard which I almost missed), ready to join in the fun and the pressing of the *mosto*.

"Usual," Giuliano had told me, "we get 'bout another two hundred liters out of that stuff. Sometimes more. 'Pends on the pressure you give it when y' do the squeezin'. Y' gotta be careful though. Do it slow. An' the wine's not so good like the first run." He gave me a nudge and tippled an invisible glass of wine into his mouth "But nobody notices, eh?"

I agreed. I'd sampled his previous years' vintages—first run and *torchio* pressing—and I couldn't tell the difference. Both were bold,

full of body and fruit, and while not "long in the taste," certainly of enduring impact and strength.

The *cantina* looked much the same as it had two weeks before, with its dangling ceiling strings of brilliant red *peperoncini*, salami, *pancetta*, *coppa*, *soppressata*, pecorino, and cascades of wizened, sun-dried tomatoes, which bore an unsettling resemblance to some deep-fried witchety grubs I'd eaten (or at least tried to eat) in the Australian outback a few years back. I seem to remember they tasted a little like peanut-flavored popcorn. Not bad, if you didn't dwell too long on the gooey source of the flavor.

There were two changes this time though. The huge red maturing vat had been drained of its first-run wine (now almost fully fermented, even after such a relatively short period). What lay at the bottom was an intoxicating, redolent three-foot-thick porridge of leftover "stuff." The second change was the four-foot-high *torchio* (press), with its vertically slatted sides (similar to a barrel with gaps between the staves) bound by steel hoops, was now standing in the center of the *cantina* like a round altar awaiting sacrifices.

Giuliano had already scooped in a first load of *mosto* from the tank with his six-foot-long, three-pronged wooden fork—actually a thin tree trunk—filling the *torchio* almost to two thirds, and had pressed the *mosto* down as tightly as possible with his hands. He was now proceeding to place a circular lid on the press and then a series of thick, square blocks of wood on top of one another to spread the compression force evenly. And quite a lethal-looking device it was: a great steel contraption that fitted over the top of the round *torchio* and the wood blocks. Giuliano was now beginning to pump the *torchio*'s lever to initiate the squeezing process.

"You do it all by hand?" I asked. It already looked like hard work, and he'd pumped the four-foot lever only half a dozen times.

I should have known the answer. "Nay, David. This thing's hydraulic—my *macchina enologica*, made in Perugia, like the chocolates. S'best machine in town is this."

"Just like your *macchina da macinare*, I suppose," I said, maybe a touch facetiously.

"S'right. Just like that. Good machines make good wine. It's worth it."

I nodded. From what I'd seen of Giuliano's work, he took great pride in everything he and Rosa produced, from his handmade bricks and pantiles to his salamis, olive oil, and wine, to their hundreds of bottles of *passata* tomato sauce, and their fiery-hot pepper pickle, a true Basilicatan speciality that he and Rosa created together.

MOST *TORCHI* IN the town were still hand pumped, and it was a laborious, back-wrenching process. And such *torchi* were usually far less productive than the hydraulic kind.

"You end up with a lot of soggy *mosto*, with wine still in it. But this way—well, you'll see in half an hour or so. Mine comes out dry and hard as stale bread."

By now he'd set the hydraulic press and we watched the little pressure-gauge creep around a numbered face measuring kilograms per square centimeters.

"Three hundred's maximum—the red zone on that dial. You don't go over that or . . . who knows? You just don't. There's a lot of pressure in this thing and if 'owt went wrong . . ." His hands expressed something along the lines of a nuclear explosion.

He increased the pressure, listened to the juicy squealing sound of the compacting, then waited, allowing the wine to pour out down between the wooden slats into a wide metal container around the base of the *torchio* and then through a funnel into a one-hundred-twenty-liter plastic vat on the floor. Then he increased the pressure again. And then again.

After half an hour or so, the vat was almost full, and the pressure dial was hovering around the two-hundred-seventy-kilo-per-square-centimeter level.

"S'bout it now," Giuliano said with a satisfied grin.

At that moment Rosa and Vito came into the *cantina* from the family house, across the street.

"Well look at this!" Giuliano scoffed. "Right on time. Just when we're ready for a bit of sampling."

They laughed. Rosa pulled out some glasses from a cupboard, and I shook hands with Vito, who told me he'd just come back from a job interview. He thought that maybe he hadn't got the job because he hadn't had enough *raccomandazioni.*

"Them things are bloody essential. It's that old-boy *gens* network thing. If you don't 'ave 'em someone else'll get picked who's got more. S'nothing to do with what you know and what qualifications you've got. It's all that 'who you know' crap." He looked frustrated, like a stranger in a foreign land. Yet, despite his birth in England, he was Italian and he knew the rules. Unfair though they invariably were . . . particularly as described by Matthew Spender in his intriguing behind-the-scenes look at life in Italy in his book *Within Tuscany.* He suggests that Italy functions by the interaction of various tightly circumscribed "personal power" *clientelari* groups, so that the individual has significance and influence, not in himself, but only as a representative or member of a specific, well-defined and well-protected circle of mutual interests, reinforcement, and perpetuation. One friend told me that "some of these *gens* could teach the Freemasons and the Mafia a thing or two about *omertà* and unquestioning loyalty to the group."

"Well, never mind 'bout all that now," Giuliano said, thrusting a glass of the just-pressed wine at his son. "Whaddya think of this then?"

Vito sipped it as if he thought it might be hemlock. "I'm not much of a wine drinker," he whispered to me, but to his dad he said, "S'great, Dad, good and strong. M'be better 'n last year."

"S'what I'm thinking. Course you can't tell 'til it's sat for a few months in these demijohns." He indicated a row of a dozen fifty-five-liter demijohn bottles waiting to be filled with the new brew. "C'mon then, you two, y'can start fillin' 'em now."

Rosa and Vito nodded and began to sink plastic jugs into the new wine in the vat and pour it through filtered funnels and into the huge bottles.

"David, come an' help me with this stuff," Giuliano said, indicating the compacted pile of deep purple *mosto* squeezed just like

he'd said, to dry, cakelike consistency in the bottom of the *torchio*, which he'd opened by disconnecting the steel hoops around the slats and pulling the two semicircles of the press outward like curved cupboard doors.

You could still see the skins and stalks in the cake, embedded like fossil layers in the earth-solid mass. It took quite an effort to break off chunks of the stuff and throw them into containers to be used as pig feed or fertilizer (alas, not to make grappa). Sometimes the mass was so hard Giuliano had to use a machete to carve into it.

"Y'see," Giuliano said proudly. "Nowt goes to waste. Everything gets used for somethin'. "

"Very ecologically correct," I murmured.

"Ecological my *****," he exclaimed. "Fancy word for summat we've been doin' for centuries. Thousands of years."

And so we all continued working together, scooping the *mosto* out of the large vat, pressing it (about half an hour per load), filtering the new wine into the demijohns, pausing to sample the product—which seemed to get stronger and bolder the deeper we dug into the *mosto*—and wondering when lunchtime might finally arrive.

Giuliano was a stickler for "getting it done because after one of Rosa's lunches you don't feel like doin' nowt." So that's what we did, our faces, clothes, and hands soaked in aromatic juices and our bodies increasingly weary from a seemingly endless sequence of laborious tasks.

But eventually it was all completed. Giuliano announced that we'd done better than last year and had produced over two hundred fifty liters of second-run wine. And then, with a wide *la vita è bella* ("life is beautiful") grin, he declared that it was time to wash up, eat, and drink.

And, as happens so often in beguiling Basilicata, the rest of the afternoon sort of faded away into temporal mists after a huge lunch *à la* Rosa of homemade *tagliatelle* with her smokey, meat-flavored, tomato *ragu* sauce; a succulent and fragrant casserole of chicken in garlic sauce, served with warm fava beans and huge chunks of golden-crusted bread; then salad; and finally some of her choco-

late-cream (although as I was to learn later, not chocolate at all) dessert, which melted like cotton candy in our mouths and primed us perfectly, after coffee and grappa, for a long afternoon siesta.

And, I can't really remember much of what happened after that.

Night of the Werewolves

However, I do remember one particularly strange experience a few days later—one of my occasional confrontations and trepidatious interfaces with Aliano's dark side. Maybe I should have taken Levi a little more seriously when he wrote:

> *Some people take on a mixture of human and bestial natures . . . as werewolves, and their identity is completely lost in that of the animal. There were some of these in Aliano and they were out on winter nights to join the real wolves, their brothers . . .*

"WHERE IS EVERYBODY?" I asked Vittoria, one of the *baristi* [bargirls] at Bar Capriccio. The place was unusually quiet on that dark October evening. Biase and Salvatore were present (I suspect they actually lived there or wished they did), playing some half-hearted card game that really needed four people. Two young men were rocking and slamming the rackety football machine where you spun a series of metal tubes with wooden players attached to them and the first person to score ten goals demanded his next round of grappa from his defeated opponent. That particular machine, a new addition at the bar, was a real nuisance, not just because of the noisy spinning tubes and the raucous cries engendered by each goal, but because it had been placed right next to the bar's phone, the only one in town that functioned with any degree of regularity. It was bad enough that it was the old-fashioned pulse type, which prevented me from using my international code to dial out of the country, thus limiting me to local calls. But its location near the football machine made it even more unusable. Conversations were inevitably messy

affairs with my having to repeat everything at least twice to be understood above the din of the football machine.

But that night I had no plans to use the phone because I'd finally managed to make a couple of calls out of the country from the official Telecom Italia phone up the hill, which seemed to be working again. It had been inoperable for more than three weeks, so I'd pleaded with a *carabiniero* in the adjoining police station to call the telephone company and ask them to fix it. "But I'm a *carabiniero*," he'd replied indignantly, puffing out his crisply uniformed chest, bedecked with abundant sparkling-white leather accoutrements, like a Mussolini wannabe. But he did it anyway. And now it was working, and was a lot cheaper than the bar's outrageous "private" rates.

Vittoria's eyes sparkled and she laughed at my question about the absence of the normal rowdy clientele. Then she pointed heavenward. An intriguing gesture. Did she mean something ungodly had happened in the little village? Had a sudden act of the Creator disturbed our normal evening flow of *passeggiate* with abundant pauses for bambino-bussing, espressos and *digestivi*, followed by the later, less formal, strollings, gatherings, and imbibings until the late hours.

I used one of my ever-increasing repertoire of Italian gestures to indicate that I hadn't understood her gesture and that maybe she could give me another hint.

"Well, just look at *la luna*!" she said and giggled.

"The moon?" I said. "What about the moon?"

Then she did a delightful imitation of a prowling animal or monster or something of the kind while humming those memorable few bars of that international anthem of terror, the *Jaws* theme.

"What? What is that? What are you doing?"

"*Lupomannaro*," she whispered in a dramatic hiss. "Werewolves!"

Oh, right. Of course. Werewolves. Why hadn't I thought of that? And I was turning to leave, having decided not to order a drink just to show her that it wasn't nice to take the mickey out of a *straniero*

Vittoria

who was always polite and always left decent tips and didn't even complain (much) about the bar's rip-off phone rates.

"No, no," Vittoria said, a little more serious now. "Is true. The people do not like to walk about when the moon is full, particularly around *mezzanotte* [midnight]."

I peered outside and realized that, in moon terms, she was indeed correct. How had I missed that glorious silver ball, fat and bright, beaming over the rooftops in that cloudless night sky?

"Okay," I said to her nonchalantly. "*Va bene.*"

She giggled again and repeated her monster mimic and *Jaws* theme rendition. Thinking that she was still having a little fun at my expense, I left the bar and strolled deep into the dark village to show

her, and anyone else who might be watching, that all this werewolf nonsense certainly had no impact on a lad from the Yorkshire coal-fields who knew all about black nights and full moons and silly, age-old superstitions. The miners, among whom I had spent my early years until the age of ten, were renowned for their strange little rit-uals intended to ward off sudden dangers in the shafts and along the seams where they hacked the lumpen stuff, near naked and often alone in that terrible claustrophobic darkness. They had their mon-sters and demons all right, although, if the *Brassed Off*–like marital shoutings and bangings in their council houses were anything to go by, such creatures seemed to be more prevalent inside the tiny par-lors and kitchens of their homes rather than deep in the black, sod-den bowels of the earth.

But admittedly it was all rather odd—the silence and lack of peo-ple and movement in Aliano. And the *fossa* did look unusually deep and mysterious with its silver-tinged shadows. My footsteps rang on the rough cobblestones and echoed off the thick stone walls. I kept looking up at the moon and thinking how beautiful it was. Surely this was the time when everybody should be getting ready to do a little frantic pruning and trimming of things on the farms along the *calanchi* and the ghostly clay cliffs of the fault lines. After all, any of the popular *Farmer's Almanacs*, still used with almost religious certi-tude in those parts, made an awful lot of fuss about the cusp between the waxing and waning of the moon. And here we were, right on it.

The houses dropped away as I continued down the narrow road that wound along the knife-edge precipices separating the old vil-lage from the "not so old" (as opposed to the decidedly "new sec-tion" way up the hill). There was a breeze, suddenly cold. A couple of streetlamps were out—just like the telephone, it would be weeks before they were fixed—making everything darker. As I peered down toward the old village, huddled in lopsided disarray atop its flaking *puy*-like perch, I realized that there were no lights in any of the win-dows. Admittedly, the area looked abandoned even in the daytime, but it wasn't. I'd been there many times to sketch its narrow, twist-ing alleys and had exchanged somewhat constrained conversations

with its residents—constrained not by their attitudes, which were usually friendly, if a little guarded, but by my still-neophyte's vocabulary. Although, I'd been assured on many occasions that a far more extensive grasp of the language wouldn't have made much difference; even the "upper villagers" claimed to have problems understanding the indecipherable complexity of their dialect.

Well, I thought, they must all be in bed and shuttered up for the night. A little crazy though. It was barely eleven o'clock. But, if they were asleep I decided I wouldn't bother walking down there as I'd first intended to show everyone that at least this particular foreign resident could not be cowed by local folk tales and superstitions and werewolves! *Porca puttana!* ("Sow whore," a great epithet that uses the spitting *P*'s to splendid effect.) Who were they trying to kid? It was a beautiful night, full of gorgeously sensual moonlight—the kind they write arias of love about—and if it weren't for this strangely cold wind and that howling . . .

I stopped abruptly. A chilling sound bounced off the gray canyon walls and faded slowly into the distance. I listened again, but all I could hear was the prattle of the wind swirling the dry, brown leaves of autumn around the edge of the road.

Funny. It had sounded like a howl of some kind. Maybe just a jilted dog, kicked out of a house and left to shiver in the chill night air. Of course. That's precisely what it was.

Time to return. And as it was all so beautiful in the moonlight, I thought I'd go the top way, along the cliffs that edged the main section of the village. The vistas from there in the daytime were magnificent, across that Dakota-like "Badlands" topography that still, even after my having lived so long in Aliano, managed to surprise me with its mood of utter barren wilderness—unlike any other place I'd ever seen in Italy.

It truly was serene, the moonlight silverplating the already-silvered leaves of the olive trees, earthbound in their neatly regimented rows hundreds of feet below the iron fence rail on which I rested.

But, then, it came again. An echoing, hollow howl from the shad-

owy depths around the base of the near-vertical cliffs. And it was definitely not a dog. At least no dog I'd ever heard before. A set of shutters slammed in one of the houses behind me, and I jumped a good six inches off the cobblestones in alarm. *Dio Christo!* What was going on? All the house lights were off. No TV sounds. No muffled conversations over the last few sips of homemade wine. Absolutely unnerving silence . . . except for that howl, which came again, closer now to the base of the cliffs . . . or maybe even on that narrow track that serpentined up its flanks into the village.

I peered again down into the darkness. The moonlight didn't penetrate that far. It seemed content to sheen the olive and fruit orchards and look benignly romantic. Only it didn't feel at all romantic now.

Something was moving down there. I could hear rocks being disturbed. And wasn't that a shadow? Something very quick, moving in and out of patches of moon glow. Something coming up the cliff track. . . .

I WAS BACK so fast to our apartment that I didn't even have time to start puffing. When I did it was in great gulpy gasps that came only after I'd locked the door behind me and flung myself down in the chair by the window. Vittoria's silly little remarks had obviously mesmerized me into a half-manic state of childhood terror, taking me back to my monsters-under-the-bed years. This is ridiculous, I told myself. You're a grown man—a little too grown at times for your liking—and should not be vulnerable to such utter nonsense. So go outside onto the terrace and take a look. There's nothing there. Nothing at all. Come on. Open the door and confirm the fact that the moon is shining benevolently, the church clock is ticking away as usual, and all this werewolf stuff is a load of old codswallop, to use an old Yorkshire phrase I never fully understood.

No. I think I'd had enough for one night, thanks all the same. A wee whack of grappa and it was off to bed, boy-o, to cuddle up to my lady, who'd retired early, oblivious to the evening's trauma, and we'd both have a good laugh together about all this nonsense in the morning.

Autumn

* * *

AND WE DID. Very hearty giggles and chuckles over a large breakfast of *pancetta* and poached eggs with fresh-baked bread from our bakery across the piazza. The bakery had smelled so warm and welcoming and cozy that I was tempted to share my previous night's experiences with the two ever-smiling, gnomelike, husband-and-wife bakers.

I got as far as: "Did you hear any strange noises last night?" but before I'd finished the laborious patching-together of the question in Italian, they exchanged furtive glances, gave a brief nod of affirmation, and busied themselves around the dough-mixing machine, obviously not anxious to continue the conversation any further. Hmm, I thought, this is all most peculiar. After returning home with a mammoth loaf, I pulled out a few books from our small library over the living room fireplace and began hunting for any references to full moons and werewolves and the like.

Good old Norman Douglas pretty much dismissed the whole thing in his book *Old Calabria*, although admitting a fascination with "the tigerish flavour" and pagan myths of the wilder parts of the Mezzogiorno, its "cauldron of demonology" and a "classic home of witchcraft" full of "ghostly phantoms of the past" where "wise women and wizards abound." In his one reference to the werewolf myths he explains that "it is not popular as a subject of conversation" although he had been told that "the more old-fashioned werewolves cling to the true *versipellis* habits, and in that case only the pigs, the inane Calabrian pigs, are dowered with the faculty of distinguishing them in daytime, when they look like any other 'Christian.' " But Douglas's research got him nowhere. "A foreigner," he writes, "is at an unfortunate disadvantage; if he asks questions, he will only get answers dictated by . . . a deliberate desire to mislead." So he ended up agreeing with the local mayor, who stated emphatically, " 'Believe me, dear sir, the days of such fabulous monsters are over,' " and promptly dismissed the whole matter.

However, the ever-tenacious Carlo Levi did not. He even described in lurid detail precisely how such creatures with dual natures "both horrible and terrifying" should be greeted when they returned home from their nocturnal adventures:

> *Only at the third knock can the wife (of a werewolf) let him in;*
> *by that time the change is complete, the wolf has disappeared and*
> *he is the same man he was before. Never, never open the door*
> *before they have knocked three times. They must have time to*
> *change their shape and also to lose the fierce wolf-like look in*
> *their eyes and the memory of their visit to the animal world. Later*
> *they will remember nothing at all.*

Well that's fine for them, I thought. But what about me, us, the non-"dual-natured" of the species? I mean, as much as I agreed with the actor Peter O'Toole's little maxim, "We are all protean," I didn't think he was including a capacity for werewolf shape-shifting. And how could anyone in the village know who their wolfish companions were? They obviously couldn't keep lugging around "inane Calabrian pigs" all the time to sniff them out. And they certainly couldn't discuss the matter sensibly with a giggly female *barista* like Vittoria and her monster mimicry and *Jaws*-theme renditions. And Don Pierino, our dear priest friend here, who had nurtured countless souls in the village for more than three decades and who thought he had lured them out of all that local superstition lore, how could he possibly clarify the matter?

I asked him a couple of days later, obliquely of course, so as not to offend his priestly nature. But, as Douglas writes, "It was not popular as a subject for conversation," so he politely evaded my question and we discussed the niceties of his upcoming Madonna of the Rosary festivities and other papally approved local rituals instead.

So, I guess I'll never know. But from then on I decided I'd watch the beauty of the full moon nights from our terrace and then, like the other villagers, shut the shutters tight and, following Anne's sensible example, go to bed early.

Aliano's New Olive Mill

While the *vendemmia* is the high point of fall, the olive harvest is the lynchpin event of the winter season. Depending on the climate, it can take place any time between November and February. And, of course, just as important as the olives themselves is the quality of the milling process that converts these acrid, hard little fruits into silky sheens of extra-virgin oil. And this year was supposed to be a special year: the year of Aliano's brand-spanking-new, gleaming, stainless-steel, bells-and-whistles galore olive mill.

DON PIERINO WAS definitely excited. You could tell that by the extent to which his usual leprechaun grin was now expanding into one of those full-blown Italian smiles: bright, white teeth fully exposed, sparkling eyes, distinctly rosy cheeks and nose, and an unusual restlessness in his normally placid, priestly manner.

"In a few weeks we will have our first pressings in the new mill, our own *frantoio*!" he told us with unsuppressed glee as Anne and I sat together with him in his study. We'd been given a brief tour of the pink stucco—walled plant, just down the road toward Alianello, financed in large part by a grant from the European Union, and had been impressed by the amazing amount of complex, shining equipment, from the conveyor belts to the enormous vats in the storage and bottling room—all laid out in full accordance with those voluminous European Union homogenizing regulations. "Over four hundred pages!" the site foreman had proudly told us, as final sprucing-up of the plant was under way in October. Around the same time, the BBC World Service was remarking on our little shortwave radio about the horrendous scope of those EU requirements—over eighty thousand pages of them in small type—which the ten recently admitted new member countries had to absorb and follow to the last sub-sub-paragraph of gobbledegook. Not to mention the equally voluminous pages of appendixes.

But somehow it had all been done here, and whatever stamps

and seals and bureaucratic rites of approval were necessary for the new mill had indeed been achieved.

"It was not always so very easy. The government can be . . . difficult, and our local people are often suspicious of new ideas, new initiatives. Change of any kind," Don Pierino said as he handed me the colorful new brochure proclaiming the creation of the "*Olio dei Calanchi Maiatica* of the So. Coop. CO.ZO.A." A sprightly logo showed five black olives growing on an olive sapling with separate roots rising from the summit of one of Aliano's unique clay-soil *calanchi* buttes, all against a perfect blue sky. Then came the reminder of the benefits of olive oil in general: "The salutary effect of Olio Oil is undoubted: it is very good for the prevention of cardio-vascular diseases, regulates digestive processes, limits the tissue degeneration and reduces the risk of biliry calculous."

Other than the last phrase, which left us a little confused, the rest of it seemed quite modest compared to some of the promotional hype that appears in American and European magazines claiming just about every imaginable benefit of olive oil, from complexion and skin tone enhancement, to virility stimuli, to promises of excessive longevity and enduring well-being. Recently though there had been a few doomsayers who, reflecting that peculiar American delight in product-puffing and then product-busting (remember the oat bran, grapefruit, and pineapple diets?), had questioned some of these more outrageous claims. But I guess the olive oil—industry publicists knew all about America's yo-yo publicity antics and had managed to keep the image of "virgin" and "extra-virgin" labelings as pristine as the Madonna herself.

I read on, bemused by the brochure's Italianish promotional phraseology:

> Our Calanchi oil is an oil of high quality, thanks to the earth
> on which grows the Maiatica Cultivar olive tree. It is a genuine oil
> whose bouquet is moderately fruitted and a young taste of celery
> and hay. It is produced by old methods (grindstone and cold-

squeezing) that leave unaltered the organological and nourishing characteristics.

Above the text was a sumptuous color photograph of the cooperative's new bottles and five-liter-can packagings set among a cornucopia of sunflowers, stone jars brimming with green and black olives, gorgeous spring-green salads, garlic, peppers, and ancient and very battered cooking pans.

On the reverse side a photograph of the dramatic buttes and crags of Aliano's *calanchi* country was reinforced by more delightful pidgin English text:

OLIVE TREE

Aliano is the village of Calanchi; huge hills of white clay that makes evocative sceneries, that can be compared to those of Goreme Valley in Cappadocia (Turkey), Nebraska and Dakota. . . . Aliano has a huge acheologic patrimony dating back to Eighth Century, B.C. Traditions, rituals and religious feasts still practiced in Aliano, in a village made famous by Carlo Levi's Christ Stopped at Eboli, *help to comprehend the culture and history of Basilicata.*

Don Pierino watched us closely as we folded the brochure. "So," he asked. "You like?"

"Very impressive," I said truthfully. The fact that the So. Coop. CO.ZO.A. had managed to put together a convincing presentation of the quality and uniqueness of Aliano's one remaining staple crop (admittedly in rather bizarre English)—and in doing so had possibly saved the local farming traditions from fading into the mists of economic obscurity—was indeed admirable.

"I hope the oil is as good as this leaflet says it is," I said. "As good as that famous Florentine Conca d'oro ["Golden Basin"] oil!"

The good don gave an eloquently expressive gesture that suggested the undoubtedly supreme excellence of our village product, expanded enthusiastically upon the brochure's claims, and expounded at great length on the very special characteristics of the Maiatica olive.

We nodded enthusiastically too, thinking our friend was a natural publicist. Put him on some TV program about the unique bounties of Italian home-produced gastronomic delights, and Aliano might well find its young men scurrying back from the urban fleshpots of Bologna and Milan to capitalize on the small family farms they'd so long regarded as old-fashioned, archaic, generational culs-du-sac of nonambition.

"Congratulations," I said. "You may have given little Aliano a whole new future."

"Yes, once again!" Anne added. She was always impressed by the priest's get-things-done abilities, which to date had included the

creation of the local Levi museum, involvement in all restoration activities and in the *Parco Letterario Carlo Levi Viaggi Sentimentali* outdoor theater and cultural events, and publication of the town's spritely little magazine *La Voce dei Calanchi.*

"Oh, I hope, I hope," Don Pierino said, clapping his hands delightedly in a "from your mouth to God's ear" spirit, although I was sure he was far too respectful of the higher powers ever to use such prosaic phraseology.

"So, when does the pressing begin?" I asked.

"When the harvest starts. Maybe in two or three months. And then we should have our first new products for distribution. Everything should be *benessere* (comfortable)." He was so excited I could have hugged him. (Certainly I had no problem hugging other people, but, I thought, maybe priests don't go in for that kind of thing.) However, as we prepared to leave, telling him that we'd be there to celebrate the first extra-virgin cold pressings, he came around from behind his desk with his arm outstretched for a normal handshake. And I thought, what the heck, this man has given more than thirty years of his life to salvaging and nurturing not only souls, but the economic well-being of this little village in the middle of this wilderness. So I hugged him. And, after a moment's surprise, during which I could feel his hands sort of flustering about, he returned the hug. A good one, too. Not quite bearish but certainly— what's the word they used in church?—very beneficient. And he gave me a blessing, too. I got a personal blessing, which is a very rare occurrence for me. Come to think of it, maybe a first. His blessing of Anne was even more florid, although I noticed that, with her, he stuck to a demure handshake of farewell. Very correct local behavior apparently, especially in the presence of husbands.

A Sad Postscript During the Winter Season

Maybe rather than blessing us, Don Pierino possibly should have blessed the olive trees in the *calanchi.* They were having a tough time of it that year. Even in October the village farmers were predicting a

poor harvest and blaming it primarily on the weather, most of all on the unusually wet summer, which was a no-no when it came to nurturing the budding fruits.

And by December and January—normally the height of the harvest, with everybody out there handpicking the hard, green olives (not many tree-shakers in our area)—their predictions had proved to be all too true.

"Hardly worth going to the fields," one old man told me.

"So, what will you do for olive oil next year?"

"Use less and buy more," he replied stoically. After all this was not an altogether unusual occurrence. The old saying "One good year and two lazy ones" had proved to be a consistently true mantra down through the centuries. And the peasants accepted the paucity of their harvest with the same dogged spirit of fatalism that they applied to most of life's vicissitudes. A curse, then a shrug, then onto the next job, and the next task to be done in a lifetime of almost ritualistic rhythms.

I felt particularly sorry for Don Pierino. The harvest was so poor he'd decided it was hardly worth starting up the brand-new mill. The old one was still functioning, so it was assumed that the pressings of the meager baskets and sacks of olives brought in by disgruntled farmers would be handled there.

"I'm so sorry about your new mill," I said to him when we met one day during what should have been the beginning of the harvest. "But they say it's not unusual, a bad crop like this. Y'know, 'one good year and two lazy ones.' "

"One good and *one* lazy one," he corrected me with a frown.

"Oh, sorry. I thought . . ."

"Well, I'm more optimistic than other people," he added, with that sly grin of his. "I speak directly to the boss." He looked heavenward and smiled.

CHAPTER 9

flowing

Another Nonevent (almost)

Just as nature often played havoc with key seasonal events like the grape and olive harvests, so it did with more modest activities, like little saintly festivals.

It was happening again. Just like that Accettura cowboy rodeo. Another important local event, this time in Aliano, has been canceled at the last minute with no prior word of explanation or notification of any kind, if the number of confused faces standing along Via Roma was anything to go by. There were signs all over on glowing pink placards proclaiming Sunday, October 6th, as the day of the village's popular Processione della Madonna del Rosario, complete with two masses at noon and four o'clock, the procession itself at four forty-five, and a *complesso* (concert) starting around nine in the evening.

The streets had been given an extra-thorough cleaning by the town's two overworked sweepers, and the whole of yesterday, Saturday, had been raucous with the ear-splitting din of stage-assembly in the main piazza. Directly below our terrace, of course, on one of those unusually cool, sunny fall days when we'd

hoped to read and write peacefully outside, gazing at our beloved unhazed vistas of Pollino and her prominent Calabrian sisters to the south.

I forgave the workmen immediately. Assembling the forty-by-fifty-foot stage on rickety steel trellises on the sloping cobblestoned surface of the piazza could not have been an easy task, especially with the daily continuum of donkeys, tractors, Ape, *furgoncini, zanzare-motorini* (mopeds), buses, cars, and even the grape seller's van. He too had decided to park directly below my terrace and conduct his rowdy bargaining and disputes with scores of locals anxious to buy grapes and make their own wine for the year.

The grape van arrived about four o'clock, with more than a hundred and fifty twenty-five-kilo *cassette* of fresh-plucked red grapes gleaming in the sun. Then he departed with an empty truck at eight o'clock (leaving, much to the annoyance of our mayor, Tony, an enormous black stain of grape skins and juice on the piazza), long after the stage constructors had completed their task and adjourned to Bar Capriccio to celebrate a job well done . . . at least until a section of the stage railing collapsed and they had to reinstall it in the meager glow of streetlamps, with hands far less steady than they had been that afternoon.

Everything was set for the *festa* on Sunday. Today.

And here we are, Anne resplendent in an orange-silk trouser suit. And I'm dressed up a little bit more than usual, in neatly pressed slacks, polished shoes, and a brand-new, dark brown, made-in-Italy corduroy jacket, which I'd bought for an amazingly low price at the Carrefour hypermarket in Matera last week, and had not yet worn in public. All for what we hope will be an event worth capturing on film and in words of praise for the durability of local Catholic traditions, despite the village's noted *pagani* reputation.

And it's around four-thirty P.M. now and, I guess, the second mass is almost over, and scores of expectant faces will soon be pouring out and joining the spectators already gathered along Via Roma. So we stroll toward the church to sneak a peek at the congrega-

tion . . . and the place is empty. Gloomy and echoey. No lights except those odd explosions of electric "candles," with their flickering, flamelike lightbulbs. And we're thinking, this is all very strange and maybe we'll walk up to Don Pierino's place and ask him what's going on and . . .

And here he is, ambling happily down the hill to the piazza in his flowing black priestly robes, and I'm walking up to him with arms outstretched and palms raised in an "what's up?" gesture. (I'm learning the Italian body-language vocabulary pretty fast now.) and he's smiling and reaching out to shake my hand. We shake hands, and I ask, *"Dove è il processione?"* He smiles his little leprechaun smile and says, "Ah, that's next Sunday now." And I ask why, and he says, "Because of the weather."

Which stumps us both for a second. We look up at the sky in case we'd missed something (a huge hailstorm or maybe a sudden tornado). But no, it's still blue and bright as it has been since the first thing this morning, and so I do another one of those fancy body-language gestures, which is intended to mean: "What are you talking about? The weather's beautiful, and it's a perfect day for the *festa*, especially as we canceled a Sunday lunch with Rosa and Giuliano just to be here and she's peeved at us because of the short notice we gave her and because she'd cooked a special dish—either rabbit or boar or horse, I forget which—and we're here instead, ready with camera and tape recorder to capture some authentic local color . . . so where is it?!" (At least that's the gist of what I try to indicate in an admittedly rather over-the-top series of gestures, but it's possible some of it gets garbled in my exasperation, modulated, of course, by an attempt not to be too rude to the good don. It also being Sunday. And him being the local priest, now being watched by the whole street.)

"The forecast said storm," he explains patiently, still smiling benignly at us both. "So, we've changed it to next Sunday. Please try to come." And with that and another firm "I know you will" handshake, he's off down the street, presumably to let everyone else know that they could all go home and relax and try again next week.

* * *

SO, NOW IT's the following week, Sunday, and the weather's perfect. The stage is still standing as it has been for the last seven days, creating a dangerous traffic hazard (one bowled-over donkey and two minor fender benders), and everyone is convinced that finally the procession of the Madonna of the Rosary will really take place.

And it does, following Don Pierino's schedule precisely. Two afternoon masses and then at four-thirty the doors of the church are flung open and out comes the life-size statue of the Madonna, bedecked in blue and cream-colored robes and wearing an elegant crown. She is being carried a little precariously by six village stalwarts. Don Pierino is out front in an ornate cassock with green and gold trim and carrying a battery-powered microphone. He starts to walk and chant rather mournful litanies with the straggling crowd of a hundred or so villagers following behind him in a rather raggedy *processione* made up almost entirely of women. The women are supposed to echo equally mournful responses, but either they don't know the words or the weather's just too beautiful for somber chants and the like, so they remain silent, with the exception of six "black widows," right behind the rocking Madonna, linked arm in arm and singing out the responses with dirge-delight. It's all a little disharmonic. The good don has a limited vocal range—a wavering voice much amplified by the microphone—and a remarkable ability to switch key in mid-chant, which leaves the widows with a considerable range of notes to choose from. So, in true democratic fashion, they each choose a different one. Some falter rapidly due to a lack of lung capacity, while others keep going far too long in felinelike crescendos.

But no one seems to mind. At least they've got their procession at last. It wobbles down Via Roma, past the bars where, to give them credit, the octos stand and tip their hats as the Madonna (whom many still regard in their *pagani* hearts as a thinly disguised manifestation of Demeter, the ancient goddess of the earth) moves by,

and then promptly sit down again to resume their raucous card games.

The aim of the procession seems to be to meander slowly through the nooks and crannies of the village, bringing the festivities and blessings of the church to most parts except the old section far below (too steep downhill) and the new section (too steep uphill). Anne and I follow them, behind a rather excellent local brass band with four enormous euphonia, three French horns, some superbly in-tune trumpeters, and a dozen or so younger members with flutes and clarinets. They give the whole affair some rousing inspiration, and the crowd increases. By the time we all return to Piazza Roma, we're around two hundred strong, and Don Pierino gives the band permission to "let it rip" as the elegant Madonna is returned to her prominent position near the altar inside the church.

The band needs no encouragement. Enough of those sonorous, plodding hymns! And in a bizarre mix of the sacred with the profane, they're off, with whirlwind renditions of popular tunes, well-known Basilicatan folk songs, some catchy Germanic lederhosen-band oompah-pah, oompah-pah clapping songs, and even a few racy renditions of bar tunes, with some of the band members singing the ribald chorus lines. The crowd loves these, and joins in on the naughty bits. At least, we think they're naughty by the expression on the singers' faces and their lusty emphasis on certain key lines.

At seven o'clock the band is still blasting out its extensive repertoire. Then, as the crowd continues to grow, two vans suddenly roll up packed with boxes of electronic equipment, scaffolding, klieg lights, man-size speakers, guitars and other instruments, a huge drum kit, mikes, and miles of thick electric cable. Anne and I are back on our terrace now, watching the frantic scene below in amazement as four young men, proficient as robots, erect their complicated stage set and test out their forty huge lights. Then, as the street band rounds off its own splendid show with a very popular and spirited tune from *Titanic,* and is rewarded with thunderous, stomping applause, the stage hands set about doing their sound checks and

drum tests and voice balances, and all those other complicated pre-event preparations. These seem to take forever due to the fussy perfectionism of a young man with a long ponytail and dark glasses, who sits at an enormous control box with more switches and levers and slide knobs than a Cape Canaveral launchpad and howls out instructions in a series of catlike wails.

There's a brief interlude, when an odd tape compilation of Sade, the Rolling Stones, U-2, and some anonymous, mind-numbing, techno-pop, hip-hop syncopations blasts out into the piazza. A clarion call for the concert. And it works. An even larger crowd gathers and then, at nine o'clock on the dot, we're off.

A group of four gorgeous, long-haired ladies leap onto the stage—a Spice Girl–type quartet but without the gaudy costumes—and launches into a series of upbeat Latin-style songs backed by trombone, sax, trumpet, a manic drummer, a guitarist, and a superb keyboard artist. There seems to be no end to the range of sound effects that the keyboardist can generate from his dual keyboards, which is a relief because, from what I can tell, the guitar player is making a real mess of his solos and rhythm riffs.

The band keeps up a rip-roaring, samba-tango–bossa nova pace going for a long set, with the girls—in their identical elegant dark suits with definitely daring décolleté and seventies-style bell-bottom trousers (obviously fashionable once again to judge by the outfits of Aliano's teenagers) dancing, arm-waving, and singing in harmonious synchronization. The crowd loves them. The youth of the village are hip-hopping up a storm. The males are on one side of the piazza, prancing around with shifty-eyed, gum-chewing machismo, and the girls are on the opposite side, finger-fluttery and bathed in the glow of ripening femininity, lost in their own whirlings and complicated MTV-inspired sequences of arm gesticulations.

We decide it's time to go down and join the festivities, but as we do, the band comes to the end of its act, and then it all starts to fall apart. I have no idea who decided on the sequence of the show's attractions that night, but as soon as the girls leave, with their sexy

little waves and wiggles, up leaps a comedian dressed like a clown, except for the fact that he's wearing the traditional blue and red smock of an elementary-school boy and one of those enormous multicolored backpacks that are currently all the rage with European kids. But he's lost the crowd before he even begins his endless patter. I can see them pulling back down the street, some vanishing into the bars, others huddling in the shadows hoping the four girls will return soon.

The comedian's only real audience is a bunch of very young children—who obviously love his depiction of them and who react to his every clownish antic with screams of delight—and a few bemused parents, who stand around enjoying their children's laughter. I feel sorry for the comedian. He knows that the crowd wants the lanky, long-haired ladies back, with their erotic stage presence and fast-beat, pop-song renditions.

But rather than bring them back, quickly, the show's director sends up a middle-aged, over-the-top, Mario Lanza–style crooner, presumably a real torch-song charmer in a nightclub setting, but definitely a nonentity tonight for Aliano audiences. He dies, too, just like the clown, and his pleading *"Grazie, mille grazie"* echoes around the half-empty piazza and generates only a scintilla of sympathetic applause.

A young girl with a beautiful solo voice follows, but she is backed by a recorded, rather than a real, band, so she stands alone and a little forlorn as the chill night breezes begin to blow. Even more people drift away. Put the four girls back on, you twit, I want to shout at the show's director, but I don't. Instead Anne and I wander together down to the Bar Capriccio for a cappuccino. We realize that the whole thing is dying, becoming yet another nonevent, so we decide to call it a night.

IN THE MORNING, when I peer over my terrace railing, it's all gone: the elaborate scaffolding, the lights, the speakers, the mikes, even the stage itself. Piazza Roma is back to its normal, pleasant vacuity, edged by coteries of those chatting octos, of

course—sometimes I wonder if they ever actually go to bed—and the cheerful, bleary-faced street sweepers out with their brooms, trying to remove the last bits of evidence that anything of any import happened the previous night.

Which, I guess, it didn't really . . . except for those samba-prancing ladies with their long, dark hair swirling and bell-bottoms twirling. They were good, and maybe they'd brought a little something real and classy of the outside world into this remote community. And maybe the community appreciated all the effort that had gone into the show . . . maybe . . .

Dinner at Margherita's

A week or so later, we were guests at another event that, from the very start, never flagged for an instant.

"AROUND SIX THOUSAND olive trees, I think," Margherita said with a mischievous grin on her lean, light-filled face. "Approximately." That grin, I later realized, was a key to her irrepressible humor and her hands-on, straight-talking approach to life—a life that, for one of Sebastiano's prized teachers and co-owner with her husband, Tori, of a huge olive orchard outside Stigliano, seemed unusually full and active.

"Six thousand!" I gasped in awe. Most of our other small-farmer friends seemed to get by with a few dozen at most. This was obviously an estate of some magnitude for a town like Stigliano. I hadn't realized that when Anne and I arrived, with Sebastiano, Rocchina, and young son, Gianluca. It was dark, so other than an impressive avenue of olive trees, there was nothing to suggest the scale of this little kingdom.

"It was my father's," Margherita explained. "But he is eighty now, so he gave it to us. Well, to my husband really. Tori." Still grinning, she stroked Tori's broad shoulders spread beneath a face that was plump and constantly bemused, as if he were sharing jokes with himself and no one else. He and his wife stood together by a huge,

baronial fireplace in the large, whitewashed living room and kitchen, once the barn of the substantial stone farm a couple of miles down the steep hill from Stigliano.

We could see the lights of the town twinkling high above us along the ridge as we pulled into the estate and drove along a bumpy track down that avenue of young olive trees. Apparently Margherita and Tori used the farm for entertaining when their home in town was not large enough to hold parties. A lot of parties.

"We have many good friends, so we like to get together and talk and eat good food," Margherita told me with that wily smile, almost identical to that of her husband's. "And lots of homemade wine!"

"And what's on the menu for tonight?" I asked as I stood beside them near the roaring fire with olive logs crackling cheerfully.

"Some real simple home cooking, *nostrano*, with lots of *porcini* and *funghi*," she said.

"Ah, mushrooms. Lovely!"

"Oh, yes." Margherita smiled.

"And . . . ?"

"And more mushrooms!" She laughed, indicating a huge wicker basket filled to overflowing with at least six different kinds of mushrooms, most of which she'd gathered herself in the nearby oak forests of Montepiano and which included rarer local species such as *boletri* (smooth, round, and white like hardboiled eggs), *quaitelle* (with vibrant red caps), and *biette* (smaller, but with equally bright caps).

"A whole dinner entirely of mushrooms?" I asked, amazed by her gastronomic daring.

"Of course," she replied, with that playful grin. Tori grinned along with her. They seemed to be a couple custom-made for each other, for whom nudging, winking, and sudden mutual outbursts of ribald laughter were all an endearing part of their nonverbal dialogue.

And that's exactly what happened. A multicourse meal for fourteen friends, with Anne and me as "honored *stranieri*," conceived

primarily out of mushrooms and with the following sequence of delights:

~ First, a hand-around dish of black olives, their own, baked black and then marinated in olive oil and garlic served with home-baked focaccia.

~ Slices of hot, fire-toasted bread (*crostini*) carved from a two-foot-diameter, bronze-crusted loaf from a nearby bakery and dribbled with olive oil *bruschetta* style and sprinkled with finely ground sea salt or with a slather of Margherita's magnificent *bagna calda* hot dip of blended cream, anchovies, garlic, and olive oil—a *nostrano* delight! The cutting of the bread was an odd and seemingly precarious procedure. First you sliced the whole ungainly loaf into two halves and then, holding one of the halves against your chest with your left hand and arm, you sliced from the far end with your right hand directly toward your body, and then veered the loaf and knife away at the last second before doing irreparable damage to very sensitive upper parts of your anatomy. To see large-bosomed women do this as they suckle the half-loaf between their ample protrusions and flailed away with a large and very sharp knife, getting closer and closer to their salient bits, was a rather unnerving sight. However, they claimed that accidents were rare.

~ A simple but very aromatic bowl of homemade *orecchiette* pasta tossed in a rich sauce of fresh *porcini*, butter, cream, black pepper, and parsley and then topped with just-grated hard pecorino cheese (their own, of course). Actually, they'd called it *stagionato*, a special name for aged pecorino, which is regarded as a pungent delicacy in these parts.

~ Fat, spicy, six-inch-long sausages with a pepperoni kick and chunky pork-meat filling grilled in the fireplace. These were served, as is very common in the countryside, with no garnish except some of those blindingly hot Basilicatan *peperoncini* chopped and marinated, along with garlic in olive oil.

~ More *porcini* mushrooms, this time baked to tongue-tantalizing tenderness with a mix of chopped herbs, garlic, peppers, and cheese and served with a dark *funghi* stew laced with chilies and slathered over more fire-toasted *bruschetta*.

~ There was supposed to be a salad, but we all agreed that perhaps it was unnecessary, as we could smell the next dish: a kind of finger food savory of crisp, deep-fried, sliced mushrooms (what else?) encased in a very highly seasoned batter of eggs and flour. These exploded with trapped juices à la Chicken Kiev as soon as they hit the palate, and the contrast between the crunchy batter and the rich, moist interior was so enticing that Margherita's overworked brother (who, poor man, was not overly fond of mushrooms, despite the fact that he and a friend had done all the preparation and cooking) had to return to the stove in order to deliver two more bowls of these enticing delights.

~ And then just when we thought that it was all over, out came the *castagne* (chestnuts), a true autumn delight, to be roasted in the fireplace and served with sliced *pecorino*, more *crostini*, and rich, creamy, unsalted homemade (of course) butter.

~ And then, there was the wine. Endless bottles of unlabeled, home-produced red and white vintages from Margherita's farm and the homes of her friends, each of whom had insisted on making his or her own vintage either from a small family vineyard or with grapes bought from local and "very reliable" vineyard owners. But what was intriguing, and seemingly a custom in these parts, was that in the long period between the arrival of the guests and the start of the dinner, not a single glass of alcohol of any kind had been served. Bottled water was the drink of choice (from Margherita's own spring, of course). Any suggestion on my part—which of course, my being a very go-along kind of guest, was never made—that maybe a little *aperitivo* would be a pleasant way to get the evening started, would have been regarded as highly uncivilized. "Alcohol before food reduces

the ability of your tongue to taste," Margherita explained a couple of days later. "So we are like, how do you say, religious teetotalers until the food comes—but then with the arrival of the *crostini*, just watch those bottles of wine vanish."

And indeed they did. I lost count after the twelfth bottle. And that was around half-past midnight, long before we even started on the *vin santo* and the grappa.

So, all in all, a remarkable experience in culinary simplicity and creativity right from the very first *buon appetito* and greeted throughout by all the guests with murmurs and exclamations of pleasure—*Mangereccio! Mangiabile!* Although, I should admit that before we'd arrived at Margherita's, at around eight-thirty in the evening (dinner was served late in those parts), Anne and I had already consumed quite a range of gastronomic delights.

First, Sebastiano and Rocchina had invited us for coffee and *biscotti* at their large, modern apartment in Stigliano and then for "just another coffee" at Rocchina's parents' house, deep in the wriggling alleys of the old town.

They were a most hospitable couple, he a tiny ball of restless octogenarian energy with shining, smiling eyes peering out from under his trilby hat—apparently a permanent fixture, even in the house—and she a talker and a large-featured woman who greeted us all with kisses and hugs and coffee and the traditional demand (never an option) that "you will all have a little something to eat."

And so we had a kind of predinner dinner around a large kitchen table in a toasty-warm kitchen with a platter of *bruschetta* spread with tomato sauce (homemade of course), fat slices of pecorino (ditto), and beautiful red peppers stuffed with a mix of minced crumbled bread, anchovies, garlic, cheese, and egg and roasted in the oven with homemade olive oil. All of this was accompanied by glass after glass of the family's very dark and intense-flavored red wine. Then, as we were just about to leave for Margherita's, in walked a large segment of the rest of the family—burly husbands, demure wives, teenagers, a cousin, someone who'd just driven in

from Naples. And the whole wining and dining thing started all over again, with grandpa puffing wickedly strong little Italian cigarettes in the corner and calling out raucous comments, his trilby hat wobbling as he laughed, and grandma at the stove, happily stirring and frying, and acting as though this familial scene of bodies everywhere and everyone eating and talking all at once and babies bawling and

MARGHERITA AND TORI'S ESTATE

us trying to leave and never quite getting to the door was a regular part of her everyday life. Which, apparently, it was.

But all this impromptu feasting was definitely not part of our own cultural background, at least, not until we arrived in Italy. And I guess, as this is now turning into a kind of gastronomic-overload confessional, I should mention that an hour or so prior to arriving at Sebastiano's in-laws' house, we'd had another afternoon snack at a local farmer's newly restored property a few miles outside Stigliano.

That also had not been on the agenda. Totally fortuitous, in fact. Sebastiano was driving us around the outskirts of the town, showing us some of the local places of interest, including an enormous seventeenth-century Palladian-style palazzo sitting, or rather collapsing, in sad decay on a hilltop with breathtaking vistas in every direction. He didn't know much about the building's history, except that it was known as Masseria Palazzo di Santo Spirito and had been one of many local *masserie*—massive feudal-like farmhouses-cum-granaries-cum–worker dormitories—that characterized the agricultural system of the region until the early, and even the mid-twentieth century. Most locals seemed to be unaware of the place or certainly reluctant to talk about it (another one of those "dark side" mysteries?). There it sat, in a huge unkempt field. Its roof was badly collapsed, but it had maintained its odd combination of dignified Palladian proportions, with its distinct, fortresslike corner defense towers complete with narrow slits for arrows or guns and enormous bolted and locked gates set in massive arched stone doorways.

We mooched around for a while but, other than opening a small side door into a cryptlike storage room leading nowhere, we found it impossible to get into the main part of the structure. So, in a chilly drizzle, we decided to move on.

Sebastiano explained that the "peasant rebellions" of the 1950s in the area had convinced a reluctant government in the North that maybe it was time to focus on the plight of the poor Mezzogiorno sharecropper *terroni* or *mezzadri*. So, they started carving up the vast

absent-landowner estates and giving land grants and even new housing to the peasants. For a while things quieted down, but the now-named *contadini* continued to find small farming a pretty inadequate way to make a living and started to move to the northern cities and also, of course, to America, in search of a better life, often abandoning their brand-new houses.

But then, among the decaying relics of a good-idea-turned-bad (a familiar state of affairs in the South; even the vast, new factories around Potenza are largely echoing, empty shells today), we spotted a remarkably fresh, whitewashed restoration of one of those abandoned houses, set amid rolling wheat fields overlooking a broad, green valley and the Pollino range to the west.

"That's most unusual," Sebastiano said. "Let's see what's going on" (a man after our own serendipitous explorer's hearts).

And what we found there was a very encouraging example of what might happen to those other small farms if they had more men, like Francesco Lombardi, with the vision and ambition to revive them.

Francesco had a deeply tanned, cheerful, bright-eyed face and a most gracious manner. He welcomed us without hesitation, despite the fact that in the rain and skiddy mud of his forecourt, we had almost hit one of his new stone walls with the car and narrowly missed a cluster of newborn kittens frolicking in the wet grass.

Soon we were all sitting at a table inside a series of just-restored rooms—what were previously one-room workers' quarters and now transformed into a small, state-of-the-art cheesery ready for pecorino production on a substantial scale. As Francesco plied us with some of his superb three-month-old cheese, crusty bread, and his homemade wine, he told us how he wanted to keep the traditional small-farm way of life alive, and had applied to the EU for a matching "small farmer" grant.

"It was all so easy I couldn't believe it," he said, with a look of amazement still on his face. "I didn't have to get tangled up in that bureaucratic stuff or ask any favors from anyone or play any *gens* games. Just a few forms and a couple of visits by EU people and I had a fifteen million *lire* grant [around $75,000]. I matched this with

some of my own money and now I keep a hundred Merino sheep—very good milk—and built my own cheesery and I plant a hundred hectares of wheat. Hard wheat, the type we use for pasta."

We toasted his good fortune with, I think, at least three glasses of his excellent wine as he told us that his son was now at agricultural college and would be joining him at the farm. They intended to ensure that the place would become a model for other, more skeptical farmers that this kind of life was still feasible in an era of mega-farms and huge cooperatives.

"I have three basic values that I try to live by," he told us, filling our glasses once again and hacking off more fat chunks of his tangy, yet creamily-sweet pecorino cheese. "First, my family. I want us to be able to work together. Like in the old days. Second, I want to build something to last. Like my father tried but could not make it work. And third, I want to show my love and respect for this region, my home, and how proud I am to live here and to be a good farmer here."

We had no choice but to toast him once again, sincerely and full of admiration. Of course that meant a fifth glass of his strong, deep red wine.

SO I HAVE no idea, after those previous afternoon and early evening indulgences, how we possibly managed to eat and drink our way through Margherita's magnificent and innovative "mushroom medley" dinner, happily blasting away all our normal gustatory limitations. But somehow we did, and despite the language barrier, we also managed to conduct long, heated, but always good-natured debates over the course of our six hour get-together at her farm. And none of her friends were left out of the raucous and often overlapping diatribes. The professor, the tax collector, the barber, two farmers, a teacher, the headmaster (Sebastiano), the restaurateur, the businessman (he was very vague about exactly what kind of business), and all the wives: each one was part of the typical Italian roundtable discussions, full of gesticulations, great oratorical outpourings, punchy little philosophical aphorisms, and regular toasts

to nothing of any real importance. I seem to remember that at one rather rowdy point in the evening we even toasted the Neolithic caves on the estate "with shelves too!" Margherita said. "Seven-thousand-year-old shelves!"

The subjects ranged from the general (the latest politics, a terrible bombing of Australian tourists in Bali and what that would mean to President Bush's antiterrorist campaign, and the rising and falling standards of education) to the poor Italian grape *vendemmia* due to the rainy summer, and the antics of a certain local priest whose "remuneration" for his high position on a number of local boards was apparently making him a very wealthy servant of God.

A particularly raucous segment dealt with the impact of Carlo Levi on local economic conditions (of course, a favorite subject of Basilicatans) and the future role of the Mezzogiorno. The barber suddenly spoke with fiery eloquence about "our great Italian writer, Luigi Barzini, who told us over and over that 'Italian history has been a vain and sickening search for *Il Buongoverno* (good government) down all the centuries.' And it is clear we have not yet found it. We still have rudderless governments with an average lifespan of less than a year led by weak, corrupt politicians and an incompetent perk-laden *statale* bureaucracy!"

Anne and I had heard all this many times before, particularly the "why can't we have what they have" cry, referring to the southerners' plight when compared with the ultra-affluent, ultra-stylish, ultra-hedonistic, self-focused, greedy North.

And I don't know why I did it. Maybe just one glass too many of that deep-flavored, black currant–hued, homemade brew, or maybe I was tired of hearing that old "why not us" complaint, or maybe because, when I was a city planner, I had a particular interest in macroregional planning. The big picture. Seeing local problems as challenges in a broader context.

"Maybe we're thinking too small," I suggested quietly and, I thought, modestly. "Why should the South try to have what the North, or anywhere else, has? Why doesn't the South try to capital-ize more on its own unique attributes and see itself in the context

not just of Italy but of the whole of Europe. After all, that's what the EU is trying to create, a one-nation context within which every part plays a unique role."

"And what, Mister Englishman," asked the professor (of philosophy at Turin University, no less), "do you think the South's unique role might be?"

There was a noticeable hush. Maybe I'd pushed this too far. After all, I was a first-time guest in this coterie of old friends and lovers. Anne was giving me hard nudges and "you've gone and done it now" glances, but the *vin santo* gave me courage, and I decided to continue.

"Well," I said, thinking as fast as my befuddled brain would let me. "We know the South has a valuable role in large-scale wheat cultivation, so that's a given. And oil. In 2000 that UK company Enterprise Oil discovered the largest oil field in continental Europe, here in Basilicata, although so far it doesn't seem to have had much impact economically. But . . . well, let's take Florida, for example, in the United States. At the turn of the century it was a horribly hot, humid, mosquito-ridden swamp and semitropical desert producing some fruit and not much else. Then entrepreneurs began to realize that it had fine beaches, cheap land, a constantly warm, body-nurturing climate, and it started to become a vacation area. A bit like the vacation resorts and holiday villages along your Calabrian coast. And then gradually, bit by bit, as older people lived longer and got richer and air-conditioning became more universal, Florida found itself a favorite place in America for retirees. Inexpensive, safe, warm, easy to reach, clean beaches and ocean, plenty of room for golf courses . . . the lot. Pretty much like, say, Basilicata's Metaponto-to-Taranto coastline could be. It's largely empty now, except for a few lidos and holiday villages and a rich agricultural plain. But imagine if it were promoted as a retirement haven, well connected by highways to the rest of Italy, as it already is, and offering inexpensive land, and, well, all those other Florida attributes or like those ever-expanding 'costas' of Spain that transformed the whole economy of that country."

I looked around. I couldn't tell if any of this was having an impact. Anne was certainly still looking distinctly uncomfortable. So, I decided on a wrap-up, over-the-top fanfare.

"Imagine a huge promotional campaign. Ah, let's say, something like: 'Basilicata is Beachland—Europe's Finest Retirement Haven! Send us your thousands of cold, miserable old-age pensioners from the North and let them find a new life of luxury (relatively speaking), fresh air, fine beaches and ocean, some of the best food and fruit in Europe right on their doorsteps, and a climate that will let them bask in sunshine and happiness for the rest of their days at a price they can all afford . . .' "

There was silence except for tabletop tappings and slow slurpings of wine.

"Well," said the banker, "what about culture? And family ties?"

"Florida had no culture," I said, maybe a little cruelly, "and that didn't seem to be a problem. And families can come down to visit their retired relatives on the Basilicatan coast via those two fast national highways."

More silence.

"Or, maybe not," I concluded a little weakly, as my learning curve seemed to be getting a little limp. "I was just suggesting that if you tried to look at the South's problems in a larger context . . ."

The banker looked very unconvinced. He opened a shoulder bag he'd used to bring fresh chestnuts to the party, pulled out a neatly folded brochure, and handed it to me. "Perhaps," he said a little pompously, "you should read this part of a report, just printed, which describes our future. It's in English." I took the report. Below a fine glossy photograph of Basilicatan scenery, I read yet another masterpiece of utterly obfuscated Italianish:

NEW OPPORTUNITA FOR THE DEVELOPMENT: The Basilicata is changing. New sceneries are being opened up to the horizon. Thank you to a new politics of the concertazione on the front of the management of the natural resources like oil and water. And thank you to a way of inderstand new he/she/it/you

publishes administration of the all new as regards the past, agreement like a firm that must aim on criterions of efficiency, effectiveness, transparency, and progressive contextualism. The social fabric is entire because you/he/she/it present a low level of conflict and he/she/it/you has succeeded well to defend from the different attempts of criminal infiltrations. One of the paradigms that they drive our regional Program of Development is the ability to conjugate the logics of the economy with those of the socialita and of the sostenibilta. We have learned that if also the capital more good value is that represented from the human resources, such capital comes rultertormento gotten rich incrementato, from the values of the human promotion and of the solidarity. We will continue to build always noting of these big finishes.

I read it slowly, aloud, to the group. There was considerable nodding of heads and mumbles of affirmation. Had they understood any of this? Were there secret code words in this nonsense apparent only to the enlightened. Beyond a brief reference to the recent discovery of oil, I could decipher nothing whatsoever from all the gobbledygook. And I sensed that it was not just a bad translation but yet another example of that Italian knack for smothering logic, thought, and action in layers of gushy, romantic, and often incomprehensible rhetoric.

I was reminded of yet another outspoken Norman Douglas tirade about Italian mores, and against Italian bureaucrats, written almost a century ago but apparently still remarkably accurate:

Every attempt at innovation in agriculture, as in industry, is forthwith discouraged by new and subtle impositions, which lie in wait for the enterprising Italian and punish him for his ideas. . . . It is revolting to see decent Italian countryfolk at the mercy of these uncouth, savages [petty bureaucrats] veritable cave-men, whose only intelligible expression is one of malice striving to break through a crust of congenital cretinism.

The bank manager obviously thought differently about the contents of the brochure and was beaming. "So," he said a little too complacently, "as you can see we already have our plans for Basilicata. You have just read them to us."

Sebastiano, God bless him, smiled at my open-mouthed confusion, saw my need for moral support, and gave it fully. "I think what David is saying is a very good way to look at things. More optimism. Bigger ideas. In the South, we often see things in too narrow a perspective. In my school, for example, I'm trying to . . ." and off he went, explaining another project for "international understanding" between young students. The wine bottle was passed around again. We were back in more familiar territory now. Everyone respected Sebastiano's enlightened educational ideas, so I was off the hook. Anne was noticeably relieved, and on we went into the night, or actually early morning, with lively conversation flowing as fast as the wines, reflecting Anne Morrow Lindbergh's admiration of the irrepressible Italian spirit for "enjoying each moment to the full, the spontaneity of the now, the vividness of here." A popular Italian proverb puts it more succinctly: "*stoga o schiatta*" ("relieve yourself or bust," or, in more delicate terms, "live in the 'now' without excessive self-restraint"). And Margherita's friends certainly needed no reminder or encouragement to do precisely that.

Eventually, at around two in the morning, Sebastiano decided that it was time we should leave as we had a long drive back to Aliano. So, Anne and I said our farewells to a room full of new friends who looked as though they had no intention of leaving the wines and the chestnuts until dawn rose over Margherita's and Tori's six thousand olive trees and turned all their leaves a shimmering silver pink.

A really fine evening, I thought to myself, as we climbed into bed at around three-thirty A.M. and set the alarm clock for a late morning's rise. No point in getting worn out, I thought. No point at all. This is Italy and we need all our strength for the next bout of gastronomic exploration, rhetorical verbosity, and overindulgence.

Va bene.

The Strangeness at Missanello

Anne decided that at least one whole day of doing nothing was needed to recover from the feast at Margherita's and Tori's estate. I knew from past experience that the only way to clear the persistent fuzziness from my head and the torpor from my body was to get out into the fresh air and focus on something other than my debilitating condition.

I decided to take a drive and explore a nearby hill village, a perfect fantasy perched on a butte that, at night, sparkled with lights like an enormous Christmas tree at the narrow end of the Agri valley.

Once again I should have prepared myself by remembering a quotation from Levi's book: "There were women in the village who displayed a tendency to be free and easy, and who were concerned with all that pertained to love, above all the means of obtaining and retaining it. They were like beasts, the spirits of the earth. In a word, they were the witches."

By this time, I felt familiar, even comfortable, with the presence of local witches although, thanks to the reticence of our bank manager, we had still yet to meet Aliano's Maria. But, on this particular day, things became a little clearer. And weirder . . .

FOR AN ITALIAN, even a Basilicatan, funeral, it seemed a strangely colorless affair.

Unlike others I'd seen, either as an invited participant (one) or as an impromptu spectator (three), this funeral had none of the small-town pomp and priggery that can characterize such affairs. None at all. There was no band with serpentine euphonia that seemed to be squeezing the life out of their neatly uniformed players, or reedy clarinets fingered with adolescent intensity by girls who, you sensed, would much rather be dancing to techno or house in next-to-naked little black dresses at the local disco, the only problem being that, in that part of the country, discos were something of a rarity. (The kids stoically shrugged off this gap in their

cultural coming-of-age as something passé anyhow, although you feel, you know, that deep down they're thinking, "Just wait till I break loose and move to Bologna.") So, no band. And not much in the way of flowers either. Just a couple of well-past-their-sale-date wreaths and a few small cellophane-wrapped bouquets, which, judging by the flowers that had been squeezed out of their packaging, seemed definitely on the weary side.

The crowd appeared weary too, by the look on their strained faces. And not much of a crowd either, compared with others I'd seen. Usually one expected half the village to turn out, which, while not a large number in the case of the tiny hilltop community of Missanello, would certainly have been more than twelve. Twelve was a definite rarity at a funeral, and an insult to the meager family who were edging ever closer to the small cemetery in clothes that, while not exactly what you might call field garb, were certainly a long way from the dark Armani and Versace rip-offs that seemed to be de rigueur at such events.

I decided to skip this one. Something was definitely not right, and I felt far too conspicuous hovering around such a small and select gathering. So, I explored the village instead, huffing and puffing up near-vertical alleys and interminable sets of steps that twined and shifted direction with all the whimsical arbitrariness of an inebriated snail. Or maybe that was me. My pace certainly had little more alacrity to it than that of a snail and I didn't even have to carry my own house on my back.

Before reaching the tiny piazza by the castle on the summit, I was ready for a restorative pick-me-up, but the only coffee bars I'd noticed were down at the bottom of the hill. But I did see two other things up there. First, the stunning vista across the valley and the surrounding ranges, with Pollino and her cohorts rising high in the afternoon haze—always a beautiful sight and even more so there because of the height of the village and the fact that there was nothing in the foreground to block or reduce the scale of the panorama. As I peered over the parapet by the castle I felt myself to be floating in that warm, sparkling light that filled those valleys in the late afternoons.

The second thing I saw was the cars. Parked in a piazza barely big enough to make a three-point turn were half a dozen cars. Admittedly they were small cars—no fat, faddish Mercedes and the like—but I was flummoxed as to how they'd even got there because every street I'd climbed was either too narrow for cars or consisted primarily of steps.

Most odd, I thought.

And even odder was the intensely whispered debate I overheard when I finally reached the bottom of the hill again and ordered my *caffe Americano* (a watered-down espresso, that's all, but at least for the same price you get a regulation cup–size of brew and not one of those meager, throat-jarring thimblesful of black tar).

The young man behind the counter seemed happy to practice his English. I suggested to him that everyone in the bar seemed very serious, with none of the typical oratorical flourishes of *passatella* or epithet-laced bouts of *scopa* or *briscola* card games.

Then the young man looked serious himself and started whispering something to me about a problem with the funeral.

"You mean the one . . . the one I saw up the hill?"

He nodded and may even have winked.

"Why? What's the problem?"

He paused. These villages and villagers have their secrets. Strange things happen here for even stranger reasons. In fact sometimes I wondered if secrets were the invisible glue that bound them up in their individuality and created lifelong and clublike bonds of loyalty and pride and a mutual *omertà*-like silence. I imagined he was thinking that no matter how much he wanted to try out his foreign-language skills, sharing village secrets with a stranger who would be gone as soon as his coffee cup was empty might not be advisable in the long run. I sensed his hesitation, so I ordered an anise chaser, in the hope that he might realize I wasn't your typical sup-'n'-run customer and maybe release his inhibitions.

It worked. At least to the extent that I could disentangle his English vocabulary from the local dialect, which was incomprehensible not only to me but doubtless to most outsiders, even if

they lived only a few miles away, in villages you could see across the valley.

But the bits that did filter through the linguistic morass, as I sipped my anise and he cleaned his espresso machine, pretending he really wasn't talking to me at all, were rather revealing. Apparently, if I understood the snippets correctly, the unfortunate middle-aged gentleman whose funeral I'd almost interrupted, had not died of natural causes but rather of a curse, a spell, that had been placed on him by a jealous woman.

"Someone in the village?" I asked, sensing a real gossip scoop here.

He shook his head violently as if to say, You're crazy! We don't allow witches to live in our village. "No, no" he whispered. "One of the peddlers. A woman who visits here and makes—cooks—special medicines for peoples."

"You mean herbs and things? To cure coughs."

He chuckled. "No, not coughs. Other things. Things for . . . love. Things to . . . change things. And maybe to kill you, too!"

"She killed him?!"

He frantically waved his hands behind the counter in a "for God's sake, keep it quiet" gesture, and edged closer across the bar. "They say she was his . . . girlfriend. But he didn't want her anymore. There was someone else instead . . . another little *avventura*" (that typically masculine word for an illicit affair).

"So . . ."

"So . . . I don't know. That's what these men are saying." He indicated the half dozen or so men whispering together by the doorway

"That she poisoned him?"

He gave a splendidly "don't quote me" Italian shrug.

"So, that's why the funeral was so small."

More shrugs as he furiously polished the milk-frothing spout on his already brilliantly polished machine. One never knew the validity of such stories. Particularly in those small villages where every

day brought another drama, another soap opera scenario. Given the extent to which those wildly dramatic, soft-porn, pulpy TV "daytime drama" plots galvanized Italians of all ages year in and year out, it was not surprising that reality had long been confused with volatile imaginings, which that hot stew of local rhetoric and love of ribald and risqué tales tended to generate in abundance.

A COUPLE OF DAYS later I ran the story past Rosa, always my touchstone for reasoned skepticism, and she, unsurprisingly, dismissed it as the gossip of inebriated layabouts.

"So, this kind of thing doesn't go on then?" I asked, seeking closure to the matter. I thought she'd come back with a quick, "Of course not," and we'd talk of other things. But this time she hesitated, just a bit too long.

"Well . . . not now . . . not much."

"How much is not much, do you think? Give or take a few poisonings and stuff like that?"

"Well, it's not something you can really say definitely," Rosa said weakly. "Is it?"

A wee bell rang in my head. Back on the wall of our Aliano apartment I'd stuck a reproduction of a startling 1937 portrait of Giulia Venere by Carlo Levi (who else?). I was struck particularly by the remarkable, untamed animal spirit that infused her lean, wolfish face and the Munch-esque aura of lines and colors that made her features seem to vibrate and undulate in a distinctly unnerving manner. The famed doyenne of Aliano, Donna Caterina, sister of the pompous, overblown mayor, Don Luigi Magalone, had arranged for Giulia to look after and cook for Carlo Levi, despite her somewhat wild reputation as a "wife of many men," and her legendary skills with herbal medicines "for love and other purposes." Although full of admiration for Giulia's culinary abilities (his description of her unique dishes are salivary, despite consisting of such ingredients as goats' heads, tripe, and miscellaneous obscure offal), Levi realized that the village regarded her as "in a word, a witch." And over time he came to understand that

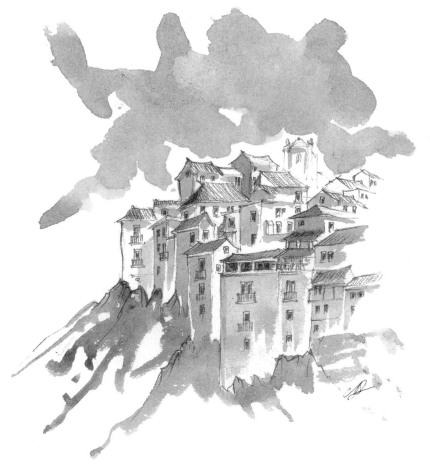

Missanello scene

Giulia was a mistress of the art of making philters, and the young girls came to her for advice on how to prepare their love potions. She knew herbs and the power of talismans; she could cure illness with the repetition of spells and she could even bring about the death of anyone she chose by uttering terrible incantations.

Somehow this seemed not to have disturbed Levi, although, as a sometime physician himself, his skills were often diametrically

opposed to hers. In the end her delicious meals (doubtless fully philtered) must have won out because, as he wrote so placidly: "And earthly creature that she was, this peasant witch was a faithful servant . . . and content with my new solitude, I stretched out on my terrace and watched the shadow of the clouds drift over the wastes of clay, like a ship on the sea" (that definitely sounds like philter-influenced writing to me).

I doubt that the poor dead gentleman of Missanello would have subscribed to such benign sentiments in the case of his own particular witch.

First Tourists, Now TV!

While it's true I was still "new" there and "still learning things," my affection and concern for Aliano and that small part of Basilicata seemed to be growing daily. Maybe I should have been signed on at the town hall by Mayor Tony as his amateur, and still neophyte, public relations enthusiast-in-residence. Of course I was fully aware that such an idea was contrary to all journalistic/travel writer ethics, but sometimes I wondered if my ability to distance myself from the affairs and fortunes of our chosen home in Basilicata had been prejudiced by overly close encounters of the emotional kind. Support-for-the-underdog kind of emotions. Because that's the type of reaction I found myself having whenever I heard my little community described with sneering disparagement or ignorant indifference. Which happened a little too often for comfort.

"Don't you realize the significance of this tiny community?" I would want to say (I may have actually said it a couple of times) before launching into my diatribe about Carlo Levi's impact and the age-old battle between the *terroni* or *catoni* and the *Don Luigis*, the plight of the Mezzogiorno in general and the plight of Mezzogiornos all over the world, and ultimately the need to discover "the Lucania in all of us."

It was a pretty eloquent presentation. It should have been by now. I'd had to put up with the "northern attitude" for as long as I'd

been here. So, maybe I'd be a freelance, no-pay, no-accolades defender of Aliano while the mayor struggled to balance his meager budget and the youngsters continued to leave and the octos faded away in brass band-and-bouquet funerals and buildings continued to crack and bend under the constant threat of cataclysmic landslides and earthquakes.

I felt a distinct cracking and bending in myself, too, and a Richter scale upsurge of an earthquake-like outrage when an Italian RAI-TV (the state-owned network) crew arrived in Aliano early one morning in numerous elegant sedans to produce a "mini-portrait" of the village. I watched their camera-wielding antics with bemusement from my terrace during the day, and as evening closed in, I descended to the piazza to observe their activities a little more closely.

"So how's your day gone?" I asked the director. After what had looked like a pretty easy-flowing sequence of shoots (the long lunchtime wine, I'd been told, certainly flowed faster than this bunch of rather indolent northerners), he half smiled at me, gave me a look of languid indifference (from behind fashionable dark glasses), and mumbled, with a Roman-like sniff from his prominent nose, "Well, there's nothing much here really, is there?"

I launched into my standard defensive diatribe, but I fear it fell on blocked ears (the director's fashionably long hair obviously adding to the problem). He then listed the shortcomings of the village. These encompassed the always-being-restored state of the museum and Carlo Levi's *confino* house; the abandoned look of much of the "old section"; the questionable quality of the recently renovated houses; the reticence of the people, who didn't seem to want to be interviewed; the definite inappropriateness of the large, rebuilt palazzo across from our apartment on the piazza—"It's like a bit of Lombardy dropped out of the skies; its architecture has nothing to do with the South" (an equally outraged friend had described it as "the kind of building that gives demolition a good name")—and on and on.

The problem was . . . he was right. The village had all these and

quite a few other shortcomings, albeit temporary in some instances. But I think it was that northerner's smirk and the enthusiasm with which he described the next few places he had on his schedule of "mini–TV portraits of Italian life" that raised my ire. There was some fancy, foreigner-occupied Tuscan place, doubtless inspired by recent popular books on the region; "a very beautiful historic village in Sicily with many excellent ruins," and somewhere up in the southern Alpine foothills near Valle d'Aosta—a town voted best something-or-other village in 2000.

Previously it had occurred to me that maybe it was time Anne and I took a journey to the North—to Venice, Bologna, Turin, and Milan—not just for the cultural riches that beckoned like gleaming Aladdin's caves up there, but more important, to see our little part of the southern world firsthand from the northerners' point of view. A perspective from the pinnacles of power, architectural pomp, and artistic abundance. But now I suddenly realized that there was really no need for such an odyssey. The North itself had descended on our humble enclave and was presenting itself in almost caricature fashion.

"But you know," I began again as calmly as I could, "Aliano is nothing if not authentic and true to its origins. The people themselves are history personified. The *calanchi* landscape is unique, and the views of the mountains on a clear day (unfortunately, it was not a clear day) are absolutely breathtaking." I was even starting to sound like a publicity brochure. "Of course there are problems, but they're working them out without the help of affluent Italian second-homers or rich foreigners inspired by popular books and looking for retreats with vineyards and five-hundred-year-old olive trees."

He was not with me. His eyes roamed the piazza for his crew. It was five o'clock and time for "the wrap." Lunch had been long and lazy, and he'd not had his siesta. "Well," I said weakly as I prepared to leave him, "I'm sorry things didn't work out for you."

His attention reverted briefly to me. "Ah, well, that's not quite true. At least we got one wonderful shot!" he said with what seemed like genuine enthusiasm.

Oh, good, I thought. Maybe all is not lost. Maybe the director was not the insensitive urbane clod he appeared to be and had captured something genuine and real that would portray the enticing essence of our unique little village.

"Oh, and what was that?" I asked hopefully.

"You! Sitting at your table high up on your terrace overlooking the piazza. Writing away. Observing the whole village. Now that was a really excellent shot."

Ba-da-bing, ba-da-boing.

Pigeon Passeggiata

Such a droll, and rather depressing, interlude deserved the nurturing restoration of a coffee break and an amusing diversion of some kind. So Anne and I spent a pre-*passeggiata* half hour sitting in the piazza watching pigeons. In fact, I think I can say with absolute certainty, that this was our first real pigeon-voyeurism experience. But the sun was still warm and our coffees so decadently rich that it seemed the perfect time and place to while away those moments of early evening hedonism after the TV crew had packed up and roared away in their fancy cars.

THE FIRST THING you notice about pigeons is that the males of the species are irrepressibly arrogant. The big, plump ones seem to spend most of their time just strutting their stuff, with their bulging breasts and ruffled neck feathers, swarthy walking-tall swaggers, and a seemingly endless desire to show off their tail feathers in elegant fanlike splays to any diminutive female who happens to be around. Most females appear to be decidedly unimpressed or turn suddenly into little feathery bundles of outrage. I mean how many tail feather displays and bulging breasts can you look at in a day before wondering if these guy pigeons have nothing better or more imaginative to do with their time? Definitely no-brainer territory here.

So then begins the little promenade, lots of mini-*passeggiate*

made up of male and female rituals of the "look at me," "no, I'd
rather not, but maybe you'll get lucky and I'll get bored and then
maybe I will" variety. You see it all the time in the nightly human
passeggiate. Of course they're far more subtle. In the pigeon world, if
the lady shows the slightest interest in the feather fan or any other
part of the male anatomy or just merely recognizes that he exists,
then up he leaps in full erotic enthusiasm ready to impale the unfor-
tunate lady on the spot without so much as a "by your leave" or a
"wham, bam, thank you ma'am."

Humans of course play far harder to get. The young, furtive
males in Aliano gaggle up in guffawing groups or play who's-the-
strongest games and all those other "look at me pretending not to
notice you girls" type of antics. Lust and lascivious fantasies swirl
around these hormone-driven lads, but "cool" is the name of the
game. The girls are cool, too, in their uniquely coy girlish way of
walking arm in arm, three or four abreast, giggling and whispering
and displaying apparent utter disdain for the presence of the oppo-
site sex.

Not so your average male pigeon. His whole day, in between sud-
den collective flurries of flight with his buddies (something deeply
genetically imprinted here) and a constant search for enticing
things to nibble on, seems to be focused on regular and rapid sexual
conquests. I'd like to be able to suggest far more significant findings
as a result of our half-hour research, but in the pigeon world, sex
seems an eternal driving force, and the females seem to surrender
regularly without complaint after the usual coquettish "and what on
earth do you think you're doing?!" protestations.

I'd like to hope we humans are above all that. And I will indeed
continue to hope, despite constantly depressing indications to the
contrary.

I explained my conclusions to Anne, who I thought had been
watching the evening pigeon *passeggiata* with as much interest and
amusement as I had.

Apparently she hadn't. "Sorry . . . what?" she said, as if stirring
from a deep meditation.

"Didn't you hear anything of my erudite observation on the love lives of our oversexed pigeons?"

"I'm sorry. I was just thinking."

"About what?"

"About . . . well . . . how happy I am here."

"Really?"

"Yes, really. I feel as if I could just sit here for hours watching things, seeing new things . . ."

"The TV crew didn't seem to think there was much to see here, except dumb things like me sitting on the terrace scribbling away."

"Well, you remember, that's what our New York friends said when we moved to Philadelphia. Even though we thought it was one of the best places we'd ever lived."

"Right. I remember. Typical New York attitude to any place outside New York. The Woody Allen syndrome."

"I bet those TV people never just sat down and watched."

"Yes, that's true. They all seemed frantically busy, except when they were lunching—which apparently took up a big chunk of their time here. But I never saw any of them just sitting and watching."

"What a shame."

"Maybe we're biased. Maybe it's just because, as we keep realizing, and being told, we're still neophytes here. Everything still feels to have a little bit of magic in it. In fact, didn't Woody once say something like that: 'If it's not magical, it's not real'?"

Anne smiled, squeezed my hand, and gave me one of her heartfelt "oh yes!" responses. I like those. A lot.

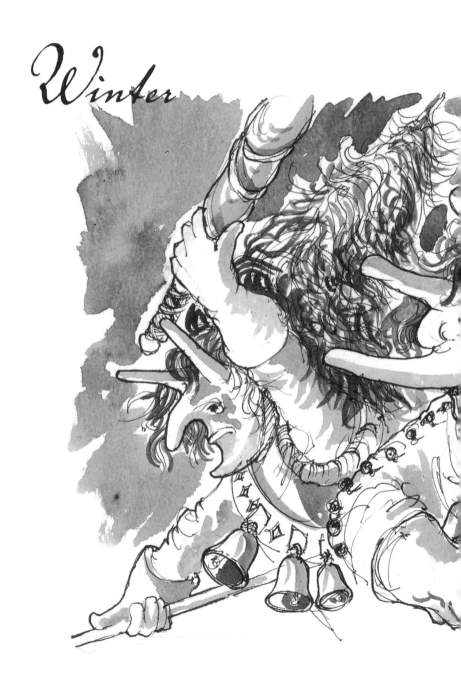

Winter

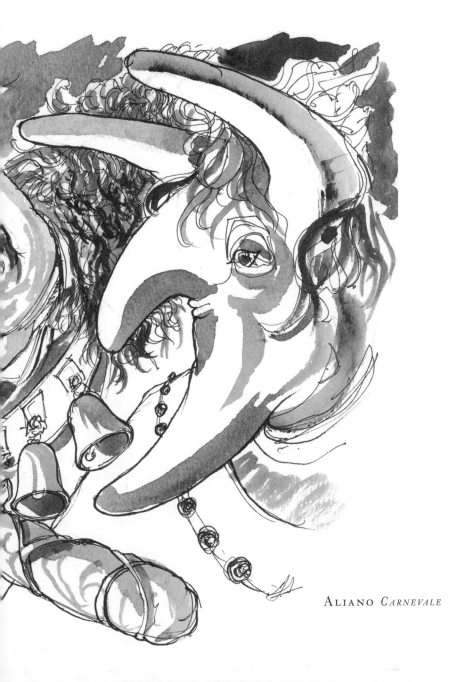

ALIANO CARNEVALE

Introduction

The season came slowly and sneakily at first. A few chilled flurries of post-autumnal air swirling the smotherings of wrinkled leaves in the piazza and sending them into dervishlike spiralings of dance. It seemed like a kind of death dance, with distinct rattling sounds as the leaves scratched and clawed at the cobblestones—a sound reminiscent of skeletal bones scraping together in some bizarre rite of passage and passing.

Then the sun would return and the soft breezes, too, seductively lulling us into a false sense that winter might be late, or might never even come at all that year.

But of course, the onset was as inevitable as the creeping assurances of aging itself. In fact you could watch its emergence in the changing rituals of the octos and even in the stoic, daily habits of the black-clad widows. Larger, thicker coats appeared, and the bench-warmers down Via Roma arrived a little later each day at their allotted spots. Some spots, where the winds were a little too chilly or where benches were shadowed by the declining arc of the sun, were abandoned until much later in the day. And there were more men inside the bars now and fewer sitting outside on the plastic sidewalk chairs. The evening *passeggiate* took on a brisker pace too, were less well attended, and shorter, as night slithered in earlier and colder.

Then came the rains. Sudden chilling *brutta stagione* ("ugly season") downpours that cleared the streets of all activity and movement. Dogs howled, knowing what such rains would ultimately bring: lethal swathes of ice on the marble and granite paving stones and even frigid January days of snow, brilliantly white and crisp but—maybe due to some greenhouse warming trend—nothing like the white bleakness described so evocatively by Levi:

> *The village struck me as more remote and lonely than ever, no echo of the outside world penetrated so far; no strolling players or peddlers came to break the monotony. . . . The wind came up in cold spirals from the ravines; it blew continuously from every direction, went straight through a man's bones, and roared away down tunnellike paths . . . and the forsaken land was piled high with snow . . . storms of winds and snow raged outside*

At this distinct seasonal cusp doors were closed tighter and dogs and cats and anything reminiscent of the old days—when houses were also communal animal byres—would be left to fend for themselves as the cold chilled not only the bodies but also the hearts of the populace. Not a pleasant prospect, but somehow most of these animals found somewhere to hide and survive the winter, maybe a little thinner, but still sparky with the spirit of feral hunters.

IT WAS THE SEASON'S hush that Anne and I found hardest to accept. I missed the morning bustle, even the noisy tractors and the cries of peddlers, and particularly the low hum of chatter and debate that floated up to our terrace after the octos had enjoyed their morning breakfast *correttis*. But early breakfasts, certainly our breakfasts, were no longer quite so early. The cold, low-slung light of the sun was barely apparent until after seven A.M., whereas in the summer, its brilliance would wake us, invigoratingly, shortly after five A.M. Now our bedclothes stayed in place as we slept longer. Then we had to decide who would make the tramp across icy tiles to the

kitchen to start the coffee, and, worse still, whose turn it was to try and light the ever-resistant fire, using the massive, tight-grained chunks of oak and olive from the woodpile on the terrace. Those burly logs always seemed to ignore the kindling succor of twigs and rolled-up spirals of burning newsprint. They just lay there, blackened by smoke and refusing to burn, or, even more frustrating, allowed themselves to be etched a little in flames, and even showed a few enticing signs of real conflagration, before fading yet again into a somnolent and ineffective glow that persisted throughout much of the day as the logs slowly crumbled into gray, heatless ashes.

And so it would go, deeper and deeper into this increasingly silent season until we began to wonder if winter would ever end and thoughts of moving for a while to a warmer clime bubbled up through the icy chill of the days. But of course, we didn't move. And neither, as far as we could tell, did anyone else in the village. We all shivered together, and smiled brittle, chapped smiles, and told each other lies about signs of an early spring or predicted, with inflated assurance, changes in the dreary sequence of days . . . changes that never came.

So, we just made the most of it. We cocooned ourselves, wore sweaters and thick socks and sweat suits, devoured books and old *New York Times Book Review* sections we'd brought with us, listened to the great symphonies, cooked up big *ribollita* vegetable soups and slow-simmered casseroles of *cinghiale* (a huge haunch of boar, a gift), venison (another gift), even *asino* (donkey; the less said about that gift the better), and great sauce-slathered platters of pasta that we created for impromptu parties with local friends.

And the days passed, and, all in all, I guess it wasn't too bad a time, at least not for us. But others suffered, particularly those whose olive groves had been hit by the poor winter weather and the fickle rhythms and moods of the olive trees themselves. That old saying "One good year and two bad" had proven itself true once again as meager December and January harvests, hardly worth the picking, had left the villagers in a dour, defeated mood. One *con-*

tadino told us angrily of his meager crop, *"Non vale un brutto pomodoro"* ("It's not worth a single lousy squashed tomato"). And, as one particular incident suggested, some were ready to blame not only the inclement weather but also the suspected devious sleights of hand of the local olive mill owners. . .

Going Deeper

Agonies at the Old Olive Mill

I could hear the woman's shrieking voice echo all the way down into the *calanchi* canyons.

I was climbing up the long hill after a sketching session on an unseasonably warm January morning and feeling pretty pleased with myself. The light and the shadows had been perfect for capturing the drama of the buttes and the rugged, slightly lopsided "old town" of Aliano, perched precariously on the edge of those clay-rock precipices. How the place had managed to cling to such an impossible perch was beyond me. But I had the same reaction almost every time I sketched Italian hill towns. Their tenacity and durability boggled the mind and senses—which is precisely why I love to sketch them.

The shouting—near-screaming actually—got louder as I approached the fortresslike ramparts of the village. I realized that it was coming from the old *frantoio* (olive mill), which was due to close soon when the new Calanchi Cooperative mill finally opened. (Don Pierino, Aliano's priest and one of the proud instigators of this sparkling new pink-stucco edifice at the edge of town, insisted that it would be "very soon. Just a few final pieces of machinery still to

come . . .") But in the meantime, the old *frantoio* was still grinding and pressing in the ancient manner inside its stone barn at the roadside, and rich, oily aromas (and some rather unpleasant black liquidy residues too) were rolling out into the street. When the screams started, a bunch of octos gathered around—as they always did near anything that had life, movement, noise, or smell—smirking and chuckling as usual. In fact, the louder and more strident the female voice became, the more they laughed and nudged one another and gave one another knowing "she's *baaack*" nods and winks. One of them kept repeating over and over "*Gassata! gassata!*" which means "excited and full of life," although I don't think he was being at all complimentary.

Never one to avoid anything with a hint of drama to it—particularly in Aliano where drama was usually in pretty short supply—I peeked through the huge doorway of the mill into its musty shadows. For a moment all looked normal. It sounded normal too; I had grown accustomed to that infernal din of cranking, grinding machinery, which lasted all day and night when the harvest was abundant. Someone was tipping sacks of olives, fresh from the field ("the fresher, the better" was the motto when it came to maintaining the best possible taste and "body" of oil), into a funnel-like device in the floor—a very oily, slippery floor—from whence they were carried by conveyor belt high up to sieves that removed leaves, pebbles, and earth. Then on they went to the water spray, which gave the ripe, deep green and purple brown olives a serenely healthy, polished gleam, before they vanished into a coarse chopping mill.

The olives emerged, battered and broken, and tumbled on into the slowly churning, five-foot-high and two-foot-thick granite mill wheels—three of them—powered by a massive electric motor (not so long ago they were donkey powered), which proceeded to crush the dear little things, flesh, skin, and stones—on a fourth horizontally turning wheel in a huge steel bowl—into a smooth, aromatic pulp. Usually a normal load "under the stones" was around three hundred kilos. Once crushed, the pulpy mix was then mechanically laid on circular straw mats, piled on top of one another and interspersed

with steel disks to a height of almost six feet, and then squeezed by a huge hydraulic steel press with such an enormous vertical force that you could actually feel the floor of the mill quivering.

The first run of cold press (you didn't even *mention* "hot press" in Aliano) extra-virgin (low acid content—usually less than one percent) oil was poured in thick, sensual torrents out of the mats and onto the centrifugal filtering system, which consisted of a large, circular, stainless-steel colander revolving at high speed, to remove water and waste matter, and finally disgorging its beautiful bounty of fruitily aromatic, yellow green oil into a gleaming, stainless-steel tub. And there it lay, winking with air bubbles, awaiting displacement into metal or plastic containers or more evocative glass demijohns—whatever the *padrone* of that particular pressing decided to use to contain his harvest and either sell or enjoy at home until the next year's bounty.

Apparently it was not unusual for the average extended family to consume upward of two hundred liters of olive oil a year. This usually required around twelve hundred kilos of olives (six kilos of olives for one liter of oil), from around a dozen or so mature olive trees, depending upon the age, quality of harvest, the spacing of trees, and all those subtle intangibles that made each year different from every other year.

After each individual pressing, the mats were cleaned and the sludge, now as hard as cardboard, was removed and further moistened and pressed for low-grade oil (*olio di sansa*, also known as *rettificato* or *lampante*) before finally being used for cattle feed or fertilizer, or anything else that ensured, in typical penurious-peasant fashion, that not a single crushed stone or sliver of skin would go unused.

It was another one of those great cycles of nature that, like the grape *vendemmia*, beats on rhythmically and ritually year after year, century after century, here in Aliano and across much of Europe, the Middle East, and North Africa.

But the screaming woman was not at all concerned about rhythms and certainly not about years and centuries. She was very

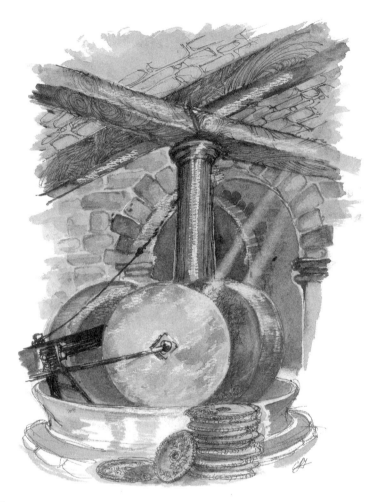

TYPICAL OLIVE MILL

much focused on the "now" as she stood with her back to me in a long, black, threadbare skirt, torn rubber boots, a matted brown cardigan, and a red bandanna headscarf stained with what could only be pigeon droppings, by the look of all the multitudinous squiggles of yellow and white goo.

I caught fragments of the outrage she expressed in a shrill shriek that matched the din of the machinery in volume and pitch. The

person she was addressing, a young, stocky man in blue overalls with a shock of olive detritus–laden black hair, seemed to be only partially aware of her presence and was certainly unmoved by her protestations. Something about her *partita* (small amount) of olives—most locals had managed to harvest only small amounts that year—being the best in Aliano, and why hadn't she been told when they were going to be pressed, and how could she know if this oil was from her own olives and not from the grove of some uncaring peon who didn't prune his trees correctly or, worse still, someone who had used a *bastone* (stick) to knock olives from the trees rather than picking them by hand in traditional *molto lavoro* (much work) Aliano fashion . . . and on and on. Apparently in Basilicata the wily *contadini* olive growers tended to watch religiously over the pressing of their produce, reflecting an inbred mistrust of millers, who had, on occasion, been known to underweigh the sacks of olives or substitute inferior produce and keep the cream of the crop for themselves.

The frantic woman—this very suspicious *padrona*—kept lifting the index finger of her right hand and screaming, "Just taste! This cannot be my oil!" And then she turned and saw me. I realized then that she was carrying a small plastic cup containing, presumably, a sample of her oil. She kept dipping her finger into the gold green liquid, sniffing it, licking it, and then holding it out to the unfortunate young man, who kept as busy as he could moving the crushing mats around. Then she stuck out her finger at me instead and cried out, "Lick it!" As politely as I could I resisted the invitation, so she held out the plastic container and bawled something like, "Help yourself if you're so fussy." So, what else could I do? I reached into the cup and stuck my finger in the oil. I smelled it. It seemed fine to me—very aromatically olive-like. I licked it. It was delicious—full and fruity and with none of the acid overtones of olives that had lain around too long after picking or had been left on the branch so they fell or that were shaken from trees onto widespread nets, a real no-no in this part of the country.

I tried to be tactful. In fact, all I said was something innocuous like "very nice," but her voice once again soared into the operatic

stratosphere and her deeply furrowed, lean and foxy face became even leaner and foxier—one might say almost wolfish—as she hurled rather offensive epithets about *stranieri* (foreigners) and what the ****** did they know about real olive oil, before turning back to the young man in the blue overalls—who, very sprightly and understandably, had taken advantage of her diatribe with me, and vanished.

At this point the woman had reached a ballistic, all-engines-go point, and I half expected to see her rocketing through the rafters and pantile roof of the mill and out into the bright blue yonder, clutching her little cup, her red, pigeon shit–dotted bandanna trailing behind her. Her apparent out-of-control dementia reminded me of a line in Robert Fox's book *The Inner Sea*, when, on a visit to Aliano in 1983 he asked after Donna Caterina, who had tended to Carlo Levi's comfort during his *confino*. He was told that she was still alive but "shrieking at the moon, as mad as a hatter."

For a moment I wondered if this lady was some reincarnation of the unfortunate Donna Caterina but decided not to research the matter further. Rather, like the young man at the press, I decided retreat was by far the better part of valor, so I eased my way through the chuckling cluster of behatted, walking stick–wielding octos outside, and made my getaway up the street.

A single glance back made me realize that I'd definitely left at the appropriate moment. I saw the woman rush outside and hurl her little plastic container of oil in the general direction of the rapidly dispersing audience of chuckling elderly spectators. Then she gave her bedraggled mule, tied up outside the mill, a hefty boot in the backside, which generated a raucous, bellowing protest from the unfortunate creature and, for a moment or two at least, drowned out the unhappy woman's lamentations.

IN ALIANO, which prides itself on the unusually high quality of its oil, the winter olive harvest can last for weeks, especially if it's a "one in three" year. It's a slow business of handpicking, often by both men and women, and the loading of twenty-five-kilo boxes

similar to those for the *vendemmia* but stretched out over a longer period to ensure that the olives are picked at the very peak of ripe perfection and quickly taken to the mill before that insidious acidic oxidization process begins. Of course there's always the lurking fear of leaving the picking a little too long and risking a frost or, worst of all, a repeat of the devastating "Day of Wrath" of January 19, 1985, when a winter ice storm in some regions sent temperatures to as low as minus fifteen degrees centigrade. At that point the sap froze, and in doing so expanded, and millions of olive trees literally exploded, especially in Tuscany and Chianti, where orchards are still recovering from the massive devastation. (One interesting fact emerged, however, from that calamity, which sent the government into a frenzy of olive oil–industry investigations: Despite the decimation of over three quarters of the trees in some areas, barely a dent was noticeable in "regional olive oil exports"!)

But despite the slowness of the harvest, and the fear of storms and the back-wrenching nature of the work, there's a mellowness to these time-honored rituals. It's rather touching to watch each tree being treated as an individual, with its own particular quirks and needs and its own sense of timing and, ultimately—if the weather's been good—a generous reward to the farmer for an enduring and endearing partnership in productivity. Of course there are always those who will never share my somewhat sentimental perceptions, and the woman with the "lick this!" finger, I'm sure, is one of them.

Creatures of the *Calanchi*

Another equally bizarre experience—and one more excursion into Aliano's "dark side"—occurred unexpectedly a few days later.

I WAS DOWN in Aliano's *calanchi* canyons.

Now, why was that? you might ask.

Well, first because it was a fine, warm day and the air was crystal clean and I was restless in the house. Stepping outside into the bright sunshine, I felt as if I'd walked into one of those bucolic ad

scenes for bottles of pure spring water. And second, Gianfranco, Giuseppina's son and the father of two adorable youngsters, had promised to take Anne and me horseback riding in the canyons. I had salivated at the image of us sitting on fine steeds acting out Wild West roles as posse leaders in pursuit of malingering desperados, or something equally bold. Gianfranco had promised this two weeks ago, but he still hadn't turned up with suitably saddled creatures dripping with leather and brass accoutrements, pawing at the cobblestones, and chomping at their bits for "the big ride."

In fact, I hadn't seen him at all—which is perhaps just as well from his point of view, as there were a few more fix-up jobs needed in our apartment. Not big things, really. More like petty annoyances, such as repairs to the heavy wooden blinds that you hauled up on a kind of rope-and-pulley system inside each room and which kept getting stuck or tangled or generally busted. And the TV, of course. Not that Anne or I wanted one, but it was still sitting there in Giuseppina's living room, its blank black screen looking like something out of a scene from 1984. We felt that Gianfranco might as well fix that, too, seeing as he was around. It might give us a few nightly belly laughs as we tried to understand why near-naked dancing girls kept popping up in the middle of serious *Who Wants to Be a Millionaire?*–like shows, shaking their prominent bits and pieces while the contestants took breaks and the quizmaster ogled these gorgeous things like the letch I was sure he was. And *Popeye:* endless nightly shows of back-to-back *Popeye* cartoons, and in prime, adult-viewing time for some bizarre reason. And then the "talking heads": interminable lines of them, prattling on at typically Italian racetrack speed, no one listening to anyone else, everyone gesticulating and arm waving, and laughing at their own witty repartee, none of which was in the least intelligible to either of us. Or the studio audiences either, by the looks on their blank, bored faces—at least until the director pushed his "Smile," "Scream," "Applaud," or "Go Hysterical" buttons, backed up, I'm sure, by inane laugh tracks.

As I said, it would have made an amusing diversion during our cocktail hour at least.

But Gianfranco had so far failed to arrange for such amusements. Nor had he fixed the two nonburning burners on our stove, nor the mysterious leak in the bathroom fixtures that always seemed to leave us with a puddled and very skiddy floor, the bathroom being one of those lethal all-tile designs that have always seemed to me to be lawsuits waiting to happen.

And, of course, as noted, no horses.

"The heck with it," I said to Anne. And I was off by myself into the *calanchi* for a nice long *scampagnata* (outing). Once again, and very wisely as it turned out, Anne was not particularly keen to join me on this particular expedition, but I was eager to get some photos of my little village perched precariously high above on its cliffs of ever-melting clay. "You will like," Gianfranco had insisted. "Many nice photographs and sketchings there for you, I think."

IT WAS A LONGER and steeper walk down than I thought it would be. Actually, very long and very steep. And very muddy. It seemed this corpse green/gray, not-quite-rock terrain, possessing a distinctly Samuel Beckett—like bleakness, had a remarkable knack for not absorbing rainwater but rather letting it just sit there, making any path a permanently puddled mud slide. Or at least until the torrid days of high summer arrived, when it reverted to ankle-deep dust that coated everything, including your ears, eyes, and mouths, with layers of talcumlike powder that, like stage makeup, stuck to everything.

But I was in the middle of an unexpected mud season and wallowing along up one of these dramatic soft-wall canyons that looked as if they might decide, at any moment, to adjust their almost-vertical profiles by allowing slimy deluges of molten, porridgelike detritus to be expectorated down upon anyone dumb enough to be messing around below. Like me. And a very messy me at that.

Carlo Levi, as usual, captures the unique character, the genius loci, of the *calanchi*:

> *And all around white clay, no trees, no grass, only clay dug by*
> *waters to create hollows, cones, lands with a malicious look, like*

a lunar landscape . . . and everywhere nothing else but white clay precipices, on which the houses above stood as if floating on air. And the clay started to melt, to slowly trickle down the slopes, sliding down, gray streams of mud in a liquefied world. . . .

"The silence here is nice though," my little eternal optimist piped up. "No one around to disturb you. You've got the *calanchi* all to yourself. Perfect for photographs, don't you think?"

I like my little optimist. Couldn't do without him, really. On many occasions he's the happy little watchman at the gates of my deeper, darker, emotions—the "black ogres" as I call them—making sure they're locked up solid and secure against any unexpected inner tumult awaiting me.

"Best not to go there," he'd chirp up if I was about to descend into occasional moments of desperation.

"Right-o," I'd say. "Good idea. Let's have a chuckle or two instead."

Which is what I normally did, until the mood mellowed and I got on with whatever it is I was doing before my darker self tried to lure me in.

Which it was doing again.

"Oh, forget it. It was nothing," insisted my mental gatekeeper.

"No, it was something, I heard an odd noise . . ." I said, not feeling quite so optimistic now and remembering that strange line of Levi's, "Invisible animal forces here reveal themselves in the air."

"Like what?" the optimist asked with an indulgent chuckle. "What could possibly be bothering you in such a nice, quiet little canyon like—"

"Dogs, I think," I said. "Barking."

"Ah," my optimist responded. "Well, at least it's not wolves, is it? Or boars? Or bears?"

"They don't have bears around here anymore. Boars, yes. And wolves, too, so I've been told."

"Yes, but this thing is white. It's not a scroungy old gray monster with big fangs and those kinds of things."

"But it's very big. More like a small lion."

"Don't be silly."

"And there are two of them."

"Oh, that's nice. Maybe they're just out for a little stroll, like you."

"Make that three."

There was a rather unnerving silence at the optimist's end of the conversation.

"I said there are three of them."

"Yes, yes, I heard you." The optimist's voice was now distinctly less optimistic. "Well, let's see, maybe you've had enough of this canyon for the moment. Why don't you just slowly turn around and stroll back out . . ."

"They're starting to run."

"Run?"

"At me. Now. They're coming like the clappers! And they're snarling and showing their teeth."

"Ah." Another unnerving pause at the other end. "Well, you could try a gentle trot."

"A trot?!"

"Okay, so you want to panic? So panic! Run like hell if you want! Might not be a bad idea, actually, under the circumstances."

So I ran like hell and skidded and slid and ran again, but those fangy monsters were gaining on me fast. And I knew exactly what they were. They were those lethal Calabrian sheepdogs (*pastori maremmani*) that the local *pastori* (shepherds) used to protect their flocks of sheep and goats and themselves from anything less threatening than a nuclear attack. They might look rather sweet and cuddly when they're lolling around at the roadside or in the fields, but, from two prior experiences, I'd learned that even a hint that you'd like to pat the cute, white, furry heads of those creatures—once renowned for their wolf-fighting abilities—and they'd transform themselves in a nanosecond into slavering, snarling beasts ready to tear off your arms for lunch and devour the rest of you leisurely. All this while one of those

shepherds doubtless watched with a devilish smirk on his weather-worn face and without so much as a "stop that now, stop eating the nice man" suggestion of protest.

"I'm running as fast as I can!" I called out to my optimist, but, like the shepherd, he seemed to be showing total disinterest in my impending fate.

I was on my own. Doubtless the demons behind my mental gates were prancing and screeching with delight knowing that I'd soon be entering their darkest realms of despair.

I was running the wrong way, too. I didn't recognize any of the topographical features—not surprising, as all the *calanchi* start to look alike after a while. And what was even more interesting was the

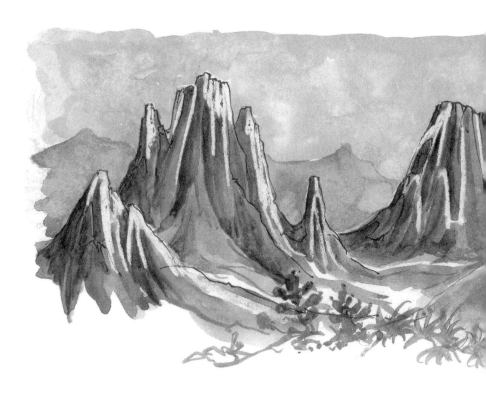

CALANCHI LANDSCAPE

fact that it seemed as if my course was coming to an end at an abrupt drop-off just a few yards ahead.

"I'm trapped!" I shouted to my optimist.

No response.

"Are you deaf? The bloody things are almost on me!"

"Well . . ." There he was again, with that irritatingly benign tone of his. "What's over the edge?"

"A long drop."

"Vertical?"

"Almost."

"Well, if you don't fancy being torn apart in this god-forsaken place you decided to explore, you might consider jumping."

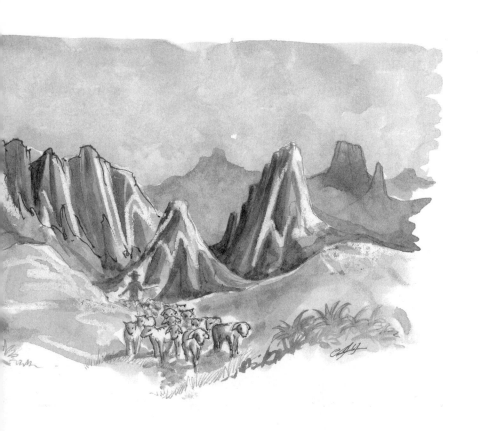

"Jumping!?"

"Well, it's either jumping or watching bits of you get ripped off and disappear into those slavering mouths in what I feel might be a rather painful demise . . . for both of us."

So, I jumped.

I half-closed my eyes and let myself fall, legs downward, and doubtlessly doomward. Well, legs down at first. Then it all got a bit mixed up, with legs up and head down and then sideways and then a somersault or two. After that I sort of lost track.

At least the mud at the bottom of my slide was soft and there had been no protruding boulders on the journey down. But there's soft and then there's something that more closely resembles a mud Jacuzzi, which is what it felt like as my body continued to spin and flail about in a foot or two of the gooiest, grayest, most god-awful goo it had ever been my displeasure to experience. Of course, people pay small fortunes for this kind of mud bath treatment in fancy health resorts, but somehow it loses its appeal when it's free and unrequested.

But at least there were no dogs. They were still high up at the edge of my drop-off, barking and howling and snarling and slavering—but definitely not coming down. In fact, their attention seemed to have been diverted now as they began squabbling among themselves, then lashing at and trying to bite chunks off one another in an apparent tirade of "You let him get away, stupid," "No, you did, you idiot," "No, you did . . ." and so on.

Slowly I rose, soaked and shivering. The dogs paid me no more attention, and one can assume (hope) that they ultimately all devoured one another in a frenzy of frustration and bloodlust as I wallowed like some kind of mud monster slowly downhill to where the *calanchi* opened out to a benign scene of leafy olive orchards and orange trees bedecked with garlands of fat, round fruit.

I won't bother describing the rest of my limp-legged clamber (distinctly resembling one of those Pythonesque "silly walks"), back up to the village, through the groves of gum trees. (These oddly out-of-place Australian imports are found throughout the

South, and are dismissed in no uncertain terms by Norman Douglas in his book *Old Calabria* as "this grey-haired scarecrow, this reptile of a growth," and an "abomination.") I used the most elusive paths and back alleys I could find to avoid contact with anyone I knew. Or anyone at all.

AS A LITTLE POSTSCRIPT to my *calanchi* calamity, I got a call that evening from Gianfranco, who informed me with unabashed enthusiasm that he'd managed to arrange for horses the following Saturday "so we can all have together a nice ride in the *calanchi*, eh?"

The Day of the Pig

We managed gracefully to postpone Gianfranco's outing but couldn't avoid the day we'd been anticipating for quite a while . . . and dreading.

Anne had been dreading it simply because she wanted nothing at all to do with, shall we say, the mechanical side of pork production. Of course she didn't at all mind enjoying the actual products themselves. In fact, she adored home-cured Lucanian *prosciutto*, *coppa*, and *soppressata*, and was intrigued by all the multitudinous flavors of the sausages and salamis made by our friends. She also had been known to regularly indulge in breakfast platters of fried *pancetta* and eggs and to crunch through crisp sautéed *guanciale* (cheek jowl) in the belief that it was some kind of extra-fatty belly-pork with a special flavor that three months' salted aging and hanging in a cool *cantina* could create.

But the actual slaughtering and butchering of the pig held no appeal for her. "No, thank you," she said. "I want to continue liking pork."

"NEXT SATURDAY at my grandfather Nicolà's farm," Massimo had told me on the phone. "Ten o'clock in the morning okay for you?"

"Sure. Fine," I said in a steady voice that belied far more reluctance.

"After we kill, big *pranzo*, lunch, eh? Lots of pig to eat!" Massimo added with a chuckle, and I could imagine his cherubic face grinning with expectant delight.

"Great!" I said and tried to mean it.

"*Va bene*, David."

"*Va bene*, Massimo."

It occurred to me that I could pretend I'd misunderstood the date. Or come down with the flu. Or suddenly had to go to Potenza. Or Naples. Or anywhere.

But, "No," my conscience told me. "One of the reasons you're living here is to try and record and understand life the way it is lived in these wild hills, and if that means having to watch a pig being decapitated, then that's what you have to do."

"ACTUALLY," one of Massimo's English-speaking friends told me after I'd arrived promptly at Nicolà's farm on a bright blue and unseasonably mild February morning, "we don't cut the heads off until later on."

"Heads?"

"*Scusi?*"

"Heads. You just said 'heads.' Plural."

"Yes. That's right. There are three pigs to be butchered this morning."

"Three."

"Yes. And not too old. Only eight or nine months. About eighty kilos weight each one. Not like the big adults. They can weigh over two hundred kilos."

"These are not suckling pigs, *porchetta*? The meat that almost melts in your mouth?"

"No, no. *Porchetta* is very young pig, maybe only two to three months."

"So, that's around a total of two hundred and fifty kilos. Well over five hundred pounds. That's a lot of *prosciutto* and salami to make."

"Well, no," my informant said. "They're too young for that. The meat is too small for *prosciutto* and *coppa* and all those things. There'll be plenty of sausages though. The women will be cleaning the intestines in the main house, and they'll stuff them with chopped-up meat for sausages later. Most of the meat will be used for cooking—stews, roasts. That kind of thing."

"I understand. And you were saying about not cutting heads off . . ."

"Well, not at first. That's not the way. First you have to cut the vein in the neck and drain off all the blood. And the heart has to keep pumping, otherwise the blood stays in the body, and that is not good for the butchering or for the meat."

I considered this for a moment, trying to envisage the upcoming ritual. "So, the pig, it stays alive while the heart pumps and you drain out all the blood from its neck?"

Massimo's friend, a tall, swarthy man with the build and earthiness of a real *contadino*, which, of course, he was, looked at me closely and then smiled. A rather paternalistic smile. "Ah, your first time, eh?"

I was tempted to deny what to him must have been glaringly obvious. (Sometimes I got tired of being the eternal neophyte, always on the learning end of things.) But I just nodded and grinned. A little sheepishly, I guess.

He nodded back and patted my shoulder, which felt a little odd as I was sure I was a good decade or so older than he. But he had the advantage of years of this kind of rural rite, and I was standing there, worried about the poor pig with its throat cut but not being really dead.

"No, no. Don't worry. The pig's brain is dead. There's no blood going to it, so it dies very quickly. But the heart keeps pumping."

"Okay," I said uncertainly.

And it was then that the squealing began.

There were eight of us altogether standing at the base of Nicolà's huge two-storey stone barn, once used as the original farmhouse, until the new farmhouse was built in 1820, immediately across the

courtyard. Four of the men were there primarily for their renowned strength in holding down extremely nervous and energetically flailing pigs. Massimo was playing his usual run-around, do-whatever-is-needed role. Nicolà, the eighty-five-year-old grandfather patriarch, was also present to observe, criticize, and praise where appropriate, and generally to keep an eye on all the flurried activities of the morning.

Marcello was the key man responsible for overseeing and undertaking most of the actual butchering. ("You must watch him when he halves the pig," Massimo had told me, his voice resonant with respect. "He is like a surgeon. Right down the backbone. Straight line. No wobbles.") And indeed, Marcello had something of a surgeon's aura about him, too. His fine-featured face; prominent, aristocratic nose; thin pianist's fingers; and lean, muscular body—all made him stand out from the bulky, farmhand appearance of the other men, who seemed to regard him as the natural leader of this little throng.

And then there was me, relegated to my familiar role as observer, recorder, photographer, and "occasional helper," if help was ever needed, which turned out to be almost never and which was fine with me. The things I was to experience that morning had a strange effect on my body, which became progressively drained of energy, doubtless a result of symbiotic identification with the draining lifeblood of the three pigs.

IT ALL BEGAN with squeals from the first pig being pushed and dragged from its sty down the sloping, hay-littered cobblestones to the massive, thick-legged slaughtering table set in a walled yard at the low side of the barn. Nearby were a handful of cows, a five-hundred-kilo bull, two donkeys, a baby donkey called Jacob, and numerous sheep and goats, all occupying the various stalls and byres in the lower level of the barn. And, just like me, they too seemed to demonstrate symptoms of symbiotic reactions as they added their brayings, mooings, and baa-ings to the increasingly high-pitched scream of the pig.

The poor animal seemed all too aware of its impending fate. I wished someone would stun the thing and let it meet its end in a blissfully unconscious state. But in this scene of almost medieval intensity and seeming barbarity, the pig, flailing and contorting, was hoisted by the four burly farmers onto the table, with its head projecting off the edge. Massimo was kneeling directly below with a huge bright yellow plastic bowl.

Marcello stepped forward with a knife, a remarkably tiny knife—more like a pocket device than the massive cleaver I'd expected. He waited patiently while the men struggled to restrain the pig's movements and at one point I saw him very briefly, and very gently, stroke the pig's head and cheek with his delicate, long-fingered left hand. I don't know if it was some kind of ancient *pagani* tradition—a sort of blessing of the animal for its bounties—but I felt a lump gather in my throat at the sight. Just about the same time, the pig must have felt Marcello's other hand stroke its throat, gently searching for the primary artery.

It all happened so quickly, I'm not sure I really saw it. Maybe I closed my eyes for an instant. But the knife cut a knick—quite small, barely a couple of inches across—the pig gave one last piercing shriek, then its head fell and its blood gushed in deep red spurts into Massimo's bowl . . . and continued gushing as the heart pumped on.

Steam poured out from a dark, cavernous room at the side of the table, where an enormous witch's black cauldron of water was boiling on a crackling log fire. And to complete this Macbethian witchy diorama, a wizened old woman sat in the shadowy murk, stirring the steaming water with a metal rod, with what can only be described as "an evil grimace" on her face. Upon reflection I'm sure she was merely expressing her pleasure at the upcoming cornucopia of sausages, skin, trotters, fatback, bacon, and numerous other bits and pieces that would soon be the result of all these ritualistically bloody processes.

I wondered if they planned to parboil the pig (the cauldron seemed large enough to hold the whole animal), but then Massimo

delivered the bucket of blood to his mother, who was in charge of the innards aspect of the gory procedure, and then scurried back and forth carrying huge jugs of boiling water from the cauldron. These were poured carefully over each section of the carcass as the men meticulously scraped off all the hairs with more of those small, ultrasharp knives, revealing a detergent-white skin with a soft, cushiony-smooth texture.

The next steps were the removal of the head; gutting of the now-pristine animal; careful removal of the intestines, liver, kidney, heart, and other delights; and meticulous cleaving of the carcass into two neat halves for delivery to Massimo's hotel kitchen and its final butchering into roasts, joints, and sausages. I mention these tasks rather hastily and objectively as I don't think a cut-by-cut description of all the various processes is really necessary and, having seen them performed on two pigs (I'd had enough by the third), I'm not sure I'm up to regurgitating all the grisly details.

Suffice to say that at the end of the morning there were three gleaming-white, hairless heads on display, ready for some medieval-style bacchanalian feast, and three meticulously halved carcasses prepared by Maestro Marcello. And of course a mass of all that inner stuff, which the women whisked away to the house for cleaning and chopping and other messy but meticulous processes of sausage-making and the like.

Nicolà seemed a little weary, too, by the time the third pig was hoisted onto the slaughtering table, so we strolled together around his farm as he told me tales of his life, his pride in his family ("Eight! I made eight fine children!"), and his and his wife's ability to live an almost totally self-sufficient life on his one-hundred-twenty-acre estate. His wife was sitting on a chair out in the sun knitting a sock ("from our own sheep wool," insisted Nicolà). She smiled as Nicolà took me inside the farmhouse to show me his racks of salamis, *coppa, soppressata,* and other pork products dangling from the high ceiling over the stairwell.

"We used to have a small inn here a few years ago. And a restaurant, too. Before my son Angelo and my grandson Massimo opened

THE PIG SLAUGHTER

up their new hotel and restaurant in Accettura. We were quite famous, I think. People wrote about our traditional dishes and described all the things we made here on the farm—all the different salamis and things, our own olive oil, our wines, our bottled sauces, our fruits and vegetables, our own *burro* [butter], ricotta and *scamorza* cheese, pecorino cheese, too, from our own sheep, and provolone, which we aged for more than a year. Delicious! Oh, and our own wheat, too, *grano*. We have more than forty hectares of wheat

that we used for our own bread and pasta. We hardly needed to buy anything. People bought from us instead!"

We strolled slowly uphill on a rough track and turned to admire his estate. It was set in a beautiful bowl-like enclave, bound along the high, enclosing ridges by parts of the Montepiano forest. The steeply sloping hillsides were now all meticulously plowed wheat fields just beginning to glow a soft emerald green as the furlike shoots of winter wheat, planted in October, were beginning to grow in preparation for the July harvest. The farmhouse itself, strangely evocative of Andrew Wyeth's paintings of the Kuerner farm in Pennsylvania, sat like a sturdy, square fortress halfway down the folding contours of the fields. Its windows, cut into two-foot-thick stone walls, were small and few. The even older barn across the cobbled courtyard took advantage of the slope of the hill to create entrances on each of its two levels. Echoes of the shouting and laughter of the men completing the slaughter of the third and final pig wafted up across the wheat fuzz on the fields.

Nicolà smiled. Farming was his life, and he obviously loved every aspect of it—even his memories of the old days when he and his family plowed these steep slopes with hand plows and oxen. In fact, he was so fond of his ancient, primitive plows and other museum-quality equipment, that he still kept them, rusty but intact, in a shed by the side of the barn. Pride of place was given to a "French reversible plow," which he tried to define for me. He laughed when I indicated my confusion.

"What will you do with all these things when you retire?" I asked.

Nicolà's laughter increased. "Retire?! I'm eighty-five now and have no plans to retire! The day I retire will be the day I am dead!"

I laughed too. I'd heard that kind of "retire from what?!" response from so many people in love with their lives and their work to the point where they saw no difference between the two.

"And what happens to this beautiful farm then?"

I wished I hadn't asked that question. His mood changed faster than Basilicata's spring weather, and a look of frustration or anger flickered across his face. He sighed. "I hoped some, one, of my

children or grandchildren would . . ." There was a long pause. "But, they have so many other things they want to do with their lives."

And then came the anger, suddenly and in a flood that made his bronzed, stately face go steel-hard. The lines on his forehead looked aged and tormented, but his eyes were moist. "It will be a desert!" he said loudly. "All these villages around here. No young people left. No one on the land. No one proud of land. All full of old people. Dying, dying. All dead soon. And this land, all the lands. Back to forest. Or desert . . ."

LATER ON, while lunch was being prepared on embers taken from the fire under the cauldron, one of the men approached me and we talked about the farm and Nicolà.

"Did you hear what the men call him?" he asked me.

"No. I didn't notice."

"They call him *Cavaliero*. It is a name of great honor because he received many awards during the last great war. Then when he came back home he made this farm to grow wheat. And peoples say he saved our village, Accettura, because we had no much wheat and very little bread after the war. We ate weeds, wild onions, anything. But the *Cavaliero* grew enough wheat for all of us, and he did not charge high prices that other people did and that we could not pay. So he saved us. And people love him and respect him very much. And today that is rare: honor and respect. In the old days you earned respect, and it was very important. If you lost respect, you were nobody."

THE *CAVALIERO*, Nicolà, was toasted heartily over our huge casserole *pranzo* of pork chunks slowly simmering with bay leaves, olive oil, onions, *peperoncini*, and thick red wine. It was a simple-sounding concoction, cooked over a mound of smoldering embers in a huge earthenware pot, but when I tried to reproduce the superb dish on several occasions on our own stovetop in Aliano I never quite managed to capture its intensity and richness.

We served ourselves on old porcelain plates and, munching great

slabs of golden bread, we all stood around the slaughtering table, which had been covered with a plastic cloth to disguise its previous use earlier that morning. Nicolà's strong red homemade wine flowed from large glass flagons and the traditional cries of *"Buon appetito!"* and *"Salute!"* and my favorite *"Cin cin!,"* echoed against the thick stone walls of the barn.

I felt that I was experiencing, touching, something unique that morning. Maybe it was the absolute freshness of the meat and that mood of ancient, time-honored rites that seemed to permeate the atmosphere. Or maybe it was just the camaraderie of a bunch of hardworking men, mainly *contadini* farmers, who continued to share a timeless tradition together and would do the same thing every year until they themselves faded back into the earth—which, hopefully, would continue to be as fruitful as it is today.

But I knew that all would agree with Nicolà. If the land was not nurtured by people like them, it could indeed ultimately "become a desert."

Postscript

Apparently the pork casserole we'd all enjoyed in the late morning was merely a prelude—a minor *merenda* (snack)—to a far larger traditional *pranzo* (lunch) at Massimo's restaurant overlooking Accettura. I hadn't realized this so I'd consumed the equivalent of a hearty midday meal with the men. When the time came for us all to move from the farm, I inadvertently glanced at the three grinning, decapitated pig heads hanging on the barn wall and decided: enough pork for one day. In fact, enough pork for quite a while. So, I slipped away from the farm, pretending ignorance of the celebratory feast. Looking back I realize that I possibly reacted a little too hastily and doubtless would have enjoyed a splendid, wine- and *grappa*-laced bacchanal, which, I'm sure, could have made a far more colorful tale.

As indeed it will. Next year, maybe.

Giuliano's Little Trick and Rosa's Magic

A week or so after the pig fest I experienced yet another rather unique, and certainly unexpected, event as part of my ongoing rites of passage here.

FOR ALL HIS tendency to portray himself as a kind of chuckling, good-natured bumbler, Giuliano apparently had a wily side, too. Others had warned me of this in a kind of warm-spirited, wink-and-nod manner, and suggested that I should be a little wary of the wheeler-dealer persona in his nature. But I preferred to take him as I saw him—as a generous and helpful friend who was always ready to advise and assist us and expand our network of new acquaintances and "interesting characters."

But there was a particular day when I realized that maybe one reason Giuliano was so helpful and so willing to be seen with me around Accettura was the fact that the small village was rarely visited by "writers" (or any other outsiders, for that matter)—certainly not by writers writing a book on Basilicata and linked, albeit tenuously, to such venerable publications as *National Geographic* and the *New York Times*. It was a win-win situation. I benefited from Giuliano's help, and he, in some modest, secretive way, seemed to gain a little local kudos from his association with me.

On this particular day, Giuliano chose his moment well. We'd just enjoyed one of Rosa's splendid five-course lunches (another one of her "just a *spuntino*" [snack] masterpieces)—featuring as *secondo*, pungent, garlic-filled rolls of thin-sliced veal that had been slow cooked in her own rich homemade tomato sauce—and Giuliano and I were basking in the glow of glasses of grappa and Rosa's thimbles of robust espresso coffee.

"So, we workin' on your 'farm calendar,' right, David? This afternoon?"

This was one of those on-off projects I'd begun weeks before. I wanted to create, mainly for my own education I think, a sort of month-by-month chart of all the things that small farmers had to do

in order to be traditionally self-sufficient in terms of producing their own olive oil, wines, cheeses, meat, prosciutto, and all those salamis, fruits, and vegetables—the lot. I wasn't quite sure what I would actually do with the chart. Maybe there was a part of me that wondered if Anne and I could handle a subsistence existence if we ever decided to constrain our peripatetic ways and settle down enough to try the "simple life" for a longer period

"Yes. I'd like that. We've got quite a few things to cover. Also I need more details on all those pork products you've got dangling from the rafters in your *cantina*. I want to know how you both make the perfect prosciutto, *coppa, soppressata.* . . ."

"'Azright. Rosa knows all that. But she 'as to go out for a while so we can start that later on."

"Okay. Fine with me," I said, looking forward to another glass or two of grappa, for digestive purposes only, of course.

"So I was thinkin', maybe you like visit our school, where Rocco, my grandson, goes. It's a nice little school up by church."

"Oh, I've been to quite a few schools, Giuliano. Sebastiano has taken me around to most of his places in Aliano and Stigliano."

". . . And the headmaster say he like show you 'roun' . . ."

"I honestly don't think I . . ."

". . . 'bout two o'clock this afternoon. If is awright with you."

Giuliano looked at me appealingly, and I realized that he'd already set the visit up. He wasn't really *asking* me, but *telling* me what our agenda for the afternoon was to be.

"Course, if you don' wan' . . ." he said with a sad frown.

What the heck? I thought. I could hardly say no when I'd just enjoyed a superb lunch at his home, and we had nothing else to do anyway until Rosa came back later on.

"Okay. That's fine," I said, sensing I had been cleverly nudged into a corner. Often my first reaction to such a situation is to become unusually assertive and openly negative. I guess that's what happens when you've spent a large part of your life "on the road" and you treasure your personal freedom and boundless choices almost as much as life itself. But this time, I surrendered with barely a whimper.

A few minutes later we were rolling up to a very airy contemporary structure set on a high bluff overlooking the village and the sequence of ranges and hill villages that eased eastward into a heat haze. Most of the schools I'd seen previously had similar locations, and their classrooms invariably had large picture windows offering enormous vistas of wild Lucanian landscapes—a refreshing improvement on the hovel-like pit that was Aliano's school in the thirties and described so evocatively and with outrage by Levi.

I assumed that, as had occurred on my other visits to schools in the region, I'd be shown the halls bedecked with proclamations and school awards and photographs of soccer teams, and then a few of the classrooms filled with charts, projects, maps, and artwork done by the children (another notable improvement on Levi's morose descriptions of the typical classroom environment in his days).

But this time things were a little different. Suspiciously different. When we arrived the headmaster came out to greet me formally, saying how honored he was to have "a very famous writer from America" visit his small school. I looked at Giuliano, wondering where the "very famous writer" label had come from. He nodded and grinned mischievously. Then the teachers, all women, were introduced to me one by one. Fortunately the first to be introduced spoke and taught some English, so the comments of the others, with references to my twenty-odd travel books and *National Geographic* magazine and my illustrations, etc., were translated with embarrassing floridity. Once again I realized that Giuliano had been here and prepared the ground well by telling them about my books and articles. One glance at his glowing face, basking happily in reflected glory, was enough to confirm my suspicions.

That glance should also have warned me of things to come.

The hallway was suddenly full of marching lines of young pupils—all the girls in white Alice in Wonderland–type "overdresses" and all the boys in traditional royal blue smocks. They walked summarily in single file past our little gathering of teachers and down the corridor into one of the larger classrooms at the end of the building.

The headmaster watched them pass with a look of paternal pride and then asked if I was ready.

"Sorry?" I said, already suspecting what the answer would be. "Ready for what?"

"Well, Giuliano said he thought it would be very nice if you could talk to our pupils about yourself and what you do."

My smile suddenly felt very tight and tense. "Oh, he did, did he?" I looked around for Giuliano, who was now conveniently half hidden behind two of the teachers and studying some framed documents on the hallway wall with rapt attention.

"So, if you would like to come with me . . ." the headmaster said, indicating the way down the corridor to the classroom, which resounded with the giggles and shouts of young pupils, doubtless delighted by a chance to miss afternoon lessons.

And there they all sat, fifty or so of them, with expectant faces—some smiling, some as solemn as little magistrates—and ranging in age from seven to eleven. Then the teachers marched in and arranged themselves, sentrylike, along the walls and by the door. Barring a hasty exit on my part, which I must admit seemed a tempting "fight or flight" option for a moment or two, I realized I was now expected to entertain these youngsters and the teachers by . . . by doing what?!

It's not that I was unfamiliar with the lecture circuit and expectant audiences, but usually I was well prepared, with notes and even a slide show. In addition my listeners were usually adult and ardent lovers of travel and adventure tales, relatively familiar, at least vicariously, with many of the countries Anne and I had explored, and possessing patient attention spans . . . and were invariably fluently English-speaking!

I realized that I was faced with a black hole of experience. I had the distinct feeling of being sucked into sensory oblivion. I had never before talked to a gathering of very young schoolchildren. I think my sister's experience as a schoolteacher and her descriptions of the terrors of "keeping the little darlings focused and amused for more than thirty seconds at a time," had convinced me that such a

challenge was one I was quite happy to forgo for the rest of my natural life.

Until today.

And no one was helping me. Teachers had hissed and cajoled the room into timorous silence, and were now watching me intently, with anticipatory half-smiles on their faces. The headmaster gave a brief speech in Italian, presumably a promo-pitch for my appearance, and then nodded smilingly to indicate that the floor was now all mine. And, of course, Giuliano was by the window, giving me one of his broad, encouraging grins.

It was at that moment that I spotted Rocco, Giuliano's physically disabled grandson. He was sitting in the front row in his wheelchair, his face beaming with expectation and pride as he indicated to his friends that "this is the man I've been telling you about who is always eating far too much of *Nonna* [Grandmother] Rosa's food at our house" (or something along those lines). His smile—always a beautiful smile that seemed to glow with the pure pleasure of living and learning—did the trick. He and I had been chatting a few weeks previously about the things he enjoyed most at school and the dreams he had for his future. And suddenly I knew exactly what I would try to talk to these eager young pupils about: I'd talk about dreams and how the life that Anne and I were trying to live (propelled by serendipity, luck, and pure bloody-minded zaniness) actually still seemed to reflect our earliest dreams.

And so, assisted by the English teacher, who offered to interpret (I have no idea how well, but she seemed to enjoy herself), I began.

"When I was a very little boy, I remember having this fantastic dream. I was in this big, big balloon painted with red and blue dots and floating high above the ground and being blown along by warm breezes all over the world . . ." (Fortunately there was a big map of the world on the wall behind me—the perfect prop.) "Whenever I wanted to explore somewhere—mountains, lakes, deserts, big cities—I could pull on a little rope and the balloon would float down out of the sky and rest on the ground, and I could get out and go off

to meet the people who lived there and eat strange foods with them and dance their dances and listen to all their wonderful stories. And then, when I had learned and seen lots of things, I could get back in my balloon and pull another rope and soar back up into the sky again and go looking for somewhere else to explore and to learn about. And you know what happened? That dream—the dream I had when I was about your age—came true. And for a long, long time I have been exploring the world—anywhere I want to go—sketching, writing, taking photographs, eating really strange foods, and listening to lots and lots of people tell me about their very different, but always very interesting, lives."

And I had them! I could tell by watching their faces that the idea of dreams actually becoming real had somehow struck a chord in their young heads and hearts. There was no whispering or yawning or sudden trips to the bathroom. They just sat there, staring at the map as I told them about all the places Anne and I had explored in our thirty or so years of traveling together. But I also made it clear that Anne had her own special dreams, too. Inspired by the adventure travel books she read during her childhood, she had decided she wanted to explore Africa and other developing regions of the world. Through her work with people who were blind, she'd traveled extensively and loved what she did. And somehow, during her many years of overseas work, the two of us had always been able to combine our mutual dreams of traveling and exploring together.

I realized after a while that half an hour had passed in nanoseconds and I decided it was time to wrap things up while the children (and teachers) were smiling and still seemingly attentive.

"So, what do you think is the meaning of everything I've been talking to you about today?" I suddenly asked the children. I realized later that this was perhaps a risky thing to do, particularly as the silence that followed my question seemed to go on and on . . . until the responses began to flow, one by one. And I stood there amazed at their comprehension and moved by some of their interpretations:

"You must try to find a dream for your life . . ."

"You must try to make your dream true by what you do . . ."

"You must not be frightened if you do different things from other peoples . . ."

"Try to find someone to share your dreams with and see if you both can live your dreams together . . ."

"Even when bad things happen, you must remember your dreams . . ."

"It's all right to have more than one dream or to change dreams . . ."

"It's good to try to understand and help other people . . ."

Some of their other comments had everyone clapping and howling with laughter:

"I would like to travel in a much bigger home than yours!" (a reference to the tiny, cramped VW camper I'd explained was our first "earth gypsy" home).

"I will never eat dog!" (I don't remember any reference to eating dog in my talk, but who knows? Maybe I got a little carried away in my monologuing . . .)

"I don't want to go anywhere with spiders."

"Is it all right to be a girl train driver?"

"I want to plant lots and lots of trees and make the world very green . . ."

"Do you think you'll ever explore the moon?"

I seem to remember that my response to that last question, when the giggling finally faded away, suggested that the moon was merely a stepping-stone to all the amazing galaxy-filled infinities beyond. I was going to try and offer a Carl Sagan "billions and billions" picture of the whole universe but decided that they'd all possibly had enough ideas and concepts dangled in front of them for one day.

ON OUR WAY back to Giuliano's house he couldn't stop chuckling. "That was fantastic, Dave. They loved it! 'Ow many times have you done this kinda thing at schools?"

I decided to be honest. "This was a first."

"No, no," he said, still chuckling. "No, I don't believe . . ."

Me neither, I mumbled to myself.

And then he switched roles and became my agent and general factotum again. "Look, ah, on the way back, why don't I introduce you to our mayor? Only a few minutes. He's very nice man."

"Giuliano!" I said as stubbornly as I could.

There was a brief silence. But then my irrepressible friend was off again: "You remember you and Anne was talkin' 'bout lookin' at 'ouses for sale 'round Accettura and Aliano? Well, friend of mine 'as got this 'ouse not far from 'ere. Right on the top. Beautiful views of everything. Not expensive to buy. So maybe you wanna take a quick look . . . now?"

All I did was turn and give him my best attempt at the silent assertive look.

"Oh, 'azright, 'azright, David." He chuckled again. "We got work to do with Rosa."

"'Azright, Giuliano," I said and started chuckling too. I felt stupidly, blissfully happy.

And even happier when Giuliano happened to mention—maybe as compensation for his sneaky little conspiracy—that "Rosa is cooking for dinner tonight one of your favorite things, her *sotto il coppo.*"

And as usual, he was right. This traditional masterpiece was indeed one of my favorite Lucanian slow-cooking creations. It consists of a sublimely fragrant and tender casserole of chunks of rabbit, small cubes of pork jowl (*guanciale*) and potatoes coated with olive oil, salt, pepper, and *peperoncini*. Rosa cooked this for three or four hours in an earthenware pot sealed with a clay lid (custom made and decorated by Giuliano as one of his new projects), in a nest of embers at the edge of an open fire—in our case Giuliano's fine, handcrafted fireplace built entirely out of his own bricks.

As the three of us worked together through the afternoon and into the early evening on the "farm calendar," the dining room slowly filled with enticing aromas, and despite all my vows to forgo dinners after large lunches, I looked forward to breaking them. Over and over again.

R OSA'S CULINARY MAGIC revealed itself in other ways later that day as we delved into the mysteries of *maiale* (pork).

Along with a few trusted women friends along Via Galliano in Accettura and a couple of female family members, Rosa is one who can rapidly transform a just-deceased four-hundred-pound mature porker into a remarkable range of extremely tasty delights—at least eleven—all of which I'd seen on many occasions dangling from the rafters of the Mingalone *cantina*. And in addition to a hearty supply of cutlets and chops (*braciole and bracioline*) and huge roasts, she wastes not one iota of pig and even finds succulent ways of using skin, ears, tails, and all those other curious oddities.

The following is a virtually unedited transcription of her commentary on the various *casalinghi* (home-produced processes) involved, presented in her unique blend of Nottingham, "South Italian," and Accettura dialects and phraseology:

"What you've got to realize, y'see, David, is that pork is really our main meat. We've plenty of lamb, too, because this is sheep country—you see the *pastori* [shepherds] and their white dogs everywhere." (I remembered the white dogs all too well from my recent traumatic experience in Aliano's *calanchi* canyons.) "But pork is king. There's an old dialect saying around these parts, '*Crisc'lu purch'ca t'ung'lu muss*,' 'Keep a pig and you'll oil your snout.' In fact our Lucanian pigs and all the things we make from them was praised by a lot of them Romans—you know, Cato, Apicius, Pliny—I remember that from school. In fact, all across Italy you'll hear sausages and salamis called *luganega*, which means that Lucania always produced the best. But funny thing is, it's not difficult really. Good sea salt is your main item. And patience. You need quite a bit of patience. And muscle. You need a bit of that, too. If I need a lot, I get Giuliano.

"I always start with the prosciutto because it's the most difficult to get dead right. Some years we don't make it, 'specially if there's likely to be a real hot summer. Prosciutto has to hang for at least a year—better two—and it doesn't like too many shifts in temperature.

It can spoil, go off, if you're not real careful. But generally this *cantina* of ours keeps a pretty even temperature year 'round, so usually it's all right.

"And what you do is this. First, I don't bother with smoking. Some do, and they make that *speck* ham—a bit like the German aged ham, but you need a special smokin' room, and most of us in Basilicata like it just salt cured. So I take the hams, the big back legs, cut the trotters and the hocks off them. I use those for other special dishes. Slow-cooked hock and cabbage—a beautiful dinner that. Trotters are good, too, but it takes forever to get them real tender so that everything just slips off the bone when you suck them.

"Anyway, so I get this big cauldron and fill it with moist salt—about thirty grams per kilo of meat—and press it into the ham all over. Then you let it sit for up to thirty days or so, turning every two days in the salt. Some people mix in some *peperoncini* or black pepper with the salt, but we don't. I like it pure myself.

"So, then, after all that turning in the salt, which takes out most of the blood and water, you want it as dry as possible, otherwise it'll spoil. You wash it really well in cold water. Then you lay it on a board on the floor and cover it with a tea towel or some cheesecloth, then put another board on top, and then you put a really heavy load on top of that—about four hundred pounds—to press it and squeeze it as dry as you can without breaking the flesh. Giuliano usually does this bit with his homemade bricks and whatnot. And you leave it for about forty-eight hours without moving it.

"Now you've almost finished. What you do next is rub the exposed part of the meat—where it was cut off the trunk of the pig—with a sticky mix of hot *peperoncini*, salt, and lard, to keep bugs and flies off and to give it that special Basilicatan tang. Some people use just lard. Some use a mix of fat, paprika, pepper, and whatever other spices they want, really. It all depends on what you like.

"Then you put the ham in a muslin or cheesecloth sack and hang it up for two years. I check it from time to time by just opening up the flesh a little bit and smelling it. Sometimes one'll go off but usually, after two years, you've got a lovely purple rose–colored prosciutto

that'll last our family a good three months if you cut it real nice and thin.

"Other cured meats like the round *coppa*, which is usually lean shoulder and lower neck meat, and *capocollo*—the upper neck meat—are a bit simpler. Basically you turn them in the damp salt for eight days, wash them, wrap them in a caul, and then hang them up for at least four months in those string nets.

"Then there's all kinds of salami-type things you can make. When you chop up the meat real fine, add salt and pepper, whole and crushed—*peperoncini*, too, if you want it hot—squeeze the meat into intestine skins, and hang it up for three to four months. *Soppressata* you do like that, too, using the meat from the back of the leg.

"And then there's your normal *luganega* sausages and *cotechino*, also *salsiccia*, which all need minced-up meat. We used to do all that by hand before we got the machine, and that was really hard work. Then you can add salt, pepper, and some *peperoncini* if you want—some people use garlic, fennel, anise seeds, all kinds of things. You can make very rich *salami al aglio*, with garlic. I keep my ingredients simple; I like the taste of the pork to stand out. But we've got such a lot of wild herbs growing up in these mountains—cumin, rue, sorrel, forest fennel, pennyroyal, rosemary, and them small wild onions called *lambascioni*; you see them in all the groceries still covered in soil. So some people use them in the sausages and salami recipes. And they get very fussy, too, over which *peperoncini* —capsicum peppers—to use, too. I like *pupon* best, but you've also got your *frangisello*, *cerasella*, and *diavolicchio*—the one they say has a "devilish" bite. There's another one, too. Real strong. Like Scotch Bonnet, but I forget the name. . . . Anyway, then you pump the mix with an electric sausage maker into those yards and yards of intestines that you've cleaned real good. And that's about it. Except—I almost forgot: There's *pancetta*, which is the belly pork bacon, which you age like *coppa* for about six months, and Giuliano's favorite, *guanciale*. That's pig cheek or jowl, which is mainly fat and aged like *coppa*, but it tastes so good just plain with bread or fried golden crispy with bread fried in the fat that's cooked off.

"Now you've got to remember, like I said, with a pig you don't waste nothin'. The blood we don't normally use for blood sausage—black puddin'—which we used to eat a lot when we lived in England, but not here. We make a kind of chocolaty-cream filling for cakes and things instead. We call it *pezzente*, beggar's cake! It's really very nice. You'd never know you're eating blood. Honest. In fact, you had some last time for Sunday dinner and you said you really enjoyed it. Bet you didn't know what it was though, did ya!?

"And then there's the ears and snout and all them other bits and pieces, which we chop up and layer in large glass jars separated by salt and bay leaves. You weigh it down like a galantine—press it—for a year or so. Then you take out what you want, soak it in water overnight to reduce the salt, and then boil it up with cabbage and potatoes. And it really is lovely. Melts in your mouth. We call it *cantarata* locally. I don't know what they call it up north. Maybe they don't like to eat them kinda things up there! We're not so fussy as them, us who live down here.

"Oh! And last of all. There's a lot of *ciccioli*—that's rendered-down pork fat to be used for cooking and other things. And my lovely little rolls of skin wrapped around garlic and *peperoncini* and salted for a few weeks. You wash them, too, and cook them—still tied in little packages—with lentils or beans. It may not sound like much, just flavored skin, but when I do them the whole family's over in a flash!"

So, THERE YOU HAVE THEM. All the secrets of a self-sufficient *contadino*-type of family, courtesy of Rosa Mingalone, who offered them openly to anyone willing to play with the wonderful possibilities of pork.

Rosa added her own postscript: "And what else do I do with my year? Well, I used to make cheeses—pecorino, ricotta, mascarpone—but I've got a friend who, I think, makes them better, so I use hers instead. I used to make butter, too—*manteca* or *burro*—but I'm gettin' too lazy in my old age. But I'm always makin' fresh pasta. I use the best *pura semolino di grano duro*—that really good flour made

MINGALONE *CANTINA*

from the heart of hard, durum wheat grains. They don't let me use packaged stuff much. They ask me for *orecchiette, strascinati, ferricelle, cavatelli,* and their favorite, those little, long strands you roll around a piece of wire, *truchetti.* I usually serve my pasta with a kind of ragu sauce, using very small pieces of chopped, not minced, meat. Oh, then I make at least two hundred liters of my own tomato sauce from our own tomatoes, although last year we got some kind of virus all around here, which killed them all off overnight. Lovely, big, juicy tomatoes all went black. So, I had to buy tomatoes. And I don't use no basil or garlic. Just salt. You can add other flavors later when you cook. And I do all kinds of things with olives, too—bake 'em, pickle 'em. You know. Everybody does. And jams and bottled fruit. I do all that. And we dry those big red peppers, *peperoni rossi*—not the hot ones—and toast them a little bit in a frying pan until they're dark red and as crisp as a cracker. Beautiful. It's all so beautiful, really."

Nothing needs to be added. Rosa, as usual, said it all.

More Serendipity with Sebastiano

Experiences like this (despite Giuliano's little trick) made Anne and me appreciate even more the gracious hospitality and gustatory talents of our friends, particularly Sebastiano and Rocchina, whose generosity knew no bounds. And once again we had been invited over to their Stigliano home for "a little Sunday lunch," which of course is an utter oxymoron in the Villani household. But on this particular Sunday there were even more surprises in store for us . . .

"YOU TWO—you're just like a couple of little boys together!"

I'd forgotten who'd actually said that. It might have been Rocchina, but I think it was his postpubescent, nineteen-year-old daughter, Antonella (I do like the way Italians often create male and female versions of the same Christian name), who gave one of her cute, sultry half-smiles and, between frantic bouts of gum-chewing, often made quite revelatory and perceptive statements. As teenagers everywhere are apt to do, I guess.

I certainly remember watching Sebastiano's face when the remark was first made. It scrolled through a range of possible responses, each reflecting a different persona and each of declining severity. First was the stern Italian father, head of the household, wondering if such levity of a personal nature was appropriate in his family. Particularly with guests present. Then came the director of education/headmaster disciplinarian always seeking to balance "appropriate behavior" with what he insisted he wanted most of all for his students—"Freedom to learn, think, and express themselves." And then came the man himself, almost thirty years older than his daughter, wondering if some kind of watershed in understanding and communication were being crossed and whether he might have to start treating Antonella as a young woman rather than just a girl with sometimes erratic and beguilingly bizarre outbursts of rhetoric and behavior.

And then came his smile. Then the wide grin. And then the belly

laugh, which made his brown eyes shine brightly and his thick moustache wobble in that endearing Groucho Marx manner.

"Yes, yes. I suppose it's true! What do you think, David?"

I was laughing too, along with Anne, who nodded in enthusiastic agreement with Antonella's remark. And it was definitely true that whenever Sebastiano and I got together, often for the most serious of purposes, zany things would just seem to happen serendipitously. Things we never expected and never sought to instigate or control. And we just kind of plunged in and watched to see what would occur next. Which was fine with me, because I'd spent a large part of my adult life giving myself precisely that kind of liberty. Indeed, seeking it on every possible occasion as a way, not only to spice up my existence (ever true to Jack London's belief that "the function of man is to live, not to exist") but also to provide grist for my writing and my way of learning about the wonderfully kaleidoscopic world in which we all live.

But on occasion I was a little concerned for Sebastiano. After all, he was a pillar—and a very highly respected pillar—of Stigliano society and the community of villages all around, and I hesitated to be a catalyst of anything that might jeopardize such a respected position and hard-earned reputation. He, on the other hand, didn't seem in the least concerned. "It is best that people see who you really are," he told me after a couple of rather riotous bouts of free-wheeling behavior. "They always find out anyhow, so why pretend? After all, you yourself, David, have said many times that we all have many sides, many selves to our personalities and that we should allow them—how you say—that we should 'let them out to play, eh'?"

I obviously had to agree because that's what I think and, doubtless, I'd expressed such musings on more than one occasion. "Yes," I said. "Definitely." And having affirmed the fact that we were, and intended to remain, rather like "little boys together," I asked about our agenda for the rest of the day.

"Well, first we let lunch settle a little," Sebastiano replied with a sigh of gustatory relief as the two-and-a-half-hour-long Sunday

midday meal slowly rolled to a climax in the form of an enormous cake, layered and iced with chocolate, stuffed with hazelnuts, and rich in sweet liqueur-flavored intensity.

The lunch, once again, was supposed to have been "a snack." At least that's how Sebastiano had presented it when he called earlier in the week to ask us if we could join his family and a couple of friends that weekend.

"We're not much good with large lunches, Sebastiano," I had replied hesitantly, remembering past occasions when we'd been overwhelmed by Rocchina's prowess in the kitchen. "They usually wipe us out for the rest of the day."

"Oh, no, no, no," he'd insisted. "Just a few things to nibble while we plan some other activities. Oh, and a surprise—I have a little surprise for both of you."

Surprises always piqued our interest. So, we agreed and presented ourselves at one o'clock in the afternoon on a blustery Sunday at his apartment building, perched on top of one of Stigliano's arduously high hills. Chilly mists, brought in by a north wind—"from Russia," insisted Sebastiano—whorled around the streets and blocked out all the usually fabulous views of the mountains and valleys to the south. Seven flights of stairs later we arrived at his door, breathless and thirsty. And, I regret to say, hungry, too.

"Ah, David, Anne!" Sebastiano said as he greeted us with one of his "from the heart" smiles. "Welcome, welcome, come in, come in."

We were introduced to his two friends, both sociologists and advisors on human affairs to local companies and organizations. And yet again, I had one of those increasingly frequent flashes of face recognition. It must be a symptom of the aging process because, more and more, I seem to keep meeting people who immediately remind me of other people. In this case the lady was definitely Erica Jong, or maybe Carole King, I couldn't quite decide. And he, with his portly bulk and wide, toothy grin, was Topol, or maybe Zero Mostel. (I always get the two of them mixed up.) But there was certainly an aura of *Fiddler on the Roof* in the man's hearty, booming presence as

he looked up from a frantic game of *foosball* with Sebastiano's son Gianluca, and then quickly resumed his flailing of the rods dotted with plastic players, filling the living room with great bearlike roars every time he scored.

ROCCHINA'S "SNACK" began with the usual antipasto delights of sliced salami, prosciutto, mozzarella, garden-ripe tomatoes, and chunks of golden-dough bread with that hard, bronze crust. These were followed by what we hoped would be the second and final course: huge bowls of *ferricelle,* pasta doused in a rich pork and beef ragu sauce and sprinkled with just-grated parmigiano reggiano and—here's a new one, at least for me—fresh-grated horseradish. A truly pungent kick start to the dish. But we should have known better. These were merely tidbit preludes to a huge casserole of baked turkey and pork, an unusual but succulent combination in a rich *peperoncini* sauce served with olive oil–rich heapings of oven-roasted potatoes laced with minced garlic and caramelized onions.

I gave Sebastiano one of those "I thought you said this was going to be a light lunch" looks, and he shrugged with a kind of helpless "Sorry, but you know what Rocchina's like when she's let loose in the kitchen" gestures.

We plowed through the casserole and then into a huge platter of Rocchina's homemade sausages, rich in anise-flavored fennel seeds and grilled to succulent, scarlet gold sweetness and thwacked with sprinklings of those startlingly fiery Basilicatan red peppers.

And then salad. Of course. And then some kind of cheesy-mousse dessert with slices of *scamorza* cheese. And fruit: gloriously juicy blood oranges from Topol's (I'll call him that because I've forgotten his real name) orchard near his home in Pisticci, a fascinating warrenlike hill town twenty miles to the southeast of Stigliano.

Finally came that splendid chocolate cake, served with Rocchina's own five-year-old homemade walnut liqueur made from "green walnuts with bay leaves and lemon" (aggressively strong but aromatically beguiling), followed by decadently rich and enormous

Perugia chocolates, cappuccino, and *biscotti*. Oh, and the wine, of course. Six adults managed to consume four bottles even though none of us ever seemed to have more than half a glass in hand at any one time.

"So, enough, I hope?" said Sebastiano with a sly smile.

I tried to frown at being duped into devouring such an extravaganza of delights but I guess it came out as a wide grin followed by a distinct growl from an overloaded digestive tract. "Superb!" I think I may have murmured, before slipping into a near stupor. Anne just smiled a very broad and wine-happy smile of appreciation.

"NOW," SEBASTIANO SAID, after Antonella had given us a brief but charming postlunch serenade on her *organetto* (a sort of miniature, gypsy-style accordion) and I had completed a series of circumnavigations of the living room, trying to restore some life and sense of movement in myself. "My surprise for you two."

"Ah, yes," I said, wondering what else he could possibly have in mind after such a cornucopia.

"I have a friend in town, Rocco, who has this little museum, and he would like you, all of us, to go and see it."

"How nice," I said, not too enthusiastically. "Is it a long drive?"

"Oh, no, no," Sebastiano insisted. "Not a long drive at all. Because we will all walk there."

I started to remind him that it was cold, very cold, outside, that the town was smothered in fog, and that we'd just completed an extremely long and debilitating meal. But when Sebastiano gets an idea in his head, it's very hard to talk him out of it. I guess that's why he is who he is, a director of education, who always seems to know what he wants and usually gets it too.

So, that's how we all came to be half-skidding down the steep hills of the town, then wandering up sinewy alleys of steps, endless steps, and then down again, past the remnants of Stigliano's eleventh-century castle, across huge cloud-swept piazzas where the only signs of life were those little black-clad widows, always scurrying about in what looked like life-or-death missions of utterly focused urgency.

"Are we lost?" I seem to remember croaking out at one point after a particularly laborious stepped ascent, when Sebastiano paused at the corner of one particularly spacious hilltop piazza.

"No, no. I just wanted to show you. This is our marketplace. Very good market here. Every Tuesday. Full of people."

"Really?" was all I could think to say. The place looked so deserted that even the normally ever-present pigeons seemed to avoid it.

"And here it is," he said after a tortuous, half-skidding climb down one of the steepest alleys of the town. Those marble paving stones are lethal if you're wearing smooth, rubber-soled shoes—as I was. "Rocco de Rosa's little museum."

An enormous, bowed-wall, ramshackle barn of a building loomed up in front of us. Its construction consisted primarily of huge square stones, but despite its massiveness, the whole place looked as if a quick kick in the right place or the merest nudge of an earth tremor—not even enough to cause a flicker on the Richter scale—would crumple the place in a nanosecond. Which would be a great shame, because Rocco's museum—actually an extensive collection of ancient agricultural implements, olive presses, wine barrels, *torchi* (grape-pressing machines), and hundreds of other carefully assembled, rust-bound knickknacks—was a masterpiece of visionary compilation. One man's vision, too: Rocco himself. A bright-eyed, smiling, lean-bodied man, perhaps in his early forties, who according to Sebastiano had spent most of his adult years assembling his collection "without seeking money from anybody. He did it all by himself," said Sebastiano with great pride in his friend's accomplishments.

Rocco entertained us for an hour or so with the tales and histories behind his collection, which he seemed to regard as a roomful of personal acquaintances. He affectionately stroked the huge granite mill wheels of the seventeenth-century olive press; rubbed the cobwebby, leathery rotundness of a harness that was once wrapped around the necks of mules used to turn the tree trunk–thick central wooden pivot post of the mill; caressed in an almost sensual fashion the bowed oak staves of ancient wine barrels

still vaguely redolent of old vintages; rang the big bronze cowbells dangling from the walls; and invited us to feel the sharpness of the spiked collars once worn by sheep dogs as defense against wolf attacks.

Rocco's love for his own personal creation was infectious, and as we went on to explore his upper "romantic" rooms above the presses, we found ourselves in an attic dreamworld. Here was where he kept his cheek-by-jowl piles of "emerging collections" of artifacts. They were in such wonderful heaped confusions—enormous boxes piled with old books and manuscripts; an ancient fireplace adorned with hundreds of rusty keys, some the size of kitchen ladles; dust-coated religious icons and paintings; a mini-mountain of ancient sewing machines—that you wondered how he would ever reach some of the remoter piles. To some, I suppose, it would have been just a hopeless, haphazard repository of miscellaneous junk. But in Rocco's eyes it was more, and I could tell that, one day, he would sort it all out and display it as effectively and enticingly as all the other items in the rooms below.

We all left, inspired by the man's single-minded determination, and I wondered why he had so far refused to seek funding for his pet project.

"Ah!" Sebastiano explained with a frustrated shrug. "Paperwork. So much stupid paperwork to get even a small grant in this town, in this region. And he is a very proud man and not very patient! He has, like so many Basilicatans, an inbred contempt for laws and regulations and *statali* bureaucrats!"

"But surely this is a contribution to Stigliano," I suggested. "There's no other museum here. Nothing really for visitors to see if and when they ever come here."

Sebastiano chuckled cynically. "You know, last night I went to a meeting of the Regional Planning Council. They said they wanted to make plans for the future of this part of Basilicata and they invited the people in the town and from the villages to come to present their ideas."

"And?"

"And what!? Nothing! There were less than twenty people. And no young people at all, and they are the future of this area."

"No ideas either?"

"Oh, of course. The same old stuff. Bring new factories, new enterprises. Get rid of all the red tape. That kind of thing. And you know, in that small area in the valley between Stigliano and Aliano where they built a few roads and tried to get new businesses to come . . ."

"Yes, I know the place. It has three buildings on it."

"Correct. Two are empty, and the other has been there for two years and they still don't have a telephone yet! Can you believe?"

"Unfortunately," I said sadly but truthfully, "I can. But what other ideas came out of the meeting?"

"Oh, 'let's make more tourism' was the big one! In this area, with almost no hotels, no fancy restaurants, not even a properly funded museum like Rocco's to show people our history and how we lived. Tourists need these things. You can't just say, 'Hey, it's very beautiful and dramatic down here so please come and stay with us and spend lots of money.' You know, it's all so stupid. When I think . . . when I remember that my grandparents lived in one room here with farm animals and chickens everywhere . . ."

Rocchina was walking with us and she could see that Sebastiano was about to launch into one of his familiar and always spirited tirades about the stupidity of politicians and bureaucrats and anything else that smacked of pathetic attempts at "planning" and half-baked visions of "our great new future." So, she gave him a loving but tough nudge, and he stopped in mid-sentence, blinked, and then exploded with one of his warm, throaty laughs. "I'm off again, eh?" he said to Rocchina, and she smiled and nodded. "Yes, yes," he said. "you're right. What we need now is a glass of wine."

It just so happened that, as we were retracing our steps back to the Villanis' apartment, up one of the steep, still-misty streets, I spotted a brightly lit wine shop with barrels and demijohns and bottles and someone pouring wine into liter flagons from a huge container finely carved with an heraldic crest and baroque flourishes. I

signaled to Sebastiano that I'd found a timely source for his wine and pushed open the door into the warm, aromatic store. "*Buona sera,*" I said to a half dozen or so men standing or sitting around a wooden table filled with platters of sliced salami and mortadella and thick slabs of bread. And I was thinking, what a great little place, a sort of shop-cum-bar with free snacks to boot and a dozen or so different wines to choose from.

"Ah, ... David ... " I heard Sebastiano whisper behind me. But I was intent on getting him a glass of wine. In fact six glasses—one for each of us.

"*Sei vini, per favore,*" I said, smiling at the man pouring the wine from the elegantly carved barrel.

There was what might be called a pregnant pause—actually more like an ominous silence.

"David, David!" It was Sebastiano again.

"It's okay, Sebastiano," I said, my confident take-charge persona in full romp. "I've found your wine. *Sei vini, per favore,*" I repeated.

More silence. All the men were staring at me in the oddest manner—in alarm, I think, as if some space alien had just popped in for a quickie before devouring the lot of them.

"Er, David, please. This is not a shop . . ."

I paused. "No, it's some kind of bar, right? So let's have a drink."

"No, David. This is private house. This is someone's *cantina.* It belongs to that man there, I think, the one with the bottle."

At that point, with Anne giving frantic "what are you doing now?" signals through the open doorway, Sebastiano took over, apologizing profusely for my intrusion and doubtless implying that he'd be quite happy to retreat without creating further embarrassment and drag this crazed Englishman with him before he started to get offensive.

But it didn't quite happen that way at all. Because at that magic little moment, serendipity began again, and I just sort of watched, as I have done so many times before, as the wonder of human warmth and humor and kindness worked its spell and things rolled along

without plans or schedules or anything else other than the willing-
ness to "let things flow as they will."

The men suddenly roared with laughter at my stupid mistake,
dragged out chairs from a corner, insisted we all join them at the
table to enjoy the salami and mortadella and to sample their splen-
did wines "*di casa.*" Which, of course, is exactly what we all did, with
the three ladies giggling in embarrassed delight, and Topol grinning
like a gargoyle, and Sebastiano muttering, "Whatever . . ." and
stripping off his overcoat and joining the increasingly rowdy throng.

I think it was about six o'clock in the evening when we started
our "*cantina* crawl" home. First in that warm, barrel-lined hide-
away. Then, as we were leaving, Sebastiano remembered another
friend, farther up the street, who also had his own *cantina* and was
renowned for producing his own fine wines from Melfi, using
Aglianico del Vulture grapes. So, for a half-hour we stopped at what
was a roughly converted garage. Most cantinas are precisely that,
simple garages often transformed into little masterpieces of male
conviviality, complete with fireplaces, TVs, refrigerators, stoves,
sinks, tables, and armchairs. They're basic, but ideal places for card
bouts of *scopa;* bawdy repartee at the soft-porn panderings of
evening television soaps; hearty celebrations of the glories of
fine, home-blended, crafted brews; and even commiseration and
commonsense counseling for any member of the group suffering
from temporary melancholia or even momentous troubles in mat-
ters of the heart.

And so it went. One *cantina* led to another and another until,
finally, by sheer chance, we were invited by a young man to visit his
"very new" *cantina*, which, judging from the applause by our *can-
tina*-of-the-moment occupants, was an honor bestowed upon only
the favored few.

And what a *cantina* this one turned out to be! It was more like an
elegant *taverna.* From the outside it looked the same as all the oth-
ers—utterly unimposing with large, dark-painted double doors.
But as the young man led us inside and switched on the lights—
halogen spots, no less—we were regaled with a mini-disco of sorts:

four enormous black speakers, two large-screen TV video sets, comfortable armchairs, a baronial-size fireplace with a roaring fire, an upper level reached by an elegant wrought-iron spiral staircase and crammed with barrels and wine-making equipment, and a very professional-looking bar. And, at the front, a most impressive latest-technology keyboard setup with more switches and dials than your average recording studio, and a full-blown karaoke system—my first in Italy—complete with overhead TV screen for displaying the lyrics.

In less time than it took to drink a couple of glasses of the young man's fine wine and congratulate him on the excellence of his elegant hideaway, he was at the keyboard—pounding out bossa novas, tangos, heavy metal, and Beatles rock—and gesturing for someone to pick up the cordless mike and sing something. Something in English, he thought would be a good idea. An idea much supported by my laughing companions, except for Anne, who looked ready to slide herself deftly under the table as soon as the music began.

So, there I was, mike in hand, and with those beautiful introductory chords to John Lennon's "Imagine" playing and the lyrics starting to scroll down the overhead TV screen. Without a moment's hesitation (it's amazing what a few glasses of wine will do to release the exhibitionist self), I launched into that splendid anthem of gentle anarchy and love. And what I heard coming back on those megawatt speakers was this deep, chocolatey, tears-in-your-beer, echo-chambered rendition, which sounded like no sound I'd ever made before. In fact it had been years since I'd picked up a mike, a relic of my decades-past guitar and folksinging era, but I must admit, in all immodesty, that I think even the late Mr. Lennon might have given at least a cursory nod of acknowledgment at what poured out into the elegant *cantina* that night.

Then came the applause—real, spirited, and, I think, genuine—from our small group of wandering wine-imbibers, (Anne included, much to my relief) as the last lingering chord faded. And I thought, my God, I've done it! My first karaoke experience. Despite four years of living with Anne in Japan, I'd always managed to avoid the

karaoke spotlight. And you know what? I loved every second of it. And especially singing a song of such power and intensity.

So all that of course led to another round of *vino* and a reminder of something I'd read in an Italian cookbook that "conviviality is the greatest Italian condiment." Then it all began to get a little blurry. I know that our sociologist friends had to leave for home, and Rocchina decided to return to the apartment, but Sebastiano, Anne, and I somehow floated on, at one point joining another group—a bunch of teachers in yet another *cantina*—who were discussing the final designs for their school's February *Carnevale* float. (I was told later by a kindly Sebastiano that I had made "some very useful suggestions in that area," but neither Anne nor I had any idea what they could have been.)

Finally, by chance, but of course not at all by chance, we caught up with some of the same bunch of Sebastiano's friends we'd met at Margherita's dinner party—Tori, her husband, the barber, the professor, the frustrated politician, the genius who had prepared all those wonderful mushroom creations, and a couple of others I vaguely remembered from that long and lovely bacchanal.

And wouldn't you know it, they were assembling at yet another *cantina*, which doubled as the barber's shop (a single and very ancient black-leather swivel chair by a huge mirror seemed to be the barber's only accoutrements). They were all about to prepare dinner, so of course we stayed, after a brief foray to fetch some bread, which they'd forgotten, from Rocchina's parents who lived nearby, along with two more tipples to see us on our way.

Back at the *cantina* the wine flowed and the conversation rolled. Sebastiano interpreted for us whenever he could, between his own bouts of rhetorical excess. Once again we covered the gamut, from Bush and Iraq and North Korea, to Basilicata's hopeless regional planning, to the second trial of ex–Prime Minister Andreottti (a Mafia corruption case too convoluted even for most Italians to understand), to the problem in trying to run small farms these days, to the difficulty Italy seemed to have in being taken seriously by other members of the EU. "Fifty-nine prime ministers in sixty years

since the end of World War Two! No wonder they think we're crazy," said the barber vehemently. "And our latest one, Silvio Berlusconi, is also being prosecuted now for bribery and all kinds of financial finanglings."

Then came this arrogant Englishman spouting impromptu theories on Italian political impotence by pointing at the *cantina*'s roaring fire, on which a delicious-smelling dinner of lamb pieces skewered on fresh rosemary twigs was being barbecued *alla bracia* (over the embers at the side of the fire), and saying things like: "That fire is like Italy. All those frantic flames and all that red-hot fury, but all the heat is going right out the chimney, leaving us all crouched around desperately seeking a little warmth!" Then, if that same Englishman didn't use his night-long crawl through the *cantinas* as a metaphor for Italy's lack of direction and concerted action. He suggested that the nation's "*cantina* culture" was actually a way in which everyone released their pent-up frustrations and anger with such eloquence and rhetorical panache that, in the clear, cold light of day, there was no energy left for the really hard, focused work of turning dreams and wine-laced wishes into functioning reality. "And what's more . . . by the way, this lamb is fantastic."

"David," I seem to remember Sebastiano gently interrupting at one point during my lengthy diatribe, which I'm not sure anyone really understood (myself least of all). "Why don't you forget driving back to Aliano and spend the night at our apartment?" (Anne was furiously nodding.)

So, there was my good friend and faithful companion in all this unabashed "couple of little boys together" serendipity planning the perfect end to yet another perfectly zany-crazy day.

Postscript

After this day (and others) of unexpected delights, Anne and I decided it was time we took the initiative and treated Sebastiano and Rocchina to a truly romantic, traditional dinner somewhere as a gesture of thanks for all their many kindnesses—preferably a local

place somewhere between our home in Aliano and theirs in Stigliano. The problem was that, as far as romantic restaurants were concerned, we lived in a rather sparsely blessed corner of Basilicata. There were restaurants, of a sort, but few were conducive to candle-light chats serenaded by mellow music in an ambiance created by fine dishes in a warm, rustic setting reminiscent of old stone *masseria* (farmhouse) dining rooms.

But, as often happens when you let things float around for a while, the perfect place presented itself by word of mouth. It was a relatively new creation, near the beautifully restored hill town of Guardia, and with a splendidly impressive name: Azienda Agrituristica Difesa d'Ischia. And it was everything we'd hoped for: a government-supported *agriturismo* restoration of an old farm and country house into a small nine-room hotel with a pool (even a tennis court, would you believe?), set high on a hillside overlooking the Sauro River Valley. It even included an intimate stone wall-and-wood beamed–ceiling *trattoria* proudly claiming to serve all its own produce and authentic regional dishes.

This is the perfect place, we gushed when we saw it. And so it turned out to be. The only reason I'm mentioning it at all in this brief postscript is to offer a tantalizing glimpse of what can await one even in the wilds of Basilicata. Oh, and also to warn of the dangers of ordering a "full antipasto" before launching into the rest of a traditional five- or six-course dinner.

Once we'd all got through the "*ooos*" and "*ahhs*" and "*woos*" that were our reactions to such an unexpected find, our charming young waitress confirmed in an off-hand kind of way that, of course, we'd be having the antipasto before the other courses. We said, "Of course. *Va bene.*" Then, out of the tiny kitchen run by a couple of elderly mammas—whom we spotted occasionally between flurries of steam and wielding of mammoth pots—came platter after platter of one of the most generous and surprising series of antipasto delights. These I will merely list without going into rhapsodic descriptions: plates of prosciutto, salami, *coppa*, and *soppressata*; a bowl of four different kinds of olives; platters of anchovies, pickled peppers, hot

peppers, and roasted peppers; sliced tomatoes with basil leaves and plump rounds of authentic *mozzarella di bufala*; bruschetta with fresh tomatoes and sprinklings of thirty-year-old and very expensive balsamic vinegar (a true gourmand's experience); fire-grilled slices of aubergine doused in homemade olive oil; roasted aubergine layers wrapped around a tuna-and-caper filling; cheeses—cream, provolone, pecorino (new and aged), and gorgonzola; bowls of fava beans, chick peas, and French beans in olive oil; a melt-in-the-mouth cheese-and-mushroom *frittata*; slices of focaccia with tomatoes and melted cheese; a dish of warm *bagna cauda* (that creamy garlic-anchovy—olive oil dip) served with fat chunks of home-baked bread; slices of spicy homemade sausage doused in hot sauce; and, finally, a medley of marinated mushrooms with just a touch of fresh mint eaten *stuzzichino* style (with the fingers).

And that's about all I can remember. I'm sure there was more (Anne claims she counted more than twenty-five separate delights), but the waitress had to wait for us to devour some of the dishes in order to make room for more platters and bowls. I saw her smiling a little, perhaps wondering if we'd ever get through this mammoth and magnificent spread. So, maybe unwisely, I encouraged Sebastiano and Rocchina to show her that we were certainly a match for the trattoria's sumptuous, and very reasonably priced, spread. And we did. We just about finished everything with complimentary mumblings of *mangiabile!* between all the succulent mouthfuls, but then realized that we didn't have the stamina or the stomach for the rest of the dinner. Our waitress smiled knowingly and suggested, "Just a few tidbits of grilled *abbacchio*," (delicious suckling lamb) and then straight to the desserts. All in all a truly *buon pranzo* experience.

And I thought, isn't it amazing what we have to put ourselves through and suffer just to say thank you to a couple of good friends.

Meeting Antonio—There Are No Coincidences

Then, out of the blue (actually it was a very cold, damp night) came another series of enduring friendships . . .

Winter

* * *

413

I'M ALWAYS rather nervous of such glib, New Age, hocus-pocus, psychobabble one-liners as "There are no coincidences." But I must admit that sometimes curiously intertwining and beneficial events—little synchronicities, if you will, invariably impossible to predict—seem so inevitable, timely, and right that it does make me wonder. . . .

As it did this one evening. Anne was away for a couple of days in Matera (yes, the Carrefour hypermarket and the aesthetic delights of that unique "cave city" had lured her off once again), and I was scribbling notes to myself and transcribing tapes from recent interviews. In my normally odd, but to me perfectly sensible, manner, I had dragged the mattress from the unused single bed in our bedroom into the living room by the fire. And there I lay, legs akimbo, cushions balled up under my chest, with notebooks, books, files, and folders fanned out around me in an impressive display of research and writing. Such displays, while doubtless chaotic looking to an outsider—give me a sense of achievement, direction, and purpose, a sense, however, that on that particular evening was a little sparse and confused. Questions flowed around in my head like errant moths lacking a lighted candle: Am I focusing too much on Carlo Levi and his book? Am I focusing too little on Carlo Levi and his book? Is what I am producing a memoir, a travelogue, a socio-economic treatise, or merely a random collection of tales and anecdotes about people and odd happenings in a remote corner of the world that most people have never even heard, or cared, about? And so on. The usual confusions and crises of an author at mid-manuscript point.

I was looking again at parts of my original outline for the book, particularly the part that read:

> At the heart of this book are the experiences of the author and
> his wife during an extended residence over the seasons in a hill
> village high in the mountains of Basilicata, one of southern

Italy's wildest, most dramatic, and least explored regions. In addition to a rich, humorous, and very human potpourri of stories about the people; local characters; food; markets; historical traditions; quirks; the seasonal rhythms of olives, vines, and farming; and local myths, superstitions, and pagan rites that reflect the ancient, slow-changing spirit of the region—the book will also reveal some of the underlying strangenesses and "dark side" elements of the village and the region, and will ultimately attempt to discover Carlo Levi's "Lucania within each one of us."

Well, despite the length of that particular sentence, am I still on track? I wondered. Admittedly, the more I talked with the locals and the longer we stayed there and became intimately involved in the daily happenings and rhythms of existence in Aliano and other nearby villages, the more I sensed myself identifying with their lives, their histories, their challenges, and their frustrations with the muddled ways of the Mezzogiorno. Sometimes I even found myself feeling the same sense of outrage and indignation that Levi himself pithily expressed, particularly his memorable conclusion that: "The peasants here are not considered human beings." I would sense myself agreeing with his overall realization that, in recording the patterns of lives here, the injustices, the impotence of government, and the ubiquitous sludge and slime of corruption that corroded and eroded so many well-intentioned "infrastructure-enhancement" schemes, he was becoming a spokesperson, not only for the Mezzogiorno itself, but for "the deepest parts of the soul of our world" (as suggested by one enthusiastic reviewer). The Mezzogiorno as metaphor for similar inequitable and unjust Mezzogiorno predicaments everywhere in the world.

And then I would have to remind myself, sternly, that hey, you're not here as a political advocate or a regional planner—as I might have been twenty-odd years before, in that previous life of mine—or an anthropological analyst. You're here to enjoy yourself with Anne, to participate in and celebrate the oddities and amusing and moving ironies of life here, and to create a portrait of our serendipitous

lives together in this splendidly wild and relatively undiscovered cor-
ner of southern Italy. And that's all, I would emphasize. Forget your
"planner/analyst" persona. Don't get sidetracked into defining prob-
lems and certainly not suggesting solutions. Let others far better
equipped and far more perceptive than you worry about all that and . . .

The intercom door buzzer buzzed.

That's strange, I thought. It was rare for people to come calling
so late in the day. It must be a mistake. Someone must have pressed
our buzzer when really intending to contact Giuseppina. So I read-
justed my sprawled frame, puffed up the cushions a little more, and
resumed my reveries.

Then came a knock on our door, not Giuseppina's ambiguous
rattle but a distinct rat-tat-tat that smacked of purpose and intent.

"Yes? Hello."

"Mister David Yeadon?" a deep masculine voice called out.

"Yes?"

"May I speak with you, please?"

Oh, boy, I thought. This sounds a little ominous. The police? An
emergency back home? Someone's hit my car down at the piazza? I
hadn't recycled the garbage correctly? (I hadn't.) Or, much worse,
something's happened to Anne in Matera?

"Okay," I heard myself mumble in a rather guttural tone. *"Uno
minuto."*

It was too late to clean up the splay of stuff all over the floor and
heave the mattress back into the bedroom. It was too late to do any-
thing but regret the fact that I was wearing a rather grubby jogging
suit and walking about in bare feet. (I work better without socks.) If
Anne had been around she could have handled the visitor or at least
given me a chance to make myself a little more presentable. But
Anne was away. So, the heck with it, I thought, this is my home, and
I don't have to apologize for anything.

I opened the door.

Standing there was a figure dressed almost entirely in black with
a large, black hood pulled over his head. His face, a pleasantly open
face of someone possibly in his early forties, peered out of the murk

of the staircase. He looked cold. It had been an unusually cold day, with furious Pollino winds howling up through the *calanchi* gorges. In fact, he looked very cold.

"Come in, come in. You look cold," I said.

"Oh, thank you. Thank you very much," the shrouded figure said, half stumbling into the room. "Wow! It's so warm in here. How lovely. My apartment is freezing!"

"Ah," I said, "you live here?"

"Oh, yes. I'm sorry. My name is Antonio Pagnotta, and yes, I live very close by, across from the post office. And my place is too cold. The fire doesn't work well. Always smoking."

"Ah, yes. When those winds start blowing, it can be a real nuisance. Come and sit down," I said, curious about the reason for this unexpected visit. And then I realized that sitting was a bit of an impossibility with my mattress blocking access to the sofa. So off I rambled, with apologies for the mess, etc.—which I'd distinctly told myself I wouldn't do—while kicking the mattress out of the way. "Excuse all this," I said. "The mattress is my desk, hence . . ." I let the rest of the sentence fade away. The stranger gave me a wide, understanding grin, sat down, and said, "Yes, of course, I am the same. With my work."

And that's when the magic of "no coincidences" began to kick in. It turned out that Antonio was also a creator of books, primarily photojournalism books, and that he was in Aliano preparing his latest project, *The Wheel, the Cross, and the Pen: The World of "Christ Stopped at Eboli."* Don Pierino (my loyal network catalyst) had apparently mentioned that I was there working on a similar project and suggested that Antonio call and introduce himself.

"So . . . ," I said a little warily. I wasn't quite ready to deal with professional competition at this fragile stage in my manuscript's compilation. "Your book is mainly photographic?"

"Yes. All black and white. Of the people . . . descendants of the people in Levi's book, but also, the scenery, the *festas* . . . you know. Trying to show life here as it is today and link it to Levi's time."

"Ah," I said. "Very interesting."

"So, I thought I would say 'hello' and see if I could help you at all in what you are doing here."

"Well . . ." I was still a little uneasy with the proximity of our project concepts and wondering if "help" was a euphemism for plagiarism. "That's very kind of you."

"Not at all. We authors must work together, eh?"

I laughed. Actually a sort of strangled gurgle. "Ah, yes," I said, really meaning a very different definite maybe, but maybe not. "So, you're a writer, too?"

"Well, not so much. I will be asking other people to do the writing part for me—some of Levi's relatives, some scholars, and of course the local people who I'm talking to. But the book is primarily photographs. The writing will be mainly long captions."

"Ah. You know, I've been surprised by the fact that I've not yet found a single book that tries to do what you suggest, with or without photographs."

"Yes, so have I. It seems such an obvious idea. Levi is still so important here, and in Italy generally."

"So, your audience is primarily Italian?"

"Oh, yes. Completely. Maybe just for the Mezzogiorno itself. I don't know yet."

"What does your publisher think?"

"Oh, I don't know. I don't have one yet. I'm hoping the Bank of Matera may publish the book. They have done so before with other books on this region. But I have to prepare a proper portfolio to show them. That's why I'm here in Aliano now."

As it became increasingly clear that our projects, while mutually reinforcing, were quite different in scope and intent, I began to relax a little and tell Antonio more about the intent of my own book and ask him about his life and career.

Coincidences abounded. In his forty-six years of life he had traveled to many of the places Anne and I had explored around the world. He'd even lived in Japan for ten years, from 1990, and had in fact scooped aspects of the sarin nerve gas story there—an episode where a fringe group of radical religious fanatics known as Aum

Shin Rikkyo had tried to wipe out a crowded subway in Tokyo and, although things could have been a lot worse, succeeded in killing eleven people and injuring hundreds more.

Prior to that Antonio had spent considerable time in Muro Lucano on the Basilicatan border with Campagna, a town devastated in a 1980 earthquake. He'd recorded the town's "reconstruction" and the conflicting reaction of the residents to much of the new, soulless architecture in his photographic book *I Know How Many Steps,* published in 1998. His second photographic book on Salerno University, *Faces, Chaos, and Shooting Stars,* published in 2000, was praised as a remarkable portrait of the people, politics, and dynamics of teachers and students involved in the process of education and learning.

I decided I liked him. He was direct, open, and amusing, and he seemed to possess a spirit seething with vision, ambition, and vitality. And most of all he'd helped me, right at a moment of questioning and self-doubt, to clarify the scope of my own wanderings and work there. I thought that his book, while very different from mine, would be an important contribution to Italy's understanding of itself and its heritage. And I told him so. He looked pleased—maybe a little relieved, too. He'd heard from Don Pierino of my links with *National Geographic,* and he admitted that he had feared that I might have already stolen his thunder and jeopardized his own work.

We continued sharing tales of our travels and adventures. He was obviously a serious photojournalist, with a penchant for perilous places around the world. It was fascinating to listen to his stories. I particularly admired his pluck and his apparent ability to circumvent the clutches of authorities in dangerous parts of the world many other photographers would have avoided, if only to keep his expensive collection of cameras and lenses out of the hands of envious "officials."

More important, in his first selection of Alienese photographs, I was beginning to see Antonio as something of a "primitive sensualist" who in his art was able, as Thomas Moore puts it: "to capture the eternal in the everyday—the eternal that feeds the soul—the whole world in a grain of sand." He seemed haunted by the piercing

humanity of his subjects' faces and eyes, the vastness of the individual self captured in powerful black-and-white images. There was something of that old aphorism, "the eye you see with is the eye that sees you back" in his work.

AROUND MIDNIGHT he left. I felt a little guilty at the thought of his having to return to his cold apartment by the post office so I offered him my "writing bed" by the fire in the living room. But he assured me that he had lived in far worse conditions. "And soon my girlfriend, Graziella, will be here from Salerno, so I shall be very warm then!" We agreed to meet in a couple of days, when he would show me more of his photographs and we'd continue discussing our contacts and ideas.

However, it seemed we were fated to meet earlier than that (another "no coincidence"?)—at precisely one o'clock the following day, when I was trying to sneak out of the village in my car during the silent, sacred lunchtime siesta period. For a while I'd had my eyes on a large pile of wood left over from the construction of Don Pierino's new olive mill and dumped by the side of the road. It was thin, rough-cut planking, broken and nail pocked, but I thought it would make fine kindling for our recalcitrant fire. I assumed it was there for the taking, but decided to collect my piles during a quiet period, just in case anyone should object. "Darling," my darling had warned me in her usual "what's he up to again" tone of voice, "be careful. Someone may need it."

"Yes, precisely," I said. "*We* need it," which I thought was a pretty neat response. As Anne-appointed heat maestro of the house, I was fed up with struggling, usually unsuccessfully, to burn those enormous and very dense slabs of oak and olive that Giuseppina had piled high on our terrace. At first I'd had been delighted by her thoughtfulness. Later I was a little less grateful. The damn stuff hadn't been covered against the furious and endless winter rains that came while we were away for a few days, and now the wood hissed and crackled and threw out sudden flurries of explosive flames before dying down to a simpering, glowing ash with no heat or comfort in it at all.

So I was rolling down Via Roma on the way out of the village to pick up the planks when a voice called out from the bench by Bar Capriccio: "Hey, David!"

And who should it be, of course, but Antonio, laden with cameras and looking a little weary from the morning's shoot. I stopped, and he strolled across the street. "Where are you going?"

I told him, and immediately he offered to help. So off we went together. We gathered five enormous stacks of that lovely kindling, and, as we were returning to the village, he said, "I'm going to photograph a very interesting lady who got a part in Rosi's film of Levi's book. Almost."

"Almost? How do you mean almost?"

"Well, it's a very funny story, but why don't you come along with me, and she can tell you herself."

Abandoning whatever plans I had for the rest of the afternoon (not many), I said I thought that was an excellent idea. A few minutes later we were sitting together on a lopsided sofa in a cramped little kitchen–dining room in a house hidden away in a narrow alley near the *fossa* and enjoying truly excellent espressos prepared by a young woman with a distinctly striking, film star–ish kind of face. Not the soft outlines of a Melanie Griffith but rather the stronger, attractive-but-no-nonsense ambiance of a Sigourney Weaver.

"So, that's the almost film star?" I whispered to Antonio.

He laughed aloud. "Oh, no, no, not her. She's far too young!" (Of course. I knew that.) He indicated an elderly lady in black widow's attire, complete with black shawl and walking stick. She was seated in a shadowy corner by the warm part of a wood-burning cooking stove looking a little forlorn and forgotten.

But not for long. As Antonio encouraged her to tell her story, which she'd obviously told countless times before, she suddenly became an animated and whirling-gesture raconteuse, explaining how Rosi had begged her to play the role of Levi's witch-housekeeper, Giulia Venere. She had said "yes" at first . . . until it became clear that in one of the scenes, she would have to scrub the back of a naked Levi, played by Gian Maria Volonté, one of Italy's

most heartthrobby male stars at the time. At that point she adamantly rejected the part, despite all the protestations of Francesco Rosi himself and even her husband and her own rela- tives, who relished the idea of having a film star in the family.

"I could not be near a naked man!" she explained, still remark- ably full of indignation years later at such an outrageous idea. "I was married!"

"Yes," Antonio said. "But he'd have been sitting in a tub of soap- suds, and even your husband said it was okay with him."

"That didn't matter. I had my own reputation to keep."

After that tale we couldn't stop her. She launched into a whole series of colorful anecdotes about the war (". . . terrible food—all wild stuff from the fields"); the sale of the family pig to buy cloth to make clothes and underwear (". . . in the war we had nothing . . . underneath!"); her only sight of the invading Americans coming in from Sicily to drive the Germans north (". . . down in the valley, a few of them only, and on bicycles! *Poof!* Not so much of an army!").

When, inevitably, the subject of Levi came up, she said she'd only seen him walking up and down the streets in 1935, when she was a little girl, but didn't know, even now, what all the fuss was about. "What has changed?" she said with a flamboyant gesture of raised arms and then the traditional under-the-chin flick indicat- ing the small kitchen, the ancient stove, and the even more ancient smoke-smudged photographs of family members on the walls. I pointed out the TV and the VCR on the shelf by a staircase, and she said something pithy in the Alianese dialect, which, according to Antonio, meant: "All these machines are useless and never worked properly anyhow!"

ONE RAMBLE LIKE THIS with Antonio led to many more over the ensuing days. And then came another one of his insistent phone calls:

"How do you feel about Potenza?"

"Not much."

"Ah, you, too? Like most others."

"Well, I know it's got a very interesting Basilicatan kind of history. A history from way back whenever, then it was destroyed by the Romans, then taken over by just about every warmongering militia in North Africa and Europe. And then half obliterated again and again by all those *terremoto del Vulture* (earthquakes). I didn't find much to look at really when I was there a couple of months ago. The old part on top of the hill has kind of a genteel, nineteenth-century flavor, and I seem to remember a rather pleasant winding street of shops but . . ."

"So, why not meet me there tomorrow?"

"Antonio. Did you hear anything I said?"

"Of course. I always listen to what you say. But I have a surprise for you. So how about one o'clock at Tito Station? Just outside Potenza in the mountains. Tomorrow?"

I heard myself saying "okay" and wondered if it was me talking.

"Very good. See you," he said, and was gone.

The next day, after a splendid mountain- and lake-laced drive from Aliano, I was sitting in my car at the Tito train station wondering exactly what my newfound friend had in mind this time—and what exactly was his promised surprise.

It turned out to be a number of surprises. First, he rolled up in a small, battered four-wheel-drive SUV with his girlfriend, gorgeous Graziella, beside him, her long leonine black hair blowing in a chill breeze and her impossibly long, pointed-toe boots (the latest Italian fashion) polished to a Rolls-Royce—coachwork shine.

Five minutes later we were seated for lunch at Graziella's parents' house, adjoining the station above an extremely shining, pristine-clean *forno* (bakery) and *pasticceria* (pastry shop) once run by her father, Pasquale. I hadn't expected lunch. Was this the surprise? If so, I thought, it's a good one because, not only was the home-cooked meal a typical gargantuan Italian eight-course—antipasto, pasta, *secondo* (roast lamb), salad, fruit, cheese, pastries, and coffee—midday bacchanal, but it was made especially memorable when Pasquale produced a little plastic bag from his shirt pocket just as the homemade *orecchiette* arrived.

"Maybe you would like some of this with your pasta?" he said, handing me the bag.

I opened it, and the aroma hit me with the force of a tempest. Fresh, black *tartufo* (truffles)! Rich, earthy, and guaranteed to kick your saliva glands into top gear—a scent so musky and primeval that it resonated somewhere back in your early evolutionary memory banks.

"Ah, wonderful!" I gushed. "Where do you get these? I've seen almost no truffles anywhere in Basilicata."

"I find, with my dog, this morning," said Pasquale.

"But where?" I gasped because the Tito topography was

HILL TOWN NEAR POTENZA

comprised mainly of bare, brazen foothills and mountains for as far as you could see in all directions.

"In a small forest. Not so far away." He explained how he had just purchased, for the impressive price of twelve hundred dollars, a "truffle hound" named Lola. Today had been a kind of test day for the dog, and he'd been delighted by her prowess, not only in locating the elusive truffles in the earth around the roots of oak trees, but also in digging them up ("She very careful. Better than me!") and even carrying them in her mouth—"But not with her teeth. Just her lips"—straight to Pasquale's outstretched palm.

It was obvious that Pasquale's investment, at least in his own eyes, had been a very sound one. He smiled a little complacently as he performed the ritual grating of two of the largest truffles, each the size of a table tennis ball, onto a plate, which was then passed with appropriate reverence around the table.

That was surprise number one.

Surprise number two came immediately after lunch, when Pasquale took us downstairs to show us his old bakery, now rented to a younger man. The tenant was in the kitchen creating tiny tartlets filled with *zuppa inglese* (an odd name for a kind of creamy custard) topped with clusters of chopped orange, kiwi, pineapple, and mango. The kitchen was as clean and sparkling as the store itself. Big loaves of bronze-crusted bread sat in piles waiting for the evening commuters coming home to Tito from Potenza, a few miles down the line.

I asked Pasquale if he ever made "weekend bread," one of those richly aromatic mega-donut–shaped loaves Anne and I used to buy from the Arthur Avenue bakeries in the Bronx's own version of Little Italy. Not so evocative as the Mulberry Street madness of Manhattan but, in its own lower-key way, far more genuine and with a truly enduring neighborhood feel.

Pasquale didn't seem to understand my question, so I described the ingredients: chopped-up bits of leftover prosciutto, salami, *coppa*, *soppressata*, cheeses, sun-dried tomatoes, and anything else lying around that needed clearing out before Saturday, the big buy-

ing day, when families were already salivating about and preparing for the week's great gastronomic climax of Sunday lunch.

Pasquale continued to stare at me, and I wondered if my poor Italian and gestures were not adequate to convey the magic of that special weekend, and only the weekend, delight. So I added another anecdote, a description of our "weekend bread" experiment with our local baker in Aliano, which we'd enhanced by adding an even wider variety of ingredients, including chopped olives, capers, anchovies, and peppers—a real multicolored mélange of ingredients and flavors.

Pasquale was still looking at me curiously. And then, to my surprise, he said, "Okay. I've never try, but I will explain to the new baker and together we make."

"It's so good," I said, still finding it hard to believe that "weekend bread" did not have its origins in Italy, and also surprised by Pasquale's quick decision. Basilicatans usually like to *riflettere* (reflect on things), sometimes forever.

"It sounds so beautiful," he said.

"You'll make a fortune," I said.

"A fortune would be very nice," he said and laughed the laughter of a happy truffle hunter with a fine new dog.

As we were leaving I was presented with a box of pastries, a huge loaf of still-warm bread, and three fat salamis from Graziella's mother.

This was all most unexpected, I thought, and Potenza is looking better by the minute. And that's where the three of us went next ". . . for your real surprise!" said Antonio.

WE STOPPED by a cemetery below the old city, a vast complex of family vaults exhibiting a remarkable array of creative designs and *loculi*, those tiered compartments for coffins. There were hundreds of them, six tiers high, with "sideway" compartments of around three by eight feet. Little electric lights flickered; flowers graced many of the slots; and hundreds of those porcelain-etched photographs stared out at us. Antonio had stopped by the entrance

to the cemetery to buy a bunch of daffodils and, after we wandered through the mazelike confusion of *loculi*, he stopped at a tomb, rolled up an elaborate stepladder contraption on wheels, climbed to the top level (the least expensive level due to the precariousness of those ladders), and placed the flowers in a specially designed container by a memorial panel. I couldn't make out the name from the ground.

"Come and see," Antonio said. Graziella grinned in anticipation. I climbed somewhat hesitantly up the swaying contraption and found myself looking at a marble panel with the name Giulia Mango carved on it. The significance didn't hit me until Antonio explained, "Mango was Giulia Venere's maiden name. And this is where she is buried. Look at her photograph. You will recognize her."

And there she was: Carlo Levi's witch-housekeeper, guardian of the dark secrets and even darker *pagani* ways of Aliano. Her face was obviously far older than the one Levi painted in 1935 (she died in 1974), but it was her eyes that galvanized me. Deep, piercingly black, and looking right at mine as if she were still alive, they sent a scurry of fear down my spine to my toes. Antonio sensed their power too. "Amazing." he murmured. "She is . . . here!"

Later he explained that, as far he knew, he was the first to trace her burial place in Potenza. "Much research in the records and then . . . *voila!* I finally found! I reach her. So, was this a good surprise for you?"

"Excellent," I said. "And congratulations on your research."

"Thank you," he said with a satisfied smile. "Now, more surprises." So—it turned out to be another typical "day with Antonio." He and Graziella drove me around parts of Potenza I'd never explored before, and I found it to be a far more interesting place than I'd first thought, especially when we ended up at a just-completed house of an architect-friend of Antonio's. Perched on a hilltop with an encircling panorama of mountains and valleys, the house was the epitome of stone-wall solidity. I congratulated Antonio's friend on the *feng shui* elements of his site and his bold Norman watchtower-like design. He responded with an invitation

to visit his wine and prosciutto *cantina*, a bunkerlike place where we sampled four of his 2002 vintages. I left with a couple of bottles of his best blend of Malvasia and Aglianico grapes—my final surprise of the day.

And I vowed that if Antonio ever offered surprises again, I'd be wherever he wanted me to be in a flash. Even Potenza.

A Free Day

Thankfully, tranquil interludes floated between the escapades and adventures with Sebastiano and Antonio, and there were few interludes that Anne and I enjoyed more than a totally unexpected free day.

One might assume that, as we were living the simple life down there in the wilds of Basilicata, free days must have been more the norm than the exception. And to some extent, I suppose, that's true. We were largely the master and mistress of our minutes and months. And yet, time got filled, social obligations were met in a punctual fashion, and new people to talk to popped up like *porcini* in the *bosco* (forest). Before we knew it, another day would be almost over and it would be time for sambuca and prosciutto on the terrace, a modest bit of mingling during the evening *passeggiata*, and a leisurely dinner enjoyed, usually to a background of Bach or Mozart or occasionally, if the mood was right, a little jaunty slide guitar and Texas-drawl country-and-western music, followed by a few book chapters before bed.

So, when a whole day unexpectedly offered itself, with no constraints, we greeted it like we used to greet a spell of hooky from school: just like kids.

And this free winter day was indeed unexpected. Of course we were disappointed to miss the festivities of a long Sunday family lunch at Rosa and Giuliano's home in Accettura, but it couldn't be helped.

We had prepared for the event with salivary anticipation, wrapping a few gifts for the family, and we'd set off at the alloted time to

drive up the hill out of our village, admiring, as always, those surging vistas of mountains and distant ridgetop towns and . . . snow.

Snow!?

We hadn't thought to go out on the terrace to check the terrain that morning. There were fleeting shards of sunshine piercing through the curtains, so that was enough to encourage us to be on our way. But snow? We definitely hadn't expected that. Admittedly it was only on the highest slopes, up around Stigliano, but that's the way we had to go. It looked ominous, with Lord knew how many hairpin turns and vertiginous swirlings (we always lost count after seventy or so) along battered roads on the hour-long journey to Accettura.

"Why not just give Rosa a call?" Anne suggested, always cautious when it came to skiddy hairpin turns and the like. "Make sure the roads are clear."

"Good idea," I said, especially as we were just passing our one village phone booth.

And it was then that I noticed how cold it really was. Down on the piazza there was no wind, but up here, right where they put the phone (of course), blasts of frigid air froze my fingers to purple in seconds as I dialed Rosa's number.

We exchanged our usual effusive greetings and she told me she was "just making the pasta" for lunch.

"Rosa, it's not even eleven o'clock yet. It'll go very soggy by one o'clock!"

"No, David," she said. "I'm *making it*. Rolling it, not cooking it!"

"Oh, all right, of course. Always homemade pasta on Sunday. I forgot."

"They'd kill me if it wasn't," she mumbled, but I could tell she was smiling. She was justifiably proud of her homemade pasta.

"Rosa," I said, putting on my let's-get-down-to-business voice, "I see a lot of snow over your way. . . ."

"Oh yes, there's snow all right. And ice."

"How are the roads over top?"

"Very icy. I just said."

"So . . . is it safe to come over?"

"Depends what you mean by safe, doesn't it?"

"For us, Rosa, in that little DoDo they farmed off on me at the rental place."

"Well . . ." She seemed uncertain. And then she made our decision for us. "No, I reckon you best stay where you are."

"What about our lunch?"

"Come next Sunday. And call me Wednesday morning, too. Giuliano says he maybe doing another pig next week" (not a particularly enticing prospect after my earlier pig-butchering experience).

"You don't think that . . ."

"No."

"Okay. I'm sorry. We were looking forward to a big feast."

"All the more for us, isn't it?" she said with her sly Italian-Nottingham humor.

"Oh, very nice!" I said.

"No, seriously, leave it today. There's likely going to be a lot more snow. Come next week."

"Okay. Love you. Hugs to everyone."

"Aye, all right."

"You'll miss us though, won't you?"

"Who's this speaking then?"

"Good-bye, Rosa."

"Bye. See you next week. Love to Anne."

That was it. Our gargantuan lunch had been canceled. Instead we had a whole free day to do anything we wanted. Anne was disappointed . . . for about as long as it took to change her expression from momentary glumness to one of a kid with a bunch of free lollipops thrust into her hand.

"Let's go back home and snuggle up by the fire," she said, grinning.

"We didn't light one."

"So, let's light one!"

And thus another one of those all-too-rare freedom began.

* * *

MANY YEARS AGO I wrote a short essay based around this idea of a gift of unexpected freedom. It had happened many times, but one occasion always stood out when, on a whim, we'd canceled one of those weekend-in-the-Caribbean trips at the last minute and somehow managed to get a full refund. In celebration of our unexpected savings, we spent the three days—three whole wonderful, fantasy-filled days—cocooned in our apartment in New York luxuriating in the timelessness of time and enjoying some of the best journeys we'd ever taken together. Journeys into ourselves. In a living room quickly converted, with ceiling-suspended sheets, into a sort of sultan's tent filled with cushions and pillows and surrounded by our favorite books and our favorite gourmet foods. We'd lavishly spent our refund buying delicacies we rarely if ever had the chance to enjoy and wines that we'd always wanted to sample but could never seem to justify the costly indulgence.

So that's how we celebrated our first "WWW"—Wonderful Wacky Weekend: with phones unplugged; blinds closed so that time became fluid, untied to the stages of the day; guitar nearby for impromptu bits of songwriting; a stereo for our favorite music; and notebooks handy for ideas or thoughts or anything else worth recording.

And after it was all over (we spontaneously added another day to the magic of it all) I wrote a story about this odd and wonderful experience, and who should decide to publish it but the *New York Times*, and later the *Washington Post*, and then a number of other magazines, including the *National Geographic Traveler*, which initially had some qualms about printing an "in favor of not traveling at all" piece but did so anyway.

That particular free day in Aliano, of course, was not exactly a full-blown three-day WWW, but it's not so much the amount of time you give these occasions as the kind of mood and spirit you allow to evolve.

I can't remember all the details of that particular occasion (some of them are private and therefore would not seem particularly special to others anyway), but I know they included our reading to each

other; listening to two Beethoven symphonies (as if for the first time); my cooking some odd but tasty "improv" concoctions whenever the mood struck; and Anne mapping out schemes and dreams for the rest of our lives. Well, for the next year or two at least. And so on. Just hour after hour of doing whatever we felt like doing together and wondering why we hadn't done it far more often. I mean after all, we are approaching our senior years—with emphasis on the word *approaching*—and time is not quite so infinite now as it had once seemed way back in our courting days. It had taken on a more considered aspect, an increased realization of its value and its preciousness. And unexpected free days like this one showed just how precious time could really be.

So, thanks for the unexpected snowstorm. And thank you, Rosa, for giving us the best gift of all—the gift of time.

And the gift of giving ourselves to ourselves. Once again.

CHAPTER 11

Closures

Musings on "Traveler's Melancholy"

I suppose I should admit that between all the adventures and the free days and the sheer exuberance of living in an unfamiliar and always intriguing place, there were moments when the mood would suddenly shift unexpectedly and we'd experience the oddest emotions of utter disconnectedness and moroseness.

It doesn't matter where you are or how fantastic the scenery or how outstanding the food or the evening's diversions—in fact, the more boisterous and roistering the setting, the more likely you are to get that sudden, sodden funk of "traveler's melancholy." It usually comes with sideswiping impact when you look around, smell all the unfamiliar smells, see unfamiliar people talking, hugging, and gesticulating in unfamiliar ways, and suddenly you realize that this is their world, not yours. And no matter how kind, considerate, empathetic, and enthusiastically supportive the people of this unfamiliar place may be, you know that, in the end, they will return to their neighborhoods and homes and continue weaving the familiar warp and weft of their own intensely focused lives while you remain the outsider, the observer, the stranger. The ones whom people may be curious about and, if you're found to be inof-

fensive or unthreatening, may smile at or even talk to for a while, before easing back into the comfortable nooks and crannies of their own existence.

And one of your little voices suddenly shrieks: "Take me home!"

Hating to be caught off guard by such subconscious bursts of angst and uncertainty (a fine example of Thomas Jefferson's "twistifications"), the rational mind whips out its list of "reasons for our visit and all our moving about." But it's no use. It's too late. The homesick feeling is out and rapidly turning everything around you rancid and sour with its sharp, pungent images—ridiculously exaggerated, of course—of your own real home, your own family, your pets, your store, pub, park, favorite neighborhood path. You feel this almost irresistible and certainly utterly nonsensical and irrational urge to dump everything, grab a train or a plane or whatever, and arrive in no time at all back in your familiar armchair by the fire with a glass of good wine and the Sunday paper and the aroma of the late lunch roast, and the prospect of a beer or two later on in the evening with a few friends at the local tavern.

Fortunately I realized, the more I read other travelers' tales, that Anne and I were by no means alone in these sensations. There have always been of course eternal itinerant optimists, such as the indefatigable Richard Burton (the explorer, not the actor), whose life seemed a perpetual reflection of his lust for travel: "Of the gladdest moments methinks in human life is the departing upon a distant journey into unknown lands."

Normally I would agree with such a sentiment, but when those odd moments of unexpected moroseness emerge, I find Frances Mayes (*Bella Tuscany*) sums up the dilemma perfectly:

> *I've begun to descend into what I've come to call travelers' melancholy, a profound displacement that occasionally seizes me for a few hours when I am in a foreign country. The pleasure of being the observer occasionally flips over into a disembodied anxiety. During its grip I go silent, I dwell on the fact that most of those I love have no idea where I am or what I'm doing. Then an*

immense longing for home comes over me. Why am I here where I don't belong? What is this alien place? Who and where are you when you are no one?

Diane Johnson (*Natural Opium*) got it right: "Anyone who has traveled has said, in the middle of some desert or in a moment of intense alienation in a souk, 'why am I here?' I have tried to account for these moments of travel ennui or traveler's panic we have all felt—the desperate wish to be transported by instantaneous space/time travel into one's own bed."

Margaret G. Ryan (*African Hayride*) wised up eventually: "I've done it several times . . . come to bed in a dark hotel room fighting depression, if not downright hysteria, and then wakened to sunlight and beauty and thoughts of what a fool I had been."

Gerard Manley Hopkins, however, reveals a more onerous mood: "It can be dangerous to travel. A strong reflecting light is cast back on 'real' life and this is sometimes a disquieting experience. . . . Sometimes you go into your far interior and who knows what you might find there."

Alain de Botton (*The Art of Travel*) suggests other shortcomings: "A danger of travel is that many see things at the wrong time, before we have had an opportunity to build up the necessary receptivity, so that new information is as useless and fugitive as necklace beads without a connecting thread."

Jonathan Raban, one of our favorite travel writers, describes another problem, particularly frustrating to a writer trying to meld his themes of travel and discovery into something approaching coherent verbosity: "Journeys hardly ever disclose their true meaning until after—and sometimes years after—they are over."

Albert Camus turns such adversities into spiritual potentiality:

What gives value to travel is fear. When we are far from our own country, we are seized by a vague fear, and an instinctive desire to go back to the protection of old habits. At that moment we are feverish but also porous, so the slightest touch makes us quiver

to the depths of our being. We come across a cascade of light and—
there is eternity.

"Stripped of all the trappings of home," wrote Sophia Dembling (*Yearning for Faraway Places*), "and with nothing familiar behind which to hide, we are left completely to the resources that live only within us. . . . It is both terrifying and refreshing and always, always enlightening."

And I round out these musings on "traveler's melancholy" and related oddities of travel with Michael Crichton's reminders to himself: "I need new experiences to keep shaking myself up." Pico Iyer has also given considerable thought as to why we travel and has concluded that we do so:

> *initially, to lose ourselves; next, to find ourselves . . . to become*
> *young fools again—to slow time down . . . and fall in love once*
> *more . . . By now all of us have heard too often, the old Proust line*
> *about how the real voyage of discovery consists not in seeing new*
> *places but in seeing with new eyes. . . . But it also, and more*
> *deeply, shows us all the parts of ourselves that might otherwise*
> *grow rusty. . . . We even may become mysterious—and, as no less*
> *a dignitary than Oliver Cromwell once noted, "A man never goes*
> *so far as when he doesn't know where is is going" . . . or as Sir*
> *Thomas Browne sagely put it, "We carry with us the wonders we*
> *seek without us."*

Finally, there's something uplifting in another of Albert Camus's revelations: "In the depths of winter I finally realized there was within me an invincible summer." Isak Dinesen (*Out of Africa*) expressed it more succinctly with her simple affirmation—something that all travelers should write down and carry with them: "Here I am. Precisely where I ought to be."

I think that's the thought we found most useful and uplifting during our (fortunately, very rare) and rarely simultaneous melancholies in Aliano. That and, of course, Carlo Levi's celebration of his

lot despite all the hardships and lack of freedom he suffered during his *confino* there: "An immense happiness, such as I had never known, swept over me. . . . I loved these peasants." And even on the day his official release was announced he wrote, "My unexpected joy soon turned to melancholy. . . . I was sorry to leave and found a dozen pretexts for lingering on."

If Levi could endure all that he had to during that time and still emerge with such a realization of the ultimate positive outcome of his ordeal—his love and caring for the people of Basilicata—then our little moments of uncertainty and confused displacement were barely worth acknowledgment.

So, from then on we agreed to consider them unacknowledged, particularly as we were beginning to dread the leaving of Aliano far more than the staying.

Our Nonmeeting with Maria the Witch

Some experiences—neither melancholic nor exuberant—just dangle like those metaphorically elusive carrots on sticks, shriveling a little in their inaccessibility, but still potentially full of color and flavor.

AND ONE OF our most enticing carrot experiences, the meeting with Maria the witch, had still not taken place. But, in a way, the antics involved in our "nonmeeting" with this increasingly illusionary icon of Aliano's darkside were possibly more humorous and mysterious than any actual face-to-face interview would have been.

Giuseppe, the bank manager, appeared increasingly uncomfortable in his role as self-appointed instigator of the meeting with Maria. At first he'd seemed very enthusiastic about it, and maybe we should have accepted his offer to introduce us to Maria and act as interpreter on the day it was offered, before he had a chance to reflect and reconsider—which he obviously had done on the second and third occasions Anne and I mentioned wanting to take him up on his kind suggestion.

His excuses were masterpieces of mysterious obfuscation: "Maria has not been around recently"; "No one seems to know where Maria is"; "Her neighbor told me she was in, but no one answered the door"; "I think she has been ill" (a case of the physician not being able to heal herself? Or maybe that didn't apply to a "traditional healer"?).

We realized that something had obviously happened, and that Giuseppe was now very anxious to forget his suggestion and his participation in this whole strange affair as quickly as possible. As a perfectionist of polite procrastination and the pregnant pause, he explained: "You know, I don't think I would make such a very good translator. My English is not so good really . . ."; "You know I have a feeling that maybe Maria doesn't want to meet with us." And the real clincher: "To be truthful, I'm not sure it would be a good idea at all to meet with her."

I was tempted to challenge him and ask him why the change of heart, but Anne suggested (with yet another of her quick but full-of-meaning glances) that we should liberate the poor man from his obviously ill-considered offer—which we did as politely as we could. Something along the lines of: "Well, never mind. Maybe next time, when we both come back to Aliano."

The relief on his face was an essay in instant psychological de-stressing. All his little worry lines vanished, and he once again became the smiling, benign, and generous-spirited man we'd first met and liked so much. He searched around in the drawers under his desk and produced a copy of Aurelio Lepre's *Mussolini L'Italiano*, which he insisted we keep as a gift "because you have both shown much interest in the life of this important man of Italian history." The photograph on the book's dust jacket showed the bull-jowled, thick-necked dictator posing in his familiar hands-on-hips, head-back-in-rhetoric-ready manner, and wearing one of his self-designed lapel-less uniforms criss-crossed with leather straps and bound at the waist by an enormous cummerbund-thick leather-and-brass belt. I don't remember our being particularly interested in this oddity of history. More like dismayed by the calamities he had

inflicted upon his countrymen. However, we accepted the gift and had started to thank him, but he was back in his "anything you need" delivery mode, emphasizing that all we had to do was pop into the bank and he would drop everything and help us in any way possible with anything. And oh, by the way, please would we join him and his family for lunch next Sunday at Bar Centrale at one o'clock because he had told them all about us and they would love to meet us. . . .

Maria was never mentioned again.

And what was odd, too, was the reluctance of anyone else in the village to act as go-between with the elusive lady. Once again, the responses ran the gamut from the offhand "She's never home" and "I'm not sure where she lives now" to the more direct "She's not a very nice person"; "She can be very dangerous if you're not careful"; and "She'll give you *malocchio* [the evil eye]". One particular response from someone who had been adamant at dismissing "all that nonsense about Maria and her special powers" was truly surprising: "Listen, it's better you don't get involved with these . . . things."

"But what things?" we asked. "You said it was all nonsense."

"Oh yes, of course, and I believe that. But others think differently. She doesn't frighten me. Never! But other people are very nervous . . . cautious . . . and well, for your own sakes, maybe you should just . . . not try to meet her . . . for just now."

Stranger and stranger. But Anne decided that, as far as she was concerned, she'd rather "forget the whole silly thing and get on with enjoying our life here in the village." I said something like, that's fine with me, but it really wasn't, despite Ann Cornelisen's sensible commentary on modern-day witchcraft in her book *Torregreca*:

> *Every village has one, often a woman, proficient in the art of casting and uncasting spells, of healing mysterious diseases and driving away evil spirits. It has always been a respectable, lucrative profession but it does not attract the young of today. The idea has been embarrassed underground. Medicine has improved.*

Spells have softened into superstitions and the "evil eye" has become a generic explanation for anything not understood.

Despite the apparent declining faith in witches, one dark evening on the way back from the bakery with one of those "medium"—only eighteen inches in diameter—loaves, I thought I'd just saunter past the house near the bank where I'd been told Maria lived.

The air had a slight chill to it. I climbed up through the shadowy, poorly lit cobblestone alleys. No one seemed to be around, at least not in front of me, but twice as I turned to look back after hearing sounds behind me, I was sure I saw doors crack open and then suddenly close.

As I turned the corner into Maria's street a black-clad widow suddenly scurried out of the darkness, almost bumping into me in her haste. Despite the black scarf drawn tightly around her face, I saw a flash of fierce eyes that were distinctly unfriendly. There was no response to my cheery *"Buona sera,"* which was odd because even the most reticent of the village black-clad widows— and most looked as if they wanted no contact with anyone or anything—usually gave some kind of mumbled response from behind their *burqa*-like shawls.

I was approaching what I'd been told was Maria's home, a tiny bare-stone place with an ancient unpainted door. There was a single window, heavily curtained, but a slight chink in the drapes showed there was a light on inside.

Well, I thought, all I'm going to do is say hello. Can't be any harm in that, surely. I'm not here to

GIULIA VENERE (LEVI'S WITCH)

embarrass the lady, just to ask in my still-neophyte ("cute," as Felicia, Giuseppina's daughter, described it) Italian whether Anne and I could arrange to have a brief chat with her at her convenience.

The light went out.

I had just raised my hand to knock on the ancient wooden door and the window went black. I think the curtains may have moved a little, too, closing the chink. It was hard to tell in this particularly dark part of the alley. I could hear no sounds inside. My hand was still raised.

And then lowered. For the very first time I felt a tiny frisson of fear and uncertainty. Was it possible that Giuseppe and all the others who had, for one odd reason or another, felt unable to help me meet Maria had some credible justification for their obvious, and in some cases adamant, reluctance?

There I was, standing with my loaf of bread, waiting at the door of this utterly silent, dark, but obviously occupied, house and wondering what to do next. If I knocked, the knock would be ignored. I was not wanted there. I suddenly felt sure of that. I was definitely not welcome.

Normally my what-the-hell self would have taken over at this point and forced the situation to one conclusion or another. But on this occasion, the often foolishly intrepid part of myself failed to step forward and offer his services. Even he seemed to be saying, "Let it go this time. You can always call again. Maybe in the daylight, or maybe when you return to Aliano later in the spring."

And so I found myself wandering homeward slowly down the dark alleys, clutching my loaf and feeling rather foolish, maybe even a little ashamed at my own trepidation.

But then I sensed—I knew—that Maria's door had slowly opened behind me on creaking hinges . . . and then abruptly closed again, with an angry, cracking slam.

Just like a warning. A definite *procedere con prudenza.*

Celebrating the Old Ways with Roberto Rubino

Another meeting I'd been looking forward to turned out to be far more successful, and encouraging, particularly from the point of

view of Basilicata's possible future "small is beautiful" role in the Mezzogiorno.

"HOW ABOUT A little lunch?" said the tall, elegant, mous-tached man driving his polo-green estate car across the wild, rock-pocked upland moorlands high above and beyond the city of Potenza.

"Fine," I said, but hoping it would not be another of those mul-ticourse marathon midday extravaganzas that invariably left me leaden-framed and siesta-somnolent for the rest of the day.

I looked around. We were on a narrow, winding, watershed road with huge vistas of mountain foothills and the spikey silhouettes of bare, frost-shattered ridges. Deep in the hazy valleys were salt-sprinklings of tiny, whitewashed farms. On the highest peaks, snow-sheened summits looked like melting dollops of ice cream. Fantasy-like hill villages perched on impossible pinnacles, as they did throughout Basilicata, but here, rising out of serpentining mists, their Tolkeinesque flavor seemed even more pronounced.

We continued winding along the ridgetop road, and I wondered where in all that upland wilderness of weather-chiseled strata and stunted grasses one could possibly find a restaurant.

In a hollow, we passed through a remnant of an ancient oak forest.

"Good truffle-hunting here?" I asked the man next to me, who had recently been described in Corby Kummer's intriguing book *The Pleasures of Slow Food* as looking like "the hero of an early 1960s Italian neorealist film, except that he smiles a lot. He even gestures like an Italian movie star, with big, sweeping arm movements and that language of the hands only Italians know." All in all, I thought, a very apt description.

"Oh yes. All around," he said with hands-off-the-steering-wheel enthusiasm. "And I helped start the autumn *tartufo*-gathering here."

There was no boastfulness in his voice, just a simple statement of fact. For that was what Roberto Rubino did for a living: He started things. As director of the regional Experimental Institute for Agricultural Research, linked to Potenza University and the Italian

Ministry of Agriculture, Roberto acted as a catalyst for protecting, enhancing, expanding, and promoting indigenous resources and almost-forgotten processes of agrarian production. Particularly traditional methods of cheese production.

"Everyone told me when I came here that there were no truffles in these forests," he said with a wry smile. "But they were wrong. I had my dog from Calabria, where truffles are everywhere, and we went out together and found many here. Big ones. Lots and lots of them. At first the people did not believe, so I took them into the woods and showed them."

"Seems you had the same kind of battle with your cheeses: making people believe in keeping the old traditional types of cheese and production methods in Basilicata—particularly for your *caciocavallo podolico* cheeses, your 'white cow' cheeses."

"Yes it was—it still is—not easy. You always have to figure on that old negativism. Everywhere. Defeatism. They call Basilicata *marginale*—marginal in quality of land and production and most other things. But I hate that word. There is no marginality here! We can do—we are already doing—so many things and making things better."

"I think Carlo Petrini and his *Slow Food* movement has to fight similar challenges of negativism and indifference—the steamrollering inevitability of homogenized everything."

"Oh yes, Carlo Petrini, a very good man and a good friend. His Slow Food movement is now worldwide—seventy thousand members in almost fifty different countries. What I am trying to do at my institute and with our new organization, Cheeses Under the Sky, and our cheese magazine, *Caseus*, is like what he is creating with his movement. It's all about Slow Food. To grow and produce foods naturally, to let them fully mature, to share them with others in a traditional way as part of everyday life. Carlo calls these "ark" foods and spends much time identifying them and helping to maintain, improve, and market these types of foods. That's what I hope for, too—with, of course, cheeses playing a very big part in all of this. I want to keep all the aromas, flavors, textures, and surprises of cheeses that can differentiate one region, even a single valley, from

all the others. It would be terrible if—what is that phrase that McDonald's uses? 'One Taste Worldwide,' I think, something like that—it would be terrible if that happened."

"But where did you suggest we meet this morning in Potenza?"

Roberto laughed a warm Cary Grant–type of laugh. "Yes, I know. Good joke, eh? To meet in the McDonald's car park. Well, Potenza is a difficult city, so I thought it would be better for you. But you didn't go inside I hope."

"Only to use the bathroom," I said.

"Ah, well, that is permissible. They have very nice bathrooms. Someone told me! But I promise my lunch for you will be far, far better than any fast food anywhere."

Still no sign of any restaurant, I thought.

. . . For the simple reason that there wasn't one.

We drove off the ridge road and onto a rough track, then past a sign reading Azienda Montana Li Foy, and into a farmyard with a huge new barn and pens filled with a fascinating mix of goat species, as I was to learn, from all over the world.

Roberto stood beside me, admiring his flocks. "Aren't they beautiful?" He beamed. "These we use for our experiments in animal husbandry and cheeses. We have Maltese and Ionica—those white ones. The ones with those big twisted vertical horns, like corkscrews—they're Girgentana from Sicily. Those with the really big horns are Orobica, found mainly in Lombardy today. The smaller ones are Sarda, from Sardinia, and my favorites are the floppy-eared ones with those beautiful red coats—Rossa Mediterranea, from Syria. And look at our cashmere goats. Can you see that beautiful wool on their stomachs? Only fifteen microns thick. Top quality."

"And what are those over there in a huddle?"

"*Ma!* Those are Scottish. We bought them recently from a farm north of Edinburgh. But I think they are all sick."

"Not foot-and-mouth disease, I hope! They had a lot of problems with that in Britain recently."

But he'd turned away, disgusted by these new arrivals, and called out, "Lunchtime!"

We entered a simple building that could have been a farmhouse but was used by the institute mainly for onsite courses and "long, slow, dinners." A huge log fire roared against the far wall. A long dining table with benches took up most of the room, and at the far end sat a picnic basket crammed with delights that Roberto was slowly unpacking. "See what I have brought for us—some different local cheeses, my homemade beer and wine, sausages my wife makes, a lovely big piece of *guanciale*, which we'll eat with *bruschetta* using my local baker's bread, some *manteca* [a small ball of *cacio-cavallo*-coated 'ricotta-butter'], and a real specialty . . ." He held up one of the moldiest round cheeses I'd ever seen and stroked it like a newborn lamb. "Our *caciocavallo podolico*, the one we are most famous for. The Podolico cows are a special white breed, originally from the Polish border. Normally it's aged for only up to a year. But this one," he whispered dramatically, "is one of my own, and it's over six years old!"

I will not recount (again) a crunch-by-crunch description of our lunch, except to say that everything tasted even better than it looked. Pride of place indeed went to Roberto's six-year old masterpiece of skill and patience, a pungent golden-cream creation made from the unpasteurized milk of pasture-grazing white Podolico cows and possessing the most enticing aromas and flavors of herbs, hazel-nuts, and pineapple (yes, pineapple!), and distinct overtones of a truly mature parmigiano-reggiano.

Roberto accepted my accolades with professional modesty. "I didn't make all these wonderful things. I just help local farmers keep doing it the way they always have. We learn from them, and in our education courses we pass on their knowledge and techniques along with new research and enhanced processes."

"What makes this *caciocavallo* cheese so special?" I asked.

"Oh, so many things. The free-grazing Podolico cows and their unpasteurized milk, the maturing of the curds in a whey mix in wooden vats, which keep in the special bacteria—that's the kind of thing that makes the EU very nervous! And then the *pasta filata* method of kneading and stretching the curds as they become elastic

in heated water. It makes a very unique cheese—someone called it the institute's 'calling card.' It's what makes people realize that keeping old cheese-making processes alive is totally possible. We have proved it. And we teach this and many other things to over a thousand people a year—farmers, students, hobbyists. Many types of peoples."

"Where do you teach them? Not here surely!"

"No, no, this is just our farm and upland grazing area. The kind of pastures that used to exist on the common land all over Basilicata, when they practiced transhumance—moving the flocks in summer to upland grazing areas. Some still do, but it's a tradition that's fading. We hope to revive it but . . . No, our trainers are in the town of Bella, you will see. We go there now, okay?"

On our way he explained that his great love for traditional cheese-making methods came from his having grown up near Battipaglia, the world-renowned center of true *mozzarella di bufala* cheese-making south of Naples.

"I realized that if you were true and honest to traditions and made the best possible product you could, the world would . . . how you say"

"Beat a path to your door?"

"Yes. That's right. So, when I became director over twenty years ago, I knew we had so many things to offer the world—better cheeses, better aging processes, better animals, better grazing on lands full of wild herbs that give unique flavors to the cheeses. And better work for Basilicatans. The government said we were *marginale*, so they kept sending money and factories down here. But these people are not factory workers, they are people of the land. So I wanted to find a way, a profitable way, for them to stay in their farms and on their pasturelands and produce some of the finest cheeses in Italy."

"And it's working?"

By way of reply, Roberto swung off the highway on the outskirts of the village of Bella. Suddenly, there before us, stood a huge, meticulously renovated Lombardy-style palazzo.

"No, no, not palazzo. Stables," Roberto said. "Built after World War One for the Ministry of Agriculture. The minister was from the North, so he chose this unusual style. We have full teaching and conference facilities here and twenty bedrooms. And over there . . ." He pointed over to the left of the broad lawn campus. "We have pens for the animals—mainly goats, but some Merino sheep, too, and a small herd of buffalo." And there they all were—scores of farm animals frisking, sleeping, and pursuing amorous activities in the warm afternoon sun.

"And we have a dairy, cheese-making plant, an aging 'cave,' and many offices and research facilities. We do a lot of research on animal breeds, but mainly on cheese composition—studying flavor and aroma terpenes to see how to create the best tastes, aging methods, different types of rennet, and improved cheese-making with such other traditional cheeses like *cacioricotta,* made from mixing goat's and ewe's milk. Also we have revived *pecorino di filiano,* an aged hard, sheep cheese; we hope to get a DOP (*Denominazione di Origine Protetta*) certificate for that. Oh, and of course we have our big success in Moliterno, a lovely hill village to the south of Potenza. They once used to age pecorino there in perfect cellar caves. It was very famous in New York and France a hundred years ago, but it faded away. But now we have been able to open up the cellars again, and our trainers are supervising the aging, for years, and hope to make it famous again!"

All in all his institute was a most impressive establishment, particularly the aging cave dug into the campus hillside and packed with dozens of different kinds of goat cheeses. (The distinctive "ammonia" aroma remained on my clothes for days.)

But one room made me lose my journalistic cool—not that I have much of that left these days. It was the Cheese Analysis Examination Room, which consisted of two lines of enclosed booths facing a narrow central passage. Each booth had a little trap door, which could be raised in order to pass through samples of cheeses to be analyzed by students in terms of their appearance, texture, aroma, flavor, strength, and consistency. I tried to imagine twenty or so students—some of whom would be burly hill farmers who rarely left their fields—nervously waiting behind their little trap doors at exam time

to be fed those morsels of subtly different cheeses. A sort of Pink Floyd's *The Wall* meets Pavlov's dogs.

Well, *I* thought it was amusing anyway.

Roberto was chuckling at his own little joke. "You know, I am thinking: These traditional cheeses we are making are so good, so rich, maybe we will have to put a warning sticker on them like cigarette packets—'Danger! If you eat too much of these delicious products of great quality it may be destructive to your health.' "

"Y'know, your job could be pretty detrimental to your health, too. Look at all the battles you're fighting with the big boys—all those researchers fiddling with DNA and creating new animal species; intensive feeding factories with herb-less fodder in 'industrial dairies'; widespread hormone and antibiotic injections; the obligatory processes of pasteurization and 'processing'; that depressing McDonald's 'One Taste Worldwide' mentality; mass distribution systems not geared to local 'specialized' products; the homogenization tendency of the EU and all those other bureaucratic regulators. . . ."

"Oh, yes, yes, I know," Roberto said cheerfully, "and many more. But you know, every time I eat one of our cheeses or see one of our farmers start to make real money with his own traditional cheeses, I feel very happy. And I agree with Schlosser. Do you know his book about America, *Fast Food Nation*? He condemns the plague of the industrialized agricultural system and says we must all push for the 're-localization of food.' "

"Especially in 'marginal areas' like Basilicata?"

"David!" he said, laughing and giving me another one of his extravagant hand, arm, and upper torso gestures. "You must remember—there is no marginality in Basilicata!"

At Last—*Carnevale!*

A truly climactic "celebration of the old ways"—very old ways in this case—began a few days later in Aliano. And there was certainly nothing of Roberto's *marginale* about these festivities. Weeks of gleeful anticipation and secretive preparation erupted into the great annual romp

and communal "roastings" of the pre-Lent *Carnevale*. It came with a flurry of devilish masks; skeletal-white figures; rowdy bands of wandering musicians; sudden dousings of thrown water, flour, and foamy squirtings; all suffused with a feral spirit of surprise, shock, and colorful chaos.

For Anne and me at least (despite the dousings and the squirtings), it was a key event of the year, which wove together so many of the individual threads of our experiences and our gleaned understanding of life in our little village. It was a riotous melding of the "dark side" elements that had added a strange piquancy to our lives, with the villagers' irrepressible spirit of mischief, fun, and pride in their own distinct folkloric and *terroni* heritage.

Other towns nearby celebrated the *Carnevale* in very different ways. Cirigliano offered to its proudly insular villagers a mysteriously intimate, alley-by-alley procession of musicians, oddly dressed characters reflecting village legends and folktales, frantic dancing to accordions, drums, and flutes, and feasting on time-treasured culinary oddities such as sheep's head, pig trotters, and tripe (all of which tasted far better than they sounded).

Stigliano's *Carnevale* was by far the most extrovertedly flamboyant, featuring processions of costumed dancers and musicians and half a dozen enormous and bizarre floats, including a Harry Potter extravaganza; a marvelously satirical Bush–Saddam Hussein creation by some of Sebastiano's teachers, with moving caricatured heads the size of weather balloons; and a witchy peasant tableau inspired, so it seemed, by Levi's vast *Lucania '61* artwork in Matera. Then came something that resembled a macabre graveyard scene, with skull and skeleton-like figures rising and falling and scaring the bejesus out of the children, who clung frantically to their parents in the enormous, laughing and drinking crowds filling the main piazza.

Accettura had a more modest float—just the one—but a highly charged, punkish rock band and frantic dancing kept things lively until the early hours. Giuliano said it was "lotsa fun—like we was all kids again!" Rosa displayed her usual caution but admitted that "it brought everyone together—although it were all a bit daft really."

But Aliano's *Carnevale*, while certainly modest in comparison to Stigliano's, possessed far deeper and darker elements that reflected the bedrock of ancient *pagani* traditions and attitudes there. Levi's description of his own experiences during that unique festival seem as valid today as they were in 1935:

> *The carnival season just preceding Lent, came around quite unexpectedly in these strange surroundings. . . . I saw three white-robed ghosts appear at the lower end of the village and dash up the main street. They were jumping and shouting like maddened beasts, drunk with their own hue and cry. These were peasant masqueraders. Their carnival fancy dress consisted of white robes, on their heads white knotted caps, or stockings with white feathers stuck in them, and whitened shoes. Their faces were covered with flour and they carried dried sheepskins in their hands, rolled up like sticks, which they brandished threateningly and brought down upon the head and shoulders of anyone who failed to get out of the way. They seemed like devils let loose, bursting with savage joy at this brief moment of folly and impunity so different from their usual humdrum and browbeaten existence. . . . They were trying to make up for hardship and enslavement with a parody of freedom, exaggerated, but reflecting their repressed ferocity.*

While the degree of repression and "enslavement" had obviously been much modulated since the thirties, there certainly remained a spirit of "devils let loose" in our little community.

They were everywhere. Frighteningly bedecked in garish, devil-like masks, with enormous horns and swirling *cappelloni* (head-dresses) of colored ribbons, hundreds of them to each mask, they tore around the piazza and Via Roma, chasing the villagers with sticks and whips, all the way down the *corso* and into Piazza Garibaldi. Shouting and screaming like the mad animals they were, they threatened everyone with fiendish clubs, ridiculed the village's higher-echelon "Don Luigis" (a permissible activity apparently for

this brief and bizarre rite), and encouraged youngsters to join them in their pernicious pranks, water-dousings, flour-throwings, and squirt-can antics.

The village was in chaos despite the laughter and exaggerated screams of the devils' victims. Cars, doors, and windows became smothered in squirted goo; dogs and cats ran frantically for cover, cowering in shadows; shopkeepers closed early to protect their precious hordes of goodies; and the local police kept well out of the way behind the thick, wooden doors of the *comune* (town hall).

Even the good Don Pierino, usually prime instigator of and participant in village festivities, was nowhere to be seen. Giuseppina told us he'd "gone to Rome to see the Pope." Vincenzo Uno whispered that "the poor Don hates all this *pagani* stuff and stays inside watching videos." Aldo, at the Capriccio, insisted that "he'll be keeping record of all peoples being *pagani!*"

Incanto, that dark witchy Alianese enchantment, floated thick through the streets and the shadowy alleys. Despite the tongue-in-cheek antics and attitudes of some of the villagers, Anne and I sensed that the *Carnevale* reached deep into their collective consciousness, releasing memories and myths of once-strident peasant rebellions against the stranglehold of the local *padroni* and "petty tyrants." Levi called it a "parody of freedom," and indeed in his day this was the one occasion in the year when the "repressed ferocity" of the *terroni* could be released in a tumult of cutting satire, overt disrespect, and even occasional physical confrontations. The local phrase *"a Carnevale ogni scherzo vale"* says it all: "Everything is permissible at the Carnival."

But the borderline between satire and more severe actions is sometimes thin and tenuous. And even today, after all the land reformations and social-assistance systems for the poor and for the Mezzogiorno as a whole, we could sense the ongoing frustrations of the villagers. They knew about all the petty corruption that still nibbled away at village coffers; the disappearance of the youth to the fleshpots of the North and beyond; the dispirited emptying and slow decay of the houses, creating a potential *città fantasma* (ghost town)

where there was once a thriving community; the increasing regularity of funerals for the aging villagers; the strutting popinjay pomposity of the "petty tyrants"; the cushy "early-retirement" scams of the *statali*; the entrenched power of the secretive *gens*; and the black farce of Italian authority from the most mundane village level to the peaks of national political power.

They knew all this and so much more. And they cheered as the devils attacked and parodied the rich and the powerful. And they laughed and shouted at the improvised village *sarcastica* theatrical production, the *Frase*, in the piazza, which ripped the scabs off festering wounds of economic inequality, corrupt justice, avaricious tax collectors, and the moral degradation of social institutions.

We watched that particular event from our terrace along with a

ALIANO CARNEVALE

gathering of friends we'd invited over for a thank-you dinner before our imminent departure. Although much of the dialogue was in the local Alianese dialect, we could tell just by watching the expressions on the faces of our friends—Sebastiano, the two Giuseppinas, Bruno, Margherita, Tori, Rosa, Giuliano, Massimo, Antonio, Graziella, and many others—that the scenes being played out on the rickety stage below us were tantamount to rebellion.

Afterward, when the play was over, the devils roared about the streets again and the musicians fluted, screeched, and fiddled, and the *cupi-cupi* droned. (This bizarre instrument is played by rubbing a stick through a hole pierced through the center of a hide skin wrapped tightly around the top of a flowerpot-like vessel. It gives off eerie, echoey sounds—something like a bass and drum combined.)

Other strange allegorical figures emerged, too, just as Levi described:

> *Ghosts beat without mercy anyone that came into their grasp, no matter who they might be . . . the barriers between gentry and peasants were down. They leaped diagonally from one side of the street to the other, shouting as if they were possessed by evil spirits . . . like savages run amuck or the performers of a sacred dance of terror.*

Skeleton-like figures appeared with white painted skull masks, along with odd characters dressed completely in black with tall stovepipe hats. Youngsters in capes and ghoulish headdresses—embryonic shape-shifters—pursued virginal (or so it seemed) maidens dressed in traditional peasant costumes of flowing white blouses and long black skirts. Others flounced about in 1940s-style clothes (possibly a reference to Levi's era) or parodied the ostentatious dress of *padroni* families and overuniformed officials. And every once in a while screaming, witchlike characters—*streghe*—would fly out of the shadows, scattering the crowds and scaring the children, and then vanish up the now night-black alleys.

Our friends on the terrace, despite their generations-long

Basilicatan heritage and their familiarity with all its *pagani* associations, seemed confused, even a little alarmed, at the tumult and occasional moments of terror in the streets below.

"This is . . . powerful stuff," Sebastiano muttered, always intrigued by local myths and traditions.

Rocchina nodded and looked dumbfounded by the cacophony in the piazza. "They have other things here—like the festival of Aliano's patron saint, San Luigi Gonzaga—that bring many Alianese back home for a few days. And the *Viaggi Sentimentali* events all around the village celebrating Levi's book. But this . . . this is the real stuff of their heritage from *il tempo fuori del tempo,* 'the time before time.'"

"Wild, wild!" Margherita said and vanished downstairs to reenter the fray while Tori watched her with that constantly bemused expression of his.

"'Ave y'tried my wine yet?" Giuliano asked, always focusing on the hedonistic side of life. "S'one of m'best."

Rosa ignored him and stood, rigid as a stone, watching the kaleidoscopic antics and saying nothing. I had the feeling she preferred to celebrate *Carnevale* in the more demure Accettura fashion.

Massimo was happily tipsy, smiling his cherubic smile and dancing across the terrace with whichever of our lady friends was willing to risk her dainty feet to his somewhat unsteady boots. Finally Graziella grabbed him and, despite the fragility of her delicate pointed-toe shoes, showed him that even an intoxicated buffoon could do the cha-cha if he allowed her to lead.

The two Giuseppinas were huddled in the corner by the woodpile, apparently ignoring the riotous ancics below and discussing matters of serious village gossip (many new "scandals" would emerge after the festivities were over). Bruno, like Giuliano, was seriously into the wine and dismissed all the frivolities below as "ridiculous . . . barbaric!"

As I expected, Antonio gave a more eloquent and considered summary of the whole strange spectacle. "It's pure Dionysian! It has the spirit of our ancient Greek—*Magna Graecia*—festivals for the God of Wine, Dionysus—Bacchus. It's a time for letting go, a devil-may-care spirit of getting drunk and being overtly sexual. Just look at the

phallic shapes of the noses, chins, and horns of those masks. And their underpants! They wear old long johns, *cauzenitt*, and other whatnots on the outside of their costumes. But it's also got some of our local shape-shifting elements—men being transformed into creatures, men turning into women, little girls becoming *streghe*, witches. And watch the people. See how they're laughing? But you can tell some are frightened. These beliefs and fears are still around even though the teenagers treat them as a bit of a joke. But to many it's not a joke at all. It reminds them of the old 'dark ways' and all the terrors of the unknown, and the night."

We had a close friend from the United States—Celia—visiting us for the week. Her reaction was a mix of bemusement, disbelief, and entrancement. "It's amazing . . ." was her first reaction, followed by, "You know, maybe I'll stay a bit longer."

Anne laughed and said what we both were thinking, "That's just the way we both feel."

EVENTUALLY, as the festival roared on into the night, we left the chill of the terrace and sprawled ourselves around the living room, sampling the homemade wine brought by each family. I'd explained that there would be no formal dining table seating that night and no Italian dishes would be served. Not a single one. I didn't have the audacity to compete with the highly nuanced subtleties of my friends' cuisine. Instead I had an "improv-blast" in the kitchen, concocting a host of obscure "fusion" dishes featuring elements of Thai, Indian, Chinese, French, and even a little British flavors and ingredients (thanks to Matera's Carrefour hypermarket), and serving them, *degustazione* style, in small portions.

And it worked—at least, I think it did—because there followed two hours of reassuring murmurings of pleasure, and nothing was left over, not even one of my oddest concoction: wafer-thin chicken breast rolled enchilada style around a rich stuffing of duck *foie gras* and crushed pistachios, quickly sautéed in "black butter" with capers, garnished with tiny strips of ripe mango, and served with cognac-flavored blinis!

The remainder of the dishes I'll leave to the imagination. (That's the problem with my improv cooking: I rarely keep notes and by the following morning I have forgotten half the creations I'd dreamed up.) Suffice to say, hours later, by the time the party and all the toasts to enduring friendship were over, our little gathering slithered together down the staircase to the door and out into a now-silent piazza, happy, giggling, and waving.

Anne and I watched, smiled loopy smiles, and quietly thanked this strange little village and our bizarre corner of Basilicata for all its abundant gifts.

Full Circle—Beginnings and Endings

Sometimes those frenetic *Carnevale* celebrations mark an early start to spring—a riotous last fling to lighten the long lenten days. Unfortunately, this year winter would just not quit. A sullen, shivery grayness settled over the mountains and stuck in the canyons. On most days, all we could see from our ice- and snow-bound terrace was a miasma of freezing mists, which made our isolated village feel even more remote and cut off from the rest of the outside world. Reading together, sprawled on a mattress in front of our cozy log fire (I had finally mastered the subtle art of fire-making using our hard-to-burn logs), became a prime activity of our days. Cooking up big bean-and—root vegetable soups ran a close second, along with listening to the three great Bs—Beethoven, Bach, and Brahms. A dinner out with friends became the highlight of the week, but even amid all the wine- and grappa-induced merriment, ran threads of winter blues that were hard to dispel.

BUT THEN one day in March, things changed. . . .

A fly. A single, common garden housefly. That's all it takes. A fly on the wall by our bed, admittedly looking a little shaky as it waddled toward the ceiling, but a fly nonetheless. The first we'd seen in months.

There is also something strange in the air today.

And not only in the air, which is unusually clear—the light almost
Venetian crystalline—but also in the sounds of the village.

Because there aren't any. And no one on the streets either. As
we stand on our terrace overlooking the piazza, we're surprised,
almost alarmed, by the absence of cars—particularly Aliano's pro-
fusion of ancient *cinquecento* (the indomitable "little mules" aka
Fiat 500s); the rackety scuolabus; those noisy *motorini*, trac-
torettes, and Apes; the dogs, peddlers, trilby-hatted octos on their
benches, street sweepers, gossipy groups of women in doorways,
and other women polishing steps or brushing the minutest
flecks of dust from their personal bits of sidewalk; and most
surprising of all, none of those endlessly scurrying black-clad
widows.

At least the bakery is open. We can smell that always enticing,
early morning aroma of their fresh-baked delights, from enormous
four-pound rounds (just about the shape and size, I imagine, of pre-
historic mammoth droppings) to those deliciously airy, fist-sized
bread buns. But, odd again, there's no sign of anyone popping in for
their daily basics.

Surely we don't have another fiesta in progress that someone
forgot to tell us about? We can't blame Massimo this time because,
for him, Aliano is just about as back-of-beyond as you can get,
despite the fact that it's only an hour's drive from Accettura. And
not Sebastiano either because he's off somewhere at one of those
"let's revolutionize education" conferences that make headmasters
deservedly feel so much better about their roles as creative catalysts
for change in their local improvements, but unfortunately don't
always seem to result in many real widespread changes at the
national level .

But that doesn't alter the fact that this silence and absence
of . . . anything . . . is rather disconcerting. In spite of our occa-
sional tirades about the regular morning flurry and din, which often
curtails our required seven hours of sleep (we're late-night people,
devouring books often until the early hours), we suddenly miss all
the normal village tumult and the little morning rituals of life here.

Winter

457

We've got used to them, I suppose, with a kind of "when in Aliano" acceptance. And, of course, despite all our ever-increasing network of local friends and acquaintances, we're still outsiders here, observers, so what right do we have to carp about whatever happens in the village? It's been going on for hundreds of years. And, after all, work starts early in Aliano, especially if you've got tiny fields and orchards to tend and nurture, often miles away, deep down and way across those hazy *calanchi* canyons.

And yet, despite all the strange silence, it is an exceptionally beautiful day. And unusually warm for a late-winter morning. What breezes there are brush past our faces like soft, diaphanous silk. And they possess an aroma, a perfume, very different from the winter morning pungency of wood smoke from a hundred chimneys and homes desperately trying to generate enough heat to lure lazy risers out of bed and into cold kitchens and bathrooms. I'm not very perceptive when it comes to aromas and the like, but I would say this is definitely a blossom of some sort. Maybe almond. They say almond is always the first to flower around here in the early spring. And then cherry, although we don't have many cherry trees in these parts. And then the fruit trees, the apple and pear trees particularly. But they come much later on, when the trees are convinced that the season has really changed and that they won't be zapped by a sudden snap of frost or a flurry of hard hail that would destroy the delicate flowers and threaten the quality and quantity of the summer's cornucopia.

But it's not spring, my little calendar-controller reminds me. Why, only four days ago we were skidding around on sneaky patches of ice on the cobbles and cursing the biting winds that made a stroll to the local store for milk and eggs tantamount to an arctic expedition.

Well, that's as may be, argues my little optimist. But you've got to admit, it really does feel different today. Even your body feels livelier, less stiff and creaky than usual. And the coffee seems to taste better. And we're not wearing thick anoraks as we stand here together gazing out at the Pollino massif, so crisply profiled and devoid of haze that we feel we could almost walk to its snow-sheened summit in a brisk morning hike.

And you know, I'm thinking, I like this. I like the silence and the stillness. And I like the sense that, after those long months of early evening darkness and constant battles with our recalcitrant fire in the living room, and walking around the house in thick jogging-suit clobber, our slowly revolving globe may just be inching over a little in its wobbly circumnavigations and allowing the sun more direct access into our tiny cranny of the world.

And there is color too—a pure, Wedgwood-blue sky, softer than a late spring or summer blue (on some summer days the sky is almost white against the blinding sun), but still a real blue from the Stigliano hills, across the whole of the *calanchi* and the valleys and the foothills and out over the Calabrian ridges, making them sharp as razors in the crystalline light. And the sun is giving off a soft, rich heat that is so different from the crisp chill of clear winter days. We can almost smell spring in the warmth. And it is barely nine A.M.

Then everything changes.

The church bells across the piazza suddenly begin frantic peals of celebratory chimes and the massive oak doors are flung wide open, and out they come: the octos, the black-clad widows, the mums and dads and schoolchildren and teenage nymphettes and punky boys, and the whole panoply of people who made up our potpourri village populace. Here they come, pouring out across the piazza in what, from my terrace, looks like the linear pattern of neutrons and quarks and all those other "strange" particles that appear out of nowhere when atoms collide in those enormous accelerator machines. And off they scatter, up the streets and alleys with the speed and lightness of step that seems so different from their usual sluggish winter meanderings.

I see Giuseppina heading across the piazza to our home and I wave. She looks up and gives a wonderful, warm smile.

"What's happening?" I call out.

She pauses, then opens her arms wide and calls out, "It's spring coming, David. *Primavera!* It's almost spring! We celebrate."

And I smile and think, yes, yes, indeed it is. And suddenly the world feels fresh, vigorous, and full of new possibilities. As do I.

Especially when Anne emerges on the terrace with fresh cups of coffee and gives me a hug and murmurs softly, "There really is something lovely in the air today, don't you think?"

UNFORTUNATELY this shift in the seasons was also the time for our departure. The date was fixed. We had to fly back to the U.K. to visit family, and then on to Japan, where Anne would resume her teaching. So, despite the rapidly improving weather, our mood became progressively more melancholic as our days in Aliano grew fewer.

On the morning of our departure, following a flurried week of feasts and tearful farewells (lots of *buon fine, buon principio,* "happy ending, happy beginning" wishes), Anne and I sat together quietly on our terrace for one last time, watching the village come to life in its normal ritualistic fashion. We were reminiscing about all our experiences and the kaleidoscopic range of things we'd learned over the months there. We realized that Aliano had given us abundant gifts of understanding, pleasure, and occasional "dark side" terrors. And even before we'd left, we were beginning to miss our house, our friends, and the way of life there that had opened up so many previously dormant aspects of our lives. And we were tantalized, too, by all the unlinked, incomplete threads of our experiences—the fact that we had yet to meet the elusive Maria, our village witch; enjoy Accettura's strange and very pagan *Festa del Maggio,* which features the ancient fertility rite of "marrying" an oak and holly tree; spend time trimming the vines and olive trees on Bruno's farm over in Sant' Arcangelo; and complete our "Farm Diary" of all the tasks your average *contadino* family had to do to maintain its proud self-sufficiency.

There were also many other things still to be learned: where to gather the best wild mushrooms in the fall; how to hunt boar in the winter; what the local mayors would finally do to try and reinvigorate their small village economies (and, in Aliano, rebuild that bridge!); how to cook a real *testarella di agnello*—sheep's head stew—(sounds ghastly, but if you close your eyes it's utterly delicious) and *stracotto di asinello* (slow-baked baby donkey!); how to play that raucous card

game *scopa*; how to make perfect pecorino cheese from fresh, still-warm sheep's milk; and how to deal effectively and without blowing a gasket with the utter *mistificazione* of the Italian bureaucracy's endless and inane rules and regulations.

All these things and so many, many more we had yet to understand.

And as for the fortunes and futures of our friends, so many questions and uncertainties. Would Giuliano's kiln and his pantile-making prevail over the apparent disinterest of the locals? Would Sebastiano's visions for "a new era of education" burst through the bottlenecks of bureaucratic controls? Would Margherita's and Tori's olive orchard survive more poor harvests? Would the schemes and dreams of Don Pierino and Aliano's young and ambitious mayor, Antonio Colaiacovo, ever become reality? Would Antonio, the photographer, find a reputable publisher for his book? Would Nicolà's farm become the "desert" he dreaded? Would Massimo ever get married? Would we taste Rosa's Sunday lunch again? Would anyone ever finally capture a local werewolf? And on and on.

And to add to our list of "things incomplete," who should call that last morning with his farewells but Antonio, as usual gasping with delight and enthusiasm at some new discovery. "Anne, David, you won't believe . . . I have just beaten Graziella's father three times at *scopa*, so now he respects me I think, and he may approve of my relationship with his daughter. At last! Oh, and you won't believe . . . I've just found the dragon's horns! Yesterday! Big, big horns. And part of its skull. You must come see! You remember that story we both read about the Prince of Colonna who lived in Stigliano in the Middle Ages who came down into the valley and killed a huge dragon there who had been eating virgins and all that kind of thing?"

"Yes, yes, I remember. I looked for the horns too but gave up and decided it was just another one of those local fairy tales."

"Well, it's not y'see. The horns are here, and the skull—hidden in this warehouse, because they've been renovating the church where they used to be displayed."

"Antonio. This is fantastic. For you. Unfortunately we're leaving in less than an hour."

Antonio didn't seem to hear me. "And the current prince—a direct descendant—Sebastiano and I have found him, too. He lives in Ireland, but he's agreed to come back to Aliano so I can photograph him for my book, and he very much wants to meet you both. . . ."

FOR A MOMENT, just a moment, we almost canceled our departure. We were not at all sure we were ready yet for the "real world"—a world without dragons, werewolves, and witches. But then we realized that, even if we stayed longer, we'd never stop unearthing new stories and experiences there.

So we gave thanks for all we'd gained, promised ourselves we'd return one day (soon), and wondered, after all those months, whether we really had discovered Levi's "magic key." The only way, he suggested, that one could enter and understand this strange and remote world.

Well, we decided, we'd certainly discovered the lock and explored that in considerable detail. A very complex lock, too. And I think we were offered the key, or at least a choice of different keys, on a number of memorable occasions. But none seemed to fit entirely comfortably.

NO, I'M SURE we have yet to discover the "magic key." In fact, I'm not even sure there is a single magic key. Mezzogiorno *catoni*, *mezzadri*, *braccianti*, *terroni*, and *contadini*—all once referred to somewhat dismissively as "peasants"—are not a collective mass. Certainly there still exists a tight social cohesiveness reflecting the words of Petrarch: "The burdens and the chains of serfdom / are sweeter than wandering alone." But despite the intimacy of village life and a generational intermingling that vanishes into unrecorded time, they are all still individuals, each with his or her own story and views on things and on life in general (the octos in their daily and often furious debates by the war memorial are proof enough of that).

And each individual has his or her own key. Each individual must find his own lock. Many to enter, but many also to escape. Escaping has become a way of life here, particularly for the young of Aliano, and across Basilicata as a whole. For the older men and women it's not really a choice, but they don't seem to mind. Here is where their lives have evolved, individually and collectively. And for them to leave at this point—while they might exist more comfortably else-where with their families or even in institutionalized settings—appears not to be an option worth considering. This is where most choose to remain.

So, maybe that's the real key—their deep, passionate, almost genetically imprinted love for this wild and, in many ways, untamed place. Love possibly once again is the key. Maybe a love that is not always easy to understand, but love nonetheless. Maybe different from what we normally know as love, but after our many months here, we feel we can at least begin to discern the outlines and inten-sity of that underpinning emotion.

Dag Hammarskjöld wrote, "Love is the key, the outflowing of a power released by self-surrender." Thomas Merton suggested that "love means an interior and spiritual identification with one's brothers." And it is indeed this combination of self-surrender to the flow of our experiences and our identification with the lives, events, feastings, and oh-so-human foibles and fears of our friends here, that made our time in Aliano so rich and memorable.

Once again, Anne Cornelisen captures the mood and truth in her powerful book *Torregreca*: "Lucania is real, and so are the Lucanians, who struggle today as they have for over 3,000 years, to wrest an exis-tence from the rock and clay that makes up their world."

And, of course, once again, there's Pico Iyer, that renowned travel writer–philosopher, who believes that "all the great travel books are love stories, and all good journeys are, like love, about being carried out of yourself and deposited in the midst of terror and wonder." Here in Basilicata we enjoyed generous dollops of both, in addition to all the unceasing kindness, generosity, and love of so many newfound friends.

Thus, just like Rumi ("the only reason we are here is to love") and certainly like our spiritual mentor, Carlo Levi, we have learned to love the people here, and in doing so, have discovered aspects of what he described as the "Lucania spirit in all of us"—the spirit that links the deep and ancient *terrroni* elements in every human being, in every part of the world. And maybe that is enough.

At least for the moment.

Va bene.

ALIANO—ENDURING, ONGOING ...

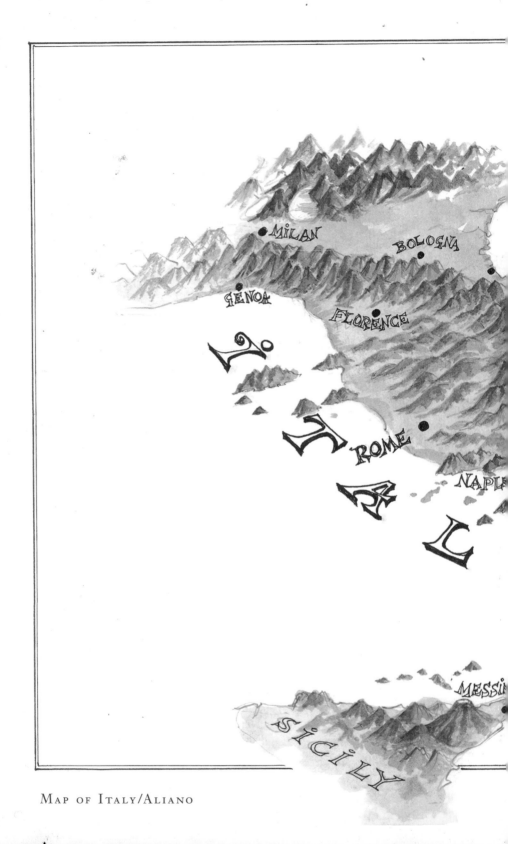

MAP OF ITALY/ALIANO